Walkers in the City

For Robbie,
with the hope that you enjoy
these photographs,

David D. Moore

Walkers in the City

Jewish Street Photographers of Midcentury New York

DEBORAH DASH MOORE

 THREE HILLS

AN IMPRINT OF CORNELL UNIVERSITY PRESS

ITHACA AND LONDON

In chapter 4, five photographs from Vivian Cherry, dating from 1947 and 1948, are presented. The images depict the transgressive play of children that references heinous practices such as lynching and ideologies such as Nazism. Cherry's photographs document and criticize the violence embedded in post-WWII culture and society. Cornell University Press reproduces and presents these images and Deborah Dash Moore's commentary in the context of academic engagement.

First published 2023 by Cornell University Press

Printed in China

Design and composition by Chris Crochetière, BW&A Books, Inc.

Library of Congress Cataloging-in-Publication Data
Names: Moore, Deborah Dash, 1946– author.
Title: Walkers in the city : Jewish street photographers of midcentury New York / Deborah Dash Moore.
Description: Ithaca : Cornell University Press, 2023. | Includes bibliographical references and index.
Identifiers: LCCN 2022023459 | ISBN 9781501768477 (hardcover)
Subjects: LCSH: Photo League—History. | Street photography—New York (State)—New York—History—20th century. | Jewish photographers—New York (State)—New York—History—20th century.
Classification: LCC TR659.8 .M66 2023 | DDC 779/.409747 23/eng/20220—dc29
LC record available at https://lccn.loc.gov/2022023459

For Mac partner in life and love

contents

ix Acknowledgments

 1 Prologue: Reframing New York

11 1. Toward a New York Document

45 2. Looking

75 3. Letting Go

109 4. Going Out

139 5. Waiting

181 6. Talking

203 7. Selling

233 Epilogue: A New York Family Album

243 Appendix: Photographers

253 Appendix: List of Photographs

257 Notes

275 Selected Bibliography

281 Index

acknowledgments

MacDonald Moore began taking photographs as a teenager, much like many of the Jewish photographers in this book. When we moved to New York City after college, Mac became a walker in the city, carrying his single-lens reflex camera with him over his shoulder, seeing the city through its eye as he got to know New York. He developed film and printed photographs in our bathroom and kitchen. Unlike this book's street photographers, he also invented a lens holster, which he patented, to carry an additional two lenses so he could easily switch them out on the camera. He shared his interest in photography with me over the course of many decades, and I learned from him not only some of its technical requisites but also theories of interpretation. This book has benefited from his knowledge in its conception, interpretation of images, and felicity of expression. In many ways, it is his book.

Walkers in the City experienced an extraordinarily long gestation, approaching two decades. Although I associate my work on the book as beginning with my move to the University of Michigan in 2005—my inaugural lecture for my Frederick G. L. Huetwell chair in history was titled "Imaging Gotham"—in truth thinking and writing down ideas started even earlier. Given the many years involved, acknowledging everyone individually who contributed to my thinking and understanding of New York City photographers would inevitably overlook many people. My alternative—to thank everyone collectively—is far from ideal, but I hope that these contributors, as readers of this introduction, will recognize themselves in one or two of the collectives and understand how much their insights contributed to shaping this book and how grateful I am for their thoughts and criticism.

I was fortunate to benefit from two academic year fellowships that explored different contexts for understanding New York Jewish photographers. The inaugural year of the Jean and Samuel Frankel Institute for Advanced Judaic Studies "Jews and the City" (2007–8) helped launch this project. I remain indebted to the lively discussions among its participants as well as the opportunity to co-curate an exhibit, *Jews and Urban Photography,* with Mac. Thirteen years later, a similar year, "America's Jewish Questions" (2020–21), at the Herbert D. Katz Center for Advanced Judaic Studies challenged my arguments. Katz fellows pushed me to refine my analysis, for which I am most appreciative. On a smaller scale, I benefited enormously from responses to

presentations of research in progress before varied audiences at the annual conference of the Association for Jewish Studies, the Yiddish Book Center, the Creole seminar in American religion, the Hebrew University of Jerusalem, where I delivered the Paley Lectures, the Association for the Social Scientific Study of Jewry when I received the Marshall Sklare award, and the conference of the European Association for Jewish Studies.

Despite this book's long evolution, I have published relatively few essays related to it. Some material was previously published in "On City Streets," *Contemporary Jewry* 28 (2008): 84–108; (with MacDonald Moore) "Observant Jews and the Photographic Arena of Looks," in *You Should See Yourself: Jewish Identity in Postmodern American Culture*, ed. Vincent Brook (New Brunswick, NJ: Rutgers University Press, 2006), 176–204; and "Walkers in the City: Young Jewish Women with Cameras," in *Gender and Jewish History*, ed. Marion A. Kaplan and Deborah Dash Moore (Bloomington: Indiana University Press, 2010), 281–304. I also wrote about photographs in "Snapshots," the third chapter of *Urban Origins of American Judaism* (Athens: University of Georgia Press, 2014), 112–50. I appreciate permission to reprint text from these previously published works.

Over the years, I relied on wonderful research assistants who helped with manifold aspects of the project. They researched photographers associated with the New York Photo League, they interviewed photographers, they searched for photographs of New York City, they pored through photo essays in magazines, and they helped to secure permissions. Noa Gutterman, Caleb Heyman, Kai Mishuris, Evelyn Plonsker, Sophie Reed, Avital Smotrich, and Ethan Stancroff did excellent work, and I am grateful for their diligence and discoveries.

Funds to cover the cost of both research assistants and permissions came from the University of Michigan, which also provided a substantial publication subsidy. Its generous financial support meant that I did not face additional barriers in conducting research or securing permissions to publish. I am indebted to the individuals, galleries, museums, and historical societies that graciously granted permission to publish photographs and recognized the constraints of an academic's budget. They are acknowledged in the captions for each image. In addition, I particularly appreciate the exceptional generosity and valuable assistance of Sarah Jacobson at the Howard Greenberg Gallery for granting me permission to publish two dozen of the photographs in this book.

At Three Hills, Michael McGandy's immediate enthusiasm for the book encouraged me immensely. His savvy comments and thoughtful criticisms improved the final manuscript. I am also grateful for the two anonymous reviewers who offered cogent suggestions for a better book as well as welcome praise for things I managed to get right. Deborah Oosterhouse's diligence saved me from some grievous mistakes; I appreciate her thoughtful copy editing.

Several individuals deserve a shout-out for being there for the long haul. Andrew Bush read versions of this book in its various manifestations over several decades, consistently with an encouragement that tempered his critique. Riv-Ellen Prell always was ready to read and to comment and, most of all, to question. I'm not sure that I've managed to answer all those questions, but I have tried. Over several lunches, Rebecca Zurier looked at photographs with me, queried me about them, commented on what she saw, provided valuable leads for additional research, and offered incisive criticism of my interpretations. She then read the entire manuscript with her superb eye and understanding of the New York art world. Coming down the home stretch, Helmut Puff generously critiqued the chapter "Waiting," sharing

with me his own scholarship. At the last minute, Lila Corwin Berman read through the biographies of photographers, catching places where I was unclear and improving the text.

My family has always been supportive of my scholarship, and this is true of *Walkers in the City*. On my desk sits a picture, taken before my talk "Imaging Gotham," of me and my mother, Irene Dash, who made the trip out to Ann Arbor for my lecture. Our sons, Mik and Mordecai, are both walkers in the city, the former with a camera and a keen eye, and the latter with a deep sense of the city's history. Their children—Elijah Axt, Zoe Moore, Rose Moore, and Oren Moore—deserve to see their names in print as walkers in the city who may someday pick up cameras to record what they see and feel.

Walkers in the City

prologue Reframing New York

In the middle of the twentieth century, a young writer and critic published a paean to the world of his working-class childhood in immigrant Jewish Brownsville, Brooklyn. Alfred Kazin called his memoir *A Walker in the City*. It contrasts his memory of wooden tenements, "born with the smell of damp in them," with "America." Westward, just across the East River, sprawled an imperious spectacle of steel, stone, brick, and glass: Manhattan, America's cutting edge. As a young man, Kazin may have crossed paths with some other Jewish New Yorkers as they worked to make sense of New York's neighborhood dynamics with cameras at the ready. Like Kazin, most of these keenly observant photographers were secular Jews. Many were also, or would become, idealistic lefties.[1]

In the late 1930s Kazin discovered the riches of the New York Public Library overlooking Fifth Avenue and Bryant Park and its magnificent, vaulted reading room. The photographers found their far more modest hangout ten blocks south at the New York Photo League, on the second floor of an old loft building with a stamped metal ceiling. Organized in 1936, it offered its members developing, printing, and exhibition facilities. A great place to argue, flirt, and share job leads, the League was a cooperative, a photography club on a mission. Working alone and in groups, these young photographers sought to help fellow New Yorkers better appreciate how they were connected and separated by such variables as age, gender, class, ethnicity, and race. Their ambitious agenda was feasible because a photograph grants each viewer a license to stare, to contemplate, and to respond, potentially intrigued, annoyed, sympathetic, judgmental, even moved to action. The Photo League exhibited photographs at their modest home base, but also in neighborhoods where League photographers had been working. They caught, winnowed, and selectively shared their images of urban interactions. They made exhilarating, unsettling contributions to street photography, reframing the routine improvisations of being among other people in the city. Together, they produced multifaceted, coherent accounts of street life in their rapidly changing metropolis.[2]

Photo League members were not the first photographers to explore New York as Empire City and Melting Pot. At the beginning of the century, lower Manhattan's unprecedented vertical scale challenged photographers as they tried to portray the massive, thrusting power of financial center skyscrapers. Their

visible concentration spoke of wealth and power. This was clear to anyone who looked from across the Hudson or East Rivers, from commuter ferries, or from one of Brooklyn's stupendous bridges. Alfred Stieglitz's photograph *The City of Ambitions* (1910) famously rendered the look and feel of this New York. The Singer Tower dominates the image. Completed in 1908, it was the tallest skyscraper in the world for all of eighteen months. Singer sewing machines facilitated the prominence of the clothing industry in New York City, an industry dominated in the early twentieth century by Jewish immigrants.[3]

Stieglitz initially published *The City of Ambitions* in his magazine *Camera Work* as part of his series of photographs about approaching the city from the water. He called these photographs "snapshots" to indicate that no tripod setup was involved; they were taken quickly with a handheld camera, as an amateur would. Stieglitz had switched from an ungainly eight-by-ten-inch camera to a relatively light four-by-five-inch format. The company that developed these portable cameras was eventually sold to Eastman Kodak, and later to Singer. Stieglitz associated "contemporary New York with the theme of a journey." He traveled from New Jersey across the Hudson River rather than from the borough of Brooklyn, a better-known point of departure for the short trip to Manhattan Island. As a sequence, his photographs "suggest the exhilaration of arrival, of the final moments of a crossing." They culminate in a commanding image of New York rising from the shimmering harbor.[4]

Stieglitz was born in Hoboken, New Jersey, to immigrant Jewish parents. He turned his humble birthplace into a signature of his identity as an American, proudly proclaiming: "I was born in Hoboken, photography is my passion, the search for truth my obsession." Stieglitz tirelessly promoted photography as an art. In his own work, he set out to capture beautiful, moving facts. In these early decades of the twentieth century, he often chose to photograph the world around him, seeing "the changes in the city's physical environment" as measuring his own personal artistic journey in search of truth and beauty. These pictures of New York City expressed his vision of photography's potential as an art form.[5]

Five years later a young Paul Strand brought an explicitly modernist perspective to his photograph of J. P. Morgan's bank on Wall Street. Like Stieglitz, Strand grew up in a prosperous German Jewish household, the son of immigrant parents. Unlike Stieglitz, he attended the Ethical Culture School, established by Felix Adler, son of the Reform rabbi of Temple Emanu-El, the city's leading synagogue. At Ethical Culture, Strand studied with Lewis Hine, who helped to cultivate Strand's lifelong commitment as a socially conscious photographer. Born in Wisconsin, Hine studied sociology at the University of Chicago and Columbia University and pedagogy at New York University. As a teacher at the Ethical Culture School, Hine brought his students with him on trips to photograph immigrants at Ellis Island in 1905, one of the peak years of Jewish immigration to the United States. He also took students to Stieglitz's 291 gallery to look at photographs as art. Strand fell in love with photography. "That was a decisive day," he recalled of his visit to Stieglitz's gallery. Strand continued to take photographs as he worked in his father's business. Jacob Strand supported his son's quest to become a photographer. Many years later, Strand dedicated a book of his photographs to Jacob, "whose faith in my work never faltered from its beginning to the time of his death in 1949. When photography as an art medium was still new and unaccepted he did not doubt its possibilities nor question his son's choice of a life work."[6]

In 1915, Strand took a portfolio of his recent pictures to Stieglitz. Impressed, Stieglitz promised him a show, his first. "It was like having the world handed to you on a platter," Strand recalled. Strand's exhibition

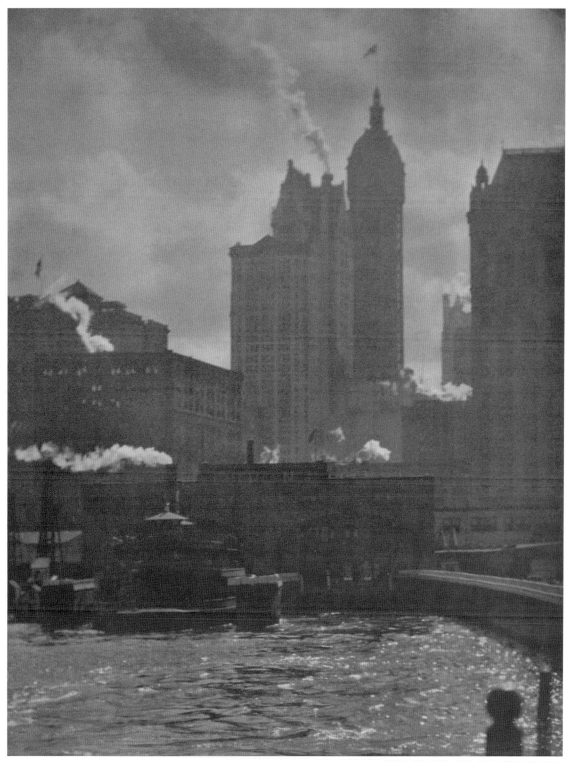

P.1 Alfred Stieglitz, *The City of Ambitions*, 1910. Stieglitz took this photograph approaching Manhattan Island from New Jersey, the culmination of a series of photographs taken of a trip across the Hudson River. Alfred Stieglitz Collection, 1949, The Metropolitan Museum of Art, New York, NY, USA. © The Metropolitan Museum of Art. Image source: Art Resource, NY.

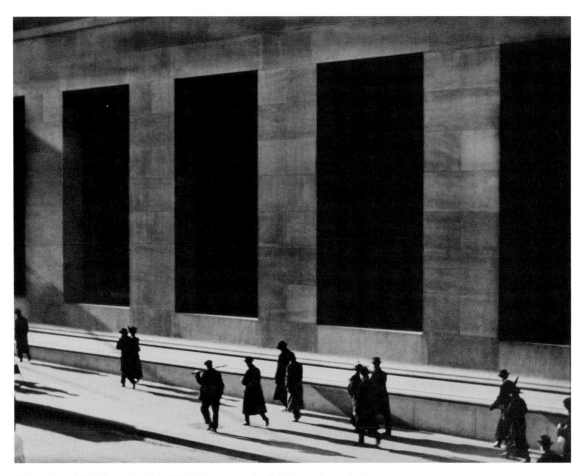

P.2 Paul Strand, *Wall Street, New York, 1915*. This photograph of J. P. Morgan's new bank on the corner of Wall and Broad Streets presents a modernist image of an urban emblem of finance capital. Paul Strand Archive/Aperture Foundation, The Philadelphia Museum of Art/ Art Resource, NY. © Paul Strand Archive/Aperture Foundation.

signaled the end of his exploration of pictorialism, an aesthetic that Stieglitz previously had advocated: "Atmosphere softens all lines; it graduates the transition from light to shade; it is essential to the reproduction of the sense of distance." *The City of Ambitions* is the best known of the pictorialist photos by Stieglitz that characterize New York as an industrial city awash in haze, fog, rain, snow, and smoke.[7]

Strand's photograph *Wall Street, New York, 1915* transforms J. P. Morgan's new bank and its building, recently constructed at the corner of Wall and Broad Streets, into a commanding icon of modern urban power. People and their shadows almost dance against the stolid dark granite of the building's regular recesses, its plate glass windows turned into blank facades. The men, and a woman or two, walk toward the sun, their profiles eerily alike. Strand chose an elevated position to look down on the bank. *Wall Street, New York, 1915* reflects the dominance of New York's robber barons who, with private funds, had saved the American economy after the 1907 financial panic. After World War I, Strand's politics drifted leftward and he became increasingly critical of capitalism. In the 1920s he started to make documentary films that allowed him greater freedom to express his political views. His interests in still photographs shifted away from picturing the city, inclining instead toward even greater abstraction.[8]

Twenty years later, Berenice Abbott, in her 1935 photograph of the uptown Garment District, *Seventh Avenue Looking South from 35th Street*, shows the main artery of the neighborhood that was home to New York City's largest industry. The challenge of conveying the grace and beauty of the city along with its untrammeled capitalism intrigued her. Unlike Strand and Stieglitz, Abbott was an out-of-towner. Born to a non-Jewish family in Springfield, Ohio, she initially came to New York City to study painting. She subsequently left for Paris, where she turned to photography, working as an assistant at the studio of Jewish

American photographer and artist Man Ray. In 1929 Abbott returned to the city. She brought with her the Parisian street photographs of Eugene Atget, having rescued them from destruction after his death. The changes that had occurred during the decade of her absence amazed her. As she later recalled, "I saw the city with fresh eyes."[9]

Her photograph peers into the neighborhood that housed the clothing business, which was the dominant economic engine of New York City for the first half of the twentieth century. The industry had relocated from the Lower East Side in the 1920s up and over to the blocks west of Fifth Avenue and north of 23rd Street. The cooperative construction of the seventeen- and twenty-three-story Garment Center Capitol Buildings on Seventh Avenue and 36th Street spurred the shift uptown. Many factory buildings were twelve to sixteen stories high. Standing side by side like sentinels, these loft buildings darkened the side streets, filled daily with shuttling trucks, delivery boys, men pushing rolling racks of clothes, and thousands of workers. Through its framing and scale, Abbott's photograph communicates the impressive, built environments of the garment industry. Her aerial perspective hides the design and productive flexibility so characteristic of the rag trades.[10]

By the early 1930s, as the Great Depression settled across the country, the center of Manhattan continued to shift uptown. The Chrysler and Empire State Buildings were merely the most spectacular signs that boom and bust were in bed together. The enormous tourism industries that brought eager outsiders into town promoted the city as the epitome of modernity. New York City offered unparalleled amenities and attractions for natives and visitors, women and men. At night, Times Square sparkled, the heart of New York's live Broadway theater and movie palace district. The area's marquees and billboards immersed strolling visitors in flashing, rippling, swirling electric lights. Crowds thronged Fifth

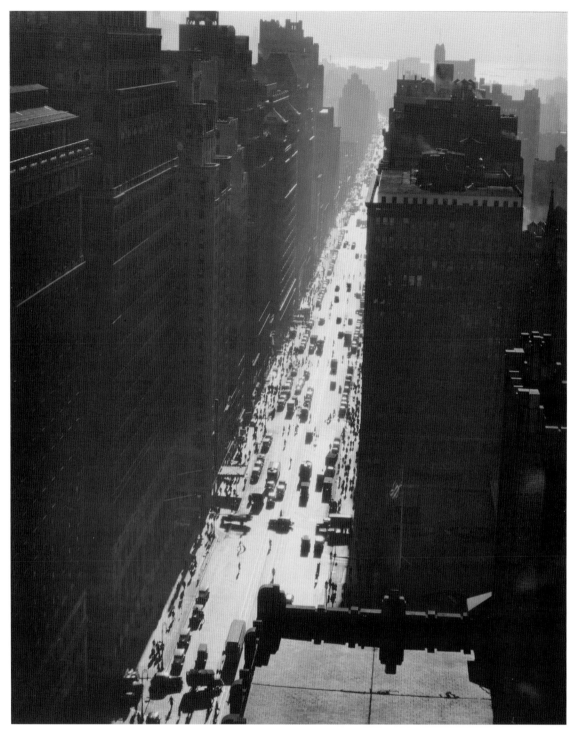

P.3 Berenice Abbott, *Seventh Avenue Looking South from 35th Street*, December 5, 1935. Abbott pictured the heart of the city's uptown Garment District, one of New York's economic engines, from an elevated perspective on the Nelson Tower. Berenice Abbott (1898–1991) for Federal Art Project. Museum of the City of New York, 49.282.240.

Avenue, drawn by elegant department store window displays and by the theatricality of people ogling one another. Magnificent Central Park, ringed by improbably large apartment buildings for the wealthy, tempted visitors and residents with respite from the working city's pace. The park offered winding paths, gracious lawns, placid lakes, and stunning views. Thus New York confirmed its status as America's global metropolis. It lived up to its billing as bold and brash, crowded, complex, filled with contrasts of rich and poor, glamor and grit. New York had become a world-class visual feast for residents and visitors alike.

There was another New York, one that attracted the attention of young American photographers, many of them the children of eastern European Jewish immigrants. Their parents had arrived in the city during the heyday of mass immigration. From 1880 to 1924, when Congress drastically restricted immigration, over a million Jews migrated to New York, part of massive numbers coming from southern and eastern Europe seeking economic opportunity. Then the Reed-Johnson Act of 1924 tightened existing bans on Asian immigration and sharply reduced immigration from eastern and southern Europe.

New York's almost two million Jews made up around a third of its population of 7.5 million in 1940; they were the city's largest single ethnic group. Catholics constituted the largest religious group in New York, albeit divided by ethnicity. While Irish, Italian, German, and Polish Catholics shared a common faith, their very different immigrant backgrounds often generated intrareligious conflict. Only 6 percent of the city's residents were Black. Some lived in Brooklyn or in San Juan Hill, on Manhattan's west side. Most lived in Harlem. Formerly a largely Jewish neighborhood, Harlem thrived as a Black cultural and intellectual center in the 1920s before succumbing to poverty and overcrowding during the Great Depression. Almost 30 percent of New Yorkers were foreign born, a more substantial proportion than in other large American cities. Many of the greatly reduced numbers of immigrants arriving via Ellis Island prior to World War II chose to stay in the city.[11]

New York remained a visibly immigrant city, with many non-English-language signs identifying storefronts. Immigrants and their children made up close to two-thirds of the city's population. Neighborhoods endured as ethnic enclaves deep into the twentieth century. Crowded into densely populated streets with tenement housing, especially on the Lower East Side and in such Brooklyn neighborhoods as Brownsville and Williamsburg, eastern European Jewish immigrants helped to make the garment industry a major force in the city's economy. Their sons and daughters knew a different world.

Born in the second decade of the twentieth century, most of these second-generation Jews grew up in the city and attended its public schools where they spoke English, although many also picked up some Yiddish at home. As native sons and daughters, most came of age in mixed neighborhoods of Jews and Catholics in Brooklyn, the Bronx, and Upper Manhattan. Many lived in modern tenements with steam heat constructed in the post–World War I period, where they shared bedrooms with siblings. Their apartments also had bathrooms, kitchens with ice boxes, and hot and cold running water. For children, their neighborhood blocks were bounded by school and stores, interspersed with local synagogues and churches, and an occasional park. But since Jewish kids went to public school and many Catholic children attended parochial school, these religiously different children primarily encountered each other on the streets. Those streets had their own rhythms, patterns of gendered behavior that children learned.[12]

Second-generation Jewish kids played on the sidewalks and made their way around town on foot

and by public transit. They learned to walk the blocks while conscious of who was behind them, who was hanging out in that doorway, who was approaching. They could interpret gesture and dress, swagger and style among people who would remain a bit of a mystery to their parents. Urban living fostered an awareness of people and place. Girls learned about gendered codes of behavior, how to survive on the street and enjoy it. In short, young people possessed street smarts.

A significant cohort of these young Jewish men and women embraced photography and its possibilities. A camera's basic documentary potential presented an intrepid New Yorker with a world of challenges: how to see, how to re-view the street and make sense of its traditions and its occasional outbursts of chaos. With their urban smarts and small cameras, these aspiring photographers learned to roam safely and productively. As they grew older, they opted to ride the elevated and subway trains beyond their local blocks to explore other neighborhoods across the city. In summertime, some brought their cameras to the beaches.

The discovery of what a camera might do excited these young working-class New Yorkers. With a camera around their neck, they had an excuse to walk unfamiliar streets. Photography gave them a sense of purpose and a reason to leave home. As they learned how to photograph the city's streets and its people, they developed a point of view. They blended personal perceptions, politics, and aesthetics. They married a straight photographic aesthetic—shooting outdoors in natural light—to a left-wing political perspective that highlighted the inherent worth of urban working-class people and their cultures. Drawn initially to witness the city in its multiplicity, Jewish photographers engaged in a fierce dialogue with New York. They "set the terms of discourse, blending into it a tone of activism and melancholy that was recognizable, yet ambivalent and skittish."[13]

These photographers drew upon their upbringing as Jewish American New Yorkers to picture the city's diversity as it swirled around them. Seeing with a camera's eye helped them better understand their city and their status as Jewish New Yorkers. Jewish photographers, the critic Max Kozloff suggests, understood the city as "not so much a place to be described as a setting that poses a question: what is the relatedness of seer and seen, as influenced by the social orders represented by the city?" Kozloff proposes that efforts to answer this question produced a Jewish style of photography. Characteristically these photographs participate in an ongoing search for solidarity, understood not as a fact "to be taken for granted," but rather as "a created and always liquid condition, reversible as a tide."[14]

Touched by left-wing radicalism that flourished among second-generation Jews in the 1930s, these photographers considered photography a social and political tool. It could influence how people interpreted their conditions. A focus on their fellow New Yorkers affirmed the capability of photography to help them grasp their world. And with understanding came the potential power to change society. Photography offered a means to forge connections with fellow New Yorkers, people both like and unlike these Jewish photographers. It opened a path of association at a time of social and economic dislocation. These photographers documented the lives of those they considered most vulnerable to the riptides of capitalism in a multiethnic metropolis.

Jewish street photographers shared the experience of maturing during the Great Depression, a repertoire for interacting with non-Jews, and politics that leaned distinctly leftward. Most graduated from high school; some, from college. Both were free in New York City. Educated by the city's public schools, they were not children of privilege. Several lost their fathers when young, through death or

desertion. A few of the women lost their mothers to death or depression. Informed by their working-class experiences, they came to share a social aesthetic of photography. What types of photographs were worth taking? Under what circumstances should one take or not take a picture? These street photographers weren't drawn to New York as Gotham or Metropolis, the magnificent cityscape that spoke so powerfully to Stieglitz, Strand, and Abbott. Visions of capitalist modernity did not grab them. They focused, instead, on working-class people in their own neighborhoods where they lived, worked, and relaxed. As

street photographers, they pictured public spaces, mostly outdoors, occasionally indoors in cafeterias and waiting rooms. In the process, they produced a distinctive portrait of the city based on eye-level interactions and attuned to stories that unfolded daily on the streets. Walkers in the city with cameras, they presented a Jewish vision of New York, a place they claimed as their hometown.

This book invites readers to walk the streets of mid-twentieth-century New York City during the decades when it was a working-class and, in its politics and culture, pace and style, a Jewish town.

1. Toward a New York Document

Beginning in 1936, many aspiring Jewish American photographers, men and women, began to find one another at the New York Photo League. This photographers' cooperative was simultaneously a hangout, darkroom, photo club, exhibit space, advocacy group, and school. The League "served its members' social, intellectual, artistic, and political interests." Jewish connections through friends and acquaintances, high school and college, gradually forged an ethnic network of young women and men dedicated to picturing the city. And for them, unlike Alfred Stieglitz, Paul Strand, and Berenice Abbott, that meant its people.[1]

Two young working-class New York Jews, Sid Grossman and Sol Libsohn, teamed up to launch the New York Photo League by refashioning an existing photographers' cooperative. Libsohn later recalled that he and Grossman "were involved in left-wing stuff in City College of New York." They met in the cafeteria alcoves where political debate flourished. After having collaborated on a literary magazine, *Naivete*, they both joined the Workers Film and Photo League, located in a run-down loft building at 31 East 21st Street in Manhattan, north of Union Square. They wanted a darkroom, a scarce commodity in the city.[2]

The New York Photo League emerged from the Workers Film and Photo League, established in 1930. Its purpose was "to provide militant workers (and the unemployed) with the skills to create photographic records of the class struggle, to assure a flow of illustrations for radical publications." It traced its origins to a similarly titled 1920s German Communist organization that inspired several Photo Leagues in various cities throughout the United States. Although the New York group dropped the term "Workers" from its name, it remained committed to communist analysis of social problems. In 1934, a subgroup called Nykino formed that focused on documentary films. Two years later, the photography group split off from the more politically engaged film section, encouraged by Grossman and Libsohn.[3]

The new Photo League was internally unstable. Grossman and Libsohn became upset when professional colleagues began to treat the League merely as a job agency, albeit one that employed collectivist principles. "So Sid and I said, 'Well, somehow, this is all screwy,'" Libsohn recalled. "These guys don't seem to want to hang around with us and vice versa, so let's see if we can talk this out." Although only twenty-three in 1936, Grossman persuaded the

small membership of maybe two dozen to include novices as equals in sessions dedicated to planning projects and critiquing one another's work. Chagrined, most of the older professionals set themselves up across the street as a freelancer's cooperative. The split foreshadowed the life cycle of a rejection of commercialism in the 1930s to be followed by a return to commercial photography in the 1950s.[4]

Grossman's idealism and ideology, and certainly his oratory, carried the day. *His* Photo League was committed to education and socially engaged photography. In common with earlier League incarnations, members rejected "bourgeois" practices: nude, landscape, and still-life photography. They also disdained pictorialist photographers. According to *Photo Notes*, the League's newsletter, these champions of photography as an art form "have never entered the 20th century." As for "modernists," they "retired into a cult of red filters and confusing angles much beloved by the manufacturers of photographic materials." This critique damned the capitalist character of such photographs along with their aesthetics. League members, by contrast, stood between these two photographic modes. "The Photo League's task is to put the camera back into the hands of honest photographers, who will use it to photograph America. We must include within our ranks," *Photo Notes* emphasized in 1938, "the thousands of New York's amateurs."[5]

Photography was for everyone, especially workers. It was understood as accessible, a technique that could be mastered by amateurs that spurred a heightened social consciousness. Seeing the streets through a camera's lens opened untold possibilities for solidarity. Taking photographs was a form of creative labor, and the Photo League was eager to welcome new members in this endeavor: "We must also include the established workers who have creative desires and who do not find an adequate outlet in their day to day tasks." The League had a single salaried secretary; it ran as a cooperative.[6]

In 1938 the League started a school, an initiative that modified its character as a photography cooperative. Libsohn and Grossman offered a joint advanced class lasting fifteen weeks. Grossman and Libsohn subsequently continued separately as teachers, although they often coordinated their classes. Grossman ran the school. To attract students, the League offered a 20 percent reduction in tuition for union members. It usually offered three types of classes: Basic Photography, Advanced Photography, and a Documentary Workshop. A year later *Photo Notes* observed, with a bit of frustration, that "many members" were working in a "haphazard fashion." The Photo League, it explained, "is not an organization of people who just listen to lectures and discuss the latest fine grain developer." Members should take a class, work under the guidance of "an advanced worker," or join a production group. The League promoted collaboration not individualism, education not dilettantism. Photographers were "workers" just like so many other New Yorkers.[7]

Working-class Jews, native New Yorkers, came to the League for classes that encouraged them to acquire a language for talking about photography. "It was not enough just to learn your technique or say I want to photograph," Sandra Weiner recalled. "You really had to develop something in your head, you had to develop a point of view." Not explicitly Jewish, either religious or sectarian or even political, the League's majority Jewish membership freed its Jewish members to ignore their Jewish backgrounds. Non-Jews who joined felt comfortable in a New York Jewish milieu. The photographer Morris Engel later recalled, "The age span at the Photo League was mostly on the younger side; few were middle age. There were no blacks, few women and it was heavily Jewish." Walter Rosenblum, assisted by his wife Naomi, who wrote

a history of women photographers, remembered the women. According to him, women constituted a substantial and important minority. He was right. Women also assumed leadership positions at the League, such as heading the critically important School Committee.[8]

Rosenblum discovered the Photo League as a teenager when a friend in the camera club at City College urged him to join. Like many, he joined to use the darkroom only to realize the real riches of the League were the other photographers there, especially those taking classes. Rosenblum started with a beginning class with Grossman that turned him on to the excitement and seriousness of photography. Then he joined the documentary course. "His workshop provided the finest training ground for the serious photographer that I have ever experienced," Rosenblum later affirmed. "While he paid attention to the technical problems we faced, his primary purpose was to help us develop as human beings." Rosenblum had already experienced the camera's liberating power in high school. "It forced me to look more deeply at my environment," he recalled. He "discovered an interest that took me out of myself and into the world that surrounded me."[9]

Students learned from Grossman not only about how to take pictures but also about the history of photography. If they knew nothing about art, he sent them to visit the Metropolitan Museum of Art to learn. He encouraged them to check out the new Museum of Modern Art. The League often obtained free passes to special shows for its members. If students didn't have a political point of view, Grossman pushed them to develop one. If they had never looked before at photographs, he urged them to visit the few galleries that showed photographs. He also took them to visit the photographer and filmmaker Paul Strand at his New York City home. Rosenblum remembers vividly how Strand showed the students paintings by John Marin, Marsden Hartley, Arthur

Dove, and Gaston Lachaise, as well as some of his own, mostly abstract photographs. "Strand drew the students' attention to form, shape, value, control of the formal elements within the frame and the importance of print quality."[10]

Rosenblum took the photograph *Chick's Candy Store* with a large-format nine-by-twelve Maximar view camera on a tripod as a student in Grossman's documentary class in 1938. It was part of an assignment to pick a project. Rosenblum initially had told Grossman that "he wanted to photograph New York City," an ambitious goal. Two days later, Rosenblum realized this was impossible. So he went back to Grossman and said, "since he lived on the East Side, he would photograph that." Grossman said nothing. "He knew," Rosenblum recalled, "but he also knew you have to learn on your own. So East Side . . . so where? East Side is a big area. I kept walking around and walking around until I found a street that interested me, Pitt Street." Then he decided to photograph that street until he realized that was too much. Finally, he chose one block and the area around a single store. "I spent six months there," he said. "All my spare time I'd go down there photographing. But it was the most rewarding experience of my life," he affirmed. "Everything I've done after that has been 'Pitt Street Revisited.' It was a great learning experience."[11]

The Lower East Side's streets were gendered spaces. Men commandeered sections of a block while women occupied other areas. *Chick's Candy Store* pictures men and boys hanging out, listening to a portly, well-dressed man vigorously making a point. This could be a political discussion or maybe just a well-told tale. The speaker is sufficiently engaging to hold the attention of a mixed audience of six. Their relaxed postures—two guys have crossed their feet, standing on one leg—suggests that they have been listening for a while. Inside the store a man sits by the window, holding the door open, perhaps to be

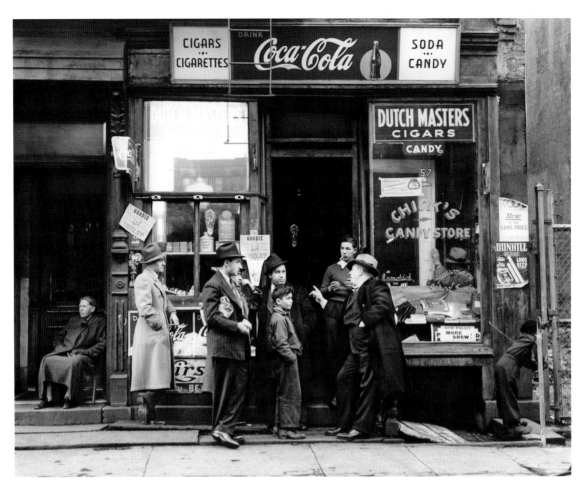

1.1 Walter Rosenblum, *Chick's Candy Store*, 1938. Rosenblum's photograph of a store on the Lower East Side captures its neighborhood attributes as a local gathering place for men. © Walter Rosenblum. All rights reserved. Used by permission of the Walter Rosenblum Archive.

better able to follow the harangue. But the speaker doesn't reach everyone. On the photo's edges appear two apparently unengaged figures: a young boy on the right seems to be balancing on a cellar entrance, and on the left a woman stoically sits in a tenement doorway, facing away from the men.

Candy stores were ubiquitous in working-class areas and sold more than candy. Chick's advertised both Dunhill and Kool's tobacco, along with Coca-Cola, cigars, and cigarettes. Beneath the store sign painted on the plate glass, curved lettering announced the availability of stationery and school supplies. These signs beckoned a diverse clientele. Open from early morning until late at night, candy stores often had the only public telephone for use in the immediate neighborhood. With all these features, these shops provided a convenient gathering spot to meet friends, glean news, and pass the time.[12]

Young New York Jews like Rosenblum took different paths to reach the long flight of stairs leading up

to the League's modest headquarters. Some were teenagers still in high school and curious about photography. The cost of an introductory course was not prohibitive; $15 would get you fifteen sessions. Some came because they wanted to learn darkroom skills and could purchase time at the League's facility for little money. Membership cost $3.50 in 1939; an extra $1.50 secured darkroom privileges. Members used their own camera and film, provided their own paper, and paid ten cents for chemicals per session. The League's loft space had a large room for exhibitions, classes, and meetings; a small cubicle set aside for an office secretary; and in the back, one darkroom for processing film and another, with second-hand enlargers, including an old Elwood, for printing. Despite clumsy equipment that was far from state-of-the-art, it was better than trying to develop film at night in an apartment bathroom or kitchen. By working together with others, League members received training in the technical and expressive potential of variable exposures, shutter speeds, and depths of field, as well as darkroom craft. Irrespective of motivation, most League members stayed because they got caught up in the excitement of photography. The field burgeoned with possibilities in the late 1930s. Photographic weekly magazines, such as *Life* and *Look*, attracted growing numbers of subscribers eager to see the news and not just read about it.[13]

A network of sympathies and interests bound League members to each other. Photography united them, of course. So did a stew of progressive and leftist politics. "We thought that using photography, we could get better housing, we could get people to break down the race bias, we could realize all kinds of wonderful, socially progressive goals," George Gilbert recalled about his fellow League members. "I realized that the camera was a tool for convincing people there had to be a better way to live." Jewish backgrounds that seldom needed or

wanted articulation also connected members. Engel described League quarters as "a refuge, a home." Rosenblum agreed. "In the Photo League you had a home," he affirmed. For Engel, the League "filled a gap in my emotional life. I entered and pleasure came." Engel's father had died when he was three. He grew up in a female household with his mother and three older sisters. He loved photography and would visit the Museum of Modern Art's free library to look at the British, French, and German photo annuals. "I would thumb through every page and look at the different pictures," he recalled. "It was my self education in the kind of photography I liked." He also watched the free foreign films at the museum. Then he saw an ad for a photography course at the Photo League. It seemed like fun. He could afford it since he was earning ten dollars a week as an office boy, a job he took to help support his mother. He joined the League in 1936 as a teenager. His experience was not uncommon.[14]

League members shared "styles of talking, habits of looking, and categories of perception. . . . Through their intense, ongoing discussions about photography as a group activity, members came to employ vocabulary that linked aesthetics and social action." These Jewish-style ethnic arguments overflowed with passionate and energetic contention, with members interrupting one another to make their points. Intense conversation generated excitement and encouraged participants to formulate and articulate their political and aesthetic visions. The non-Jewish photojournalist W. Eugene Smith recalled, "they carried on some of the best debates about photography I ever heard." An unselfconscious Jewishness inflected modes of speaking. This Jewishness derived from an awareness of minority status and a recognition of pervasive antisemitism among non-Jews. Rooted in assumptions about the world as a potentially dangerous place for Jews and collective experiences growing up within a culture with a different

calendar from the majority, this type of New York Jewish consciousness "facilitated creative conflict among photographers." In some circumstances this extended to between them and their subjects. At the Photo League, young Jewish photographers were freed to argue about what made for good photographs without having to deal with a commercial art establishment that disdained Jews. In taking up photography, considered a practice and craft, not an art, they avoided some of the antisemitism endemic to the art world. Photography's visual dimensions tempted some who had aspired to become artists but thought they couldn't draw. A "city that felt half Jewish" in those years fueled their mutual fund of experiences and welcomed them into the streets.[15]

New York during the Great Depression was a union town. In New York, the difference between "left wing" and "right wing" often signaled conflict between Communists and Socialists. In 1936 Socialist union leaders organized the American Labor Party to allow their members to vote with good conscience for Franklin D. Roosevelt for president without pulling the despised Tammany-dominated Democratic Party lever. The communist left also maintained a strong local presence, electing members to the city council. The Photo League participated in this radical political culture. It advertised in the communist press and joined the Popular Front, a Communist-initiated and party-sponsored endeavor also organized in 1936 to broaden the party's appeal to workers by establishing an antifascist coalition. Meetings of liberal and popular-front organizations (like choir practice at a Methodist church) were good occasions for making friends and arranging dates, as many old Jewish lefties would later admit, with a touch of nostalgia. Rebecca Lepkoff remembered the free parties, with music and dancing. Maybe, she recalled, they tried to recruit members to join the Communist Party. She listened to the radio and was aware of Hitler's rising power in Germany. Monthly membership meetings

on Friday night at the League usually had music, dancing, contests, and door prizes. A second monthly meeting regularly featured lectures and discussions. The Photo League had its couples: Dan and Sandra Weiner, Sid Grossman and Marion "Pete" Hille, Ruth Orkin and Morris Engel. Suzie Harris called it "a marvelous lonely hearts club. It made quite a few matches."[16]

League photographers supported one another through their collective projects as they explored neighborhoods they might not otherwise have visited. In 1938–39 Grossman and Libsohn led a documentary group project on the Chelsea neighborhood on Manhattan's west side that abutted the docks on the Hudson River where longshoremen worked. Both the section's evident poverty—half of the area's families lacked steam heat—and the cooperation of a leading social welfare organization spoke to League political concerns. Its Irish Catholic population marked it as different from the neighborhoods uptown and in the Bronx where Libsohn and Grossman grew up. In fact, Grossman liked the working-class neighborhood so much that he moved there. He felt he belonged, and he made the neighborhood his own. With their cameras, League photographers negotiated among strangers (possibly racist and antisemitic), albeit fellow working-class New Yorkers.[17]

Grossman's photograph of a woman waiting at the corner of 23rd Street and Seventh Avenue, just up the block from the famed Chelsea Hotel, catches the neighborhood mood. Behind her, a jumble of signs that adorned city streets appeals to potentially hungry New Yorkers as they exited the subway station (or, alternatively, ready for them to grab a bite just before catching a train uptown to work). The reflections from the ubiquitous plate glass added to the type of visual confusion characteristic of the city. Grossman cropped the photo to draw attention to the individual woman. Grossman's biographer Keith

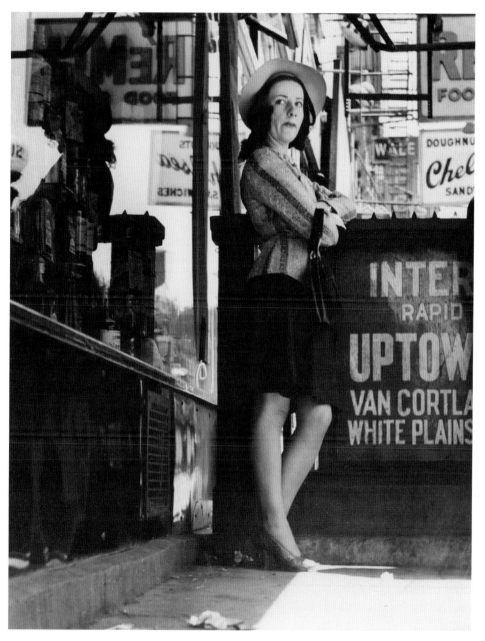

1.2 Sid Grossman, Untitled (woman standing by 23rd Street IRT station, from the series "Chelsea Document"), ca. 1938–39. The woman is watching the street even as Grossman is observing her, two complementary modes of looking characteristic of city streets. © Howard Greenberg Gallery, New York.

Davis suggests that the single woman "is presented as an element of stability in a dynamic and disorienting space." He also imagines her "as an emblem of the urban working class." And he goes on to argue that her presence "suggests a kind of human still point in an optical and conceptual maelstrom—an assertion of physical reality in the disorienting kaleidoscope of urban commercial culture."[18]

"Time changes images," writes the art critic Suzanne Bloom. "By what means can we hope to connect equally with the implicit and explicit nature of these images," she asks in regard to an exhibit of Sid Grossman's work, "especially in view of their present isolation relative to their original integration?" League photographers shared a reformist outlook with photographers on the federal Farm Security Administration project but did not agree with them that some authentic, hard-but-happy life was slipping away. Setting out to make strong, honest, good-looking photos of life on city streets, New York Photo League members sought to communicate these with their neighbors and with people who might be led merely to gawk at Gotham's bustle. The work of League photographers represented a frank contemporary appraisal of modern life and not a saccharine elegy of ethnic distinctiveness.[19]

Issues of how to picture the city surfaced explicitly in anticipation of the opening of the 1939 New York World's Fair. January's edition of Photo Notes sounded the alarm. "When the World's Fair opens in New York in April this year, the hundreds of thousands of tourists are going to buy hundreds of thousands of guidebooks, picture books, and souvenir post-cards that are being produced with one idea only—to make profits for some business firms." Photographs, the League recognized, made money for capitalist enterprises. "But will these pictures really show New York?" the article asked. "There will be endless skyscrapers, views of Times Square, monuments and the usual 'points of interest' that you see in all publications of this type." Then Photo Notes reiterated the question in more critical language. "But will these out-of-towners take home with them photos of the real New York—the people, streets, buildings, rivers, centers of culture, entertainment, sport, the ghettos, etc. of New York? In other words, will it be the real New York or just a guidebook New York that doesn't attempt to even scratch the surface of our great metropolis."[20]

League members were right to worry. When the World's Fair opened on April 30, 1939, what New Yorkers and tourists alike found was a documentary, The City. Made by Ralph Steiner and Willard van Dyke, with music by Aaron Copland, it screened continuously at a specially constructed theater at the fair, a centerpiece to the entire, sprawling event. The film contrasted the bucolic countryside with urbanization's horrors. In keeping with the fair's theme of "the world of tomorrow," it concluded with a glorification of suburbanization and the "new city" movement. The film relentlessly skewered urban culture, updating Aesop's story of the country mouse and the city mouse. Its images of city life, largely taken in New York, included "a battered horse eating from a feedbag." Shots of men and women eating at a food stand invited a damning comparison of beast and person. Steiner, who filmed the metropolis section, also depicted an extended series on mechanized food production, with machines slicing and toasting bread, making pancakes and sandwiches. The people pictured sitting at a lunch counter do not converse. They stare straight ahead or read a newspaper. In the city, social engagement is reduced to men ogling women, both on the street and from a second-story window.[21]

The film represents traffic as relentless. Crowds and cars define the city. Crossing the street is a harrowing venture. The movie presents a massive traffic jam with a well-dressed young man stuck in

a taxi, its ticking meter mercilessly registering fare increases as he desperately sticks his head out of the cab, wondering what's going on. "The traffic jam sequence was done on Seventh Avenue in the heart of the Garment District," Steiner later recalled. "I was in a station wagon blocking all the intersections—stopping traffic. It was quicker than going to the police and getting permits."[22]

Steiner's *The City* presented an outsider's antiurban view. He grew up in Cleveland, Ohio, in a bourgeois Jewish home and received his first camera at age twelve. Steiner took up photography at Dartmouth. "In those days—1917 to 1921—to be at Dartmouth, Jewish, neurotic, and shy was like being a Martian with a green head and four eyes," he subsequently told an interviewer. "I was a skinny little guy, afraid of the world, and couldn't very well be captain of the football team, so I took up photography." After graduating from Dartmouth, he attended Clarence White's School of Photography. In the 1930s Steiner flirted with radical politics. He joined the Workers Film and Photo League, and subsequently worked with Paul Strand at Frontier Films, his communist documentary film company. Steiner also made government-sponsored documentaries. He earned a livelihood as a freelance commercial magazine photographer. His photographic aesthetic inclined toward the avant-garde, emphasizing unusual angles. In 1939, his friendship with movie-theater owner Alfred Mayer led to an introduction to Mayer's brother-in-law, Clarence Stein, a city planner, who hired Steiner to film *The City*.[23]

Berenice Abbott's new book, *Changing New York*, published by E. P. Dutton and Company as a guidebook for tourists at the World's Fair, offered a more complicated challenge to the Photo League's announced vision of New York. The book collected a series of photographs taken over the course of three years in the late 1930s. "To photograph New York City," she explained in her application for funding from the Works Progress Administration's Federal Art Project, "means to seek to catch . . . the spirit of the metropolis, while remaining true to its essential fact, its hurrying tempo, its congested streets, the past jostling the present." Abbott often spoke at the League. She advocated documentary photography, which, she explained, "tries to get at the root of things, at the cause, at the foundations, at the truth." Older than most members, she had gained her experience in Paris. There she participated in its flourishing world of experimental art. Influenced by the Parisian cityscapes of Eugene Atget, she used a large-format camera as he had to capture New York in dramatic ways.[24]

The photograph of the Riverside Drive viaduct at 125th Street in Manhattan and a complementary photograph of the Hell Gate bridge pictured from Astoria, Queens, exemplify elements of her perspective. She took both in 1937. Both photos demonstrate the grace of utilitarian steel structures. Both track the passage of time in a changing city. Both document the city and its foundations. Both ignore the city's people.

Abbott's picture of the viaduct conveys the sense of its scale by including storefronts and a water tank. The latter's hulking curves complement the grace of this mammoth viaduct. Street-level details indicate that Abbott is picturing an immigrant city. The stores shown on the lower right of the shot are two meat wholesalers, Gus Buxbaum and Michael Vitolo, one Jewish, the other Italian. A couple of blurred figures cross the street—Abbott had set her shutter speed to highlight the built environment.

Abbott's portrayal of the Hell Gate bridge appears at once airy and powerful, vaulting over a placid East River. Its dark pattern of weight-bearing steel occupies the upper half of the picture frame. In the distance can be seen part of Ward's Island Bridge, echoing the movement of Hell Gate. Both structures, built in the early part of the twentieth century,

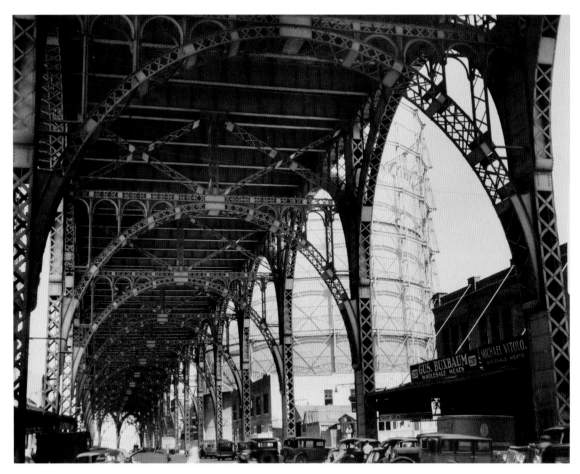

1.3 Berenice Abbott, *Under Riverside Drive Viaduct*, November 10, 1937. The vaulting steel viaduct shadowed the street life beneath it, dwarfing its human figures. Berenice Abbott (1898–1991) for Federal Art Project. Museum of the City of New York, 40.140.265.

testified to the city's importance as a site of architectural engineering and technical expertise.

Although Abbott supported the Photo League and lectured there, she tended not to photograph people on the streets. Characteristically, even most of her street-level photographs emphasize buildings. Abbott aimed "to capture the perpetual transformations that the city was experiencing." She originally envisaged *Changing New York* "as an artistic work to be distinct from the purely documentary photographs of the period," but negotiations with the publisher led to a different type of book. Her photos presented League members with a conundrum. Although her photos surely portrayed the real New York, their framing missed the kinds of human interactions that were central to the moral, political, and aesthetic vision championed at the League. Abbott's images were what out-of-towners got to see at the fair and in most tourist-oriented presentations.[25]

Realizing the need for an alternative picture book, one that would do more than "scratch the

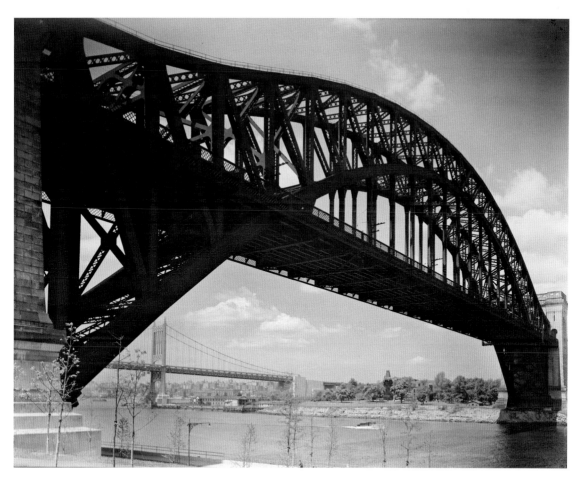

1.4 Berenice Abbott, *Hell Gate Bridge I*, May 25, 1937. Graceful bridges for trains (in the foreground) and people (in the background) connected Manhattan with the boroughs of Brooklyn and Queens, presenting the possibility of spectacular views from shore. Berenice Abbott (1898–1991) for Federal Art Project. Museum of the City of New York, 43.131.4.436.

surface," the Photo League created a committee to address the issue. The League favored committees that involved collaboration as the best way to get projects started. In anticipation of the opening of the World's Fair, the January 1939 newsletter announced the committee's formation. Its goal would be to produce a volume that would compete with commercial books sold at the fair. Photographer Robert Disraeli agreed to lead the committee and write a script—probably a shooting script of subjects to be photographed.

The committee sought the cooperation of other photographers in their project, dubbed a "New York Document." They aimed, but failed, to publish a book. They proposed the project far too late to challenge the antiurban perspective presented at the fair. Disraeli and his committee—which included established photojournalist Eliot Elisofon and documentary film maker Leo Hurwitz, critic Elizabeth McCausland, and the radical Jewish poet Sol Funaroff—conceptualized the project. The newsletter article outlined the types

of pictures they thought should represent the real New York, revealing that planning for the committee distilled concepts even if it did not produce a book. This vision confirmed choices already being made by many photographers associated with the Photo League. These photographs might be characterized as a historical "New York Document" that presents the city as it was observed mostly by young Jewish New Yorkers. Encouraged by the League to look at their own urban milieu, their photographs pictured a different city from commercial portraits of New York.[26]

From *Photo Notes*'s perspective, to represent the real New York meant starting with "the people." In the 1930s this phrase signified a socialist political perspective that valorized ordinary working-class men and women. Then came streets. That's where one finds the people in a city like New York. Street photography occupied pride of place among Photo League members, though they often preferred the term "documentary." In the United States (beginning in the 1920s and extending for half a century), documentary had leftist associations. An urban alternative, street photography, possessed its own less pleasant resonances. The earlier meaning of street photography designated a type of outdoors commercial portraiture where a photographer often brought a pony along as he walked the blocks seeking customers. This work was on par with knife sharpening, rag selling, and busking. The Jewish immigrant Arthur Fellig, before he became Weegee, a famous tabloid photographer, started out in the itinerant trade of street portraiture. "We called it kidnapping," he said. "We'd find a kid, put him on the pony, take the picture, and then try to peddle it to the kid's mother, five cents a print."[27]

This was not what the League had in mind when its instructors sent students out to take pictures on the city's sidewalks to learn basic photographic techniques. The League's advanced class and its Feature and Documentary Groups consistently focused on the city and its people. As collective projects, these groups often decided to document a particular street. A related approach targeted an entire neighborhood, such as Harlem uptown or Chelsea downtown. When the newly formed Documentary Group planned its "Chelsea Document" project in 1938, the announcement prompted the newsletter to propose a new slogan for the Photo League: "We Cover New York." Radically different neighborhoods in their culture and population, Irish-American Chelsea and Black Harlem shared commonalities in their working-class residents and rundown housing. These facets of urban life interested Photo League photographers as appropriate subject matter.[28]

The 1939 list of appropriate subject matter for a New York Document reflected the approach of teachers at the Photo League. In addition to photographing people and streets, their list mentions several distinctive physical attributes of New York, such as centers of culture, entertainment, and sports, activities occurring on the city's sidewalks. At the end of the list appears "the ghettos." This term referenced not necessarily Jewish sections of the city (unless they were working class), but poor neighborhoods that housed immigrants and Black people. Pictures of these various aspects of New York would convey urban reality to those unfamiliar with the city.

Efforts to get the New York Document off the ground foundered. The following month's issue of *Photo Notes* reported on attempts to organize an exhibition and was silent about the book. An exhibit of photographs by American photographers at the World's Fair would signal the importance of photography in the United States. Then the League decided to run an exhibition of its own held during the fair but not in conjunction with it. The League had a gallery space, also used for meetings and lectures. It regularly mounted shows of student prints and

of photographers whose work the League's Exhibit Committee admired.

In the April issue, *Photo Notes* announced a meeting of members to discuss and criticize prints turned in for the prospective "New York Exhibition" that had taken the place of the New York Document. A flyer promoting the exhibit employed the language of Robert Ripley's popular magazine column, *Ripley's Believe It or Not!* Published regularly in the *New York Post*, the series featured unusual photographs provided by readers. However, the Photo League's call for photographs used Ripley's concept to different ends. "Believe it or Not! Millions of New Yorkers have never visited the Statue of Liberty or the Empire State Building," it proclaimed. Everyone knew that, of course. The point was that those two iconic structures had come to "represent the nation's picture of our metropolis!" Image mattered, in ways the League tried to explain. Then came a list of views promoted as a typical New Yorker's perspective: "traffic cops and subways, slums and skyscrapers, night clubs and relief bureaus, libraries and jails." Suggestive dyads like these organized urban representations for Photo League members. Characteristically, this new list specifically contrasted examples of wealth and poverty, such as skyscrapers and slums, or night clubs and relief bureaus, and municipal services like libraries and jails.[29]

Photo Notes contended that it was important that Americans coming to the World's Fair see the city as its residents saw it: as an American city, with the problems and possibilities of any large metropolis. Photo League members wanted New Yorkers to take control of their own image making. It was ready to enlist amateurs to do that. Opportunities for social solidarity and cultural communication existed if one could counteract false images and stereotypes. "Most New Yorkers viewed their city from its streets, through its apartment windows, on its buses and subways, and occasionally from its rooftops. Visitors were primed to see Gotham as a geometric grid that sprouted skyscrapers, but day in, day out, the city presented residents with an eye-level experience."[30]

With the World's Fair came an unexpected opportunity to reform Gotham's image. "Millions from all over the country will flock to the World's Fair," the League announcement declared. "They ought to see the New Yorkers' view of New York!" The fair at Flushing Meadows was constructed on the site of an old ash dump in Queens. One of the outer boroughs, Queens had a relatively small population. Some of its neighborhoods included several suburban-style housing developments that excluded Jews. Flushing Meadows, the League proclaimed, "will be pretty, but it won't be the city." This call for photographs wielded the word "pretty" pejoratively; it suggested artifice, a frivolous commercial entertainment.[31]

The Photo League, the announcement told fellow city dwellers, "is planning an exhibition of New York as YOU see it, as opposed to the way the picture postcards, guidebooks and the rotogravure sections 'see' it." By putting scare quotes around "see," the League's flyer implicitly pointed to capitalist agendas that produced merely promotional stock photos for consumption and purchase by out-of-towners. By contrast, the League opened its doors to all New Yorkers. Properly considered, photography was democratic. Anyone potentially could take good pictures. Some of the League's best photographers, like Morris Engel and Jack Mendelsohn (Manning), joined as high school students. Mendelsohn started out taking photos with a Bakelite snapshot camera when he was fourteen. "The name is unimportant, the picture is," the announcement assured its readers. Submitted photos would be hung "in many galleries, and the Photo League will see to it that they are viewed by many people."[32]

Since it had little access to magazines and newspapers, not to mention rotogravure sections, the

League could only promise to exhibit the photographs on its own walls as well as where people might encounter them, in places like libraries and YMCAs, colleges and settlement houses. Exhibition offered an alternative to publication. "Here are the requirements: An honest viewpoint. A clean lens. And—your pictures on 8 x 10 glossy, if possible please!" The League claimed New York as its turf. Its appeal was aesthetic and moral, personal and political.[33]

Taken together, the call for photographs and the initial description for a New York Document outlined the parameters of both a new photographic practice and a fresh vision of New York City. The two were increasingly aligned from the perspective of the Photo League, even as it sponsored lively debates on the significance and role of photography in the modern world. The previous year Harold Corsini, "one of our youngest and most talented members," had a show at the League. Head of the camera club at Stuyvesant High School, Corsini discovered the League when still a student. Son of Italian immigrants, he joined the Feature Group that was documenting Harlem together with Mendelsohn and Engel. One of his photographs, of several young men playing street football, aroused "controversy" for its overhead point of view.

In announcing the exhibit, *Photo Notes* admitted that Corsini's photos were "arresting" and hoped that the exhibit would stimulate "some clear thinking on certain aesthetic considerations." Corsini's photo captured an appropriate topic, namely sport, but his unmoored bird's-eye view emphasized abstract street shadows rather than particular people interacting in a neighborhood locale. Such a modernist perspective veered too close to outright abstraction for some. Corsini grew up in the city, but his photograph questioned the primacy of an honest viewpoint for Photo League members.[34]

League photographers demanded both objectivity and engagement. The "objective" lens, as it's called technically, introduces light into an optical system. The Photo League promoted a resonant trope of clean, honest, objective, and interactive interestedness. "For these street photographers, technique was methodology: . . . Committed enthusiasts of so-called 'straight photography' urged one another to take unstaged photographs of 'real' people in 'real' circumstances." These pictures should then be developed and printed without special darkroom manipulations. As Eliot Elisofon explained, "We do no retouching, try to avoid abnormal angles, light simply, use sharp lenses, and pose our subjects in normal positions." Elisofon's words illuminated the inherent tensions of straight photography, since he admitted to posing subjects. "For its proponents at the League, the 'straight' photo held the potential to harness a photographer's instantaneous choices—in perspective, framing, and timing—on behalf of truth, or at least of honesty."[35]

Photo League images of New York street culture focused, therefore, on the instant, those passing exchanges that characterize social interactions in crowded places. Where many contemporaneous sociological arguments and the prevailing tropes of literary modernism found evidence of anonymity and even *anomie*—that is, the isolating and alienating aspect of modern, urban life—Photo League photographers particularly discovered social relations that bound New Yorkers together. As photographers, they, too, were attached to the residents of the city, not only as a political principle, but also as a photographic method in which they cultivated reciprocity with neighborhood residents.[36]

Morris Engel's photograph of a young Black boy standing in the foreground with older boys enjoying a strong spray of water approaches a visual clarification of the concept of an honest viewpoint.

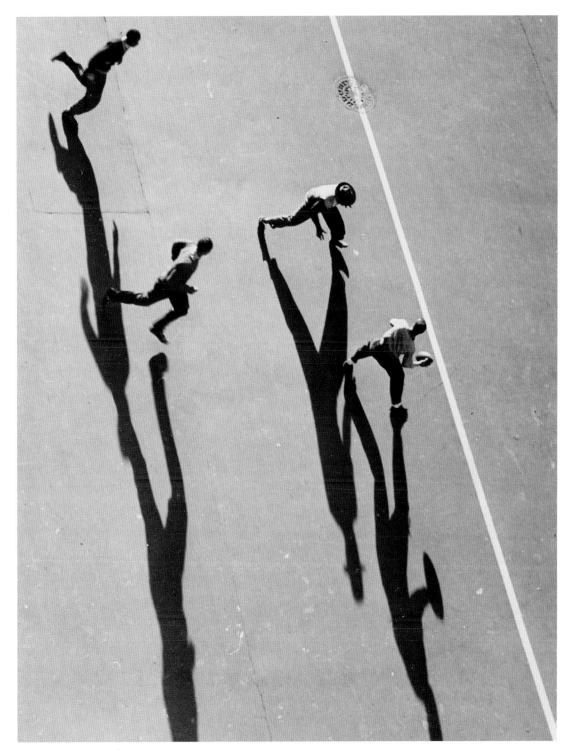

1.5 Harold Corsini, *Playing Football,* ca. 1935–37. The overhead perspective on this game of street football produced a striking image of long shadows and stimulated vigorous debate among New York Photo League members on whether it was an honest photograph. Courtesy of the George Eastman Museum.

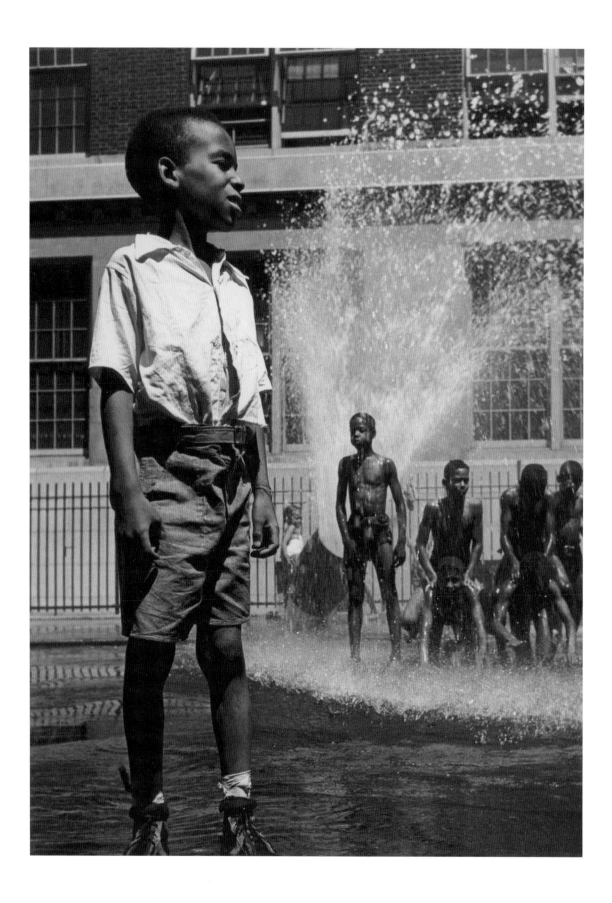

Engel pictured the boy up close and intimately, and simultaneously monumentalized him with his camera angle. Behind him, the other boys are getting ready to race. The setting appears to be a school yard, with a metal fence in the background. Behind it can be glimpsed the neat windows of a large institutional building. Corsini's and Engel's photos demonstrate how perspective and selectivity can influence whether viewers feel invited to consider a picture like Corsini's as merely striking or, like Engel's, as worthy of contemplation. The contrasting approaches of Corsini and Engel remained unresolved at the League. Both men participated in its Harlem Document project. Corsini also worked with Arnold Eagle as his assistant, teaching photography under the auspices of the National Youth Administration.[37]

The League's photographic enterprise was strikingly consonant with the philosopher John Dewey's notion of a "work of art" as a renewable engagement in which artists and audiences, in effect, work together. As Dewey argued in 1931, "art products" draw sustenance from everyday experience that anchor, and center, larger "works of art." League photographers organized themselves thematically to represent the everyday life of poor and unemployed people, mirroring them back to themselves and windowing their lives outward to the larger world. And they promoted photographic practices and styles deemed straightforward. "You make the best photograph of that which affects you most strongly," Walter Rosenblum explained. "We feel deeply about the people we photography [sic] because our subject matter is of our own flesh and blood." This was an important assertion. "In Harlem or on the East Side we aren't tourists spying on the quaint mannerisms of the people. We aren't interested in slums for their picturesque qualities."[38]

League photographers were often labeled the "Ashcan School of Photography," linking them to modern realist and left-wing painters working in New York City. The label indicated that they were socially conscious photographers; it did not suggest any more direct connections or influences between the two groups, workers in different media, that chose New York as their subject. Aware of "the social, political and economic forces shaping their environment," League photographers manifested "that awareness in and through their work." This went beyond overt expressions of "political ideology, revolutionary sentiment and/or visionary idealism."[39]

Ralph Steiner, who taught briefly at what he subsequently called "the Communist dominated photo league," had an ambivalent relationship to the League. On the one hand, he considered the students too politically doctrinaire. He recalled asking his students what they saw on Park Avenue. The street traversed both wealthy and poor sections of Manhattan. Steiner wanted them to compare the avenue on the rich but staid Upper East Side with its lively character in Harlem. He didn't like the students' answers. They ignored the vitality of street life in Harlem, he claimed, and instead came as Marxists, as though "through a thick volume of *Das Kapital*." On the other hand, when he became photo editor at the left-leaning New York newspaper *PM*, Steiner promoted the League in a two-page spread. "Best Buy," he wrote, "is a school that teaches students to make pictures as good as these." Featuring photos by Leo Goldstein, Dan Weiner, Morris Huberland, Max Zobel, and, yes, Harold Corsini, Steiner recommended the League's school. It "can teach you to make technically decent pictures that get across what you think and feel," he urged.[40]

The contemporary photography project of the New Deal's Farm Security Administration (FSA) shared elements with the Photo League's aesthetic ambitions. "The FSA's photographs of desperate and dispossessed people, as edited by [Roy] Stryker and reproduced over and over again by the media, have

1.6 Morris Engel, Untitled (young Black boy in front of fountain), ca. 1936. Summertime in the city brought children out onto the streets and play areas to cool off, mostly without adult supervision. © Morris Engel.

become American icons," writes historian Michael Lesy, "but these images of suffering, affecting as they are, are only an outcropping, the tip of an enormous buried mountain range of ordinary life that the FSA recorded for posterity." Lesy's interpretation emphasizes elements of congruence with the Photo League. "This visual record of everyday existence, its commonalities and singularities, its mysteries and its truths," he argues, "is the real subject of the FSA's enterprise." Stryker guided that enterprise through his detailed shooting scripts, instructing his team of photographers what to picture to promote the political concerns of the New Deal's agricultural programs. The scholar Alan Trachtenberg disagrees with Lesy. The FSA's "overarching theme," he contends, was "surely the end of rural America and its displacement by a commercial, urban culture with its marketplace relationships."[41]

League photographers recognized that the *real* New York was thriving, even if obscured by prevalent modes of representation. In addition, "most of the Leaguers identified strongly with the subject matter that they photographed, and much of it reflected their Jewish heritage," argues scholar Fiona Dejardin. "Sandra Weiner noted that her husband, Dan—born in 1919 on East 104th Street, Harlem, an area then inhabited by poor immigrants—was typical of the group." Identifying with their subjects, Jewish photographers often skirted neighborhoods where they felt uncomfortable in the late 1930s, such as German sections of the city where antisemitism pervaded the atmosphere. The photographer Louis Stettner affirmed that the League "encouraged a profound give-and-take of feeling between photographers and their subjects. It frowned upon taking pictures of so-called 'bums' or derelicts. . . . It was considered trite and overdone, bordering on needless sentimentality."[42]

Aware of the power of commercial culture, League photographers knew that out-of-towners flocking to the World's Fair would want to buy a postcard of the Empire State Building, the world's tallest skyscraper in 1939. Completed in 1931, the Empire State Building embodied Gotham to millions. The image of the 102-story building appeared in many different formats and media and was touted as a technological wonder and expression of the modern age. "In just 19 months, steelworkers, masons, glaziers, pipefitters, and workers in dozens of other trades buil[t] the 102-story building, with seventy-three elevators, sixty miles of water pipes, and five acres of windows." It also acquired the nickname the "Empty State Building" due to an absence of commercial tenants, although the New York World's Fair Corporation occupied an office on one of its higher floors. Regardless of its financial prospects as a massive real estate investment, it was undeniably impressive and ubiquitous on postcards sold to tourists.[43]

The commercial firm Ewing Galloway's *The Empire State Building* pictures the new skyscraper looming over the city. Around its base cluster a mix of industrial, commercial, and residential buildings. The view looking west, taken from Madison Avenue, emphasizes the Empire State's singularity, a symbol of urban power and technical prowess. The handful of other tall buildings are distant and comparatively modest in height. The city appears serene and peaceful, not the city most New Yorkers knew.

The striking photographs of the construction of the building by Lewis Hine, photographer, sociologist, and reformer, emphasized an alternative view of the city. League members embraced this elderly pioneer of photographs he called "Work Portraits." Sol Libsohn was among League members happy to claim Hine as a worthy model. As Libsohn understood it, Hine "instinctively" grasped "the real meaning of

1.7 Ewing Galloway, *The Empire State Building*, 1931. Taken from Madison Avenue and looking west at the recently completed tallest building in the world, this commercial photograph emphasizes the Empire State Building's singularity and dominance over New York's skyline, ignoring the Chrysler Building to its north and east. Irma and Paul Milstein Division of United States History, Local History, and Genealogy, New York Public Library.

1.8 Lewis Hine, *Two Workers Attaching a Beam with a Crane*, 1931. Hine's photographs of the construction of the Empire State Building presented the extraordinary skill and verve of the workers. In this photograph, he also shows the watchful presence of the boss. Photography Collection, The Miriam and Ira D. Wallach Division of Art, Prints and Photographs, New York Public Library. © NYPL.

the work he was called upon to do. He recognized the dignity" of the "workingman and woman and reflected this in his work." His two groundbreaking photographic series on immigrants and child labor were at once poignant and unsentimental. A series on the breakneck construction of the Empire State Building was a unique statement of socially conscious photographic exposition. The engineering project directive was to complete one floor of the structural steel frame per day. Hine's photographs show these men dealing gracefully with the extraordinary demands of their labor. *Two Workers Attaching a Beam with a Crane* vividly portrays the focus, nerve, and strength of these construction workers.[44]

Hine also alludes to the relationship of boss to worker. Hine catches the boss, in a jacket and a homburg hat, watching from a platform. One man wraps his legs around a beam as he works; the other man stands, leaning over, one hand steadying the wire securing the girder and the other hand steadying himself. Hine provides an eye-level view of all three men. Men and steel are captured proximately, like a utility crew in the street; yet all around them and far below great Gotham stretches to the horizon like a meadow. (It is the sort of confounding perspective that would also characterize some spacewalk photographs half a century later.) The photograph looks north, with the large expanse of Central Park visible on the right and the Hudson River off to the left. Understandably, beams were tethered by safety lines, but the men were on their own together. League members appreciated Hine's contextually honest viewpoint.

In January 1939 an exhibit of Lewis Hine's photographs opened uptown at the Riverside Museum, not far from Columbia University. Several Photo League members had promoted this retrospective show for the aging photographer as a tribute. For several years, unable to find work, Hine had been destitute and living on welfare. Hine subsequently left his

photographs and negatives to the League, and members assembled thirty portfolios of prints for sale to raise funds to help him.[45]

Sid Grossman reviewed the exhibition of 128 prints for *Photo Notes*. Grossman wrote approvingly of Hine, who had started photographing in 1905 with his series on immigrants at Ellis Island: "He knows the people as human beings and he understands their problems in the broad social sense." Grossman quoted from Hine's preface to his book, *Men at Work*, where the mature photographer lauded the skill and effort of those who make and manipulate machines. Grossman elaborated: "His portraits of the immigrants, who stayed to build and live in America, take one right into the human being; from the photograph emerges a complex personality, made of bone and muscle, and skin that is tanned by wind and sun, or pallis [*sic*] from exhausting work in factory or slum." Grossman concluded his review: "Only photography has the necessary quality of reality that will convince the spectator that the people in the photographs really lived and built the America we know." Hine's pictures of workers appealed to League photographers, although he was not trying to photograph the city.[46]

It was hard to resist New York's picturesqueness. Its gorgeous waterfront panoramas seduced many New Yorkers. Not League photographer Dan Weiner. The playwright Arthur Miller recalled an exchange he had with Weiner that exemplifies the difference between panorama and quotidian. "A couple of years ago Dan and I were driving over a long causeway in Brooklyn which sweeps down along the Bay," Miller wrote. "On the right, below, were the South Brooklyn rooftops and the pigeon coops, straight ahead in the windshield was the Manhattan skyline on the other side of the river. The sun was burning in all the windows, the buildings looking like blinded men with orange eyes." Miller was impressed. "'There's a picture for you to take,' I said to Dan. He laughed and politely

1.9 Dan Weiner, *Portrait of Arthur Miller, 1956*. Weiner's portrait of the playwright places him firmly in Brooklyn, where Miller was born and educated. The iconic Brooklyn Bridge can be glimpsed in the upper portion of the photograph. Photo by Dan Weiner. © John Broderick.

but firmly corrected me. 'There's no people there. I'm not interested in scenery.'" Nonplussed, Miller tried another tack. "I said that it had meaning anyway, lower New York, Wall Street blinded by the sun and yet strangely heroic, maybe like a god burning and aghast." But Weiner didn't buy Miller's abstractions. "He wouldn't waste a shot on it even when I offered to stop the car," Miller admitted. "'Those kind of pictures don't need me,' he said. 'I want to get people in some kind of relationship to meaning.'" Miller kept on driving. "We went on and into the tunnel without the picture."[47]

Weiner's portrait of Arthur Miller standing beneath the Brooklyn Bridge on the Brooklyn side

deftly illustrates just what Weiner had in mind. Miller and the city connect in the photo. Behind Miller, a worn ad for J. Bunck & Co., manufacturer of wire brooms and brushes, reminds viewers of the industrial city. Although the graceful arches of the eastern tower of the bridge are visible, commenting perhaps on Miller's play *On the Waterfront*, the worn brick of an old building attracts equal attention from the photographer. The bridge is relegated to background scenery. Only a knowledgeable New Yorker would realize that the river flowed not many blocks from the site of the photograph.

By comparison, Samuel Gottscho's photograph of that Brooklyn waterfront, even with people in it, portrays the type of scene Weiner rejected. The picturesque tugboat, chugging close to the shore,

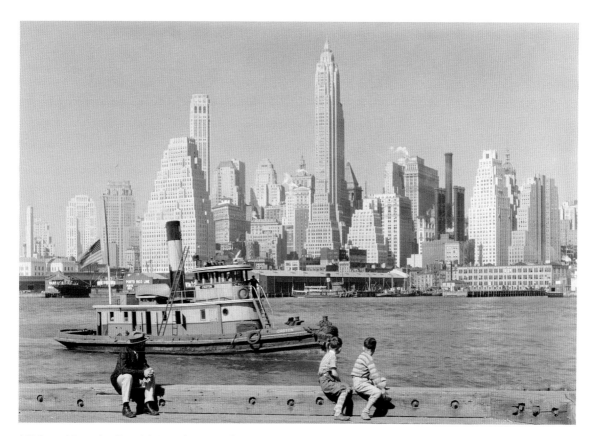

1.10 Samuel Gottscho, *Financial District from Foot of Fulton Street East River, Tug in Foreground,* ca. 1930. Gottscho specialized in photographing the city's architecture, often moving beyond documentation to evoke the glamor of skyscrapers, as in this photograph taken from the Brooklyn shore looking across at Manhattan. Samuel H. (Samuel Herman) Gottscho (1875–1971). Museum of the City of New York, 88.1.1.2411.

contrasts nicely with both the skyscrapers across the East River and three individuals in the foreground: two boys sitting cross saddle along the wooden pier and a man with a hat taking the air. Gottscho, a commercial photographer who specialized in documenting real estate and buildings, took many such classic New York shots that captured the city's distinctive glamor. Often breathtaking views of Manhattan were easily seen from the river's edge in Brooklyn, and residents regularly enjoyed them on walks, family picnics, and while fishing. Gottscho's photographs also appealed to tourists coming to the World's Fair. League photographers recognized the allure as they struggled to make room for pictures that eschewed the city's architectural and natural beauty. They would take photographs on the waterfront without Manhattan's skyscrapers as the backdrop.[48]

The changing character of the physical city complicated the Photo League program. In the late 1930s, an expansive program of public works complemented large-scale private construction projects, such as Rockefeller Center in midtown and an enormous housing project in the Bronx called Parkchester, sponsored by the Metropolitan Life Insurance Company. In response to the devastating

impact of the Great Depression that threw so many out of work and made so many homeless, New York City's administrative agencies embarked on an ambitious program of public housing in Manhattan, Brooklyn, and Queens. The city also completed a new subway line in 1933. The Independent Subway ran the length of Manhattan under Eighth Avenue, then swerved into the Bronx beneath the Grand Concourse. On its southeastern stretch, it traveled underneath the East River to Jay Street in Brooklyn, and out to Queens. The subway helped to spur private construction of apartment buildings along its route. In 1936 the Triborough Bridge, a seven-year federally financed project that helped employ construction workers, connected vehicular traffic from the Bronx and Manhattan with Queens and Nassau County. Four years later the Queens Midtown Tunnel opened and brought Long Island Expressway traffic right into the heart of Manhattan.[49]

These public works included parks and recreation centers, some of which featured swimming pools, such as one photographed by Grossman in Harlem. Like Engel, Grossman lived in a fatherless household, since his father separated from his mother while he was still a child. His mother worked as a cook, traveling each summer to the Catskills and returning to a different apartment each fall in New York at the end of the resort season. Grossman wrote when he was nineteen how "every time I become conscious of the barrenness and ugliness of my home, I in turn become conscious of my poverty." His biographer describes him as growing up in material insecurity, physical dislocation, social marginalization, and financial uncertainty. Grossman received his first camera from a more prosperous cousin. For much of his life he eked out a living on the margins of the professional photography world. In the early summer of 1939, he secured a coveted job working on "The Negroes in New York" for the Federal Art Project. He took photographs in Harlem and nearby

at the Colonial Park pool, constructed in 1936 and located below Sugar Hill, Harlem's more prosperous section. Grossman took distant shots, as Corsini had, that transformed the swimmers into abstractions on the water. Grossman's photo suggests that the vigorous debates at the League regarding aesthetics and how to picture the city had not been resolved.[50]

Grossman did not just keep his distance. He approached the swimmers with his camera, as in his photograph of boys and girls lying on the concrete steps beside the pool. The figure entering the picture on the left is blurred and gives a measure of tension to the scene, much like Engel's photograph of the boys in the spray. Davis considers this "a key work from this series" and argues that it "was made even stronger by an accident of exposure" that introduced that dynamic blur. As he notes, "Grossman set his camera and tripod about twenty feet from a group of young bathers sunning themselves on the pool's concrete terraces. At the instant of exposure, however, an unrelated figure intruded into the left side of the frame."[51]

At the time, Grossman did not print the picture, and it remained unseen for several years. The shot anticipates some of the directions his New York photography would take, with extensive work in the darkroom necessary to develop and print the photo. The image reveals "Grossman's interest in engaging with his subjects openly, rather than employing a more surreptitious candid approach." It also demonstrates the difference the pool made in children's lives. Unlike the boys enjoying the water spray in Engel's photograph, at the Colonial Pool, Black kids could escape the hot sidewalks and enjoy the pool's light, cleanliness, spaciousness, and freedom. Although boys and girls could swim together, the pool remained a de facto segregated space, deliberately designed for Black and Puerto Rican New Yorkers by the city's Parks Commissioner, Robert Moses.[52]

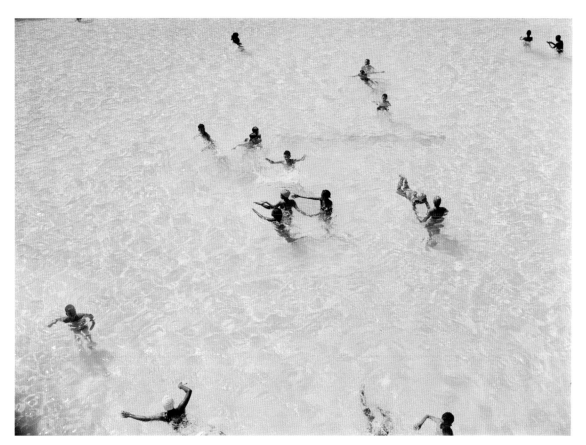

1.11 Sid Grossman, *Colonial Park Pool below Sugar Hill*, 1939. Grossman received an opportunity to work for the Federal Art Project on "The Negroes in New York." Parks Commissioner Robert Moses located a swimming pool in Harlem for Black residents to keep them from visiting pools in white neighborhoods. Sid Grossman (1915–55) for Federal Art Project. Museum of the City of New York, 43.131.9.76.

Grossman subsequently decided to crop and print a different version, one that emphasized his engagement with the young swimmers rather than their pleasure at the pool. "These moments of mutual regard," Davis contends, "convey a heightened and shared awareness of the act of picture making." Later, "Grossman rethought this image in the darkroom, choosing to reshape it as a tightly cropped vertical. With an exquisite formal logic," writes Davis, "this version contrasts the rhythms of young bodies with the geometric structure of the concrete terraces. By highlighting the backward glances of the youths, this version also accentuates Grossman's act of engagement with his subjects."[53]

League photographers initiated an extended project of street photography as the key alternative means to seeing and understanding New York. Their perspective as natives contested established aesthetics. Strand revealed these new perspectives in his introduction to the catalog of Morris Engel's show at the New School for Social Research in December 1939.

Characterizing Engel as "a part of a vital development in American photography," Strand noted how "an ever growing number of photographers, many

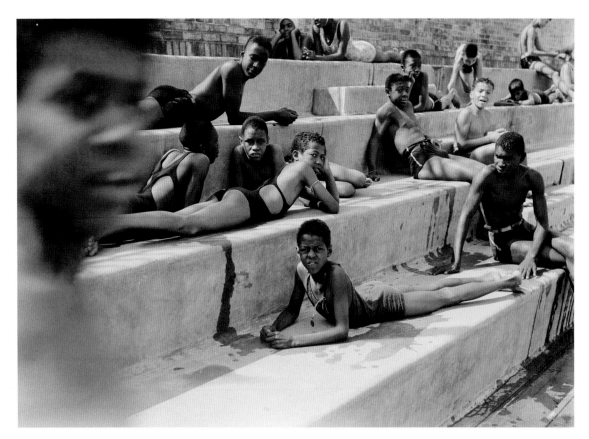

1.12 Sid Grossman, *Swimming Pool and Children*, 1939. Grossman set up his camera and tripod close to the children who were sunbathing on the concrete terrace. His shutter caught a boy passing close to the camera. Sid Grossman (1915–55) for Federal Art Project. Museum of the City of New York, 43.131.9.62.

of them still young, have turned their cameras upon their environment and have begun to document both America and the time in which they themselves live." He described Engel, already with four years of work at the Photo League under his belt, as "a young man of twenty-one who sees people with compassionate understanding, as they move within the city's tumult or relax for a few hours at a nearby beach." Engel "sees his subjects very specifically and intensely. They are not types but people."

Strand aimed to disconnect Engel's photographs from a particular ideological inclination. He credited Engel's vision, not the speed of his shutter, for seizing the expressiveness of a person "as he or she moves down an avenue or street, amid the welter of city movement." In fact, as Strand observed, "sometimes it is not one person but several whom he photographs"—for example, "a man glancing at a girl as he goes into a subway." Indeed, Engel's photograph of *East Side Sweet Evelyn* captured the dense network of looks given and taken, a circulation of attention characteristic of city streets. It also dramatically portrayed the freedom white men possessed to stare at women.[54]

Strand was right to single out Engel's effort "to photograph relationships between people." Not just portraiture on the street but an interaction was the "most vital and interesting quality" that distinguished

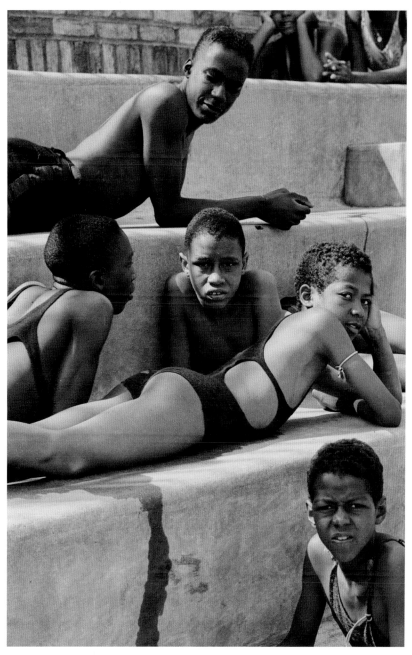

1.13 Sid Grossman, *Harlem, WPA*, ca. 1939. Grossman subsequently cropped and printed this image to bring viewers closer to the children to emphasize their engagement with him. © Howard Greenberg Gallery, New York.

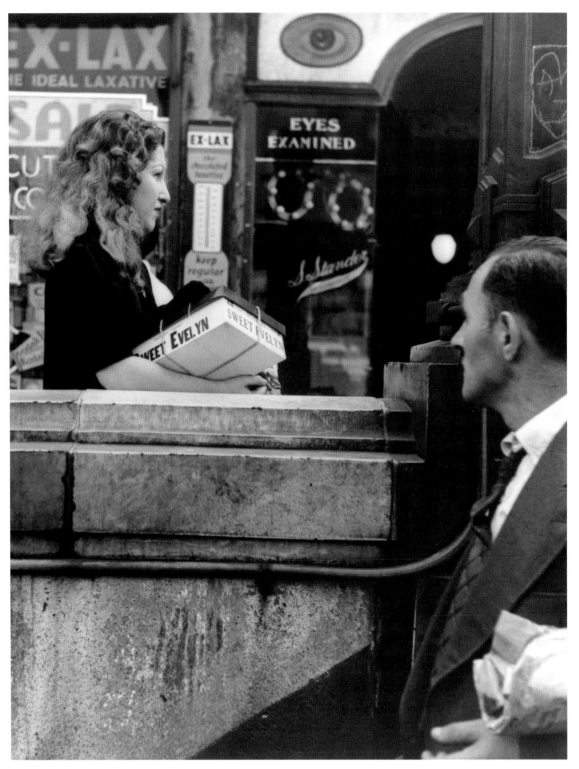

1.14 Morris Engel, *East Side Sweet Evelyn*, ca. 1937. Engel caught this man casting a sidelong glance at a young woman amid signs advertising the "ideal laxative" while heading down the steps to the subway. He also presented an image of "eyes examined" as the sign portrayed. © Morris Engel.

Engel's work. These everyday public interactions on city streets conveyed the real New York. Engel's photographs intercepted intimate dynamics of looking that can connect strangers and even estrange friends. For *East Side Sweet Evelyn*, Engel arrested a man's stolen glance at a young woman walking on the street as he enters the subway. The man indulges in the male prerogative of eyeing women, a practice that "legitimated the dominance of masculinity, whiteness and heterosexuality. An ocular desire for the female body was a crucial element of this version of hegemonic masculinity." In this situation, the woman resolutely keeps her eyes focused forward. But the image itself was *taken*. Simultaneously, the photograph implicates its viewers who are invited to consider this flashing moment of voyeurism. The downtown chatter of commercial symbols and icons comment on this close encounter, most especially the eye that stares out, unblinking, advertising "eyes examined."[55]

East Side Sweet Evelyn presents an honest, unposed photograph. Engel did not crop the original frame. It captures the circulation of gazes in the city. It also clearly portrays the gendered dynamic of looking. And then there is that optometrist's sign. Had Engel parked himself at that spot, fishing for a sublime happenstance? The window of opportunity was narrow. Like many great photographers, Engel repeatedly harnessed luck and pluck, patience, and skill.[56]

As espoused by Photo League members, street photography sought to portray relationships, a sensibility of circulating attention. "A certain set of social and viewing relationships operates in public places," notes art historian Rebecca Zurier. "Civic behavior sanctions looking at other people, and anyone in a position to look is vulnerable to being looked at in turn." Urban spectatorship is part of the city's fabric. New Yorkers did it all the time. But it took Photo League photographers to connect these behaviors to

a political, moral, and aesthetic perspective. Modernity required that individuals practice their performance skills to get by in the city. If everyone *passes* in this sense, wearing faces and clothes for varying occasions, Jewishness reveals itself as a normative condition. As the nineteenth-century Jewish poet Yehudah Leib Gordon famously urged, "Be a man in the street, and a Jew at home." Young Jews at the Photo League tried to reveal their city visually by exposing its web of sightlines. The structuring energies of their photographs of New York often relate to tensions of looks averted, of eyelines that drill through pictured space or that spark like crossed tram wires.[57]

After the United States entered World War II, the FBI investigated the Photo League. A 1942 report described it: "For the most part, the members are interested in the serious aspects of photography—that is documentary pictures of social significance. They are all pretty definitely pro-labor and a great many are obviously Communist in their leanings." The report came close to hitting the mark. The phrase "documentary pictures of social significance" even suggests a bit of wry G-man humor. It echoes a refrain from *Pins and Needles*, the popular musical revue produced by the International Ladies Garment Workers Union in 1937: "Sing me a song with social significance / there's nothing else that will do . . . or I won't love you." As one scholar observed, "the League was born in a heyday of political activity, when a large percentage of artists and writers firmly believed that it was their patriotic duty and their legal right to find alternatives to the stultifying effects of the Depression era." The FBI report went on to note: "The members are mainly workers whose avocation is photography and who follow it as best they can in their spare time."[58]

World War II disrupted the collective spirit of League photographers. Many of its male activists enlisted in the armed forces. Some served as

photographers in Signal Corps units, several overseas. In the 1930s a trickle of Jewish refugees fleeing Hitler escaped to the United States, including some photographers. Following World War II, additional Jewish photographers arrived from other cities—Chicago, Baltimore, Philadelphia, Pittsburgh—augmenting and diversifying the experiences of League members.

During and after the war, New York became a major center of photographic production in journalism, advertising, fashion, business, portraiture, and sports. As the garment industry had expanded during the immigrant era, so did possibilities for work in photography in the years after World War II. Photographs displaced drawing in fashion advertising. As a result, the character of photography changed. Jewish photographers who found work in fashion discovered that most art directors did not care about radical politics. By the 1950s, photography became increasingly commercial, a means to earn a livelihood, and, simultaneously, expressive of personal ways of seeing, potentially an art form.

The postwar Red Scare and the McCarthy era spurred attention to communist commitments among Photo League members just when members, including some of the most ideological, were moving away from consciously taking documentary pictures with social significance. Instead, they were experimenting with a more overtly personal photography of existential scrutiny. The war and its violence reverberated subtly in their photographs. That violence included the murder of millions of Jewish civilians by Nazi Germany.[59]

Released from the austerity imposed by the war, New York City boomed, benefiting from a renewed prosperity and rising consumer spending. New York's working class experienced unprecedented economic success that registered in rising income. "Culturally, socially, and politically blue-collar workers loomed larger at the end of World War II than at any time

before or since." At the League, Jewish photographers continued to share their images and learn from each other in classes with master teachers. Even as the city changed, they sought to picture and reflect upon ordinary urban life. Their photographs transformed everyday sights. They invited contemplation of frozen moments of time and consideration of the fabric of social life in the United States' largest city when "high culture and rough culture, provincialism and cosmopolitanism, the smart aleck and the cool coexisted in working-class neighborhoods." In many ways Jewish photographers were portraying and responding to familiar elements of their own Jewish American culture as it emerged in the city. Historian Joshua Freeman argues that "the sensibility of New York workers—savvy, opinionated, democratic—helped set the tone of the nation in the postwar years." Jewish photographers resonated to the city's mix of high and low culture often shaped by fellow New York Jews. Photographers at the League captured that milieu even as their overtly left-wing motivations shifted, partly for personal reasons and partly in response to the rise of anticommunist pressures.[60]

There were very different notions of what a left-wing photographer should shoot in the 1930s and 1940s, not to mention the 1950s when communism and other varieties of progressive politics were under attack, including the Photo League. In December 1947 the League landed on the attorney general's list of subversive organizations. Jewish photographers associated with the Photo League usually eschewed standard popular-front images of strikes, evictions, protests, and rallies. And when they did take such photos—for example, Jerome Liebling's powerful and provocative 1948 picture of a May Day stand-off in Manhattan's Union Square—they often produced arresting images far removed from the canons of socialist realism or the dictates of didactic political photography promoting a message.[61]

1.15 Jerome Liebling, *Union Square, New York City, 1948*. At a May Day gathering, the men faced off in front of police. Liebling, standing with the men, focused on the cop's hat, the symbol of authority. Jerome Liebling Photography LLC. © Jerome Liebling Photography, LLC. Courtesy of Rachel Liebling.

Liebling's photo of a fragment of a cop's hat with its shield of authority, taken from the photographer's position among the men facing the policeman, transforms this confrontation into an unexpected and abstract, yet emotion-laden, image of citizens versus the state. Standing among the men, Liebling focuses sharply on the cop, letting the foreground blur. If it does not surprise today, that may be because the idea of the embedded photographer who spends time within a specific group (often a military unit) has become far more common than it was in 1948.

The son of immigrant parents, Liebling grew up in Bensonhurst, Brooklyn, a mixed Jewish and Italian

neighborhood, during the Great Depression. Like many Jews who gravitated to photography, Liebling received his first camera as a gift. In Liebling's case, his father, a restaurant worker and strong unionist who loved America, gave him a camera. Liebling promptly began taking pictures of poor people to convince his father of his false faith in the United States. After a three-year stint in the military during World War II in the 82nd Airborne, glider infantry, Liebling returned to attend Brooklyn College on the GI Bill. There he took a photography course with Walter Rosenblum. Like Liebling, Rosenblum grew up the son of immigrant Jewish parents and served in the armed forces during World War II. In Rosenblum's case, he was a member of the army's 162nd Photographic Company and saw action at D-Day. Unlike Liebling, he came of age on the poverty-stricken Lower East Side. Rosenblum's father was Orthodox, not a union man. Both Liebling and Rosenblum embraced left-wing politics. In 1947 Liebling followed Rosenblum and joined the New York Photo League. Still a student at Brooklyn College, Liebling recalled how he "was filled with ideas and ideals about documentary photography, the Bauhaus aesthetic, photojournalism, filmmaking, and how all of this related to politics." Liebling discovered "many like-minded people" at the League who shared his politics, supported his growth as a photographer, and taught him how to think about photography. "Rosenblum led me through the streets," he recalled, "and helped me establish where my sympathies would lie." Those sympathies, shaped by his Jewishness, politics, and experience at the League, resided with the poor, the working classes, and Black people.[62]

By the 1960s, New York had changed yet again, fueled by vast demographic transformations. As Freeman writes, "the influx of African-Americans and Puerto Ricans to the city and the outflow of whites" injected "a spirit of militance" into the city. Attitudes toward photographers, especially street photographers, shifted as photographs saturated public consciousness. A decade after the Photo League closed its doors in 1951, "creative" street photography began attracting attention as art.[63]

In the 1990s, William Meyers, both a photographer and a critic, organized a meeting to discuss Jews and photography. He sought to understand the extraordinary presence of Jews in twentieth-century photography. Two questions intrigued him: Why did so many Jews become photographers, and why did they choose to make the kinds of pictures they did? At one point in the discussion, he asked, "Why was it that of all the ethnic groups in New York City in the 1930's and 1940's, it was the Jews who took it into their heads to go to Harlem and photograph the blacks there?" Naomi Rosenblum, a teacher, wife of the left-wing photographer Walter Rosenblum, and author of *A World History of Photography*, promptly replied, "We weren't Jews; we were leftists."[64]

She expressed the self-identification of many New York Jewish photographers at the time. They chose a political identity for themselves; Jewishness did not need to be chosen or even necessarily acknowledged. It just existed. Meyers didn't exactly disagree. "Leftism provided these Jews with a way of seeing," he contended. "They could photograph blacks, and migrants, and derelicts, and gangsters, the dispossessed and the homeless," he continued, "because they had a social framework in which these subjects could be understood." Meyers's remark lumped "blacks" together with gangsters and derelicts as socially despised "others." Photo League photographers rejected this conflation of identities. They did not picture Black people as gangsters or derelicts, dispossessed or homeless, but rather portrayed them as New Yorkers, sharing common qualities with working-class whites. League members rarely

photographed gangsters, derelicts, migrants, or, for that matter, wealthy and prosperous New Yorkers.[65]

Jewishness was malleable. One category of identity based on politics did not preclude another based on ethnicity. Naomi Rosenblum articulated a pervasive political self-consciousness among Jewish photographers at the time. However, her statement only opened discussion because "leftism"—whether of the socialist or communist or antifascist or even New Deal democratic variety—did not, in fact, translate directly into ways of seeing. In that limited sense, Meyers was wrong.

New York Jewish photographers produced a distinctive urban vision, nurtured initially by the Photo League but extending beyond it. Looking at New York through Jewish eyes, shaped by their upbringing and sharpened in discussions at the Photo League, a cityscape emerges of working-class people, not monumental buildings and grand vistas. By focusing on New Yorkers' patterns of living—their use of public transit, their behaviors on city sidewalks, their pursuit of leisure at Coney Island—the city Jewish photographers portray reveals its forms and textures of life. Their city is constantly renewed through its residents' conversations, the ways New Yorkers wait or hang out, get along and get by. Finely tuned negotiations determine how they stand in line, or share a stoop, or a bench. Body language is a dance of telling and asking that shapes the "presentation of self in everyday life," as the sociologist Erving Goffman memorably put it.[66]

These photographers believed in the inherent dignity of the individuals they photographed. Their perspectives reflect, in part, personal and communal commitments to left-wing politics, which in turn draw upon their New York Jewish upbringings. Their pictures are neither agitprop nor mere expressions of their Jewish identities. These photographers sought to understand both themselves and their city. And

through their own freewheeling discussions about photography that often lasted into the early morning hours, they learned to see their own city differently. It was no longer just a place of crowds and garbage, of despair and longing, of suffering and violence, of injustice and ugliness. It also became a site of performance, reflection, and intercourse, a place of creative disorder, imagination, and, on occasion, unexpected beauty. As walkers in the city with cameras, Jewish photographers captured their impressions in images. Their camera lens let them penetrate the ugly façade of poverty to see the people and their humanity. They used their cameras to make sense of the world and to find their own place within it. As they fashioned an aesthetic guiding their choice of what to photograph as well as how to photograph, they produced a dialogue, created by both photographer and photographed.

The photography historian Jane Livingston persuasively claimed that there was a "New York School of Photography" demarcated by the years 1936–63. Her choice of photographers and some photographs overlaps with those presented in this book, but her interest emphasizes the important visual connections and contributions to the history of photography made by these photographers. Similarly, curator Lisa Hostetler revisits many of these New York photographers in her book on the psychological gesture in American photography. She narrows her time frame to 1940–59, yet her visual argument connects with this volume.[67]

The following chapters build on their insights as well as those of Max Kozloff, who tackled the question of the photographers' Jewishness in influential ways. These chapters add a concern with the visual history of New York City and the complex Jewish role in creating that history. On the sidewalks, rubbing shoulders with working-class city residents, these Jewish photographers produced a compelling

portrait of an American city across three decades. Their photographs help convey what it meant to be a New Yorker in those years and why Jews embraced New York in all its fractured chaos as the best place to be both different and free.[68]

"The New York Photo League incubated an ethnic Jewish discourse about the responsibility of photographically observing looks on the streets of their multiethnic city. At the League, taking and making photographs and talking endlessly about them were things Jews did among Jews, but with the door open." Through visual dislocations that embrace and interrogate, their pictures discomfit viewers for cause.[69]

Photo League images did not displace the Empire State Building, nor did they manage to convince New Yorkers or other Americans of the accuracy or necessity of their honest viewpoint. With the benefit of hindsight, these images of New York City can be understood as a genre of Jewish cultural production. Urged to photograph their city, the one they knew from eye-level experience, League members produced a distinctive historical visual record of New York. The streets beckoned them as sites to forge an identity with their cameras amid intimacy and differences. Photography provided a key to claiming their place within the city's robust heterogeneity.

2. Looking

Around 1940, Helen Levitt took a photograph of a young girl and boy dancing on the streets of Manhattan. The photograph has since become famous, but at the time it was part of Levitt's larger project of photographing children playing in the street. Dancing, with its performative dimensions, could be understood as a form of play. Children of various ages did it often, at times to music from a radio, as in another photograph Levitt took in Harlem (to be discussed below). In figure 2.4 one can almost hear the music by looking at the children doing the jitterbug on the sidewalk while others watch and enjoy their performance.

Summer in New York is a great time to catch impromptu performances, fleeting or sometimes, thanks to Levitt, permanent. In one photograph, a girl dances in bright sunlight while the boy turns in the shadow of a building. She appears slightly older than he, her gestures overtly dramatic. Her left hand thrusts forward urgently, and her knitted brows telegraph seriousness, yet a nonchalant left leg hangs back. His left hand blurs backward as he pivots under his right hand. Confidently, he speaks or sings to her. Levitt and her camera and, therefore, multitudes are their curious audience.

Levitt's photograph arrests a relationship that appears complicated to adult eyes, since the girl is white and the boy is Black. Those adult categories of social separation and difference don't appear to matter to either child. "Levitt chose deliberately to represent children coded quite explicitly as working class and racially heterogeneous," argues the scholar Elizabeth Gand. Looking more closely past the difference of skin color, commonalities stand out. Both children have arms raised—the boy only one, the girl two—and they appear to be turning. Both are nicely attired. Their clean clothes, shoes, and socks bespeak loving care on the part, one assumes, of a mother. Self-presentation on the city's streets was a way of claiming an identity that poverty would deny individuals. It expressed, too, a certain modest democratic ethos.[1]

The rest of the photograph eludes specific identification. In the background there is the "front stoop of a tenement building with a wrought iron ornamental railing and fence. The gate to the below-grade apartment is closed. The street is angled, so the steps account for the slanting sidewalk by being irregular in height. Clearly this is a hilly section of the city" (most likely uptown, probably Harlem, an

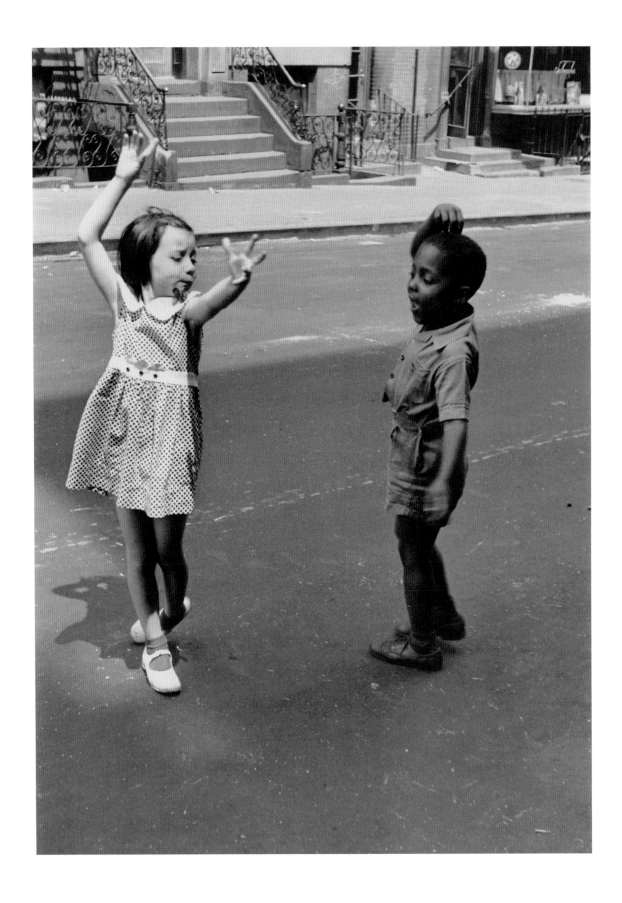

area that attracted Levitt). "On the right, a storefront with a sign for 7Up in its window indicates a mixed residential and commercial neighborhood" typical of working-class sections of the city.[2]

Levitt comes close to adopting a child's perspective, looking only slightly downward at the children. Her photograph suggests some possibilities of childhood in the city and the power of play to engage friends across color lines. It narrates an understanding of "streets as sites for imaginative performance. It invites storytelling" with its "language of choreography" rather than of composition. It invokes a street culture that verges on a transformative innocence. "The ballet of the good city sidewalk never repeats itself from place to place," the urbanist Jane Jacobs writes, "and in any one place is always replete with new improvisations."[3]

Levitt later recalled that she gravitated to photography because she wanted to be an artist but couldn't draw. She "started to take pictures of black people and working-class neighborhoods." Growing up in Bensonhurst, Brooklyn, a mixed Italian and Jewish, mostly middle-class neighborhood, Levitt confessed that she found Black people "extremely exotic." She wanted to photograph the working class and their "conditions," understood as a political term that drew attention to exploitation and oppression. As she admitted, "I was affected by the time," that is, the Great Depression of the 1930s and the flourishing of radical politics in New York. So she "started photographing people."[4]

Conventions of looking on city streets constrained women, although a white woman with a camera around her neck asserted her right to stare. Female street photographers often "exposed their intentions as they observed others." Unlike many male photographers, they usually avoided direct exchanges with their subjects. Using their camera as a kind of passport to explore the city, they entered unfamiliar territory. There were some masculine domains—especially in the world of work—that they tended to avoid. Unavoidably, "the frisson of gendered attention [wa]s not an uncommon aspect of photographic interactions."[5]

Race complicated the issue of a woman's gaze. Levitt's photograph of a group of Black people presents a subtle series of performances for the young white (Jewish) woman with a camera. The men and boys "are arrayed around stairs at the entrance to a brownstone." Two men ignore her. Sitting on a stone stoop, one of them reads a book. The mustached white guy standing in the doorway may be unwrapping a cigar. The other four fellows not only notice the photographer, but also pose for her. "The boy holding a basket stands still," a faint, cautious smile on his face. A young man sitting on the stoop, feet and arms crossed, smiles more broadly. Their expressions are contained, tentative. They differ from the posture of a well-dressed young man in a stylish leather jacket who stands at the foot of the stairs. With one hand on his hip and the other behind his head, "he flashes a broad grin as he turns to look right at Levitt." And in the center, wearing torn knickers, a striped sweater vest, hat, and scarf, a teenager poses, hips slouching forward and to his right. "A Bert Lahr smile, outrageously winsome and demure, plays across his face." He possesses, notes writer Adam Gopnik, "extraordinary style and grace in his beret and wide knickers." Gopnik called the photo "an ideal fashion picture, a perfect study of a certain kind of hard-earned African-American slyness and hyper-awareness." Gopnik does not dwell on its gendered dimensions, including the fact that these Black men and boys feel comfortable looking at a white woman, long a taboo in American society. A curious energy vibrates between these fellows and Levitt and her camera. The range of responses evinced suggests that they peg her as an outsider, but not a journalist, and apparently not exactly a tourist.[6]

2.1 Helen Levitt, *New York* (cropped), ca. 1940. The two children perform for themselves and Levitt's camera, the girl in bright sunlight and the boy in shadow. Helen Levitt, NY, ca. 1940. © Film Documents LLC. Courtesy of Galerie Thomas Zander, Cologne.

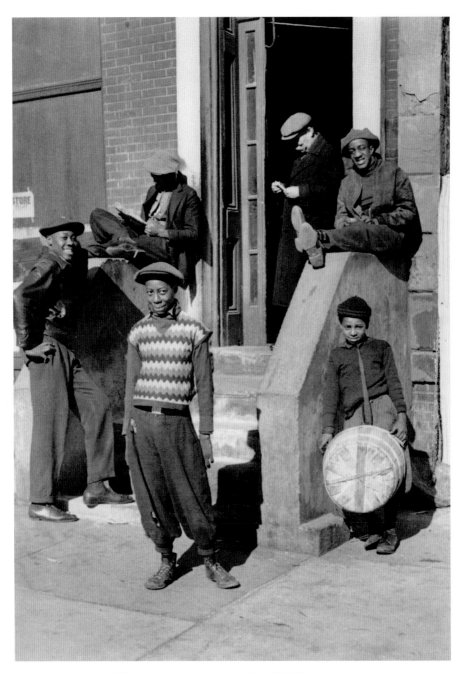

2.2 Helen Levitt, Untitled (Black boys and men on a stoop), ca. 1940. This group portrait of Black neighbors and perhaps friends portrays varied poses for Levitt, a white woman photographer in a Black neighborhood. Helen Levitt, NY, ca. 1940. © Film Documents LLC. Courtesy of Galerie Thomas Zander, Cologne.

"Life was in the streets," recalled Ida Wyman. "That's where you were. Nobody thought of it as *street photography*. Most photographers' photos were out of doors." Shortly before her seventeenth birthday in 1943, during World War II, Wyman graduated from Walton High School in the Bronx. Searching for work, she landed a job in the mailroom at Acme Newspictures, the only "girl" there. Soon she graduated to printing, joining an all-male photo darkroom staff. She previously had taken pictures with an inexpensive camera and had joined her high school's camera club, which had its own darkroom. Now, with her wages, she purchased a 3¼ x 4¼ Graflex Speed Graphic camera, complete with leather case, film holders, and film. It was slightly smaller and less expensive than the 4 x 5 Speed Graphic, the standard camera for news photographers. "Hefting that case onto my shoulder made me feel truly professional," she remembered. "I'd load up my film holders in the Acme darkroom and set out looking for pictures on my lunch hours."[7]

Wyman photographed office workers and laborers on their lunch breaks, men at work in the nearby Garment District, and people and businesses in the streets near her Bronx home. Her picture of a newspaper girl conveys the choreography of ordinary street commerce. Wyman engages neither the young woman selling papers nor the older woman purchasing one. Her more hesitant posture as a young woman with a camera contrasted with that of Levitt, who sought out and engaged people at their leisure.

Levitt started photographing kids not out of any particular love for children. "It was just that children were out in the streets," she explained. Gand contends that it's a bit more complicated. "In order to understand the significance of Levitt's sense of the street child," she writes, "we need to restore her photographs to their historical specificity by relating her work to the intense production and circulation of images of children in the 1930s and 1940s, when a

veritable child mania burst forth in American culture, as a torrent of photographs, paintings, exhibitions, books, movies, and articles made children newly visible as objects of study, ideals of contemplation, and targets of political policy." As a woman photographer, Levitt possessed easier access to children. They did not see her as a threatening figure.[8]

The writer Francine Prose described Levitt's people as stepping into a role on the streets with "paradoxically unselfconscious theatricality." Levitt's New Yorkers, remarked Gopnik, "dress up and act out." According to John Szarkowski, curator of photographs at the Museum of Modern Art: "Her photographs were not intended to tell a story or document a social thesis; she worked in poor neighborhoods because there were people there, a street life that was richly sociable and visually interesting." Szarkowski marveled at how "these immemorially routine acts of life, practiced everywhere and always, are revealed as being full of grace, drama, humor, pathos and surprise." In Levitt's photographs it is "as though the street were a stage, and its people were all actors and actresses, mimes, orators and dancers."[9]

Her photograph of jitterbug dancers conveys just that sort of expressive "unselfconscious theatricality." Boy and girl are well partnered; he holds her hand as she swings out to music that probably pours out of the radio shop. Two other girls work on their steps together, but they seem less confident. A small group of onlookers surrounds the two dancing couples. A web of circulating sightlines converges upon the dancers. A man with a cigarette watches the two girls; a woman in the background leans on a large box and turns to view the scene. One shirtless boy, apparently holding scooter handles, stops to watch. A girl, arms behind her back, gazes intently at the dancers, her feet in a modified third position as though ready to dance. At the store entrance a smiling boy leans against the door frame, arms behind him, left leg crossed over right. To his left, an adult

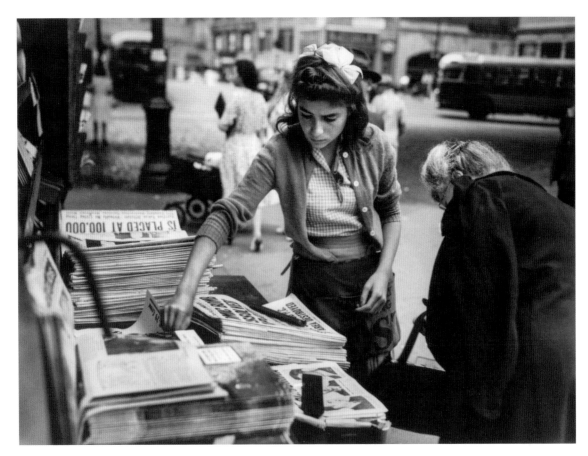

2.3 Ida Wyman, *The News Girl,* 1945. Buying and selling newspapers on the city's streets occurred in all sorts of neighborhoods. Women and men ran newsstands, a means to earn a modest livelihood. © Ida Wyman. Courtesy of Heather Garrison.

man with a cocked hat lounges on a metal chair just outside the store, one leg resting on the step at the entrance.

These postures of looking indicate neighborly modes of participation. The men and women, girls and boys, form an appreciative audience for the dancers. It is a cloudy summer day, cooler outside than in stuffy, cramped apartments, a good place to pass the time. Unlike Levitt's photograph of the two children, this picture conveys the lively dimensions of New York street culture, both its performers and its audience members. It is, in short, the real city, and an

honest photograph, according to aesthetic and political categories championed by street photographers of the New York Photo League. The writer E. B. White observed that in New York City an individual was able "to choose his spectacle and so conserve his soul."[10]

Looking back from a later century at these photographs of New York street performances, they seem to capture memories. Photography, writes the photo historian John Berger, is "the process of rendering observation self-conscious." A photo reflects the decision to preserve a record of an event as important. Berger implies that a public photograph is a field that invites shared memories produced by those who click the shutter, develop the negative,

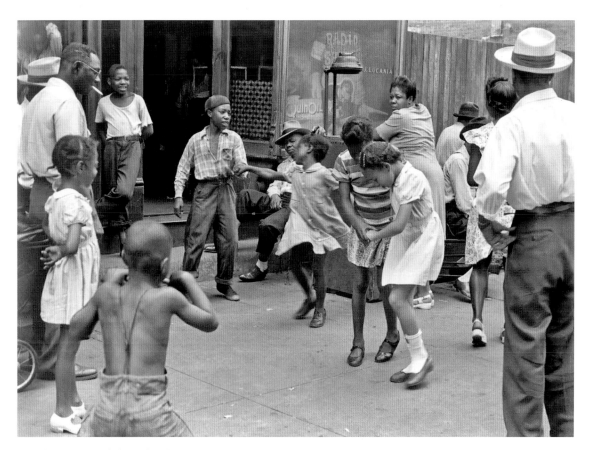

2.4 Helen Levitt, Untitled (jitterbug dancers), ca. 1940. One can almost hear the music pouring out of the store animating these jitterbug dancers whose sure command of the steps attracts an attentive crowd. Helen Levitt, NY, ca. 1940. © Film Documents LLC. Courtesy of Galerie Thomas Zander, Cologne.

select one image in particular, and then create one or several prints. Photos are taken but also made. Most photographic prints expire in a dark drawer, unappreciated, unshared. If fortunate, people may see a print or, more often, a copy of a print. None of these activities occurs in isolation. Someone arranges photos with an eye toward specific contexts of display: on one page among others, or on a particular wall next to other sequenced photos, those few that are present and the many that are absent for cause. Performance scholar Barbara Kirshenblatt-Gimblett observes: "Ethnographic objects move from curio to specimen to art, though not necessarily in that order." Something like this also occurs with street photographs. With luck their contingencies are sharpened and expanded, whether in a magazine, a book, online, or on the wall of a museum, gallery, or home.[11]

The daughter of middle-class Russian Jewish immigrants, Helen Levitt first savored the power of images at the movies. Like many young New York Jews, as a child she went regularly on Saturdays, not to synagogue, but to watch "the serial." A serious fan, she even "turned down a birthday party once to go." Levitt also loved to watch foreign movies, a passion that led her to the left-wing precursor organization

of the New York Photo League, the Workers Film and Photo League. The photo historian Jane Livingston observes that while "it is impossible to document exactly who among the photographers saw what films, and at what point in their lives," it is clear that movies "were a part of the everyday cultural environment and the intellectual milieu" in which New York street photographers matured.[12]

Levitt not only frequented the movies, she also regularly visited one of the few commercial art galleries in town that exhibited photographs. In 1930, she dropped out of high school and served as an apprentice to a Bronx portrait photographer while holding down a job at Gimbel's department store. Then, at Julien Levy's gallery in 1935, she saw the work of the American photographer Walker Evans, the French photographer Henri Cartier-Bresson, and the Mexican photographer Manuel Álvarez Bravo. Their photographs encouraged her to move beyond "the confines of commercial, journalistic, and documentary photography." After she had started to take her own photographs, she became friends with Evans, who was ten years her senior. She briefly dated him and helped him to print images for his 1938 exhibition at the Museum of Modern Art. Evans subsequently introduced her to James Agee, his partner on a book, *Let Us Now Praise Famous Men*. Then Levitt worked side by side with Evans on a series of subway photographs that he took surreptitiously between 1938 and 1941. And she, too, collaborated with Agee on a book, *A Way of Seeing: Photographs of New York*. Evans also introduced Levitt to his friend, the radical immigrant Jewish painter and photographer Ben Shahn. When Cartier-Bresson came to the United States after World War II, she accompanied him around Brooklyn when he was taking photographs. All three photographers Levitt claimed as influences on her own work.[13]

That work began around 1936 when Levitt was in her early twenties, like Sid Grossman and Sol Libsohn. Her first published photos appeared in the July 1939 issue of *Fortune* magazine. "Levitt's great breakthrough followed from her recognition that children's art and play were subjects worthy of investigation," argues Gand. "Between 1936 and 1938 she began to organize her vision of urban experience around the imagination of the child." She received her first solo show of photographs of children at the Museum of Modern Art in 1943. Levitt exhibited her photographs at the New York Photo League that same year, but she avoided participating in their collectively organized Feature Group projects.[14]

As Levitt's photo of the jitterbuggers illustrates, street performers convert passersby into audiences. And as her picture of six guys on a stoop makes clear, in some situations a street photographer functions as a catalyst. Her evident interest stimulates some subjects to assert agency. To varying degrees, this is part of taking people's pictures: in a portrait studio, at a family picnic, or among acquaintances or strangers on a city street. As the shutter is clicking, this or that person looks back with annoyance, bemusement, amusement, curiosity, or disdain. On the street "definition(s) of the situation" are always contested and often fleeting. Given or taken, agency modifies definitions of the situation. Photographs do, per Berger, make "observation self-conscious," and this process continues to morph as long as people take photos, pose for photos, and look at photos.[15]

Sometimes photographers found the audience more interesting than the performance. When that happened, they occasionally produced a kind of tableau vivant, almost an unstaged mirror of a performance, as happened in Sol Libsohn's photograph of a cluster of people on Hester Street in 1938. Here the ritual of looking—by the photographer and by the people on the street—reveals "self as both subject and object." Libsohn portrayed a kind of

regenerative public web of self-presentation on city streets that lent flexible form to the "liquid condition" of metropolitan life.[16]

Hester Street is a record. It captures particularities of an evolving urban social performance. "Not only does Libsohn picture young, old, and middle-aged working-class Jews in the most iconic of New York Jewish neighborhoods, the Lower East Side, but he also shows an interactive stage. Neighborhood seating was flexible, with risers and balconies at every stoop and window. Storefronts served as backdrops." In this case, at least one event is playing out somewhere else, off camera. People on the steps, looking in one direction, may be watching a parade, a labor rally perhaps, possibly an accident or altercation. Libsohn isn't interested. He looks at the spectators, inducing some of them to stare back at him, questioning his camera's incursion. Decades later, the photograph can be viewed as almost ethnographic, picturing Jews in the streets when the Lower East Side was still a Jewish neighborhood, despite greatly reduced numbers. Or viewers can just see working-class New Yorkers, men, women, and children with no ethnic references.[17]

In Libsohn's photo the kinetics of looking turn on multiple pivots. "The only figure wholly in focus, an older woman with arms folded protectively across her flower print housedress, anchors the eccentric orbits of his characters." She alone looks upstream to her left. Of three women, only she has planted herself at the edge of the flow of the street. "Street activity draws parallel looks from the gallery; but one guy has had enough. Libsohn records the effect of his intrusion." The price of admission: he gets nailed by converging stares, as does the viewer of the photograph. That boy up close: maybe he's got a word for Libsohn. The man on the right glances sharply from under his hat, giving as good as he gets. A couple of steps down from the sidewalk on the left, someone coming out of grocery store looks dead at Libsohn;

and in turn, the intensity of his glare draws a glance from a passerby.[18]

Eventually a viewer of the photograph shifts from the people to notice the eyes on the optometrist's sign staring unblinkingly, promoting vision itself. "And beneath one eye, the Hebrew letters advertising to Jewish customers announce that this is a Jewish neighborhood." These optometrist signs with their single eye were all over the city, especially in a neighborhood like the Lower East Side. The training involved in becoming an optometrist represented a step up for aspiring second-generation Jews, not quite as good as a physician or a dentist, but still a position as a professional that combined an educated status with the independence of a small-business owner. If one looks hard enough one can see, behind the sign, in shadow, a man, leaning on a banister and looking out the window, peering out toward the street.[19]

When Paul Strand saw the photo, he criticized it for being two photos combined. There is the photo on the steps of the building, and then there is a second photo on the street itself, with the boy and man staring at the photographer. Furthermore, they are slightly out of focus, Strand said, and they interrupted the other photo, which Strand thought was excellent. Libsohn disagreed. Moments before or after, he explained, "there would have been no photograph; there was nothing he could do about the person who walked in front." This was a single photo, and he wanted to keep the interactions and the motion captured by his camera.[20]

"I had a deep interest in the ordinary people who lived there then, and when I saw this group I was overcome by another feeling I often have," Libsohn recalled, "that streets are often like stage settings, and sometimes you can catch people on those settings in very penetrating tableaux." The subject of his photo was the interactivity of urban looking itself. Street performances could not easily be divided

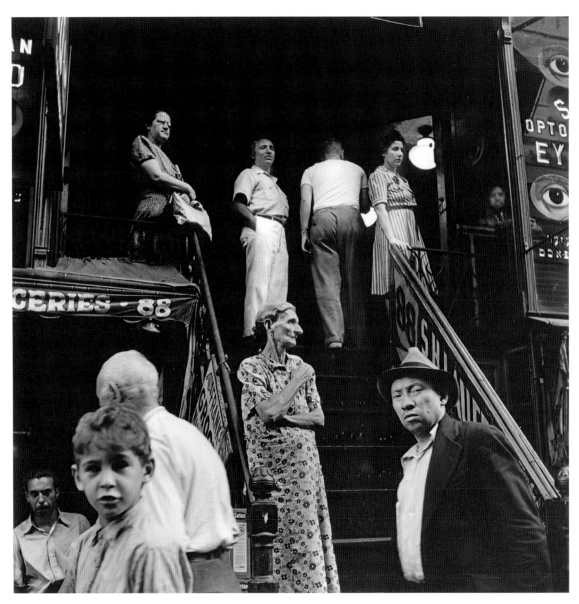

2.5 Sol Libsohn, *Hester Street, 1938*. Everyone possesses the power of looking on New York City's streets, and the circulating gazes and stares create a performance piece captured here by Libsohn. The Art Institute of Chicago/Art Resource, NY. © Estate of Sol Libsohn.

according to formal compositional grounds. Unlike Sid Grossman, who decided to crop his photo of the kids at the pool to remove the person moving into the frame, Libsohn held on to the full image despite its blurred figures in the foreground.[21]

Like Levitt, Libsohn, too, aspired initially to be an artist. As a teenager, he left his immigrant Jewish parents' home in a mixed working-class neighborhood in the Bronx to work in Manhattan. He even posed as an artist's model. Unlike Levitt, Libsohn graduated from Roosevelt High School and completed two years of college, going at night. He gravitated to the radical political discussions in the alcoves at City College, where he met Sid Grossman. Together they joined the Film and Photo League. Then they started to learn more about photography. "We went around to visit Alfred Stieglitz," whom they knew was a famous photographer. "Stieglitz was very strange sitting in his back room with his cape on," Libsohn recalled, "and here's two raggedy guys coming in. You know, wondering what the hell are these guys doing here? I felt very uncomfortable."[22]

Libsohn possessed a sharp consciousness of class differences. He noted them in his own extended family, and between the filmmakers and photographers at the Film and Photo League. Most of the former "came out of families with money." The filmmakers also differed in the kind of work they wanted to do, and in their politics. Libsohn remembered them, and such older photographers as Paul Strand and Walker Evans, as "forbidding," unlike Ben Shahn, who "never gave you that attitude." Shahn shared an interest in social realism and "the value of the photograph as a document." As Libsohn explained about the League's Chelsea Document when selections were published in the 1940 issue of *U.S. Camera*, photography "has the quality of extreme clarity," presenting "to the audience a vivid realism. Documentation of a social scene or photo sociological study is one of the functions to which photography is particularly well

adapted." At the same time, he recognized that the subject matter, and all the details, possessed their own powerful valence just like music or poetry. Photography had what he called "added conviction."[23]

Working as a photojournalist did not stop Dan Weiner from picturing a similar type of street performance. Weiner titled his photograph to indicate what was happening off camera. His picture of the diverse crowd watching the laying of the cornerstone of the United Nations building by the East River at 44th Street includes mostly men, young and old, black and white, working class and middle class. Only a single well-dressed woman stands among the crowd.

Weiner is not the only one with a camera; a young man standing on the truck carrying large wooden wheels of cable also looks into one. But Weiner chose to picture the onlookers, considering their performance as interesting as the cornerstone-laying ceremony. As in Libsohn's photo, Weiner's picture conveys a measure of focused concentration among those watching the event unfold. While newsworthy, the establishment of the United Nations building in Manhattan also possessed political resonances. The UN promised international cooperation rather than war, a commitment to peaceful resolution of national conflicts. Many New Yorkers supported such a liberal international politics in pursuit of peace.[24]

Like Libsohn, Weiner grew up the son of Jewish immigrant parents, albeit on 104th Street in a brownstone shared with his grandparents in a working-class section of east Harlem. He, too, wanted to be an artist, an ambition that sparked conflict with his father. When he was fifteen, Weiner's uncle gave him a Voigtländer nine-by-twelve-centimeter camera for his birthday. At eighteen, he left home, determined to paint. With his mother's help, he attended the Art Students League. There he would have encountered paintings by John Sloan, one of the Ashcan School artists who taught at the League. Weiner continued his art studies at the Pratt Institute, but at the same

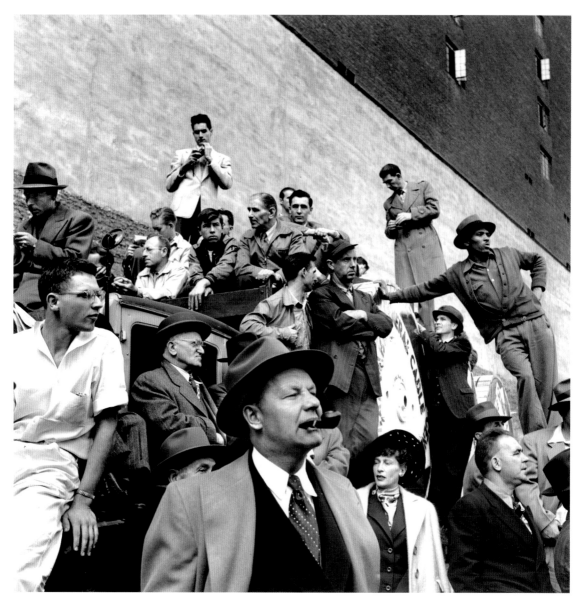

2.6 Dan Weiner, *Crowd Watching UN Cornerstone, 1949.* Laying the cornerstone for the United Nations building on the edge of the East River marked a hopeful moment after the devastating violence of World War II. Photo by Dan Weiner. © John Broderick.

time he made photographic portraits to earn a liveli-hood. He subsequently apprenticed to a commercial photographer, and after meeting Sandra Smith, whom he married in 1942, he concentrated exclu-sively on photography. Both joined the Photo League, and Dan taught there while Sandra took a class with Strand. In 1942 Dan was drafted into the military as a photographer. He spent three years in the Signal Corps of the Army Air Corps in Georgia, teaching re-cruits photography. These experiences allowed him to master a Contax camera with 35 mm film. After the war, he returned to the Photo League even as he pursued a career as a professional photographer, first in fashion and then in photojournalism.[25]

A photographer's presence often produced looks by others. Consider the looking in Lou Stoumen's *Sitting in Front of the Strand, Times Square, 1940.* "The young man with hands clasped sits on a ledge in front of the Strand Theater. He gazes soulfully upward, a look perhaps of disquiet on his face." Be-hind this wistful stranger a large sign flashes on the Strand. "It advertises the movie *City for Conquest,* a tough Warner Brothers romance in which Jewish box-ers, dancers, gangsters, and composers are coded as another ethnicity."[26]

"The stranger may be in his own world, but he is hardly alone. Stoumen's photograph records its own intrusiveness, modest as it seems, for within an image apparently focused on a sweet-faced dreamer, another figure has been caught looking, or rather has been induced to look. His presence is subtly disruptive, for his sightlines call attention to those of the photographer." He is part of the show, as the photographer (fronting for viewers?) is part of his. "What is going on, his glance seems to ask. Why is this photographer taking this guy's picture? Is he famous? Should I recognize him? Is he posing, part of a fashion shoot? Stoumen's 1940 photograph plays with the play-within-a-play of New York City. The young man, who might be imagined as prey or friend or savior, is oblivious." Here is a proper story: the plot of the image has thickened, because in looking at the *surface* of the picture, it ceases to cooperate with the convention that viewers notice things in photographs transparently, innocently.[27]

Stoumen came to New York City from Bethlehem, Pennsylvania, and gravitated to Times Square. As a student in Grossman's class at the Photo League he rejected Grossman's assignments and picked his own. Considering himself a "country boy," he found Times Square to be the center of the world, much more appealing than the Lower East Side. He joked that "at puberty I discovered photography and girls." When he gazed into the glass of a reflex camera for the first time, the image "seemed more urgent and vital than the 'reality' in front of it."[28]

Passive engagement of viewing others involves staging of self-presentation. Photographers on the city's streets consciously observed these rituals of address, as the sociologist Erving Goffman put it. Goffman provides a historically appropriate perspec-tive and language for seeing and interpreting street culture. His evocative, metaphorical sociological analysis references the theatrical, not the patholog-ical. He and Jewish street photographers disagreed with the modernist architect Le Corbusier. "The street wears us out," Le Corbusier said. "And when all is said and done, we have to admit it disgusts us." For Goffman, dirty streets promiscuously teeming with crowds and knots of mixed humanity, pushcarts, and commerce served not as backdrop for sermons about the poor, the need for better housing or play-grounds, or textbook illustrations of disorder and vice. He noticed instead, as did Jewish street photog-raphers, how streets organize themselves according to unwritten rules that govern ordinary interactions and rituals, quotidian "contacts between deities."[29]

Born in Canada in 1922 to Jewish parents, Goff-man came of age during the Great Depression like

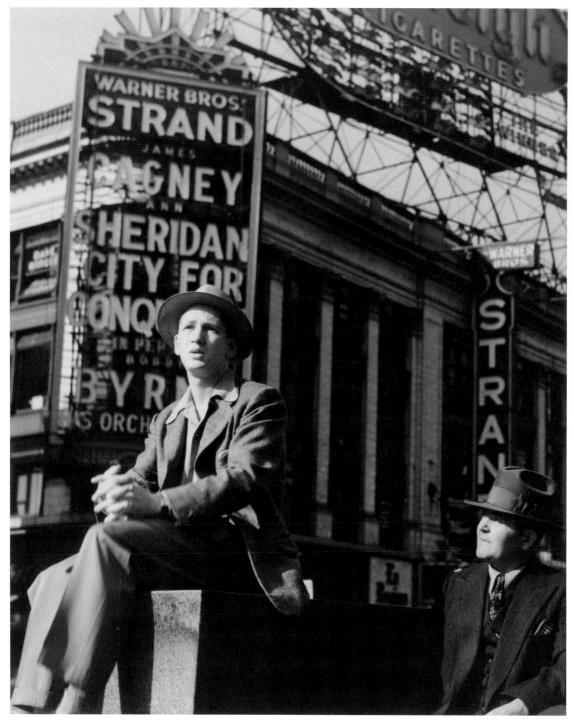

2.7 Lou Stoumen, *Sitting in Front of the Strand, Times Square, 1940.* As a newcomer to New York, Stoumen gravitated to Times Square, an endlessly fascinating place where his camera prompted others to stare as well. The Jewish Museum of New York/Art Resource, NY. © The Estate of Lou Stoumen and the Barry Singer Gallery.

the Jewish street photographers. He finished his undergraduate studies at the University of Toronto as World War II was ending. When he did graduate work at the University of Chicago, he entered a school "considered at odds with the then dominant, professional schools at Columbia and Harvard." Goffman's own work placed him at odds with his own school. He graduated in 1953 and went to the National Institute of Mental Health in Bethesda, Maryland, for four years before settling down for a decade in Berkeley. His work in the 1950s can be read as one strand of a broader psychological social critique of American middle-class culture. Goffman wrote as an observer of human interactions, developing his theories about the nature of the self from what he perceived in everyday life. After a fashion he shared the perspectives of Jewish photographers who found themselves drawn to picture daily performances as they played out in urban neighborhoods.[30]

In his essay "The Nature of Deference and Demeanor," published in 1956, Goffman suggested that ideas developed by the French Jewish sociologist Emile Durkheim regarding the nature of religion "can be translated into concepts of deference and demeanor, and that these concepts help us to grasp some aspects of urban secular living." Goffman explained the implications of his argument, namely, "that in one sense this secular world is not so irreligious as we might think. Many gods have been done away with, but the individual himself stubbornly remains as a deity of considerable importance." He continues, "In contacts between such deities there is no need for middlemen; each of these gods is able to serve as his own priest."[31]

Goffman was among the first to admit that "the general notion that we make a presentation of ourselves to others is hardly novel." Rather, he stressed, "the very nature of the self can be seen in terms of how we arrange for such performances." Individuals, as performers, are "concerned not with the moral issue of realizing these [social] standards, but with the amoral issue of engineering a convincing impression that these standards are being realized. Our activity, then, is largely concerned with moral matters, but as performers we do not have a moral concern with them." Goffman intended these statements descriptively, not judgmentally. When an activity largely addressed moral matters, the performance associated with the activity was concerned only with efficacy. To drive home his point, he writes: "As performers we are merchants of morality." Goffman's goal in using the rhetoric of stage and performance as well as religion, ethics, and commerce invited attention to "developing an apt terminology for the interactional tasks that all of us share."[32]

There was no better place to catch performances that possessed all of Goffman's attributes than the annual San Gennaro festival held on the Italian Lower East Side neighborhood. The festival on Mulberry Street regularly attracted crowds to its fair, with food and games of chance designed to raise funds for the Catholic church and its religious societies. Italian immigrants from Naples established the festival in 1926. Often estranged from an American Catholic church dominated by Irish clergy, Italian immigrants turned to their hometowns' patron saints. They brought statues of these saints to their New York neighborhoods from Italy. Although most of the year the saints resided in the church basement (where Italian parishioners often were relegated), once a year the faithful would take them out onto the streets in a festa that blended religious healing, identification, and the temporary sacralization of profane space. "Parades, processions, and festivals turn public thoroughfares into arenas of shared interests," notes the scholar Joseph Sciorra. "The paraded image of a saint," he explains, "encapsulates a sacred narrative," and then "superimposes this mytho-historic time onto the everyday sidewalks and street corners." In the San Gennaro festival, as in the

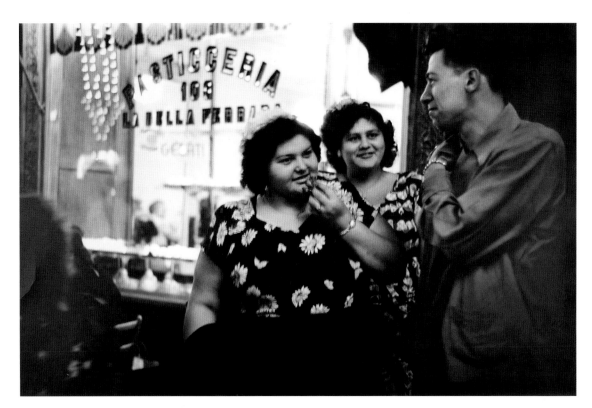

2.8 Sid Grossman, *Mulberry Street, New York*, 1947. The glow of the famous Italian pastry shop backlights the intimate exchange among two young women and a young man. © Howard Greenberg Gallery, New York.

festa of Our Lady of Mount Carmel on 115th Street in Harlem or the three separate processions to celebrate St. Cono in Williamsburg, Brooklyn, "mundane and everyday spaces of bus stops and front stoops" were "transformed into extra-ordinary carnivalized and consecrated sites in dramatic and emotionally charged ways through the display of privileged objects and behaviors."[33]

After he returned from military service in World War II, Sid Grossman gravitated particularly to New Yorkers' explicit public performances, such as the San Gennaro festival. Grossman's photo *Mulberry Street, New York* (1947) apprehends two women and a man standing outside of Ferrara's, a popular Italian American pastry shop in lower Manhattan's Little

Italy. He catches the interactions of the two women against the glowing pastry store, their size amplifying the appeal of its famous sweet temptations. One woman is holding a flower, and she seems to be speaking to the young man standing and grinning to her left. His left arm is raised so that his hand rests upon his shoulder in a gesture of separation and self-protection. Or maybe he is just a bit shy, but still wants to talk to the woman. Behind and between them stands another woman. She dares both to smile at the young man and to gaze at him. Both women wear flowered dresses in honor of the Italian American festival.

Grossman had observed exuberant religious expression and self-fashioning on the streets of Panama City when he was serving in the army. Now he gravitated to versions of such public religious

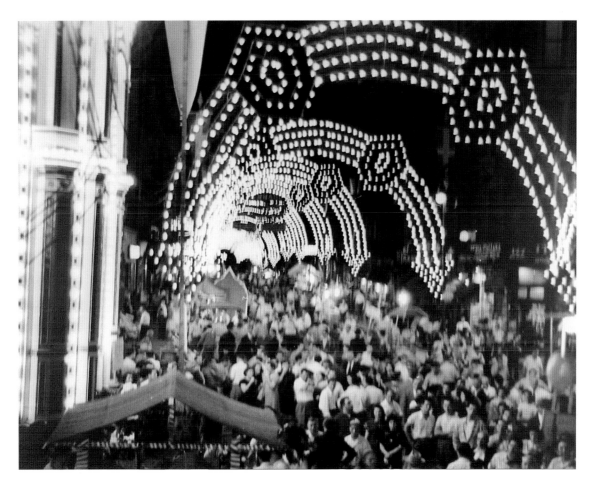

2.9 Sid Grossman, *Mulberry Street*, ca. 1948. The festa of San Gennaro transformed the quotidian streets of Little Italy on the Lower East Side, bringing crowds to savor the festivities. © Howard Greenberg Gallery, New York.

performance in his hometown. His photo of the brilliantly lit street at night conveys the press of crowds at the San Gennaro festival as well as the grimy blocks' transformation into a carnival site. Grossman "abandoned any sense of traditional objective documentation. Instead, he photographed as a participant in the action," argues Keith Davis, "explicitly *within* the physical and emotional reality of the experience." Taken from an elevated distance, the picture reveals a street transformed.[34]

While these religious festivals and processions shared a common connection to Italian American immigrants who initiated and performed them, the impetus for the San Gennaro festa came from a group of café owners who decided to sell their wares in the street. Subsequently, the festa expanded from a single day to a week-long event, highlighted by a procession of a statue of the saint on a Saturday afternoon. "The festival was in full swing when I got there," recalled Helen Gee, owner of the Limelight photo gallery and café, about her visit in the early 1950s. "Mulberry Street had been cordoned off and for a half-mile stretch, from Chinatown north

through the heart of Little Italy, the streets were alive with color. People came from all over, to eat, to stroll, to play carnival games, but it was the neighborhood Italians, dressed in their Sunday best, that gave the festival its flavor."[35]

That flavor and its visual dimensions appear vividly in Dan Weiner's photograph of well-dressed men guiding San Gennaro along the streets in a parade of floats. His image disrupts distinctions between normally different city spaces. *San Gennaro Smoker, NYC, 1952* fragments sidewalks, buildings, stoops, and streets, obliterating some through its intimate portrait of the parade. As in Libsohn's photograph of Hester Street or Weiner's picture at the UN, there is no horizon. Even the curb of the sidewalk disappears. The man smoking on the float behind the saint and the men accompanying the saint perform a powerful tableau that proclaims simultaneously Italian Catholic and Italian American identity. San Gennaro possesses all his characteristic iconographic properties: miter, vials of blood, crozier. Behind him, an American flag on the left of the photograph accompanies a large banner topped by a cross. Between the first and second floats can be glimpsed a white-jacketed trumpeter playing music. Weiner's photo displays "emotionally powerful and durable demonstrations of affiliation and diversity" in a "highly concentrated and heterogeneous urban area."[36]

Pictures of the annual San Gennaro festival on Mulberry Street, the heart of Little Italy, capture its sensuous power. "The self is constituted" at the festa, as the religious studies scholar Robert Orsi has argued, "by a kind of religious kinetics in the full gaze of the community." Embodied at the street festival and pictured in Grossman's and Weiner's photographs were what Orsi called "essential elements of comportment—the necessary gestures of the Italian American self." Although the machinery of self-production is cumbersome and occasionally breaks down, when a performance succeeds, it imputes a firm self to the performer.[37]

Women played significant roles in the festa, often carrying its emotional and religious meanings. Their piety found expression in public. Two photographs by Grossman of two generations of women on the streets during the festival exemplify Orsi's "religious kinetics." The older women navigate the crowded street arm in arm, a mini phalanx. One woman is glancing down. A lottery ticket sticks out of the bag she is carrying. Her age, her somber black dress, and her lowered gaze bespeak her traditionalism and devotion. Her partner is more vibrant. She appears to be talking, her raised eyebrows and hand gesture emphasizing words spoken vigorously. Behind them swirl white shirts of men while at the edges of the photo appear women's patterned dresses, stripes and flowers. The fragments of bodies, the singularity of the gesture, and its accompanying stare impress the spectator. One might view this street performance as unguarded, though Goffman urges an effort to see such behaviors as constitutive of ceremonial public selves.

Games of chance—and the legal opportunity to gamble by purchasing lottery tickets—enticed New Yorkers to the festival. In a second Grossman photograph two woman contemplate their odds of winning the raffle. One checks her ticket; the other gazes upward at the board announcing the winning number, her hand at her mouth. One could be forgiven for assuming that she has been moved religiously. Two older men look at her, sharing in their glances some of her anticipation. Both wear badges on their lapels indicating that they are members of the San Gennaro society that sponsors the festival. Behind them lights arc down the street. Grossman's photographs at the festival capture what Goffman called "the presentation of self in everyday life."

How did Sid Grossman, one of the left-wing founders of the New York Photo League, come to

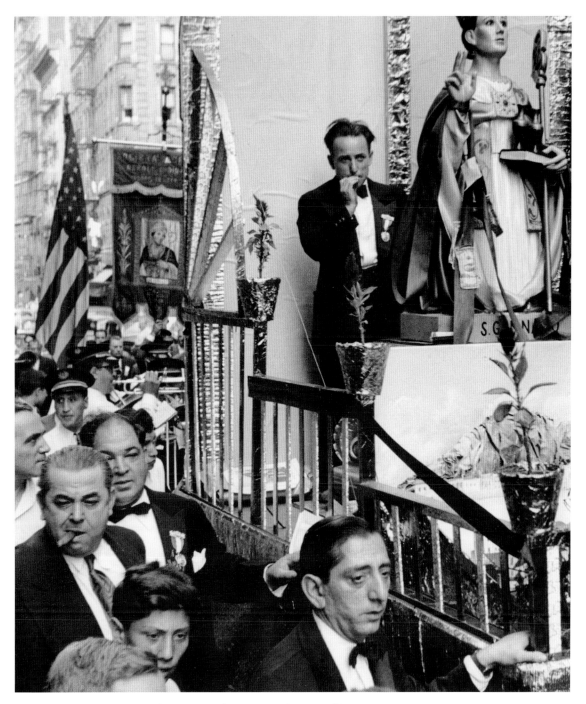

2.10 Dan Weiner, *San Gennaro Smoker, NYC, 1952*. Floats carrying the statue of San Gennaro, accompanied by the Italian men who helped to organize the festa, imbued the ordinary streets with a sense of the sacred. Photo by Dan Weiner. © John Broderick.

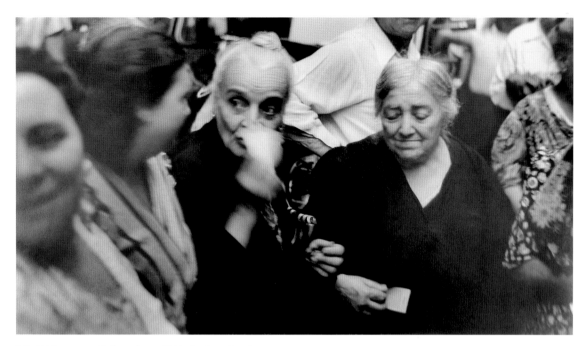

2.11 Sid Grossman, *Mulberry Street*, 1948. The festa freed women to join in the crush of crowds without any male escort. © Howard Greenberg Gallery, New York.

take these pictures of the Italian religious street festival? After military service in World War II, including two years stationed in Panama, Grossman returned to New York City with waning ideological commitments to communism coupled with an increasing dedication to photography as a personal practice. Grossman believed that "the function of the photographer is to help people understand the world about them." Although he learned photography largely on his own, he became one of the League's most famous teachers. "Sid seldom looked at the students' work (he looked at mine once, and I was elated when he praised it)," Gee, a former student, recounted, "but what he gave us was more valuable than individual criticism. His passion and commitment were lessons in themselves. For Sid," she explained, "photography wasn't a thing apart, not something you did with only half a heart; it called for total involvement." His classes reflected progressive teaching practices:

learning by doing. Since he earned little from teaching at the League, he also did freelance photographic work. During the war, Grossman began to experiment with a small-format camera with more sensitive film. He shot a series in Panama on a Black Christ street festival "with glaring flash" that anticipated his San Gennaro photos.[38]

The war changed photography and introduced new ways of seeing. Pictures were often blurry, grainy, and seemed unposed. Despite censorship by the military that restricted what could be published, war photographs possessed an immediacy that brought a taste of the action to the home front. United States' authorities only gradually allowed publication of raw images of combat and suffering, including photos of dead GIs. Small thirty-five-millimeter cameras, such as the Contax and Leica, used by Robert Capa and other war photographers, were notable for their optical speed and operational flexibility. Since sharp,

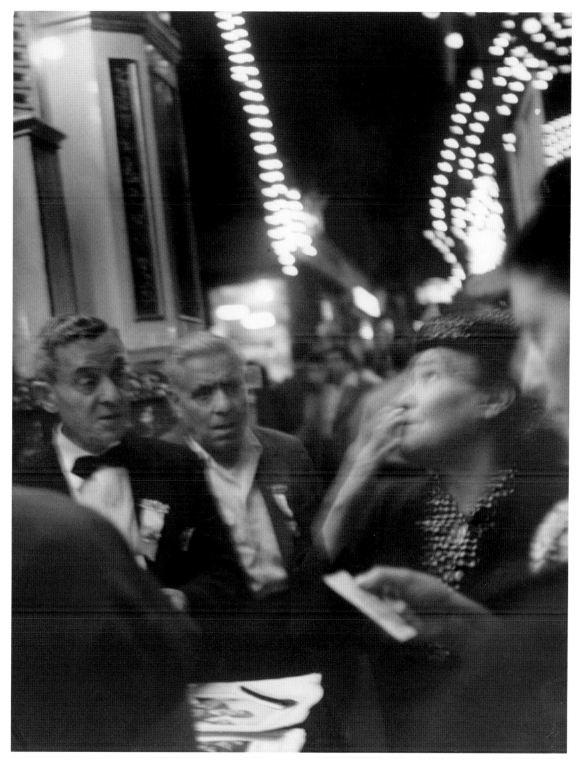

2.12 Sid Grossman, *San Gennaro Festival, New York City,* 1948. Games of chance played an important role in the festa as a means of raising money for the church. Here a woman watches in anticipation to see if her raffle number will win her a prize. National Gallery of Art. © Howard Greenberg Gallery, New York.

high-sensitivity film did not become available until after the war, rapid wartime methods of processing film to reach newspapers often produced a grainy effect. Nevertheless, increasingly 35 mm cameras came to be accepted as legitimate professional tools, gradually displacing larger-format cameras. Production and consumption of photographs expanded during the war along with the number of magazines.[39]

The conflict transformed the image of photographers. "Before the war, photojournalism had been of relatively low status," notes historian Eric Sandeen. Public perception of the news photographer matched the persona promoted by Weegee: a "hardened, intrusive, flash-bulb-popping character." This gradually changed as pictures of combat helped rally women and men on the home front. The war gave "photographers a culturally important role to play." At the start of the war reporters billeted with officers, but photographers bunked with enlisted men; by the end of the war, photographers achieved equality with reporters.[40]

New York City also changed after the war, as did New York Jews. Wartime prosperity overcame the difficult years of the Depression. The city's garment industry, employing 350,000 workers, reached its peak in 1947. Despite a steady decline throughout the following decade, fifteen years later it still produced 28 percent of the nation's clothing. New construction altered the cityscape, funded in part by government investment in public housing, bridges and tunnels, parks, and schools, not to mention airports. The city tore down the last of the elevated trains in 1955, opening Third Avenue to sunlight. A sense of prosperity pervaded New York. Printing and publishing flourished, sustaining a growing appetite for photographs.[41]

Collective projects that had characterized the Photo League in the 1930s gave way to individual and personal ones. The horrors of the war years, the deaths of millions, including six million European Jews, affected many, especially American Jews. As life on the streets changed, so did ways of visualizing street culture. The type of intimacy from common urban experiences that characterized the relationship of photographer and photographed gradually faded.

Candid street photography, personal and expressive, assumed prominence as newcomers arrived from abroad or from other parts of the United States. They encountered New York initially as strangers, or as New Yorkers liked to say, "out-of-towners." Louis Faurer came from Philadelphia, the son of working-class Jewish immigrants. Robert Frank came from Switzerland, where he had grown up in a bourgeois Jewish family, sheltered precariously from the Holocaust raging throughout Europe. The two met in New York and shared a darkroom. Faurer confronted the city's famous anomie. He, too, went down to the streets of San Gennaro, but his dual portrait of Robert and Mary Frank as a couple conveys the festa as an apparition. Its lights glow in the background as Mary pensively glances away from Robert, a bag of nuts in her hand. They are looking downwards, apparently watching. A strange statuesque head upstages both of them, its one eye gazing unblinkingly out at the world. Faurer's photograph enshrines the subjective and experimental that reflected a changing postwar ethos.

Even Faurer's photo of a boy with items to sell—hats, stuffed animals, and pinwheels—evokes a sense of the bizarre. Three women and a man walking by in the background seem oddly transfixed. The pinwheel handles above their heads look weirdly ritualistic, as if passing through timeless space. Reflections, of a woman in the background and of pinwheels across the foreground, heighten the phantasmagorical feeling of the scene. The oddities of happenstance attracted Faurer, as they would

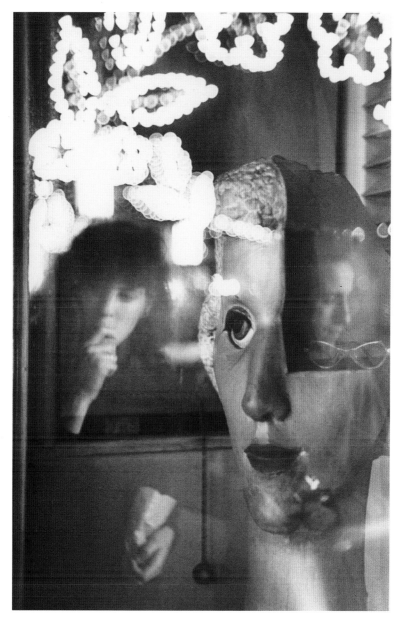

2.13 Louis Faurer, *Robert and Mary Frank, San Gennaro Festival, New York,* 1950. Faurer's double portrait of the photographer Robert Frank and his wife Mary offers a decidedly phantasmagoric picture of the San Gennaro festival's mood. Estate of Louis Faurer.

Garry Winogrand. Faurer found New York different, intriguing, and strange, although Philadelphia had its Mummers Parade every January 1, not to mention a thriving Italian immigrant neighborhood. New York's scale, population density, and foreignness set it apart from Philadelphia and enticed Faurer to experiment.

William Klein never joined the Photo League, although his background, as a poor Jewish boy conscious of class differences, matched many who became members. Klein grew up feeling like an outsider. His father lost his clothing store in the Depression and eked out a living selling insurance to wealthy relatives. Klein hated the Irish kids on his Harlem block, longed to join the Boy Scouts, sang in the synagogue choir, and made the Museum of Modern Art his second home at age twelve, soaking up German expressionist films there. With his first camera, a Brownie, he took portraits of his mother. Although he grew up on the edge of Harlem, attended City College at the age of fourteen, and studied sociology, he ran away from the city into the U.S. Army as World War II was entering its final year. "For the first time I was away from home, dating girls, eating pork. I enjoyed it." After a tour of duty in occupied Europe, Klein used his GI benefits to study art in France. And then he settled there, an artist expat. During a short stint studying with Fernand Léger, he was sent out into the streets and taught about "hard-edged geometric painting." He subsequently experimented with photographic abstractions.[42]

When Klein returned to New York with his French wife, Jeanne, in 1954, he decided to keep a photographic diary. He opted for "a camera loaded with high contrast, high speed film, and often with a wide angle or telephoto lens." "These were practically my first 'real photographs.' I had neither training nor complexes," he later confessed. "By necessity and choice, I decided that anything would have to go. A technique of no taboos: blur, grain,

contrast, cockeyed framing, accidents, whatever happens." Klein gave himself permission, but so does any photographer. As in many enterprises, photography involves a series of choices that make and remake the product. One takes or shoots or snaps this and that, and then one prints this but not that, and on and on. Klein retrospectively described himself as "a make-believe ethnograph in search of the straightest of straight documents, the rawest snapshot, the zero degree of photography. I would document the proud New Yorkers in the same way a museum expedition would document the Kikuyus." His aggressive quest took him back to Harlem as well as out to Brooklyn.[43]

Unlike by-the-book ethnographers, Klein instigated performances. Well acquainted with "good photography" and news photography, he parodied them. Then Klein added: "Almost every American dreams of driving a second-hand car across the country after school, before work, as initiation, to see what's out there, to find out who he is. Me too. But I never did. Instead, I went into the Army of occupation in Europe. And instead of discovering America, my trip was New York—and photography." From the outset Klein saw himself as a pseudo-ethnographer, not just in retrospect. He possessed an insider's knowledge about New York, and he was also an outsider by choice, an expatriate. "In New York I took responsibility for the people I photographed," he affirmed. "I felt I knew them—the people, the way they relate to each other, the streets, the buildings, the city. And I tried to make sense of it all."[44]

In an interview twenty-five years later, he recalled some of his emotions upon returning to the city where he had grown up a poor boy in an observant Jewish family, too embarrassed to bring friends to his home to visit, chafing under Sabbath restrictions that kept him from riding his bike. "My eyes were popping out of my head when I returned," he remarked.

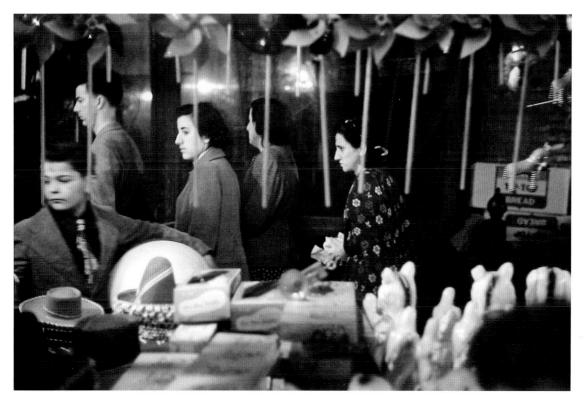

2.14 Louis Faurer, *San Gennaro Festival, New York, NY,* 1950. Rather than focus on the items for sale, Faurer evokes an insubstantial milieu of people floating among the pinwheels. Estate of Louis Faurer.

I was at last coming to terms with the New York I was brought up in, the city I thought had excluded me. I never felt part of the American Dream. I was poor as a kid, walking twenty blocks to save a nickel carfare. Most of the city seemed foreign to me—hostile and inaccessible, a city of headlines and gossip and sensation. And now I was back with a secret weapon—a camera. I thought New York had it coming, that it needed a kick in the balls. I felt I knew that city. I figured I had a right. I'd been living in Europe for more than six years. I'd left as a kid and now I was coming back in my twenties with a French wife, a new set of references and habits, the beginnings of a career as a painter.[45]

Klein's brash reflections characterize his take on documentary photography as a kind of personal ethnographic engagement.

Dance in Brooklyn, 1954 conjures different sensations than Levitt's photograph, yet they share common elements. Klein shoots up close as a girl and boy dance for his camera. One recognizes movement: arms raised, a spin in progress. A longer shutter speed creates a blurred image of motion itself. "The force with which the girl . . . gestures toward the photographer (and the viewer) betrays the encounter between photographer and subject as a strident,

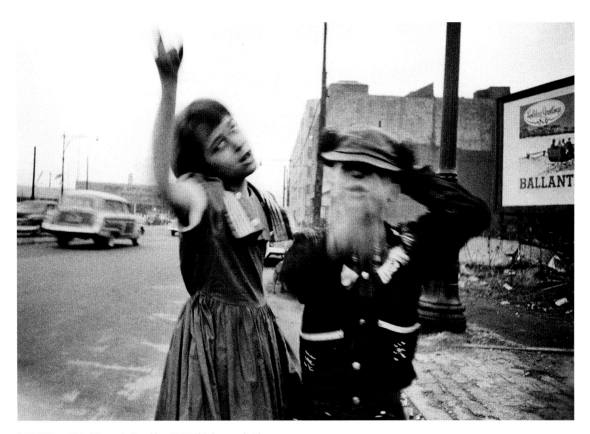

2.15 William Klein, *Dance in Brooklyn, 1954*. This boy and girl also dance in the street, but Klein's camera freezes their movement in a blur that makes them appear as aliens on the shabby streets of Brooklyn. © William Klein.

active affair." The girl's eyes glancing upward suggest trouble, a trance or worse. Motion makes it difficult to recognize her partner's cowboy suit, his hat, or her own tidy sailor's dress. Blurred motion and film grain paint a jaw-dropping beard on the boy. Klein places his dancers in the center of the picture, where, for a prolonged second, kid aliens hold the stage.[46]

As for that street, it is plainly pedestrian. On this cloudy summer day, the abandoned lot reveals only weeds and garbage and a beer ad left over from Christmas past. Klein shows concrete evidence of everyday life among New Yorkers, its unavoidable banality. Blur enacts the motion that otherwise would

have been frozen. A trap has been blown by spooky kids from outer space. And Klein has the uncanny evidence of life on this otherwise drab street. These were the 1950s, a boring but haunted decade just begging for a kick in the butt. As someone who spent the McCarthy years of anticommunist investigations in Europe, Klein enjoyed a freedom when he visited New York less available to other street photographers in those years.

Klein invited and sometimes provoked performances. Like many Photo League photographers, he liked to chat with people as part of his picture-taking process. But Klein's "dialogue generally went like this," he recalled. "Who's that for? I would say, totally irresponsibly, *The Daily News*. I'm the Inquiring Photographer. You're Kidding! When's it coming

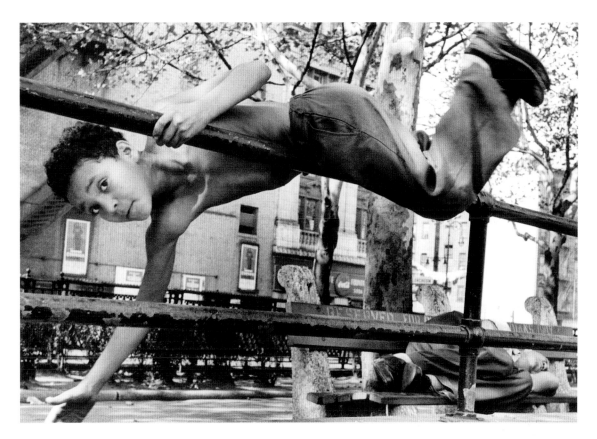

2.16 William Klein, *The bars of a 2 by 4 park. A bench, home for the homeless, New York, 1955*. The adroit boy shows off for the camera, and Klein captures his athleticism that makes do with the bars of a fence. © William Klein.

out? Tomorrow. No shit!" Klein took advantage of the extent to which photography had permeated the consciousness of urban residents who eagerly consumed a daily array of images in the local press. "I was under assumed papers, posing as a newspaperman," he later confessed. "If someone thought they'd make the newspapers, it was okay by them. Everyone in New York thinks he has a right to make the newspapers once in a while."[47]

Visualizing street culture had become commonplace by 1954. Klein exploited his position as a professional stranger, an insider who could pose as an outsider. Occasionally when challenged as

a white man in Harlem, he was not above passing as French. Although he made Paris his home, he never lost his American accent, and he retained his urban street smarts, "completely comfortable in a crowd," as he put it. "I like the street." Going to a branch of City College at 23rd Street and Lexington, he "was always crammed in with people. Running to catch the subway" was a familiar experience. Klein's insider/outsider status let him get to know people and also capture the weirdness of exposing them on film.[48]

Klein's photograph *The bars of a 2 by 4 park. A bench, home for the homeless, New York, 1955* engages a boy and catches him showing off, spinning over the bars of the fence, performing for the camera. Behind him the picture records "other elements of

this Harlem city park: dappled trees, bushes, and, most obviously, a man sleeping on a bench. His body blocks out part of the stenciled phrase: Reserved for Mothers and Children's Guardians Only." At one level, his presence compromises the "officially posted aspirations for the park as a disciplined, middle-class public space."[49]

The two horizontal movements of boy and man, one filled with energy and the other in repose, embody the street's strongly gendered comforts and freedoms. "During the day, the park, though small, is a safe place for males to play and to sleep. It is no longer a space for women, with or without children in tow, though it is scarcely removed from the street." A corner luncheonette beckons beyond the trees, below the apartment house windows. The massive side of a local movie theater abuts the luncheonette, with two rows of stairs climbing its walls like so many trellises. "Like many of Klein's photographs, this shot reconceives elements of the city's disorder. Up close, Klein catches the tautness of the boy's arms and the reciprocity of his inquiring look. Did you get it, mister? By the fifties, cameras had become repertory actors in the urban mix."[50]

"Klein wielded his camera as an intervention. He wasn't interested in being an empathetic observer, but neither did he care to show or assert reality. The city turned him on. It was all there for the taking: open, curious, a little scary. Always a good talker, Klein chatted up strangers on the street. In return, New Yorkers readily posed or acted out for him. When they didn't, he shot them anyway." "I appreciated New York like a fake anthropologist, treating New Yorkers like Zulus," he said.[51]

Klein also considered his photographs to be "moral statements." The Jewish fashion photographer Richard Avedon agreed. "I can no more than Bill Klein make a picture that doesn't make a moral statement. We all shared this moment and this inheritance." Others were "dealing with surface," said Avedon. "We needed another way." His "we" refers to "New York photographers, the mostly Jewish group that had initially coalesced around the Photo League for fifteen years and then disbanded. Moral or honest; to them it was a distinction without a difference."[52]

Many years later Klein told a critic, "Jewish kids are not supposed to be technically handy," an observation at odds with the complex technical requisites of photography. Klein then went on to propose "one of my theories, I think there are two kinds of photography—Jewish photography and goyish photography. If you look at modern photography," he elaborated, "you find, on the one hand, the Weegees, the Diane Arbuses, the Robert Franks—funky photographs. And then you have the people who go out in the woods. Ansel Adams, Weston. It's like black and white jazz," he concluded in a telling comparison. Unlike members of the Photo League, Klein was ready to provoke. Bringing Jewishness to consciousness, rather than letting it rest comfortably in the background, raised difficult questions of aesthetics and morals. To label photographs "Jewish," to contrast them with non-Jewish (goyish) photographs, and to link this distinction to the difference between Black and white jazz disrupted the political and sociological vision that many Jewish Photo League photographers had cultivated. It also reframed Klein's ambivalent relationship with New York, the half-Jewish city he felt needed a "kick in the balls."[53]

Klein's ethnic binary resembled that of Lenny Bruce. Bruce divided America into Jewish and goyish. "To me, if you live in New York or any other big city, you are Jewish," the stand-up Jewish comedian assured his listeners. "It doesn't matter even if you're Catholic. If you live in Butte, Montana, you're going to be goyish even if you're Jewish." Klein and Bruce used Jewishness as an encomium to describe a nonexclusive composite sensibility of New York Jews. Such riffs on Jewishness don't assert ideas or attitudes

abstractly considered; they're about style. Klein's analogy to "black and white jazz" referenced the fitness of manner through which expression can be characterized and graded. In these "funky" photos, viewers may feel exposed, opened to risks of seeing and being seen.[54]

Observing city streets as sites of interaction, as places to stage performances of the self, attuned Jewish urban photographers to ritual gestures, individual glances that were part of the fabric of urban society. Their images evoke the texture of this street culture, its variations and complexities, and the abrasiveness of encountering strangers. These photos invite contemplation of cities as places of performance and looking. They are not, by any means, the only way to visualize street culture, but they appear to be a way that made sense to New York Jewish photographers. Their photos reveal a level of discomfort with neighbors that unavoidably accompanied a sense of accountability for the ways of representing the otherwise hidden dependencies of being strangers together. These photographers portrayed what it might mean to account for one's interactions.

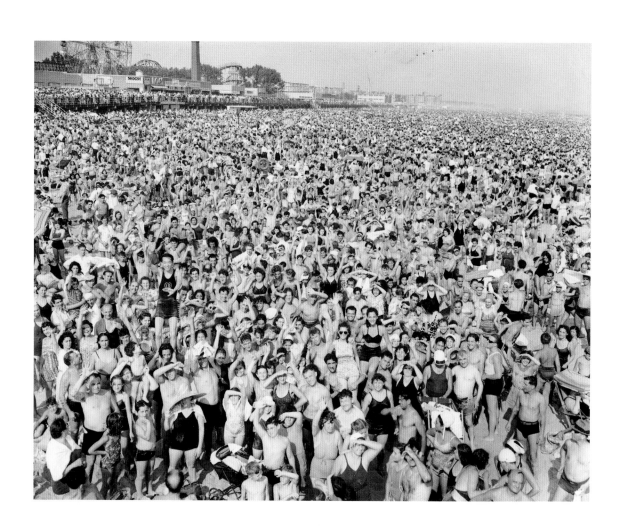

3. Letting Go

Sunday, July 21, 1940, promised to be a scorcher in New York. The tabloid photographer Weegee had just landed a regular gig complete with byline at *PM*, the recently established New York City picture newspaper. Expecting to find the masses on the sandy shore at Coney Island, he went to photograph the crowds. He was not disappointed. In a bid for a position with the paper, he had already gone the previous month and taken just such a photograph of a mobbed seaside. This time he repeated what had worked in June. He climbed up on a lifeguard station and successfully attracted attention from the men, women, and children enjoying the beach. The photo ran in *PM* the following day, Monday, under the headline: "YESTERDAY AT CONEY ISLAND . . . TEMPERATURE 89 . . . THEY CAME EARLY AND STAYED LATE." Estimates put the number of people at close to a million.

Weegee's photograph certainly captured the multitudes at Brooklyn's most popular seashore. Coney Island's famous ride, the Wonder Wheel, can be glimpsed in the background on the left. But the diverse throng of people waving their arms and shielding their eyes as they stared into the sun made the photograph so effective. Everyone, it seemed, including one guy standing on the shoulders of a friend, wanted to be in the picture. Not an inch of sand was visible. The *New York Times* ran a version of the photo the following Sunday. And Weegee concocted a good story to accompany his trip to Coney Island. Some sleuthing on the part of Weegee's biographer, Christopher Bonanos, reveals that the photo probably was taken on July 4, a date that always drew crowds even when it wasn't sweltering. Weegee most likely just saved it for when the weather would warrant publishing such a photo. Bonanos asks, "Does the fudging [of the date] affect the truth of the moment" Weegee captured? And he answers, "A little. It is, regardless of the date underneath," he concludes, "a great picture of real moment. Just, perhaps, not *that* real moment."[1]

Coney Island, a popular beach off the southern shore of Brooklyn, initially attracted prosperous New Yorkers who possessed the leisure time to vacation by the sea. By the early twentieth century, it drew middle-class and working-class city residents

3.1 Weegee, *Coney Island, July 21, 1940*. Weegee fudged the date but not the crowds on the beach on a hot summer day. © Weegee/International Center of Photography.

not only to its beach but also to its rides and carnival attractions. Luna Park, Steeplechase, roller coasters, a wax museum, games of chance—all invited patrons to experience thrills and to gawk at others who were doing the same thing. Photographers were integral to this milieu of display. They set up studios where a person could have a picture taken with any number of props to help present the type of persona desired. A photograph memorialized a visit to Coney Island.[2]

The American Jewish poet Delmore Schwartz, in his short story "In Dreams Begin Responsibilities," presents a somewhat different perspective on Coney Island and photography. Published in 1938, it describes a silent movie of the narrator's parents' courtship filmed on a Sunday afternoon at Coney Island around 1909. After his father proposes marriage and his mother, sobbing, accepts, they enter a photographer's studio. "The camera is set to the side on its tripod and looks like a Martian man." The photographer instructs them in how to pose. His father drapes his arm over his mother's shoulder. They both smile. The photographer brings a bouquet of flowers to his mother. But something is wrong. The photographer isn't satisfied. As he explains, "he has his pride, he is not interested in all of this for the money, he wants to make beautiful pictures." Over and over he tries to change this, adjust that, until Schwartz's father loses his temper. The picture is taken "with my father's smile turned to a grimace and my mother's bright and false." Are these American Jewish dreams in which the responsibilities of family begin? And if they are, what role might the Coney Island photograph play?[3]

Coney Island as a space of intimacy in public encouraged contemplation of human relationships. "From the beginning of Coney Island's history as a resort a strong element of its appeal lay in the way it permitted respite" from formal, highly regulated social situations. Coney's attraction, argues its

historian John Kasson, "furnished an occasion for relaxation of proprieties." Cameras were as much a part of the beach and boardwalk as bathing suits and towels. Their glass eyes joined the thousands of other eyes that observed sunbathers on the sand. Many working-class New Yorkers could not afford the dime for a semiprivate place to change blocks from the shore (let alone the fifty cents for private bath houses) and didn't want to wait in line for one of the municipal lockers. Working hard six days a week, they didn't want to waste their leisure time. So they changed on the beach, in public, shrugging off the stares of onlookers.[4]

Many different types of people, not just New York Jews, came to the beach, boardwalk, and amusement park—the rides, sideshows, restaurants, and hot dog stands—that together constituted the "nickel empire." The term, coined by an anonymous *Fortune* magazine writer, referenced the character of business on Coney Island. "To Heaven by Subway" described the extraordinarily diverse crowds who stepped off the train, "shedding their identities, with their inhibitions, in the voice, the smell, the color of Coney Island." The article also acknowledged the residential population of 100,000 that "swells in summer to 200,000 and is divided into two parts by a Main Street known as Surf Avenue." The *Fortune* piece characterized the northern section away from the beach as filled with "drab rooming houses and inferior residences."[5]

Fortune's term caught on. The nickel empire promised cheap pleasures. Anyone who could afford the cost of a nickel subway ride could take the train to the last stop and get off at the huge, multilevel Stillwell Avenue station. There, at the "Times Square of Coney Island," the intersection of Stillwell and Surf Avenues, Coney Island's amusements, beach, and boardwalk beckoned. Extension of that subway in 1920 encouraged ever greater numbers of New Yorkers to flock to the seashore. By 1923 the city

opened an eighty-foot-wide public elevated wooden boardwalk that ran between the acres of sand and the rows of stores, allowing visitors to observe what was going on along the shoreline. The municipality also widened the alleys leading to the beach and boardwalk, turning them into regular streets. Of most importance, the city transformed the beach itself into a public space open to all.[6]

These civic improvements, completed by the mid-1920s, initiated substantial changes in the area. They brought new residential and commercial construction along with tens of thousands of people to the once remote sandbar that originally constituted Coney Island. Now subdivided into sections, only the midsection retained the name Coney Island. On the western tip, a few lucky residents lived in Sea Gate, a private residential area of mostly single-family houses, adjacent to the middle section. Lower-middle-class Brooklynites inhabited the section east of Coney Island called Brighton Beach, a densely populated neighborhood of apartment buildings.

During the 1930s, Jews and other New Yorkers hard hit by the Depression settled in the modest cottages and flats that they had previously rented only during the summer months. These residents thought of Coney Island as their local beach. "We went to the beach every day, saw fireworks on Tuesdays," recalled Florence Adler. Every Saturday, she "went to the Tuxedo Theater, a block away. For twenty-five cents we saw two features and cartoons. It was an all-day thing."[7]

The growth of a permanent population spurred the city's Department of Education to build a new high school for the area. Abraham Lincoln High School opened its doors in 1929 to students living in Coney Island and southern Flatbush. Located a few blocks from the seashore, Lincoln was an outpost of progressive education. The principal, Gabriel Mason, "urged students to become engaged, idealistic citizens in a world threatened by fascism, Nazism, and what appeared to be an endless depression." During the 1930s the school sponsored an expansive array of extracurricular activities, including a photography club. Photography clubs increasingly joined school sports, newspapers and yearbooks, debating and chess clubs, as appropriate high school extracurriculars designed to encourage well-rounded students.[8]

Morris Engel grew up on Coney Island. He attended Abraham Lincoln. Like other locals, he regularly visited the beach for pleasure and a chance to relax. His photographer's eye caught the many forms of leisure pursued by the individual men and women, boys and girls, who sprawled pell-mell across the sand. Despite the crush of people and the absence of any privacy, the beach loosened inhibitions. It was a place not only to take off your street clothes but also to engage in private forms of intimacy in public. Couples lay next to each other on the sand; they embraced among strangers. Teenagers fooled around. Parents coddled children and played with them as though they were in the comforts of home. Here were the tangled masses, happy to be free.[9]

The 1939 Works Progress Administration guide offered a succinct account of what went on at the beach: "Bathers splash and shout in the turgid waters close to the shore; on the sand, children dig, young men engage in gymnastics and roughhouse each other, or toss balls over the backs of couples lying amorously intertwined." This Coney Island drew photographers, especially those from the Photo League, who sought to picture the relationships among New Yorkers that forged the city's multiethnic culture. Charles Denson, who grew up on Coney Island in the 1950s, always carried a camera to take pictures of daily life. He remembered "Woodstock in 1969, when a half-million, half-naked people gathered peacefully in a small space to have a good time. The media made a big deal out of it," but Denson wasn't impressed. "After all, that happened every weekend in Coney Island."[10]

Two years after discovering the Photo League in 1936, Morris Engel took his camera to his local beach and snapped a series of photographs. The pictures reflect some of what he learned from classes at the Photo League as well as his participation in the Feature Group's project on Harlem. Engel placed himself among the masses, on the sand, mixing with the multitudes. He did not solicit attention as Weegee would do, nor did he invite beachgoers to pose. Instead, he photographed unobtrusively, up close and personal. These were his people.

The boy's expression telegraphs his situation. He is wet and cold, inbound from the water. Engel, from down among a jumble of sunbathers, frames the boy between two cropped bodies that bookend the scene. The oblivious lad, intent on getting somewhere—perhaps to his towel—doesn't notice Engel. Neither does the sunbather whose toes occupy the foreground. But upstage, in sharp deep focus, a guy with arms folded breaks the fourth wall, nailing Engel, and every viewer of the photograph. The play is short but has staying power.

Coney Island fascinated Engel. Its ever-changing spectacle repeatedly drew him back to the beach. In the late 1930s, as he looked for interesting scenes, sometimes his very presence set in motion events that with luck, pluck, and skill, he photographed at key moments. Freezing action doesn't necessarily help viewers to piece together plausible versions of events. Engel had a knack for taking photos that seem to encode narrative relationships. He used a Rolleiflex, a twin-lens reflex camera that produced two-and-a-quarter-inch square negatives. Much later he recalled, "It was a very good camera for me because I could shoot with it held at my hip; I just had to glance down . . . and see the top of the picture," he explained. "I didn't have to look at the camera anymore so it was relatively easy for me to shoot completely candid pictures as people would be completely unaware of my shooting." Did they care

that Engel was taking their photograph? Probably not. They were on the beach to relax and savor some leisure. Film historian Charles Musser describes Engel's photos as "strong, intimate compositions that respected and humanized his subjects." He adds, "Engel's stills embodied a Popular Front culture that focused on working-class life without being explicitly ideological." Timing was an important part of but not the whole story. Spatial framing triggered and shaped temporal framing. This may happen as the shutter is clicked. Darkroom cropping can also stimulate each viewer's active role in imagining narratives.[11]

Fifteen years later Engel returned to Coney Island to shoot an experimental film, *Little Fugitive*, that encouraged French film critic François Truffaut to make his first movie, *The 400 Blows*. Truffaut credited *Little Fugitive* for inspiring the French New Wave and the use of nonactors in feature films. The movie, coproduced and directed by Engel, Ruth Orkin, and Raymond Abrashkin (Ray Ashley), dramatized the kinds of situations that Engel had captured with his still camera. "I did shoot *Little Fugitive* to a degree as if I was shooting stills," he admitted. "I had spent a lot of time on Coney Island shooting candid photographs and it wasn't all that different." Looking at his photographs from the late thirties, elements of narrative appear at play.[12]

For example, the photograph of a woman standing on a ledge with a small girl next to her contains a potential story. The woman is waiting for water and facing toward the fountain, her brow furrowed. The girl nestles close by but stands in the opposite direction, her head tilted down. She holds a bottle of soda pop in her right hand and bends her left hand so

3.2 Morris Engel, Untitled (boy at the beach with an inner tube), ca. 1938. Cold and wet, the boy is heading back to a blanket or at least a towel. The crowds don't bother him as he moves deftly among the bodies on the sand. © Morris Engel.

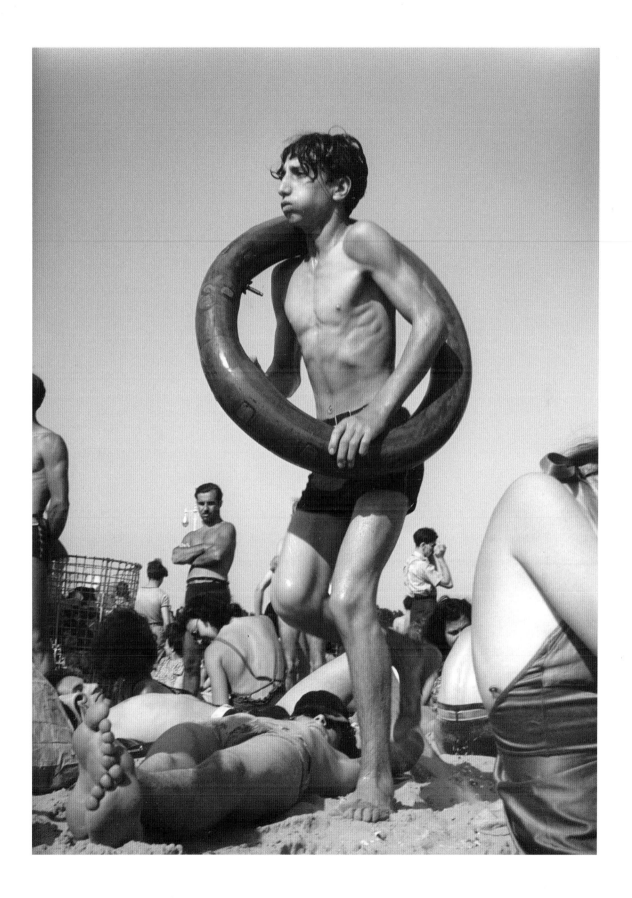

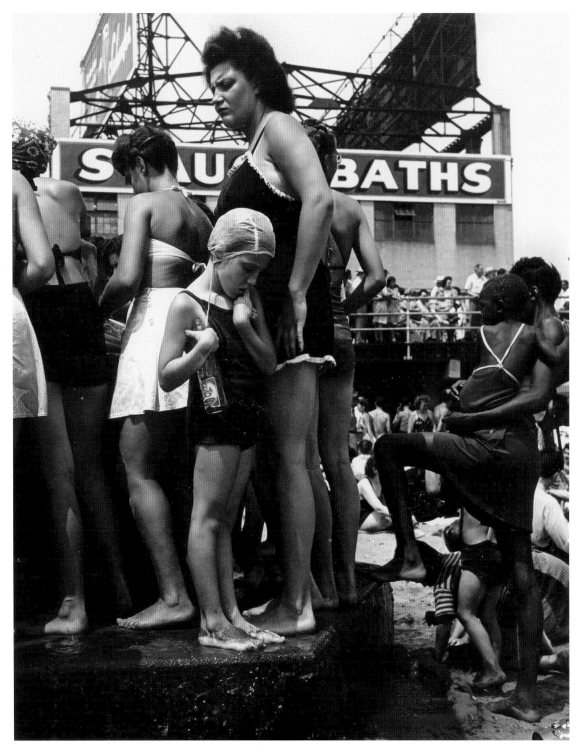

3.3 Morris Engel, Untitled (water fountain, Coney Island, NYC), ca. 1938. Women and children crowd around the water fountain waiting to get a drink. Engel's photograph shows the mixed multitudes at the beach. © Morris Engel.

that her thumb is close to her mouth. It is not clear if Engel has pictured a mother and child, an ambiguity that invites storytelling. Off to the right, another pair of woman and child more definitely suggests mother and daughter. The girl is holding onto the woman, with an arm around her back, while the woman has one leg lifted to provide a seat for the girl, grasping her tightly. Both look in the same direction, toward the water fountain. Engel's photos record the normative mixing of races on the beaches of Coney Island. "The people who come to Coney are of all ages, all races, all colors," not to mention that the languages "are as varied as skin color," proclaimed a *New York Times* reporter. In the background, multitudes congregate on the boardwalk in front of one of the many public bath houses.[13]

The main event in another Engel photograph is a woman drying a small boy. He clutches a super white towel that contrasts vividly with the rich darker shades of this sunlit photo. People stand around, as if waiting or pondering events not shown here. The woman drying the little boy looks down to her right at something off camera. A little way farther off to the left several couples face this way and that. On the right side, a lone man gazes resolutely leftward across the frame, as if waiting for someone. A few feet further back, a woman in a two-piece swimsuit squints as she looks down. The older boy in the foreground may well be junior's big brother. He looks up at someone, anxiously, quizzically, but not at the man biting his lips. Engel cropped this side of the scene, thickening its mystery. Engel's photographs portray relationships in their ambiguities. He organizes the drift of people onto the picture plane and invites viewers to sense the stimulating presence of variety, to see what happens when hundreds of thousands come to enjoy the seaside at the same time.

A decade later Harold Feinstein visited his local beach: the same, but different, Coney Island. In 1946, at age fifteen, he borrowed an upstairs neighbor's

Rolleiflex and started taking photographs of his neighborhood. The war had just ended, and the beach was as crowded as ever. But the city was on the verge of change, propelled by migrations of Puerto Ricans and African Americans. Two years later as a teenager Feinstein discovered the Photo League, just as Engel had. It provided a place to learn photography and to hang out with like-minded people. Relatively politically naïve, he later realized, "undoubtedly some of my political views were formed by the Photo League's environment." Feinstein recalled that on his first night at the Photo League, the photographer Paul Strand was speaking. He was hooked. "Rubbing shoulders with fellow photographers headed in a kindred direction and getting caught up in the debates and discussions within the group," he remembered, "was almost as stimulating as the photography."[14]

Like Engel, Feinstein grew up in Brooklyn, but in Bensonhurst, the same neighborhood as Helen Levitt. Unlike Engel, he knew his father, a meat dealer. "As a boy, my father would give me 25¢ for the day. A nickel would get me a ride on the trolley to Coney Island and I'd use up the money on rides, attractions, and plenty of candy. I'd earn a little more by drawing portraits on the boardwalk." The youngest of six children, he possessed a keen artistic eye and temperament that set him apart from his siblings. At fifteen, to escape his immigrant father, who abused him, Feinstein left home. On the beach, Feinstein gravitated to father–child relationships rather than photographs of women caring for children.[15]

Consider two photographs of fathers with their children, both taken in 1949 when Feinstein was eighteen. In one, Feinstein pictures a father and son standing at the water's edge. Both have rolled up their pants so that they can wade in the sea. The boy tentatively steps toward the surf; his father, hands in his pockets, looks down and watches. The father is somewhat incongruously dressed for the beach:

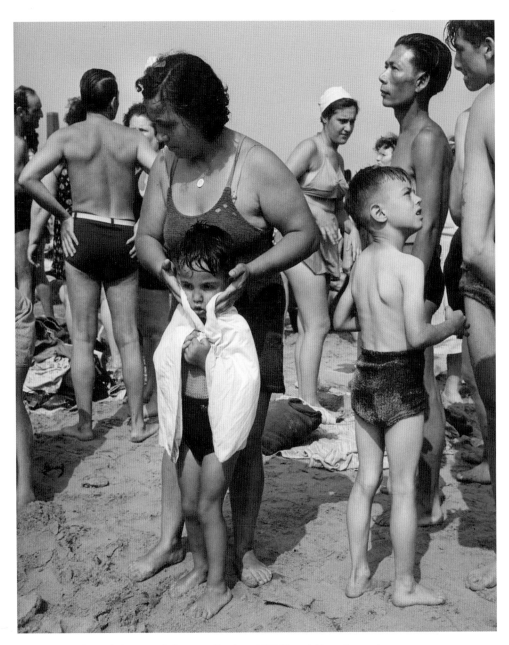

3.4 Morris Engel, Untitled (woman drying a small boy), ca. 1938. The miniature drama of a woman caring for a child catches the photographer's eye, along with a number of other plays occurring off camera. © Morris Engel.

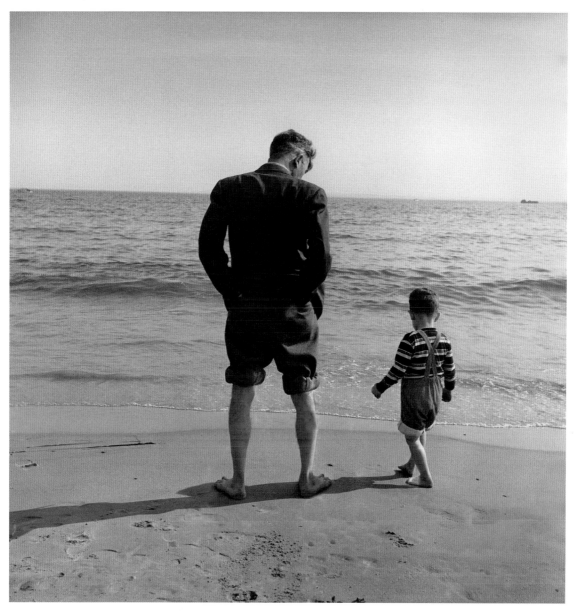

3.5 Harold Feinstein, *Father and Son by Water's Edge, Coney Island, 1949*. Although father and son face the sea and not the shore, the camera catches an intimate relationship just from the photo's framing and the paternal downward gaze. © Harold Feinstein Photography Trust | haroldfeinstein.com.

he wears a jacket as well as slacks, but his muscled calves suggest an athleticism beneath the formal street clothes. Feinstein's generous framing gives the two some space, which adds to the sense of intimacy portrayed.

Feinstein's distance disappears in the photograph of a Haitian father with his daughter. Feinstein's camera looks down on the pair, emphasizing the sweep of the father's arm and hand that firmly holds the girl. With one hand, she grasps his shirt, revealing part of a white shirt underneath, while she wraps her other arm around her dad's neck. Neither father nor daughter looks at Feinstein. Highlights on the swirling sand form a dramatic background for the pair. "You have to see people through the eyes of someone who loves them," Feinstein later reflected. "Coney Island has provided some of the most visible ongoing images of interracial community," writes the curator Robin Jaffee Frank, "making it a touchstone for how notions of inclusion and exclusion play out in American public life."[16]

Two years later Feinstein captured a striking, idyllic father-and-son portrait. The boy, comfortably ensconced on his dad's shoulders, gazes at a fireworks display behind Feinstein. The father, however, stares directly at the camera. Cigarette dangling from his mouth, he eyes the photographer. A shallow depth of field separates the pair from the high-contrast background. Several blurred figures are oriented left to right like the father. Perhaps this is a circus tent, with lots for the boy to see from his elevated perch. A palpable sense of affection and longing connects this series of photographs by Feinstein.

Most beachgoers tended to ignore the boardwalk once they reached the sand. Feinstein reversed the typical voyeur's perspective. Looking up from the sand, he pictured a kind of dual world. The famous parachute jump provides a backdrop for the well-dressed man leaning on the emergency telephone box. To his right, a young man sitting on a bench,

his head cocked to one side, appears to be talking to someone standing in front of him. Two other figures walking on the boardwalk appear only as heads, while a third is divided by the fence post. Taken together, it is an unusual vision of Coney Island, one that Feinstein returned to repeatedly, as in the lineup of men in fedoras standing evenly spaced on the boardwalk.

The boardwalk was part of the local scene for Coney residents, a place to enjoy a leisurely stroll, inhale the salt air, take in the sunshine. None of the well-dressed men pictured in Feinstein's photograph are interested in bathing. Their formal attire—suits, ties, white shirts, and overcoats—along with the toppers indicates the extent to which clothing style identified New Yorkers. The garment industry not only employed hundreds of thousands, but it also produced self-consciousness about dress among city residents. As the men's attire indicates, the weather doesn't invite bathing; the beach itself looks pretty empty. One guy in the middle of the frame acknowledges the photographer and smiles. Here is a view of Coney Island as yet another New York City neighborhood, so different from Weegee's iconic image, or even Engel's stories from the sand. Feinstein offers a picture that represented the real city as set forth in the Photo League's New York Document.

Coney Island also drew a cross section of diverse visitors. At 2:35 on a partly cloudy afternoon, everyone is dressed for moderate, changeable weather. They're watching and perhaps listening to something off to their left. Two teenage boys, most likely brothers, are looking good in identical sweaters and white shirts. Next over is a GI in uniform, on leave and still in the service. Although the war has ended, the draft has not. He and a young woman stay close. Perhaps she is just listening, or maybe her mind is somewhere else. In the middle, a guy dressed to the nines squints from the sun's glare. To be dressed like that, he must have business elsewhere, later on.

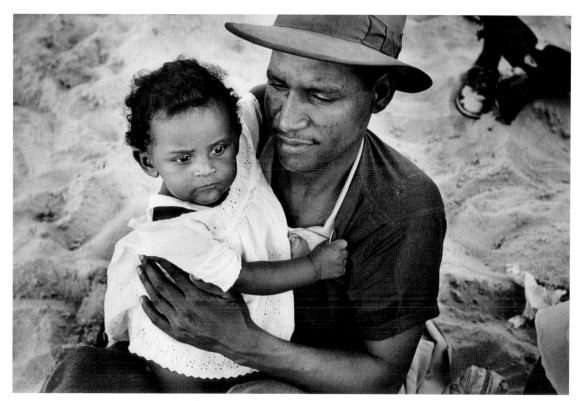

3.6 Harold Feinstein, *Haitian Father and Daughter, Coney Island, 1949*. A father's parental love for his young daughter pervades this double portrait. © Harold Feinstein Photography Trust | haroldfeinstein.com.

Or he might have left a formal event and headed down to the boardwalk for a break and some fresh air. Of the pair of women, one is wearing fashionable sunglasses. No need to squint. She smiles down at Feinstein, having noticed he is taking her picture. The scene resembles Sol Libsohn's *Hester Street* crowd, with an older couple sitting on the bench behind and a girl fooling around on the railing, a tiny pocketbook dangling from her wrist. Feinstein could have cropped the picture's right side more tightly, narrowing attention to the people who form a tidy line. He resisted. As he said later, "I love Coney Island where it's all hanging out." For Feinstein, Coney Island "was a true spectacle of what America was." His photo offers a snapshot of conversations temporarily suspended in favor of taking in an event of shared interest.[17]

It was easier to take photographs on Coney Island as a man than as a woman. Engel's and Feinstein's pictures reveal their comfort as young men mixing with the crowds. Ida Wyman's atypical photograph of the boardwalk captures neither crowds—visible beyond the boardwalk on the sand—nor the excitement of games and amusements, nor even conversations. Instead, she photographs from behind three isolated individuals, each wearing nice street clothes.

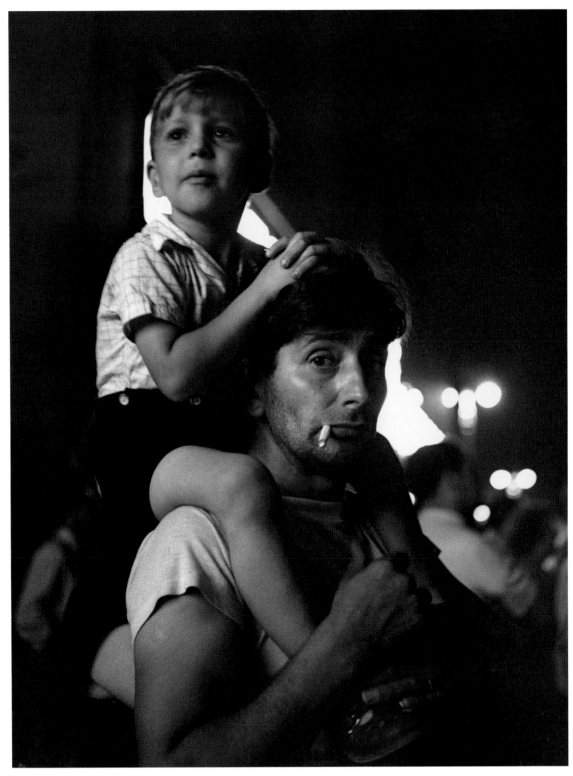

3.7 Harold Feinstein, *Boy on Dad's Shoulders, Coney Island, 1951*. Another dual portrait of father and son portrays a sense of the fun available at Coney's amusement park. © Harold Feinstein Photography Trust | haroldfeinstein.com.

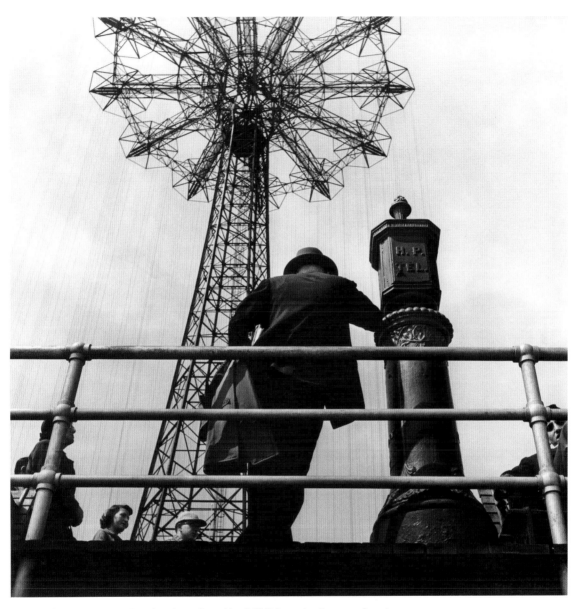

3.8 Harold Feinstein, *Man at Parachute Jump, Coney Island, 1949*. Reversing the gaze of most visitors to Coney, Feinstein looks up from the sand at the boardwalk and its amusements. © Harold Feinstein Photography Trust | haroldfeinstein.com.

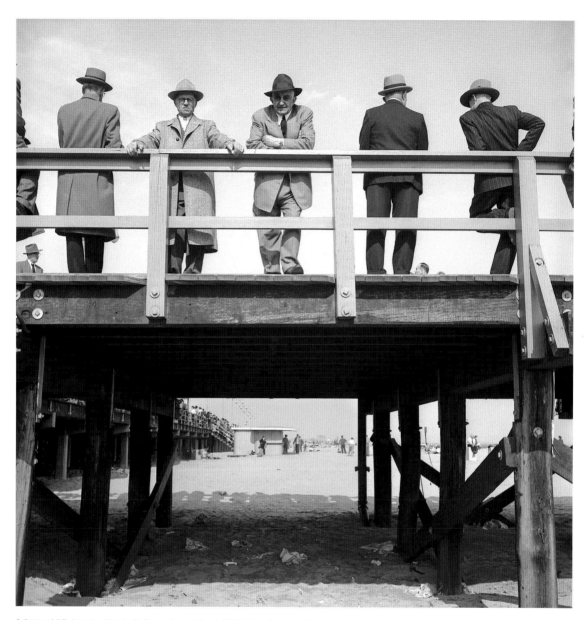

3.9 Harold Feinstein, *Men in Fedoras, Coney Island, 1950*. This photograph reminds viewers that Coney Island was also a Brooklyn neighborhood, available for a pleasant stroll even in chilly weather. © Harold Feinstein Photography Trust | haroldfeinstein.com.

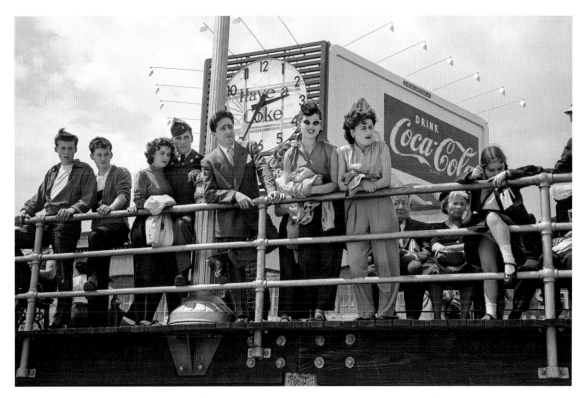

3.10 Harold Feinstein, *Coke Sign Boardwalk, Coney Island, 1949*. An array of visitors to the beach crane to see—and maybe hear—something off camera. The lineup presents an amusing mix of styles of dress and demeanor. © Harold Feinstein Photography Trust | haroldfeinstein.com.

The short man in the center of the photograph peers into a mostly empty wastebasket, his hands clasped behind his back. He may be checking out the headlines of a discarded newspaper. Or possibly, despite his dress, he's hungry. A woman in heels walks briskly by. The man with his foot on a bench scans the nearby beach scene below. Although no one at Coney Island has any presumption of privacy, the poignancy of Wyman's photo stems, in part, from the way it frames a viewer's own discretion in the process of spying on isolated individuals on the margins, hanging out, or passing through.[18]

As a woman photographing, Wyman recognized that she "wasn't threatening" and, she confessed, "I wore saddle shoes with bobby socks." Such garb indicated an innocuous youthfulness rather than womanhood. Wyman thought, "I saw the street more clearly carrying the camera." Observant and inquisitive about the world around her, Wyman begged her immigrant Jewish parents to buy her a camera when she was in high school in the Bronx. Like many New Yorkers who fell in love with photography, she did enlarging and printing in the family kitchen until she got a job developing and printing photographs at Acme Newspictures. After the war, her husband's friend Morris Engel introduced her to the Photo League. "The League's philosophy of honest photography appealed to me," she recalled. "I also began

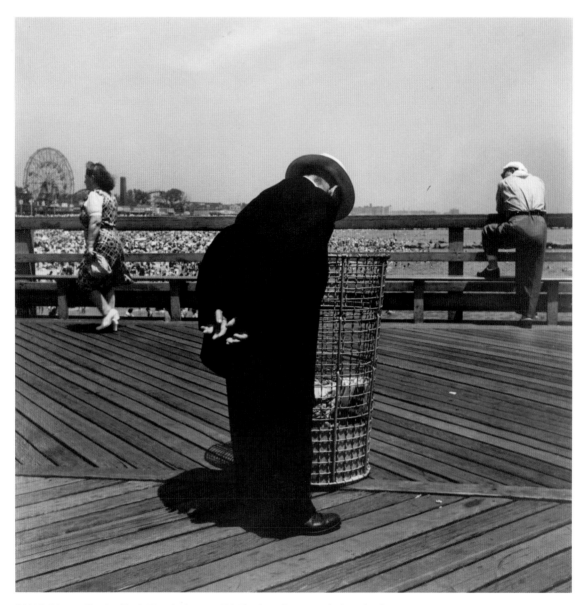

3.11 Ida Wyman, *Man Looking in Wastebasket*, ca. 1950. The three figures on the boardwalk each go about their business as the photographer brings them together in an image that possesses a measure of poignancy. © Ida Wyman. Courtesy of Heather Garrison.

to understand the power of photographs to help improve the social order by showing the conditions under which many people lived and worked."[19]

There were many ways to portray people letting go at the beach. Lisette Model arrived in New York from France in October 1938 after taking a very different series of pictures of leisure on the French Riviera. Unlike Coney Island images, these photographs of prosperous bourgeois men and women on holiday were rather intrusive, intimate, but not friendly. Model herself had grown up within this class, in a prosperous Viennese household, the child of a mixed Jewish-Christian marriage. She was baptized a Catholic, like her mother. Initially, she hoped to be a musician and studied with the modernist composer Arnold Schoenberg. Her father's death upset those plans; her mother left Vienna and returned to France. Model settled in Paris and in 1933 took up photography, prompted by a blunt message to her as a Jewish woman that she "learn something useful, get a job, and be prepared to leave Europe." She received instruction in photographic technique from several women. When she visited her mother in Nice, Model might have chosen to blend in with the fashionable crowds on the Riviera. Her decision instead to take pictures of strangers in fancy clothes at an exclusive resort can seem judgmental, depending on the context of their display.[20]

Published in a left-wing French journal as social criticism, *Promenade des Anglais*, a title from the street in which the photos were taken, served as Model's portfolio when she came to New York. Although she earned a livelihood from employment in a darkroom, Model also walked the city's streets, exploring visual themes that attracted her attention. In 1941, the editor-in-chief of the fashion magazine *Harper's Bazaar*, Carmel Snow, hired Model to shoot outdoor photographs perhaps transgressive of glamor as a concept. Model accepted this as territory she would explore. Snow and her art director, Alexey

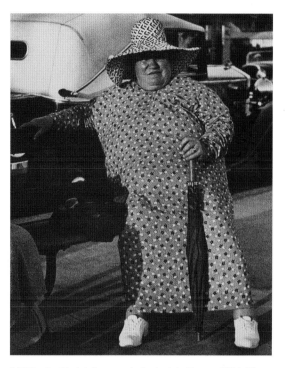

3.12 Lisette Model, *Promenade des Anglais, Nice,* ca. 1934–37. Model's portrait of a wealthy woman, part of a series she took in Nice, France, commented acerbically on her pursuit of leisure. © Lisette Model Foundation, Inc. Courtesy of National Gallery of Canada, Ottawa.

Brodovitch, thought that Model's photographs could be useful in their campaign to enlarge the domain of fashion by playfully exploring the terrain beyond the scene, as it would later be called. They liked Model's edgy, candid street photography, but they needed her to work different streets on behalf of different interests. So Model went to Coney Island to photograph a woman in a swimsuit, her assignment to illustrate an article on "How Coney Island Got that Way."[21]

Coney Island Bather shows a frame-filling woman in a bathing suit, standing in the surf, leaning forward, her hands on her knees. The cross around her neck suggests she might be Irish American. "She is

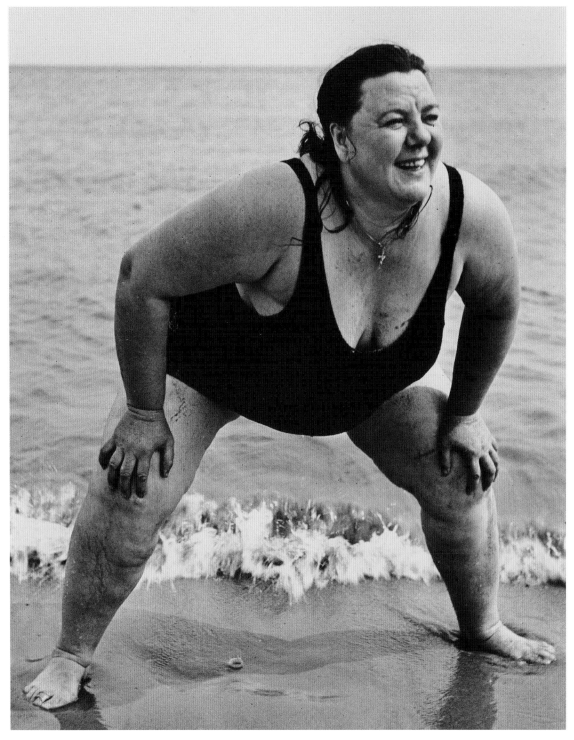

3.13 Lisette Model, *Coney Island Bather, New York,* ca. 1939–July 1941. A woman poses by the surf's edge for the photographer, ready and eager to cooperate. © Lisette Model Foundation, Inc. Courtesy of the National Gallery of Canada, Ottawa. Gift of the Estate of Lisette Model, 1990, by direction of Joseph G. Blum, New York, through the American Friends of Canada.

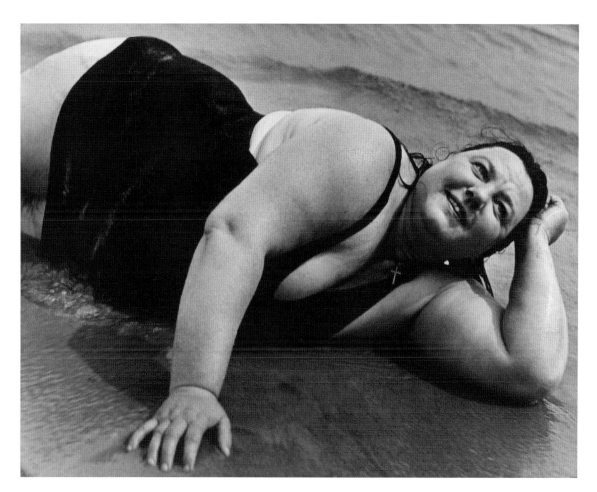

3.14 Lisette Model, *Coney Island Bather, New York,* ca. 1939–July 1941. Model opted for a glamorous pose that explicitly challenged prevalent assumptions of female beauty. © Lisette Model Foundation, Inc. Courtesy of the National Gallery of Canada, Ottawa. Gift of the Estate of Lisette Model, 1990, by direction of Joseph G. Blum, New York, through the American Friends of Canada.

relaxed, smiling, and appears to be looking straight at someone." Her masculine posture is surprising, unexpected from a woman of her age and physicality. The woman agreed to pose for Model, whose "camera peers in at an angle; the viewpoint is nonconfrontational and gives a good feel for the kinetics of the woman's pose. The framing is apparently unambiguous, but odd. Bending forward, the woman presents a low subject. Even though the camera angles a bit upward at her, the horizon line of the ocean is high in the picture because the beach slopes." There is the sense of looking slightly upward and not upward. Furthermore, given the extreme tightness of Model's framing, a viewer might expect to feel closer to the woman: her feet are planted wide, right at the edges of the frame, and her head nearly bumps the top of the frame. Model respects this woman's space. This is a matter of interpersonal manner but also of technique.

3.15 Martin Munkácsi, Lucile Brokaw, Piping Rock Beach, Long Island, *Harper's Bazaar*, December 1933. Munkácsi's photograph of the model running as part of a fashion shoot helped to move fashion photography out of the studio and onto the street. © Estate of Martin Munkácsi. Courtesy of Howard Greenberg Gallery, New York.

Model's work procedures often emphasized a sense of distance even in intimacy.[22]

Certainly, it was odd that a photo of a woman in the surf at Coney Island, whose build departed from that of ideal female fashion models, could be featured in *Harper's Bazaar*. In fact, the woman challenged onlookers who were staring at her during the photograph shoot. "What's wrong with you?" she demanded. "Haven't you never seen a fat person before?" Model also asked her to pose in a typical glamorous female Hollywood style, lying at the edge of the surf, with her head resting on her bent arm. The photo's tight framing, if not Model's technique, helped to launch a generation of close-up beach photographs. The caption in *Harper's Bazaar* read: "Coney Island Today, the Bathing Paradise of Billions—where fun is still on a gigantic scale," perhaps a tongue-in-cheek nod to the woman's size. New York's nickel empire was at once near and far from wealthy watering holes where fashion shoots had usually been staged.[23]

One of Snow's first innovations at *Harper's Bazaar* also involved a beach photo session, her opening salvo against what she perceived as an arthritic fashion publishing scene. She was determined to represent living rather than embalmed fashion. She struck early in 1933, right after being hired as fashion editor. Itching to bring the grand old magazine into the twentieth century, Snow took a model, a photographer (just off the boat from Germany), and his translator out to the exclusive *north* shore of Long Island (twenty-five miles northeast of Coney Island) to reshoot a reimagined session for the magazine's December "Palm Beach" issue. Martin Munkácsi was a Hungarian Jew. His photographic angles and timing were often boldly perfect. He had gained a reputation for capturing the speed of sporting events. And like Model, Munkácsi (re)created photographs in the darkroom, often by radically cropping his original snapshots, as he sometimes called them. In 1933 Munkácsi found himself covering Hindenberg's installation of Hitler as German chancellor. He left Berlin shortly afterward.[24]

Munkácsi knew no English, and the translator could not cope. Somehow, Munkácsi's body language convinced the shivering model to run in his direction. As she passed, he caught her in midstride. With this picture, taken on the beach at Piping Rock (a posh playground of the wealthy Astors and Vanderbilts), Munkácsi and Snow launched a new genre of high fashion photography: the outdoors action fashion shoot. In 1962, the year before Munkácsi died, Snow wrote that his picture of Lucile Brokaw for the December 1933 issue of *Harper's Bazaar* "was the first fashion photograph made for fashion, and it started the trend that is climaxed in the work of Avedon today." Brokaw was a socialite model. Munkácsi's photo depicted her "in midmotion, which accomplishes two effects simultaneously: it conveys that the subject was full of energy (an exuberant woman full of vitality), and it suggests that there was a reason for or a story behind the motion (her daily exercise routine)."[25]

Erotic energy competed with glamor and fashion at the beach. The latter didn't interest Sid Grossman, but increasingly the former did. He went to Coney Island after the war when he shifted to more expressive photography. He spent parts of two summers in 1947 and 1948 at the beach with his regular Voigtländer Superb, a large-format camera (6 x 6 cm), unlike the small 35 mm one he had borrowed to photograph the San Gennaro festa. "When I photographed Coney Island, we went there all summer and we walked from one end of the beach to the other, but I always came back to Bay Eleven before I photographed," he recalled.[26]

Although the beach seemed to be a random mix of ethnicities to outsiders, New Yorkers typically laid claim to a small section, just as they divided up their

3.16 Sid Grossman, *Coney Island, Labor Day*, ca. 1947–48.
Grossman repeatedly gravitated to the Puerto Rican teenagers
who hung out at Bay Eleven on the beach for their sense of
joy and their willingness to tolerate his camera. © Howard
Greenberg Gallery, New York.

neighborhoods and blocks. Ethnicity as well as class formed connections. The Puerto Rican kids hung out at Bay Eleven, a section under the boardwalk. Grossman found Bay Eleven the most interesting. Elsewhere, he "pointed the camera, but it didn't work. It only worked in Bay Eleven, because only there were these children who had these feelings, these limbs, these relationships, who had this peculiar kind of energy." Grossman gravitated to the amorousness generated by the music and physical intimacy of the teenagers. Relative newcomers to New York City, Puerto Ricans still possessed elements of the exotic.[27]

In one photo, a young woman with a white towel draped around her shoulders looks up at Grossman, a partial smile on her face. The young man resting his head in her lap directs his gaze toward several people to his left. Among these are a happy couple who occupy the middle of the photograph. Grossman's attention is shaped by the kinetics of looks exchanged among the friends. The crowded boardwalk is visible in the background but softened by the shallow focus on Grossman's shot.

In these photographs, Grossman departed from his Photo League mandate of the straight photograph. While he used available light and chose appropriate subjects, he also tightened the framing and "heightened the pictures' asymmetry by cropping the negatives when he printed." His photos aim for a measure of intimacy and closeness, emphasizing looks given and taken, along with the weight of tangled limbs and torsos. They suggest new directions in American street photography.[28]

This new freedom blossomed after the war, especially after the Photo League closed its doors in 1951. It was probably inspired in part by the work of several European photographers, including Munkácsi and Model. And it reflected energies released in the city after the constraints first of the Depression and then of war. By 1948, "antifascism was becoming an extinct political culture. The immediate movement from World War II to cold war made attention to class inequality not only extraneous, but unpatriotic as well." As the historian Paul Milkman observes, soon, "to advance such notions was to invite government persecution," a fate that befell both Grossman and the Photo League.[29]

The eroticism of Coney Island was hard to resist, even for someone like Dan Weiner. He took his share of straight photographs, but at Coney Island the heterosexual tangle of arms and legs enticed him. In one photo he, too, opts for what might be dubbed a low crane shot. Weiner captured the physical intimacy of people, limbs draped over each other's bodies. Their postures transform the photograph into more of a study of shapes than a display of erotic passion.

Jewish photographers gravitated to Coney Island for the crowds, the emotions, the diversity, and fun in the sun. Like others on the beach, they took off their street clothes, but they kept their cameras around their necks. They relished the opportunity to look closely at New Yorkers who, for the most part, accepted the stares of strangers as part of the beach's bargain. "Coney Island is a voyeur's paradise," Feinstein admitted. But every New Yorker is a voyeur. Looking at others saturates the urban milieu; its chaos invites gawking as a means of keeping one's balance. Coney Island's "smorgasbord of humanity" heightened its theatrical dimensions. Jewish photographers took on that challenge, especially when it came to public displays of affection.[30]

At Coney Island, photographers came with the territory, including roving ones who tried to sell potential patrons a picture. They seemed not that different from the teenagers who carried heavy cartons filled with ice cream treats or the peddlers hawking their wares. Some beachgoers deliberately performed, occasionally for the camera but more often for friends or family. Most just reveled in the release of constraints that arose from taking off one's street

3.17 Dan Weiner, *Individuals Lying on Each Other at Coney Island* (cropped), 1949. It was hard to resist the tangle of bodies and public intimacy that was a regular feature of the beach. Photo by Dan Weiner. © John Broderick.

3.18 Harold Feinstein, *Teenagers on the Beach, 1949*. Young women were often more circumspect at the beach, as in this photo with half-naked boys on either side of her. © Harold Feinstein Photography Trust | haroldfeinstein.com.

clothes in an era when urban social protocols governed how men, women, and children dressed to go outside. Unlike Weegee, who dramatized the crowds, other Jewish photographers plumbed the beach's intimacy as their story. Coney Island revealed a facet of New York not readily glimpsed on the street. Norms of public behavior guided working-class men and women; at the beach they let go and displayed affection. "There wasn't the antipathy to people taking photos," Feinstein remembered.[31]

"Hey, mister, take my photo." Feinstein complied. Like Weiner, Feinstein shot a teenage crew lying next to and all over each other. He invited their smiles by wading into the mashup and shooting downward. His presence hovers in the reflection of the large sunglasses' left lens. (Where are his feet?) Most of the boys pretend to ignore him. But one couple offers up big grins. She's wearing street clothes, while the boys have stripped to varying degrees. Her modesty suggests some of the complications of Coney's freedoms for young women. Years later, when the photograph was published in *Life*, her nephew saw it and wrote to Feinstein. She is even more beautiful today, he assured the photographer. She was seventeen then; Feinstein was eighteen.[32]

The Coney Island of children, families, and teenagers also lured couples, lovers. Engel drew close enough to a couple to capture their affection and heterosexual attraction without seeming prurient or prying. In his photo the man's bare back dominates the image. The camera also captures a thin teenager standing in the background, who wraps his arms

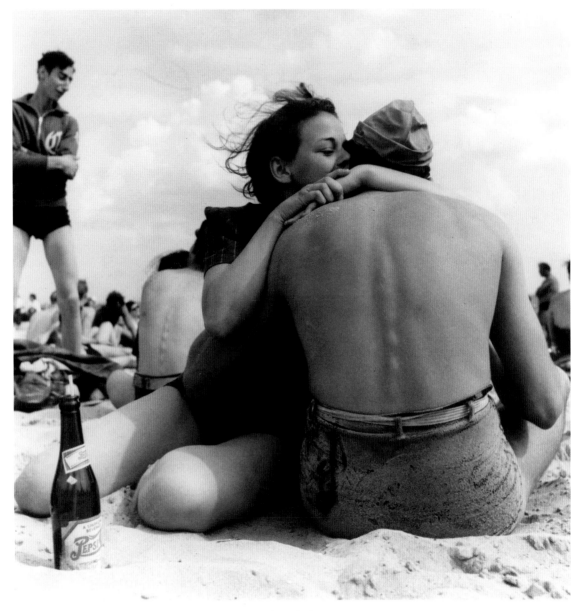

3.19 Morris Engel, Untitled (*Coney Island Embrace*), 1940s. Engel caught this embracing woman and man, expressive of the public intimacy and spirit of letting go that the beach invited. © Morris Engel.

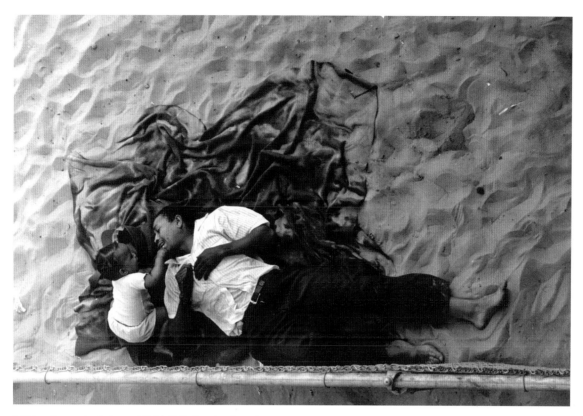

3.20 Lou Bernstein, *Father and Child, 1943*. Shooting from the boardwalk looking down at the disheveled blanket surrounding the father and child, Bernstein framed their relationship with affection. The Museum of Fine Arts, Houston, Gift of Wolf Associates. © 2005 loubernsteinlegacy.com. All rights reserved. Courtesy of Irwin Bernstein, irwinbernstein@bellsouth.net.

around his body in a gesture that amplifies the couple's embrace.

A very different type of Coney Island couple appears in a Lou Bernstein photograph, one like Feinstein's Haitian father and daughter picture. In this case, Bernstein probably shot from the boardwalk, since a railing, the top of a chain-link fence, runs along the bottom edge of the photograph. The wild array of the blanket, partially covered with sand, and the powerful contrast of the child's white clothes and father's white shirt with the blackness of his pants transform an image of familial love into one of

drama. Bernstein's photograph isolates the pair, surrounded by the empty space of swirling sand without any crowds or other people visible.

Born Judah Leon Bernstein, he grew up in Williamsburg, Brooklyn, the oldest son of Jewish immigrants from Romania and Austria. Unlike other Photo League members, Lou Bernstein only discovered photography as an adult. He received his first camera at age twenty-five, a gift on the birth of his first child, a daughter, in 1936. He immediately set up a darkroom in his apartment and started taking photographs of weddings and bar mitzvahs to supplement his income working in the Brooklyn shipyards. Four years later he joined the Photo League and studied with Grossman. Then in the early 1940s he got a job working in the paper and chemicals department of

Peerless Camera, one of the largest photo supply companies in the city. "Before long, everybody who was anybody became his customer, from neophytes buying their first rolls of film to an honor roll of the photographic greats of the day," recounted his son, Irwin. In 1958 Bernstein moved over to Willoughby's when the two stores merged. His knowledge of cameras and the craft of photography attracted hundreds of customers. Photography had become a booming business in New York, feeding an escalating demand for images in fashion, advertising, sports, as well as journalism and portraiture. But Bernstein's job meant he could only photograph a couple of days each week, which he did with great persistence and enthusiasm. Coney Island repeatedly attracted him for his days off with his camera.[33]

Bernstein kept on returning to Coney Island, finding its diversity endlessly fascinating. (Later he would regularly frequent the New York Aquarium when it relocated to Coney Island.) His photographs communicate its animated activity. In 1951 he went to Steeplechase and managed to capture its speed and excitement. The two young men, one on the spinning wooden platform and the other trying to join him, having most likely slid off, convey the type of innocent fun available on the boardwalk. Their white shirts speak to their different personalities. The boy in the short-sleeved shirt appears far more physically adept than his bespectacled friend, who wears a more formal long-sleeved buttoned shirt. These were the pleasures of the nickel empire: spinning crazily, trying to hold on, reaching for a friend and giving him a hand (and foot), forgetting oneself in the fun of the moment.

By the late 1950s, Coney Island regularly attracted teenagers looking not for innocent fun but for trouble. "At the time there were an estimated thousand gang members in New York City," Bruce Davidson recalled. "A Youth Board had been formed which sent 'Youth Workers' out to dissuade gangs from fights

and to help socialize them." Davidson didn't get to Coney Island until he hooked up with a Brooklyn gang called "the Jokers." This was an odd way to visit Coney Island. Hanging out with a gang carried an implicit threat of violence. Who knew what other gangs might also be at the beach? Who could anticipate what might ignite a fight? Visiting Coney Island in the company of gang members represented almost an opposite pole from Engel's and Feinstein's local excursions to their familiar beach. For Davidson, Coney loomed as foreign territory that he approached through his own personal mode of photography. "My way of working," he explained later, "is to enter an unknown world, explore it over a period of time, and learn from it."[34]

New York City had seen a startling rise in teenage delinquency, in part a reflection of a postwar world dominated by the Cold War, in part a response to the recognition of teen years as a separate stage in life prior to adulthood. The popular 1957 Broadway musical *West Side Story* transposed Shakespeare's *Romeo and Juliet* into a tragic conflict between two warring gangs, one white Catholics and the other Puerto Rican Catholics. Jerome Robbins's and Leonard Bernstein's original idea had been for "East Side Story," featuring Jewish and Italian gangs. The transposition to "West Side Story" and two Catholic groups divided by ethnicity and race illustrated the changes that had occurred in New York in the 1950s. The Jokers were Polish and Irish Catholic kids, who had to attend mass each Sunday. Although they lived in Brooklyn, Coney Island was not their local beach.[35]

Davidson was twenty-five when he first went to Coney Island, an army veteran, and an experienced photographer, having started taking pictures as a boy. He grew up in his mother's childhood home in the Chicago suburb of Oak Park, after his parents' divorce. His mother worked full time, and his religiously observant immigrant grandparents helped with childcare. Davidson received a camera, an Argus

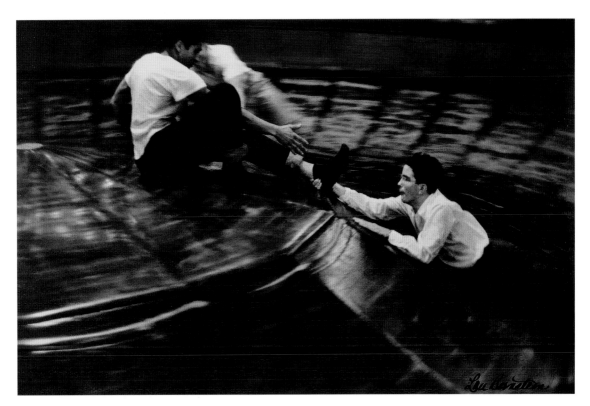

3.21 Lou Bernstein, *Steeplechase, 1951*. The Human Whirlpool at Steeplechase Park, one among many rides that enticed visitors to Coney Island, sent people spinning around on a polished wooden disk. International Center of Photography, Gift of Arlene Steinberg and Irwin Bernstein, 1992. © 2005 loubernsteinlegacy.com. All rights reserved. Courtesy of Irwin Bernstein, irwinbernstein@bellsouth.net.

35 mm, for his bar mitzvah, a gift from his uncle. After his mother remarried, the family moved up into the secure precincts of the middle class. Photography accompanied Davidson during his college years at Rochester Institute of Technology as well as his brief semester at Yale University. Like Klein, the army sent him to Europe; unlike Klein, Davidson returned to the States to make New York City his home. He arrived well after the demise of the Photo League.[36]

After reading about a skirmish in Brooklyn's Prospect Park, Davidson "decided to find the gang and enter 'the cool world' of their lives." Having grown up in Chicago, Davidson saw New York as exotic, not yet home turf. In 1959, he was an accomplished and published photojournalist, a member of Magnum, the photographers' cooperative. He adopted an ethnographic stance with the teenagers. He would be a participant observer. "At first, I attached to the youth worker assigned to them, but then stayed with the gang members as they stood late at night on the street corner, hung out in the candy store, or went to the beach at Coney Island with their girlfriends." Yet an element of danger endured. Once, the gang's leader took Davidson up on a tenement roof, where Davidson "thought the boy was going to throw him off into the street and rob him, but instead he pointed at the view of the Statue of Liberty from up there, and said, 'Get that.'"[37]

One of his Coney Island photographs of a couple shares none of the erotic energy that Grossman

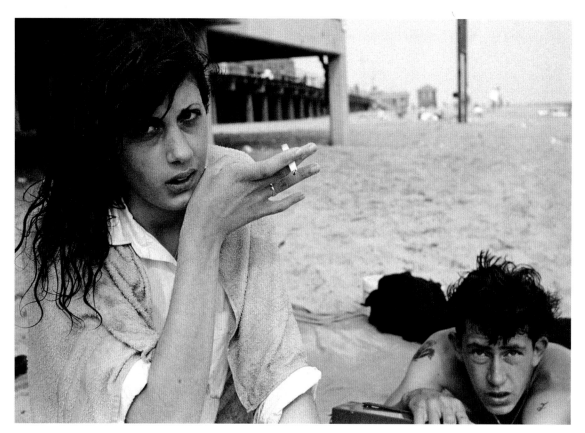

3.22 Bruce Davidson, *USA. Coney Island, NY. 1959. Brooklyn Gang*. The two teenagers eye Davidson with a measure of reserve, perhaps an indication of changing attitudes toward photographers by the late 1950s. © Bruce Davidson/Magnum Photos.

captured among the Puerto Rican kids. The girlfriend is smoking, as had been the case in Grossman's photo from the previous decade. Davidson captures her sitting separately from the boyfriend. Both stare into Davidson's camera as though somewhat annoyed that he is still there, loitering. Although Davidson hung with the gang, attitudes toward having your photograph taken had started to shift by 1959. A kind of wariness toward photographers gradually displaced the widespread embrace of cameras on the beach characteristic of previous decades. Thinking back on his experience, Davidson admitted that in general the gang members were largely indifferent to him. "I soon realized that I, too, was feeling some of their pain," he admitted. "In staying close to them, I uncovered my own feelings of failure, frustration, and rage." Coney Island, for all its vaunted pleasures and promises of intimacy, did not assuage those feelings.[38]

A different view of Coney emerges from Davidson's photographs, a kind of aching emptiness. Davidson followed the Jokers up onto a largely empty boardwalk, devoid of action. Junior and Lefty appear to be talking. Their interaction frames Bengie, one of the leaders. The other Jokers mill about. In the foreground, Junior has his towel rolled up under his arm. Lefty has taken off his shirt, revealing two tattoos on

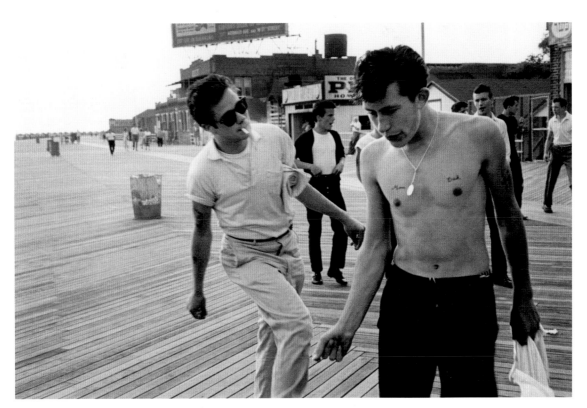

3.23 Bruce Davidson, *USA. Coney Island, NY. 1959. Brooklyn Gang. On the Boardwalk at West Thirty-Third Street, Coney Island. Left to right: Junior, Bengie, Lefty.* Davidson hung out with the Jokers, a gang of Catholic teenagers, and accompanied them on their trips to Coney Island. © Bruce Davidson/Magnum Photos.

his chest: "Mom" and "Dad." In between a St. Christopher medal swings, another symbol of sentiment and piety. Both mood and gestures seem off kilter for a trip to Coney Island. They express an alternative, personal vision that marked the decade's end.[39]

Elements of Davidson's ambivalence reappear in a photograph by Leon Levinstein. Like Davidson, Levinstein was an out-of-towner, coming to New York after World War II following his military service. He had grown up in an Orthodox Jewish home in a small town in West Virginia and then as a teenager in Baltimore. Unlike Davidson, he didn't get his first camera until he was thirty. He started to explore the

dimensions of photography when he arrived in New York City as art director of a small new advertising firm where the principals included a cousin and a friend from Baltimore. Levinstein took classes at the Photo League, including one with Sid Grossman. When Grossman left the League because of FBI harassment and started to teach privately in his loft on 24th Street, Levinstein followed him. For three years he continued to attend Grossman's workshop. Levinstein absorbed Grossman's vision of photography but not his politics. "Photography can be expressive of the strongest human feelings," Grossman explained, "including those of the photographer himself."[40]

In one photograph Levinstein captures the power of the male gaze. Two young men look at two women (one is cropped out of this print) wearing straw hats

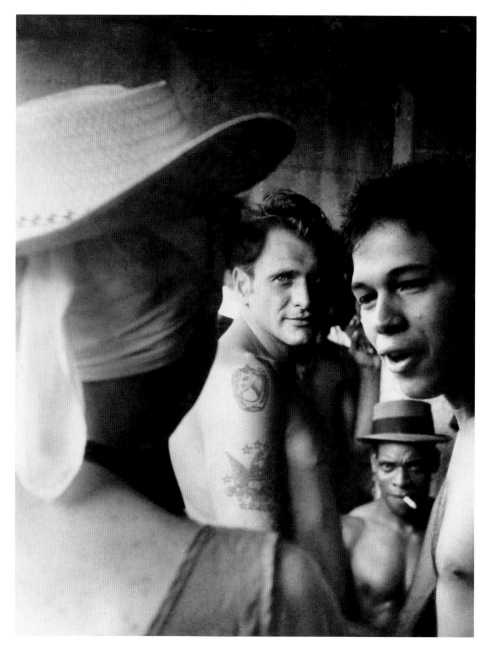

3.24 Leon Levinstein, *Coney Island*, ca. 1959. The man in the middle pegs
Levinstein, staring at him as he takes this voyeuristic photograph. © Howard
Greenberg Gallery, New York

and scarves on their head. The men's tattooed arms and bare torsos invite ogling. One man appears to be speaking to one of the women. The formidable stare of a seated man, cigarette in his mouth, emphasizes the circulation of looks. He glares right through the photograph's symmetrical gap that positions the two men. The photo historian Bob Shamis observes how "many of these encounters between the sexes" that Levinstein caught "are confined to looking—whether mutual or guardedly one-sided. In some of these photographs," he adds, "Levinstein portrays the aggressiveness of the male gaze while apparently acknowledging his own voyeurism as well." Levinstein, who did not speak often about his photographs, admitted: "Anything that comes within my sight or in my path that excites me to photograph, I'll photograph."[41]

Levinstein used a twin-lens reflex camera, a Rolleiflex. He often cropped the square negative in the darkroom. "The twin-lens reflex allowed him to point his camera sideways, while facing away from the motif and looking down," writes the critic Max Kozloff. "It was a strategy that he thought permitted him to maneuver into point blank range without causing suspicion." Levinstein did not seek to interact with the individuals whom he photographed, rejecting the mutuality fostered by Photo League photographers with the people they photographed. He preferred to work furtively, with his subjects unaware. He was a big man, over six feet tall, yet "all of the photographers who knew Levinstein remarked on his uncanny ability to go unnoticed in the middle of a crowd or in the midst of a tense situation and photograph unobtrusively." In this picture the seated man looks directly at Levinstein—and at anyone viewing the picture. His glare emphasizes the power of looking, engaged not just by photographers at Coney Island but also, potentially, by anyone.[42]

Changes overtaking New York in the postwar decades registered in Coney Island's crowds and in photographs of its beach and boardwalk. Despite the palpable tension pervading Davidson's and Levinstein's photographs, Coney continued to offer a measure of freedom. The promise of some hard-earned leisure time consistently enticed visitors to the surf and sand. Styles of dress (and undress), modes of flirting, forms of amusement and pleasure shifted only gradually as new generations discovered Coney Island. With them came photographers, who extended traditions of picturing the beach and its pleasures of letting go.

4. Going Out

"The city was my home," the photographer Arthur Leipzig affirmed. And that meant its streets as well. Apartments were too small to accommodate socializing commonly associated with home. "Going out," a popular phrase, referred to leaving the precincts of one's private home for the public home of the street. When used by adults, going out could also signal something special: attending a show or concert, visiting a museum or library, spending an evening on the town at a restaurant or night club. In these ways New Yorkers integrated going out into their understanding of the city. They went out all the time. Children started to do it as soon as they reached school age.[1]

"'Going out' was more than an escape from the tedium of work, it was the gateway into a privileged sphere of everyday life. The ability to take time out from work for recreation and public sociability," writes historian David Nasaw, "was the dividing line between old worlds and new." New Yorkers absorbed the idea that "recreation and play were not luxuries but necessities in the modern city," part of the texture of urban life. Nasaw goes on to make a different argument regarding commercial culture. He contends, "the exclusion or segregation of people of color was as necessary a condition" for the "democratization" of audiences in movie theaters, as was a policing presence provided by ushers. Segregation of Black Americans undergirded the myth of an "inter-ethnic, cross-class, genderless, luxury-laden urban democracy." In short, commercial entertainment's mythic version of an urban democracy erased differences across lines of gender and sexuality, as well as class and ethnicities, but reinforced difference based on race.[2]

Although Jewish photographers surely saw this type of mixing, they documented different interpretations of recreation on city streets. Perhaps most insistently, they photographed separate gendered spheres of play among children as well as integrated groups of Blacks and whites. They also eschewed cross-class encounters. These emphases reflect perspectives honed, in part, through discussions at the Photo League. Viewed in this context, their photographs can be understood as a Jewish take on urban forms of children's outdoor play and the pleasures of going out on the town for working-class adults.

Of course, games that children played on crowded neighborhood streets in Manhattan, Brooklyn, and the Bronx differed from the commercial

entertainment adults enjoyed at a site like Times Square. In working-class areas, the streets often seemed to be literal extensions of home. Parental eyes and ears kept distant tabs on children from tenement stoops and windows. The theater district invited escape from prying neighbors. It lured visitors with its constant spectacle, night and day. It gave adults and teenagers a chance to dress up and potentially adopt a new persona for the evening.

Cataloguing the variety of what happened on the streets became a way of taking a personal inventory for Leipzig. Inspired by a class with Sid Grossman at the Photo League, Leipzig went to the Metropolitan Museum of Art as Grossman urged his students to do. Like many Grossman students, Leipzig had not previously visited a museum. At the Met he discovered a print of a Peter Brueghel the Elder painting called *Children's Games*. Intrigued and inspired, Leipzig gave himself an assignment to document as many different children's games played in New York as he could. He "was struck by how similar games played nearly four hundred years earlier in Flanders were to the ones being played outside" his window. These photographs became his first major photo essay for *PM*, the newspaper founded in 1940 that emphasized photographs, refused advertising, and adopted a left-leaning, explicitly anti-fascist editorial policy.[3]

Edited by Ralph Ingersoll and underwritten by Marshall Field III's wealth, *PM* attracted a talented cohort of writers, editors, and photographers. Its historian, Paul Milkman, argues that *PM* leaped ahead of its competition, "presenting clearer and more vivid pictures to its daily audience than ever before or since." Its staff brought diverse perspectives to the publication, along with a shared anti-fascist commitment. The joint presence of such radically different photographers as Margaret Bourke-White, a photojournalist for *Life* known for her dramatic images of industrial sites, and Weegee, famous for his lurid crime photos of New York, suggests its visual eclecticism.[4]

A position as a *PM* staff photographer transformed the lives of Arthur Leipzig and Morris Engel, who were starting their careers in photography. "Suddenly I took the fast elevator to heaven," Engel recalled, reflecting on when he was hired in 1940 at *PM*. While the newspaper competition in New York "was overwhelmingly right of center and isolationist—only one of New York's other eight papers endorsed Franklin Roosevelt in 1940—*PM* was unabashedly pro–New Deal, pro-labor, and pro–getting into World War II." It also opposed racism and antisemitism. *PM*'s anti-fascist posture matched the politics of many Photo League members. The paper gave photographers freedom and initiative when out on assignment, along with a credit line for their photos when published. Leipzig believed "that working for *PM* was unique, because 'anything was possible.'"[5]

As Leipzig noted in retrospect, the streets "were the living rooms and the playgrounds, particularly for the poor whose crowded tenements left little room for play." Nasaw agreed. "It was much easier for a family to make space for the children to sleep than it was to find room for them to play." Indoors, he concluded, "was for adults; children only got in the way: of mother and her chores, of father trying to relax after a long day at work, of boarders who worked the night shift and had to sleep during the day." Children shared their home on the streets with others. "The street was their playground, but it was also a marketplace, meeting ground, social club, place of assignation, political forum, sports arena, parade grounds, open air tavern, coffeehouse and thoroughfare." Children's games provided a unique window for Leipzig into his own home: the city. Kids' creative play, their ability to provide their own entertainment, strengthened their own friendship circles as much as trips to Coney Island did for teenagers and adults. Children, "readily accessible in parks and on the stoops and

streets," offered "opportunities to explore some of the themes dear to the interest of [Photo] League members: the symbolism of innocence in a rough world, the expression of insouciance and playfulness in unexpected or harsh contexts, and the pathos and anxiety of the vulnerable individual."[6]

Chalk games probably were not among those sixteenth-century diversions painted by Breughel. In New York, both boys and girls loved chalk games, though they rarely played together. Leipzig's photo looks down from his window onto a street that is a stage. Prospect Place, a mixed working- and lower middle-class neighborhood not far from densely populated immigrant Jewish Brownsville, attracted upwardly mobile immigrants. In many Brooklyn neighborhoods, streets, sidewalks, alleys, parking lots, and building stoops served as gameboards, billboards, sketchpads, battlefields, arenas, fashion runways, gyms, stages, mazes, courts, racetracks, fields, and film lots. The photo's slant, with cars lining the curb, emphasizes the games' kinetics. *Chalk Games, Prospect Place, Brooklyn, 1950* composites planes of action that viewers—as synchronizing, pattern-making, sense-seeking creatures—are likely to perceive as related. Viewed from a virtual balcony, it is possible to imagine, perhaps, the vectors of dancers or athletes hitting their spots, somewhere down there among the sailboats and cowboys and flags.

Seen from above, *Chalk Games* illustrates the range of children's imaginations. It captures the intricacy of children's pursuits and the vital world of the street. Socializing out here, whether cooperative or competitive, was largely segregated by gender and, depending on the neighborhood, by race. Boys usually played together, as did girls. "On the street, you were judged by how you hit the ball, how you made out with the girls, how you stood up in a rhubarb, how much punishment you could take and how much you could dish out," Gus Tyler recalled. "In the process," the Jewish union leader concluded, "I

learned that man does not live by words alone—even if he is Jewish."[7]

Leipzig grew up in a Brooklyn Jewish family. His father died when he was still an infant, and his mother moved the family into her immigrant father's house in Borough Park, a mostly middle-class Jewish neighborhood. In the middle of the Great Depression, Leipzig dropped out of Erasmus Hall High School to work an array of jobs: truck driver, salesman, office manager, assembly-line worker. An injury suffered at a wholesale glass plant prompted him to look for a new way to make a living while his right hand healed. He took up a friend's suggestion to study photography at the Photo League, thinking he might become a darkroom technician. Two weeks into a beginner's class in 1942, Leipzig discovered his career. "My life as a photographer began in the streets of the city," he recalled. At the Photo League he spent days shooting and nights "in the darkroom and in discussion with other students and photographers. I was obsessed," he admitted. Photography offered a way to learn about his urban world and himself.[8]

At the Photo League, Leipzig mastered a craft and imbibed an aesthetic, a point of view, goals to strive for, and a focus for his life. What distinguished the League's "treatment of photography was not the belief that its work could effect social change, as is generally surmised," writes curator Mason Klein, "but that its members—predominantly Jewish, working-class, and first-generation Americans living in a multi-ethnic city—were fascinated by the city's composite nature and strongly identified with it."[9]

Jewish photographers paid attention to interracial games. Such forms of play fit their understanding of city streets as sites of interaction across ethnic and racial boundaries. Leipzig's photograph of *Stickball* illuminates that viewpoint as it pictures Black and white kids playing together. The game takes place in the middle of a street in a working-class Black and Jewish neighborhood. The manhole cover serves

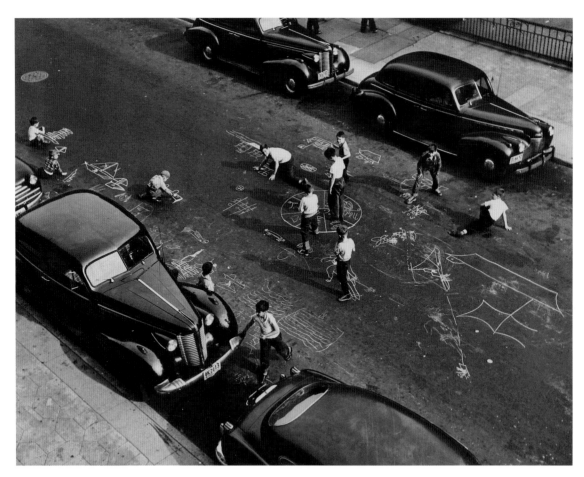

4.1 Arthur Leipzig, *Chalk Games, Prospect Place, Brooklyn, 1950.*
Looking down from his window, Leipzig pictured the imagina-
tive world of city boys playing in the streets. © Estate of Arthur
Leipzig. Courtesy of Howard Greenberg Gallery, New York.

as home plate. The graceful arch of the batter as
he prepares to swing for the ball and the reach of
the catcher occupy center stage. On the sidewalk,
a woman strides purposefully with three children
in tow. A butcher in his white apron lounges in the
entryway of his kosher chicken market, looking at
something down the block. The boys have taken
over the streets for their game. They don't need to
compete with automobiles.

On the sidewalks, younger kids played games like
Box Ball or Red Rover. Leipzig's photograph of a Red
Rover assault includes a girl who runs furiously at
the boys who are holding hands to prevent her from
breaking through their line. She has leapt into the air,
hurling herself at their outstretched arms. The dark
backdrop of the McKesson & Robbins delivery truck
sets a stage for the game. The truck driver ignores
the kids as he delivers pharmaceuticals and other
products. But an audience of one boy watches from
his perch on the mailbox. It is summertime in Brook-
lyn, where many children, starting around the age of
ten, were free to roam the streets of their neighbor-
hoods without direct adult supervision.[10]

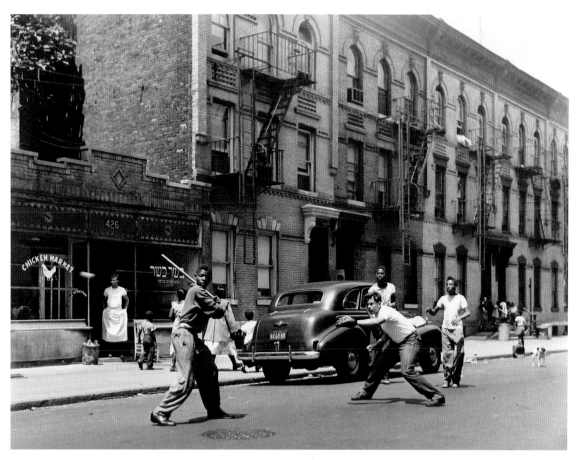

4.2 Arthur Leipzig, *Stickball, 1950*. Kids adapted the city's attributes—from automobiles to manhole covers—in the rules for stickball, a popular sport among all New York boys. This photograph shows a mixed working-class neighborhood of Jewish and Black residents. © Estate of Arthur Leipzig. Courtesy of Howard Greenberg Gallery, New York.

As World War II raged, children rehearsed the violence and conflicts convulsing the adult world. Such play often took advantage of empty lots with irregular terrain. Increasingly, photographers were part of the urban scene. Streetwise kids knew what to do when an adult showed up alone, camera at the ready. The boys "were hard at play in the afternoon," Leipzig remembered, as he "approached their vacant lot on Dean Street," south of Atlantic Avenue, a major shopping artery in Brooklyn. "They were completely engaged in their war games, using their imagination to turn simple objects into elements of the world they fantasized: a blade of grass pressed to a rock became a grenade; the empty lot was the battlefield." Leipzig wanted to photograph them, but before he could begin, "the kids saw my camera and the war stopped. They all lined up for a group photo." Chagrined, Leipzig told them that he would only take pictures if they were playing. Conscious of his presence, they went back to their war games.[11]

Children understood that they "were a subject population, liable to be scolded, chased, or arrested without warning." Weegee's photograph *The Cop Spoils the Fun* comments wryly on the tense

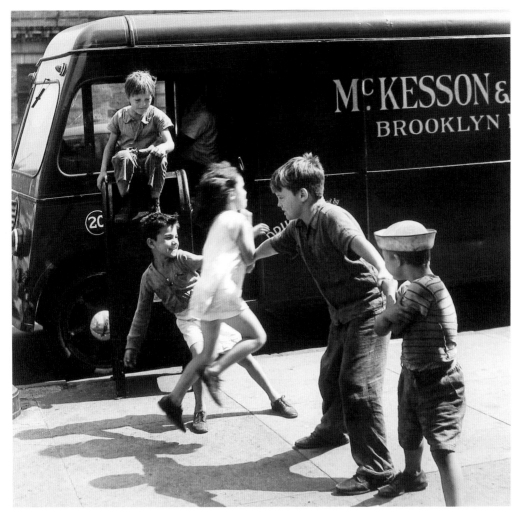

4.3 Arthur Leipzig, *Rover, Red Rover, 1943*. Part of a series of photographs of children's games on the streets of New York that he took in the 1940s, *Rover, Red Rover* conveys the intensity with which young children played. © Estate of Arthur Leipzig. Courtesy of Howard Greenberg Gallery, New York.

relationship between children and police even as it also reflects upon the presence of photographers. Shot in the summer of 1937, his photo of low-level misbehavior is Weegee's version of a picture genre that typically celebrates urban kids gaming their tough environment. Such images were staples of July newspaper photography. But Weegee was a killjoy.

His kids lose the chance to cool off under water spraying from a fire hydrant. The children, however, know they're not in serious trouble, so a couple of them cut up for the odd man using a flash with his big camera on a sunny day. "People like to be photographed," Weegee wrote, "and will always ask 'What paper are you from, mister, and what day will they appear.'"[12]

Leipzig's extended interest in children's street games was unusual among male photographers.

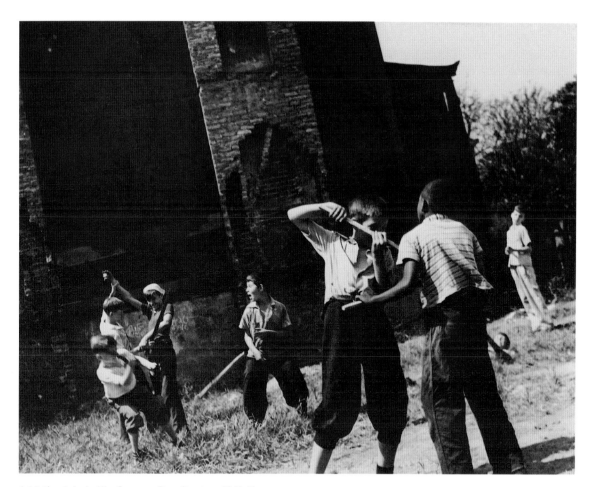

4.4 Arthur Leipzig, *War Games on Dean Street*, ca. 1943. The boys played war games in an empty lot on Dean Street, Brooklyn, conscious of the photographer and his camera, who pictured how World War II reverberated among children in the city. © Estate of Arthur Leipzig. Courtesy of Howard Greenberg Gallery, New York.

Rebecca Lepkoff, Helen Levitt, and Vivian Cherry produced rich and varied photos of kids entertaining themselves: playing, play-acting, and acting out. They photographed the New York City working-class world of childhood with the same interest and intensity as they did adults. Gendered codes of behavior and dress guided how New Yorkers presented their public selves on city streets. Women, especially, learned the rules of looking. When women gazed not directly but rather through a camera's lens, they could control what they saw. The camera's eye gave women the power to see city streets as men did. A measure of self-consciousness accompanied women who accepted this gift of freedom to stare at people.[13]

Women photographers tended to blend into the streetscape when they photographed children, since kids either ignored or play-acted for them. Rebecca Lepkoff's photograph of two boys playing Kick the Can on Ridge Street on the Lower East Side exemplifies the quotidian character of the working-class world of New York. The angles of the sidewalk and sweep of a city street add momentum to the two

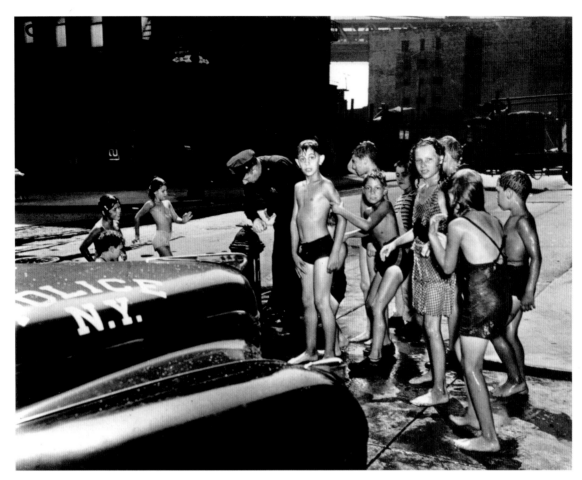

4.5 Weegee, *The Cop Spoils the Fun, 1937.* Cooling off with water from a fire hydrant was a popular pastime for children in working-class neighborhoods who had no access to either swimming pools or the beach (although the East River was close by). © Weegee/International Center of Photography.

boys racing down the block. Their focus on the can as though it were a soccer ball animates the scene, revealing the power of play to engage children. In the background a woman and children shop at a corner stand, a more permanent version of a pushcart.

The Lower East Side was familiar territory for Rebecca Lepkoff. She grew up there, the daughter of immigrant Jewish parents. Her Orthodox grandfather, the *shamas* (caretaker) of a synagogue on Clinton Street, lived in the apartment above them. Her

parents spoke Yiddish and read the socialist Yiddish daily *Forverts*. Lepkoff attended Hebrew school but didn't learn much beyond the alphabet. She regularly photographed children on the blocks around her tenement. Like Leipzig, Lepkoff discovered how the camera allowed her to picture her own intimate world.[14]

Unlike Leipzig, Lepkoff's family moved often as their finances fluctuated, always within a radius of a few blocks: Hester Street, Clinton Street, Jefferson Street, East Broadway. Lepkoff remembered her father wearing spiffy suits. On occasion he took her to the Yiddish theater on Second Avenue. When she

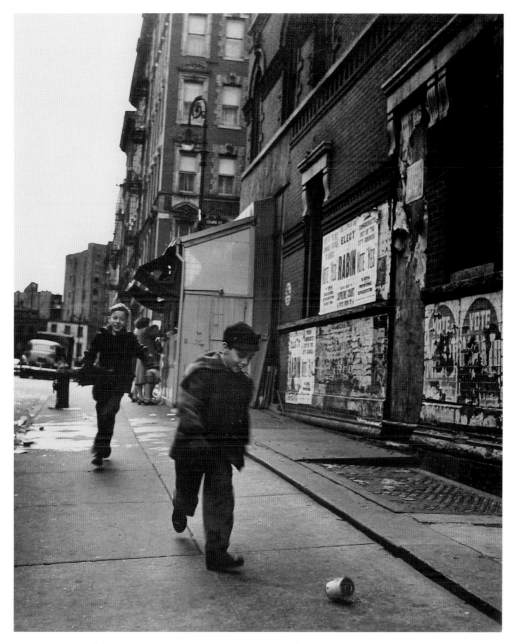

4.6 Rebecca Lepkoff, *Kick the Can, Ridge St., Lower East Side, 1947*. Lepkoff photographed on the streets of her own neighborhood, the Lower East Side, presenting those blocks as filled with social activity among children and adults. © Estate of Rebecca Lepkoff. Courtesy of Howard Greenberg Gallery, New York.

was eleven years old, her mother suffered a nervous breakdown. Her mother's illness strained the family, pushing it into poverty, although her father kept the family together. The stigma of being poor rankled. Lepkoff remembered how her teachers at Seward Park High School relentlessly criticized her, her clothes, and even her fingernails. So she quit, but she didn't tell anybody. She just spent school days at the Seward Park Public Library and read through the classics. Later, she switched to night school where the students were more serious and came to class dressed in their work clothes.[15]

Then she discovered modern dance classes at a local Jewish settlement house. Soon she was working in the garment industry and dancing with Bill Maton's experimental company during the slow season. They performed in union halls, at the Brooklyn Museum, and at the New School. At the 1939 World's Fair she received the equity pay rate for her dancing. With her first disposable income, she bought a camera, a used Voigtländer from Olden's camera store. Lepkoff's early training in modern dance tuned her "into the choreography of the movement of the streets," as she told an interviewer.[16]

As with her discovery of dance, Lepkoff started to learn photography in the neighborhood. She took her first photography class under the auspices of the New Deal with Jewish immigrant photographer Arnold Eagle. Eagle encouraged her. He took her to Harlem to photograph children in the kindergarten of the Abyssinian Baptist Church. In 1941 she married Gene Lepkoff. Four years later, a friend introduced her to the Photo League, where they were doing photography pretty much as she was. The League "opened up a whole era of my life in photography," Lepkoff reflected. At the League, exhibits, discussions, classes, and lectures brought Lepkoff into an exciting photographic milieu, shared with others. She registered for an evening class with Sid Grossman. He taught her to be selective: "Take your

photographs and make proof sheets and study them. Pick out the ones that you really think are good. And when you make a print, just don't make one print. Stop when you think you have the perfect print."[17]

A young married woman without children, Lepkoff devoted herself to photography, working part-time jobs for flexibility. She made it a practice to frequent the same streets, hanging out with her camera. She'd shoot a roll of film and then head home, often returning to the block. At night she would stay up late printing in her apartment. "Sometimes I would be on the street for a long time, so people would sort of feel relaxed about my being there," she remembered. "People ask me—how did you know what to take?" she noted. "I didn't even have to think. I just went outside, and there were the streets of my mother, of me, and whatnot. Very alive, full of activity, with people." Lepkoff concluded, "I think it helped to be a woman."[18]

Yet she was also vulnerable as a petite woman with a camera. Lepkoff recalled that once, when she took a picture of a façade of a building from across the street, a passerby who was captured in the image got upset: "When I clicked the camera, he heard it and said, 'Give me, take the film out, give me that!' Though I insisted that he was 'only going to be like a little dot,' he could not be persuaded and threatened to involve a police officer." The cop they approached listened to the man but was not persuaded. "Listen, guy, this is a free country," Lepkoff recalled the officer saying. Police could also be annoying. One time she had to deliberately lose her police escort. He thought that taking pictures of street gangs required his protection. No sooner did she evade him and sit down to change a roll of film, when another man approached her. "What are you doing here?" he asked. "Somebody is going to come and break your head." Lepkoff demurred. She didn't see anyone threatening her. In the end, she photographed, and nothing happened.[19]

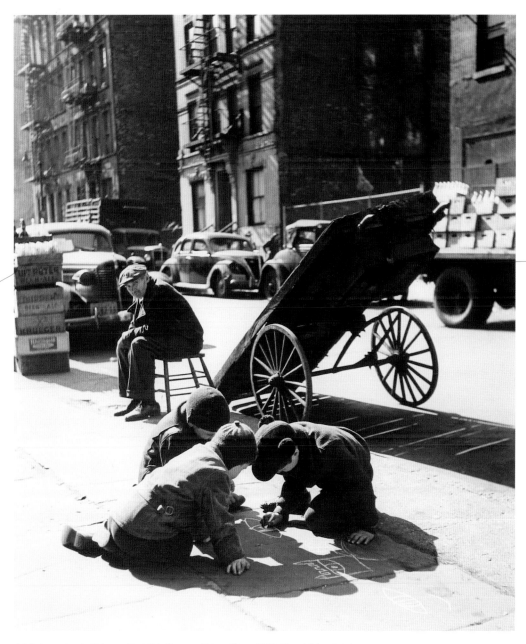

4.7 Rebecca Lepkoff, *Lower East Side (Boys on Sidewalk)*, ca. 1939. The children's intense concentration makes them oblivious to the photographer, who pictures them within the context of the poor neighborhood with its mix of residences and commercial spaces.
© Estate of Rebecca Lepkoff. Courtesy of Howard Greenberg Gallery, New York.

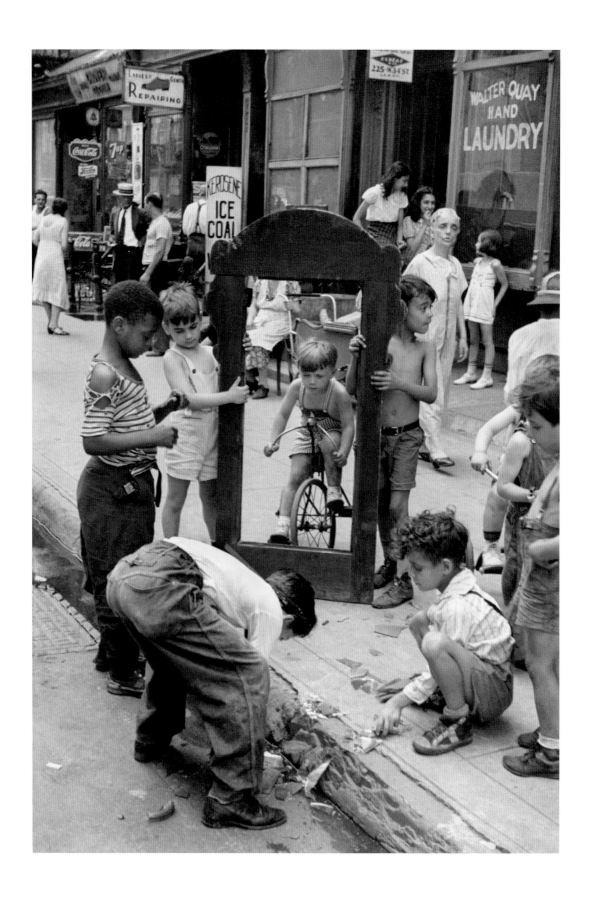

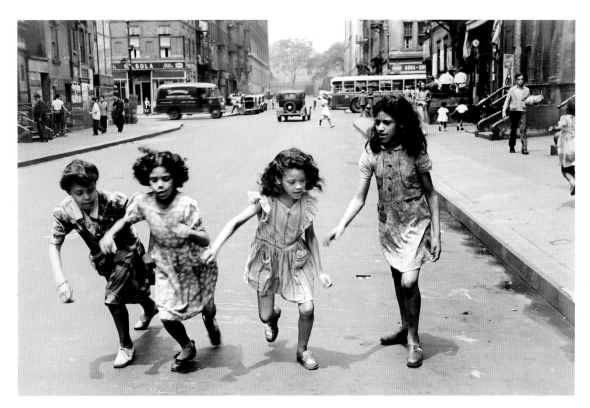

4.9 Helen Levitt, *New York*, ca. 1940. Three girls have lined up to race while an older girl gives the cue to start running down the mostly empty street. Helen Levitt, NY, ca. 1940. © Film Documents LLC. Courtesy of Galerie Thomas Zander, Cologne.

When she bought her first camera, Lepkoff started by taking photographs of children drawing on the sidewalk. The children's concentration allowed her to approach them without their paying her any attention. Her photograph of three boys engaged in drawing on the sidewalk reveals the street's dimensions: tenements on the other side, cars and trucks parked by the curb, and perhaps most importantly, a man sitting on a stool watching both the boys

4.8 Helen Levitt, *New York*, ca. 1940. Children cluster around an empty mirror frame that has just shattered, its shards of glass lying in the gutter. Helen Levitt, NY, 1940. © Film Documents LLC. Courtesy of Galerie Thomas Zander, Cologne.

and Lepkoff. An upended pushcart and the spokes of its two wheels provide a dramatic contrast to the horizontal and vertical lines of the city street. Stacks of soda bottles on a truck and the curb signal simultaneously the street's mixed residential and commercial character, typical of the Lower East Side and other working-class areas. The children's well-fitting and cozy clothes contrast with the worn jacket and pants of the man. One could almost imagine a busy mother saying, "Hey Sam, keep an eye on my kids for a few minutes while I go pick something up at the store."

The action and intensity of children's play appears vividly in Helen Levitt's photograph of an empty mirror frame and the shards of its smashed glass. She reveals how kids interact with the motion of the streets. Her photograph brings the action to the

viewer, who stands alongside Levitt and her camera. In this photo, although she seems to have missed the main event, her compensation is priceless. No three-second disaster movie could equal the narrative that Levitt's photograph frames. Elizabeth Gand argues that this photograph exemplifies Levitt's defining commitments: "the significance of children's fantasy worlds, the social experience of working-class life, and the merging of realism's descriptive powers with surrealism's exaltation of irrational desires. From the contingency and flux of everyday life," she observes, "Levitt has distilled a scene that renders permeable the boundaries between art and life, public and private, the levity of play and the gravity of ritual." Within the timeframe of Levitt's photo, only two adults seem to be paying attention to the accident or the perilous project that has ensued. One woman watches as she strolls by; her lips, perhaps, let slip an "Oops." And Levitt has quietly found her perspective of choice.[20]

Unlike Leipzig, Levitt "did not choose to depict routine or organized play such as the hopscotch, jump rope, and stickball of her youth, but rather exclusively the play of the imagination." The girl in the center of one photo is probably getting some last-second advice from her big sister. Of the three racers, this one will need to swerve around Levitt, who has positioned herself for the best viewpoint. As in many New York photos of the 1940s, residential streets are nearly empty and without traffic lights, ideal for children—girls as well as boys—and photographers alike.[21]

War and violence increasingly dominated children's imagination, especially among boys. During the war years, boys played explicit war games as well as giving contemporary resonances—"bombs over Germany"—to ordinary games of tag. Fascination with violence and war games survived the war and flourished in the postwar Cold War period as well. It is not surprising that after World War II and during the Korean War some Jewish-American photographers took street pictures of boys engaged in make-believe conflict: battles, shootouts, executions, intimidations, lynchings, and murderous derangement.[22]

"Many children instinctively grasped the corrosiveness of the postwar transformation, gravitating toward new forms of storytelling that seemed to rise unbidden from alien worlds: horror comics and science fiction films that drew upon the horrors of the bomb, the Holocaust, and the Communist menace." Jewish photographers appeared particularly attuned to the reverberations of adult aggression in boys' play. Perhaps they sensed, as Tom Engelhardt writes, that "for boys, in those years, the American way of war . . . was not a matter of death but an intense form of pleasure, and elemental happiness, and a rite (as well as a right) of passage." Even more than war games, however, Jewish photographers focused on racial violence in the United States and the ways that kids enacted on abandoned lots the racism and antisemitism pervading America.[23]

Like Levitt, Vivian Cherry opted to picture improvised play. Her focus registered war games and gang violence, including lynchings. Three photos are called *Game of Lynching*. "There were no lynchings in New York, but there [in 1947] they are, playing that game," she subsequently recalled, "and it didn't matter if they were black or white." This series documents a mixed group of middle-school boys as they stage lynchings in an empty lot. Their sheepish demeanors suggest they were acutely aware that their play-acting was transgressive and was being photographed. However, one boy's belligerent posture toward the Black youngster indicates that Cherry was not privy to some interactive dynamics. It would help to hear what he was saying as he raised his fist.[24]

McCall's photo editor rejected Cherry's series on *Game of Lynching* when she submitted the photographs as being "a little too real for magazine use."

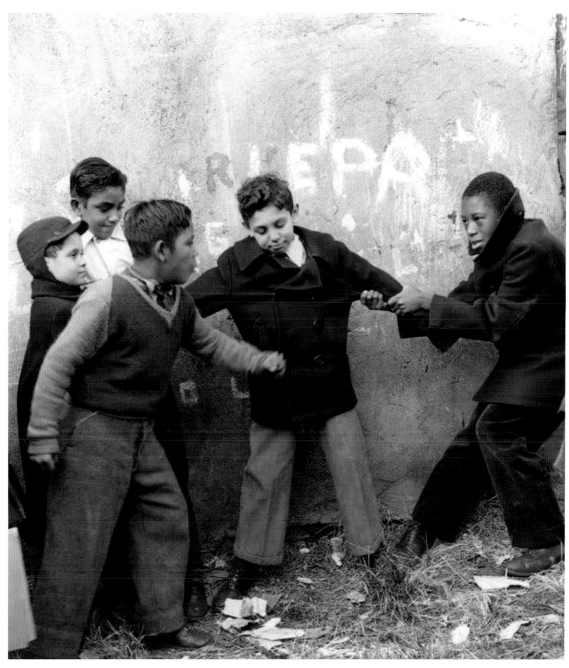

4.10 Vivian Cherry, *Game of Lynching, 1947*. Cherry came across children playing
a game of lynching, although there were no lynchings taking place in New York.
The boy's clenched fist hints at the game's violence. © Estate of Vivian Cherry.
Courtesy of Daniel Cooney Fine Art.

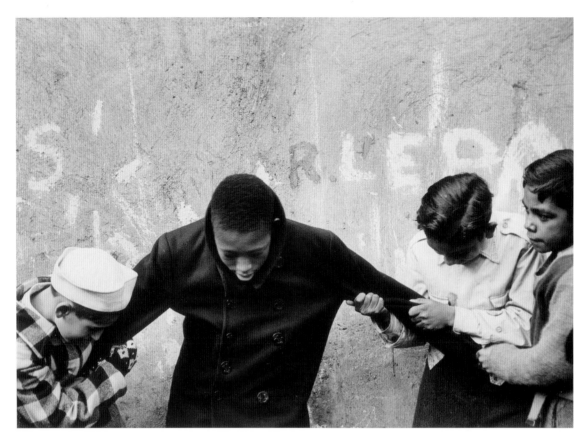

4.11 Vivian Cherry, *Game of Lynching, 1947*. The Black boy adopted a Christ-like pose as part of his role in the game. © Estate of Vivian Cherry. Courtesy of Daniel Cooney Fine Art.

He wrote in explanation: "We try to identify the reader with the story, try to say to him that this is he and his problem shown in the pictures. I'm a little afraid he'll refuse to identify himself with the people and backgrounds here, would prefer to see himself a bit idealized." Ironically, the editor used the masculine pronoun although *McCall's* primary readers were middle-class women.[25]

Cherry remained intrigued by children's games of guns. She titled one photo *Crossfire*, referring to one of the film posters above the crouching boy. That movie and *Gentleman's Agreement* were the first post-Holocaust American films to deal with antisemitism.

Crossfire, based on a novel, *The Brick Foxhole*, exposed bigotry among WWII American soldiers against Jewish, Black, and gay people. The Hays Code banned all references to nonheterosexuality in movies, so the film version focused on violence against Jews in the military. The aptly named movie advertisement above the boy's head simultaneously comments on his pose with his pistol while reminding contemporary viewers of antisemitism in the U.S. armed forces that formed the subject of the film. Cherry paid attention to antisemitism in New York, her sensitivity influenced by her radical politics and consciousness of her own Jewish identity.

In her photograph *Yorkville Swastika*, Cherry drew attention to the neighborhood where she took this

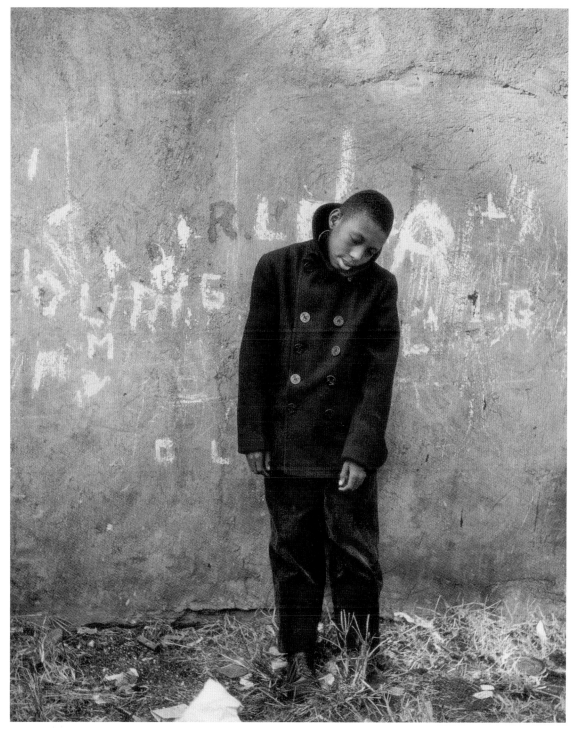

4.12 Vivian Cherry, *Game of Lynching, 1947*. This photograph conveys graphically that the boy knew about lynchings that were hangings. © Estate of Vivian Cherry. Courtesy of Daniel Cooney Fine Art.

4.13 Vivian Cherry, *Crossfire, Game of Guns 2, 1947*. The background poster of the movie *Crossfire*, a film about antisemitism, most likely spoke to Cherry as additional political commentary on a common boys' game. © Estate of Vivian Cherry. Courtesy of Daniel Cooney Fine Art.

picture for its political resonances. Yorkville was an Upper East Side section of Manhattan, known as home to many residents whose parents immigrated from various German-speaking areas of Europe. Early support for Hitler via the German American Bund flourished in the neighborhood. "One could watch brown-shirted Nazis marching down the streets of Yorkville" in the 1930s and "black-shirted Fascists meeting" in the Italian section of East Harlem. Those years saw pro-Hitler rallies and marches, as well as violence against local Jewish shop owners.[26]

Cherry's title reminded viewers that this was not a random swastika on a wall expressing antisemitism; it was specifically linked to New York Nazi sympathizers. It brought to consciousness not only the enemy the United States had defeated in the recent war but also the antisemitism that constrained the lives of Jewish New Yorkers. Antisemitism prevented them from living in certain neighborhoods, denied them job opportunities in whole industries, such as communications, and restricted their admissions to private universities and medical schools. So pervasive and widely accepted was antisemitic discrimination that *PM* "launched a campaign against hotels catering to 'restricted' or 'select' clientele—code words for

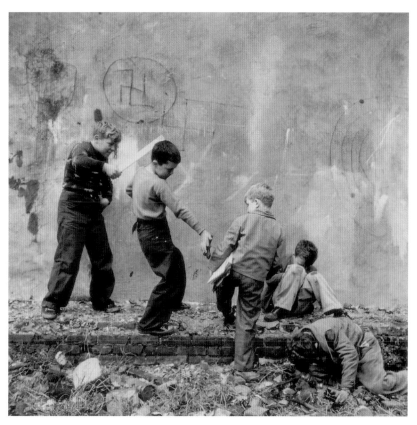

4.14 Vivian Cherry, *Yorkville Swastika, 1948*. The photograph's title draws attention to the wall behind the boys and reminds viewers of the recent horrors of World War II and the murder of six million Jews. Brooklyn Museum. Gift of Stephen Schmidt. © Estate of Vivian Cherry. Courtesy of Daniel Cooney Fine Art.

4.14a Vivian Cherry, *Yorkville Swastika, 1948*. Detail shows the boy's schoolbooks in hand.

'white Christians only'—or more precisely, against the newspapers carrying their advertisements." Under the headline "THE NEW YORK TIMES PRINTS MOST HATE ADVERTISING," it reprinted "entire pages of the offending advertisements." From the swastika in Cherry's photo, the violence cascades upon the children in descending order from boy with stick, to boy with gun, to boy with schoolwork caught off-balance, to boy sitting, until it ends with boy on his knees.[27]

Yorkville was not unfamiliar territory for Vivian Cherry. She grew up near Yorkville in East Harlem, at that time a mostly Jewish and Italian neighborhood. The family subsequently moved to Tremont Avenue in the Bronx. Like Ida Wyman, Cherry attended the all-girls Walton High School. Her mother, a piano teacher, worried that Cherry was a shy child, so she started her taking dancing lessons at age five. Cherry studied with Denishawn company and the modern dancer Helen Tamiris at her studio in Greenwich Village. Cherry's mother espoused communist politics and supported the Soviet Union; her father was a liberal. Cherry adopted her mother's politics and joined the Young Communist League. Together they attended May Day parades. When she was fourteen, her mother died. Her immigrant Jewish father, a housepainter, insisted that Cherry attend college. He loved books and would recite Russian poems. Only two colleges offered dance majors, and Cherry opted for the University of Wisconsin. But she quit after a year and at nineteen left home.[28]

Cherry found work as a dancer. She performed at two popular Manhattan night clubs, La Conga and Le Bal Tabarin, joined a carnival in upstate New York, soloed in a show at the Roxy theater, and later danced in a Broadway revival of *Show Boat*, choreographed by Tamiris. But injuries prompted her to take a break from dancing. Like Ida Wyman, she found a job as a darkroom assistant in a news photo agency. "I was walking by a printers called Underwood and Underwood, and I saw a sign saying, 'Darkroom Help Wanted!—No Experience Necessary!'" she recounted. "I remember it was the 'no experience' bit that caught my attention—I didn't know what the job would entail. At that time they were short on people to print photographs because so many men had been drafted, so I applied and got the job."[29]

Developing and printing photographs inspired Cherry to try to take pictures herself. "All day long, I was looking at these photos, and I thought 'I can do that.'" An old boyfriend gave her a used large-format camera, and she took it into the streets. A friend's father taught her the rudiments of printing. In 1947 she joined the Photo League and took classes with Sid Grossman. "But even more important was what happened after class," she recalled, "everybody going to Sid's loft, talking about photography, looking at each other's work." Those conversations helped build a shared understanding of photography and aesthetics, as well as their political implications. They extended the vision initially articulated by the New York Document.[30]

"The Photo League students take their camera anywhere," wrote the curator Beaumont Newhall in a review of a show of student work in 1948. In comparison with a similar show of work by students at the California School of Fine Arts, the New Yorkers "feel people more strongly than nature; they want to tell us about New York and some of the people who live there." Their photographs found poetry in prosaic details and lyricism in ordinary moments.[31]

Boys playing with guns did not disappear from the city's streets even a decade after the end of World War II. When William Klein returned to his hometown in the mid-fifties, the ubiquity of toy guns fascinated him. As was his wont, he instigated some drama from one gun-slinging boy. In a photograph that would subsequently become famous, he urged a kid in upper Manhattan to look tough and aim the gun right at Klein and his camera. "To my annoyance, this seems to be considered as my key image.

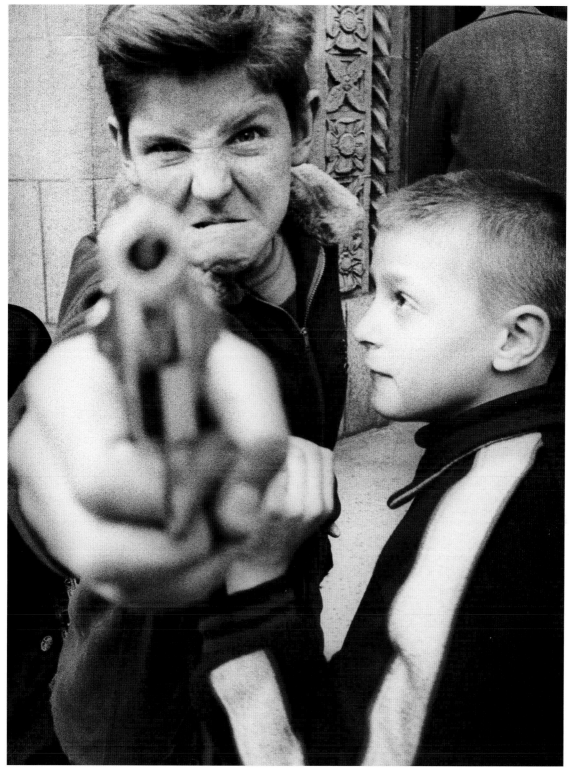

4.15 William Klein, *Gun 1, 103rd Street, New York, 1954*. Fascinated by the ubiquity of toy guns on the city's streets, Klein instigated this performance from one gun-toting boy. © William Klein.

It's been reproduced hundreds of times to illustrate . . . violence . . . what's happening to these kids . . . what is this world coming to." Klein then explains: "Well, to start with, I'm getting tired of seeing it in print and, in addition, misread. It's fake violence, a parody. I asked the boy to point the gun at me and look tough. He did, and then we both laughed, which the next frame shows." However, since the visit to New York represented a kind of homecoming to exorcise demons, he continues with his explanation, riffing on the possibilities. "Knowing this, I see it in another context. And even more, another: as a double self-portrait. I was both the street kid trying to look tough and the timid, good little boy on the right." Finally, he admits that just maybe, he really did provoke the pose: "Let's say it's an illustration of aimless violence, that setting up the photo and using it as I did, I meant it to be." Of course, Klein as a kid played Cops and Robbers; everyone did. But "we didn't shoot to kill. I forget whether or not we wanted to," he adds.[32]

On some level, Klein sought to participate with his camera. He was no disinterested observer. Unlike Leipzig or Cherry, he didn't care to record the imaginative, albeit violent, play of boys. "You shoot me, I'll shoot you," one can imagine him saying to the boy. Yet he recognized, too, that there were lots of ways to interpret guns and to photograph guns. They were omnipresent. Boys played with them everywhere. Looking back at Klein's photographs of kids playing in the street, "rather than evoking the carefree innocence of childhood," writes photo historian Lisa Hostetler, "they seem to channel a deep-seeded violent energy." But guns were only one prosthetic for New York City kids. The city itself offered many other possibilities, on the streets and sidewalks, in doorways and empty lots, not to mention commercial entertainment.[33]

Going to catch movies, even old ones, tempted children with an escape from their daily drab realities. N. Jay Jaffee photographed three children checking out a local theater in Brownsville, Brooklyn, in 1950. He used the movie's title, *Fools of Desire*, to comment on children's fascination with films, even such reruns over a decade old. In the postwar years, Brownsville, a working-class immigrant neighborhood, suffered from neglect, like the theater itself. "On rainy Saturdays when we couldn't play outside, my mother packed two salami sandwiches on rye in a wrinkled brown paper bag, and I met my friends at the Waldorf Theater on Church Avenue for a day at the movies," recalled Laura Greenberg, who grew up in neighboring East Flatbush. "Starting with the first show at ten in the morning, we watched *Movietone News*, cartoons, and the double feature. Then we watched it all over again." Leaving the theater in the late afternoon felt like returning to Brooklyn "from very far away."[34]

Greenberg's memories subtly evoke a difference between lower middle-class and working-class children. Jaffee's photograph illustrates the constraints of the latter. The three children, one wearing galoshes against the rain, peer at the photographs, most likely as a substitute for entering the theater and watching the movie. How much more distant was the city's central entertainment district, Times Square—physically, economically, and even psychologically—for children. It cost money to see first-run movies at the big, fancy theaters of Broadway. Jaffee's photograph serves as a reminder that most New Yorkers rarely made it to Times Square, despite its reputation as the premier place for going out on the town.

Times Square especially attracted out-of-towners. They found its glittering lights and crowds mesmerizing. The intersection of Broadway and Seventh Avenue with its theaters and enormous advertising signs fascinated those who saw the district as representative of the city itself. On the "Great White Way"

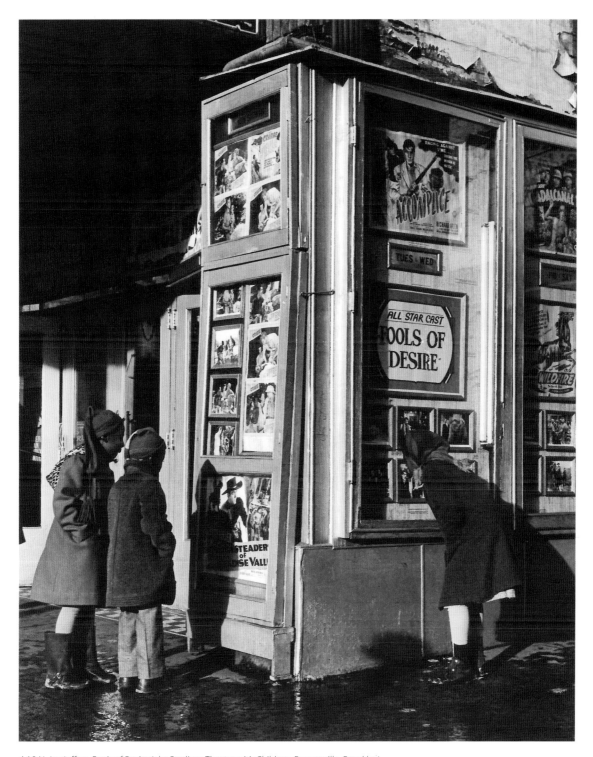

4.16 N. Jay Jaffee, *Fools of Desire (aka Stadium Theater with Children, Brownsville, Brooklyn), 1950*. At the Stadium Theater in Brownsville, Brooklyn, children peer at posters for a rerun, lured by the movies' promise of escape from the tedium of their working-class neighborhood on a rainy day. © N. Jay Jaffee. All Rights Reserved. Used by permission of the N. Jay Jaffee Trust, www.njayjaffee.com.

night turned into day and time seemed to stand still. Prior to the opening of the World's Fair in 1939, the New York Photo League had dismissed Times Square, along with endless skyscrapers, in its call for pictures of the real New York. Like the Empire State Building, Times Square represented outsiders' impressions of the city, views of New York peddled for profit by commercial firms. Yet the League did not reject centers of culture and entertainment as part of the real New York. The challenge was how to photograph Times Square honestly.[35]

Like the "nickel empire," Times Square evolved over the course of the first half of the twentieth century. Its fortunes began to rise with its new name that honored the newspaper, the *New York Times*, and its triangular-shaped building that faced the intersection of Broadway and Seventh Avenue. The decision to locate an express subway stop at 42nd Street in 1904 enhanced the square's attraction. In the years after World War I, legitimate theater, and its accompanying illegitimate vices, including gambling and prostitution, moved uptown from Herald Square. ("Give my regards to Broadway," sang George M. Cohan. "Remember me to Herald Square.") But Prohibition made roof gardens and restaurants unprofitable just as transportation helped to drive up rents in the district. Together these changes "reinforced the rise of the great movie palaces."[36]

During the 1920s extensive construction of theaters and hotels, as well as office buildings and commercial spaces, transformed the district. Jewish builders, like Irwin Chanin, played key roles in changing the character of Times Square. Chanin built six theaters between 1924 and 1927, all of them on the side streets between Broadway and Eighth Avenue, and one gigantic movie palace, "A Cathedral of Motion Pictures," the six-thousand-seat Roxy, on Broadway. These theaters facilitated the shift of legitimate playhouses from 42nd Street as they yielded to the dominance of movies along Broadway. Remembering

how much he disliked separate entrances for cheap seats in the gallery, Chanin eliminated them in his theaters. "We made a sign," he recalled. "At my theaters, the girl from the five-and-ten and the richest aristocrat in town enter by the same door. My theory is," he explained, "that people go to the theater to be happy and to forget their troubles. They can't do this if they are physically uncomfortable or mentally irritated."[37]

Although the Great Depression forced many theaters to close and froze any new development on Times Square, the thousands of incandescent lights and enormous illuminated advertising signs continued to attract enormous crowds until the blackouts of World War II. The end of the war brought new life back to Times Square. Tens of thousands celebrated victory, first over Nazi Germany and then over Japan. Many returned to enjoy a world outside of their everyday routine. By then, Times Square had achieved a central place in the nation's commercial culture that included movies and radio along with live theater. "The novelty, spontaneity, and crowds promoted by commercial districts were geared to courting impulse, inviting people to spend their time and money freely, to indulge themselves, and to condone the indulgences of others."[38]

Jewish photographers counted among the out-of-towners intrigued by Times Square. The mix of people who filled the streets coupled with the technical challenges of taking pictures at night, ablaze with artificial light, enticed them. They brought a fascination with fantasy that they sought to freeze on film, frequenting the teeming streets, night after night. Louis Faurer started commuting from Philadelphia to New York City to work in the fashion magazine industry in 1946. He did fashion assignments by day—the Garment District was located just south of 42nd Street—and prowled Times Square by night. Faurer had worked as a civilian photographer for the Signal Corps during the war. Largely self-taught, he joined

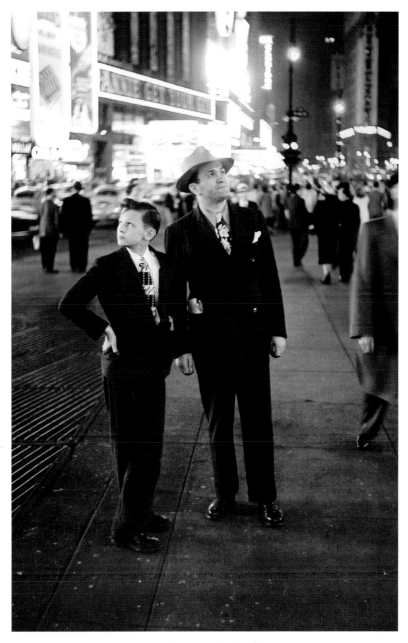

4.17 Louis Faurer, *Times Square, 1947.* The identically dressed pair present
a somewhat amusing twosome, each looking in a different direction,
taking in the sights of the Great White Way. Estate of Louis Faurer.

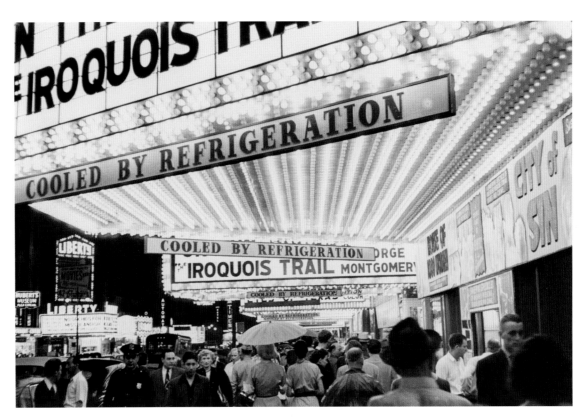

4.18 Louis Faurer, *City of Sin, 1950*. Shot beneath the marquee with its shimmering electric lights that turned night into day, the photograph radiates the pulse of Times Square with its mammoth movie palaces. Gift of Randy Kohls, 2013. The Phillips Collection, Washington, D.C. Estate of Louis Faurer.

a cluster of other Philadelphia photographers who migrated to New York to work for fashion magazines.

Unlike editors of news magazines, art editors of fashion magazines didn't particularly care about politics. Photographers appreciated the freedom that gave them. Faurer landed a position initially at *Junior Bazaar*, recruited by Lillian Bassman. There he met the photographer Robert Frank. "I photographed almost daily," Faurer said of those intense years between 1946 and 1951, "and the hypnotic dusk light led me to Times Square. Nights of photographing in that area and developing and printing in Robert Frank's darkroom became a way of life."[39]

His photographs capture the gawking the area inspired. A father and son, dressed impeccably in matching pinstripe suits, each stare in opposite directions. The father has a newspaper rolled up in his pocket, perhaps with reviews of places to go, shows to see, restaurants to patronize. The boy adopts a more nonchalant pose with which to take in the sights. Some suggest that Faurer's photos reflect a moment of "postwar euphoria"; others emphasize their visionary qualities. Curator and art historian Anne Wilkes Tucker argues that father and son "appear to be contemplating with disapproval the cost of such a gaudy display and all that it attracts." But given how they have dressed up for the occasion, scholar Jean-Christophe Agnew's observation seems more apt: "From the days of vaudeville and cabaret to the days of the movie palace and video

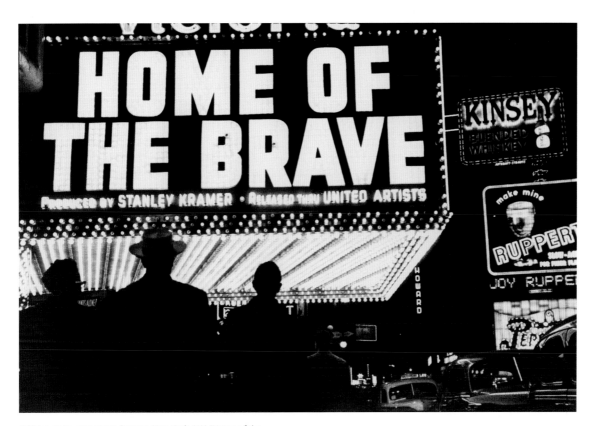

4.19 Louis Faurer, *Times Square, New York, N.Y. (Home of the Brave)*, 1950. Standing behind what appears to be a family of three approaching the theater, they materialize as a cut-paper silhouette, lurching as if drawn by some mysterious power toward the lure of *Home of the Brave*. Gift of Steve LaMantia, 2013. The Phillips Collection, Washington, D.C. Estate of Louis Faurer.

parlor, Times Square regularly changed its face in order to flatter the class authority, real or imagined, of the customers." Agnew pointed to the "convention of disingenuousness framing the theatricality of the theater district: the convention, that is, of the consumer's willing suspension of belief." When customers came for a night on the town, they purchased a fantasy, and, he notes, a right to fantasy. It was a complex negotiation, one that Faurer observed and made explicit.[40]

A photograph taken under a movie marquee, vividly illuminated with incandescent bulbs, communicates the crazy power of Times Square to transform both time and space. As someone who worked regularly in the world of commercial culture, Faurer recognized its mystique. In his photograph, the movie *City of Sin* beckons on one sign, while *The Iroquois Trail* advertises its appeal. A classic western starring George Montgomery, *The Iroquois Trail* was adapted from a James Fenimore Cooper novel, *The Last of the Mohicans*, with substantial alterations. The photograph dwarfs the people on the sidewalk beneath the lights. They form a small fragment of the image. More significant is the sign advertising "cooled by refrigeration," repeated over and over under each theater's marquee. Air conditioning tempted customers to escape both overheated apartments and steaming pavements.

"The city's postwar boom years—High Gotham—

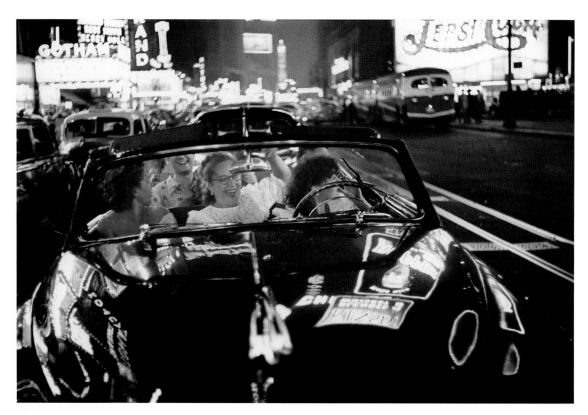

4.20 Louis Faurer, *Broadway, New York*, ca. 1949–50. The convertible's hood reflects the flashy advertising signs conveying the spirit of visiting Broadway without setting foot on pavement. Estate of Louis Faurer.

are indelibly fused to Faurer's perception of them," writes the curator Lisa Liebmann. "Hundreds of photographs confirm the depth of his infiltration. Faurer's late forties New York is a city of hotels, movie marquees, traffic, noise, jazz, fast girls, country boys, dowagers, hicks, tourists, hosiery, hats, racketeers, old-timers, circus people, and all night cafeterias." This version of New York, so vividly seen from someone who grew up in Philadelphia, differed from the local residents' view rooted in the neighborhood. Faurer captured the transience of the city. He romanced the city, but his city romance was "hard boiled."[41]

Darkness also cast menacing shadows. Another Faurer Times Square photograph emphasizes the brilliant electric lights with a somewhat more ominous character. Shot from behind three people, who appear to be contemplating the marquee, the picture conveys both drama and threat. The photograph freezes any motion, and the threesome appear transfixed by the lights. Like the movie *Crossfire*, *Home of the Brave* transposes the identity of its key protagonist. In this case, instead of a focus on antisemitism in the military, the director Stanley Kramer changed

4.21 William Klein, *Selwyn, 42nd Street, New York, 1955*. The reflective lights of the entertainments on the black car in the foreground comment wryly on the street's pedestrian action. © William Klein.

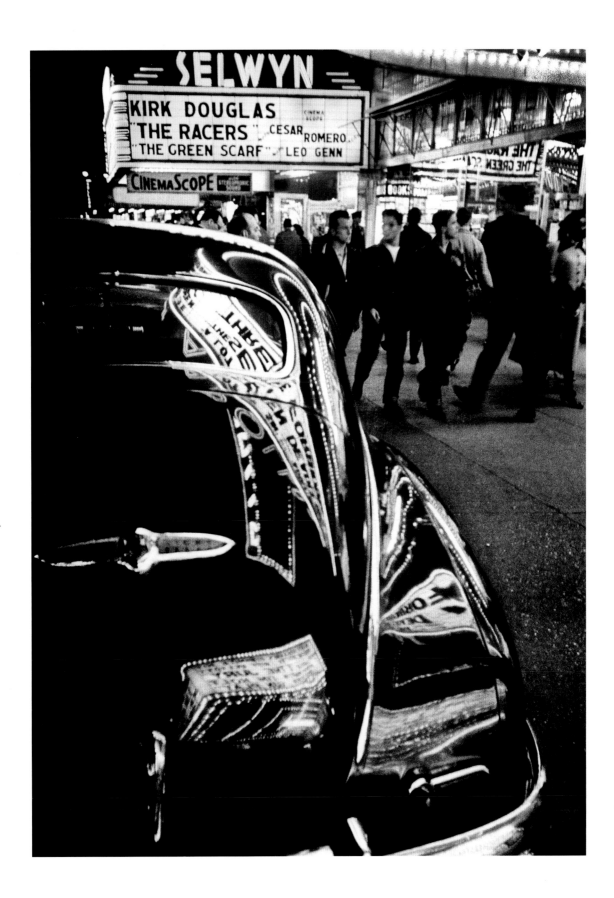

the Jewish American veteran of the Broadway play into an Black veteran. The movie, which presented a forceful case against anti-Black racism, appeared the year after President Harry Truman integrated the armed forces.

Increasingly, private automobiles clogged both Broadway and Seventh Avenue in postwar New York. Convertibles particularly appealed to young Americans, with a promise of freedom and the feel of a breeze in one's hair. On the city's streets there was less breeze perhaps but more of a chance to merge the experience of personal space with public space. Driving through Times Square allowed three young women and the man in the back seat to gaze at the crowds from the safety and distance of their seats. Faurer's exuberant photo captures not just the good times but also the wild reflections of illuminated advertising on the hood.

Times Square's iconic reputation also lured the expatriate Klein. His photograph features the shiny reflective surface of an automobile in the foreground with people and the movie marquee in the background. The street seems less crowded than in Faurer's photos. The pedestrians are definitely younger and more hip. They do not seem to be out-of-towners. They are also more male, with only one woman visible at the edge of the photograph. Few women walk on this stretch of 42nd Street. Two men in dark jackets, one in a white tee shirt, stroll by an open shop. Several other men stand with their back to the cars, surveying the sidewalk. Klein's photo emphasizes 42nd Street's midway

characteristics with all the other inexpensive amusements available.

His featured movie theater, the Selwyn, had once housed legitimate theater but switched to films in 1934 and, by 1955, was an inexpensive alternative to the movie palaces on Broadway. The Kirk Douglas movie shared a double bill with a British film, *The Green Scarf*. The marquee, *The Racers*, comments acerbically on the street's masculinity. Klein's photo exudes a more masculine aura than the earlier pictures by Faurer. As it captures the vividness of the block, it hints at a darker and seamier side to the district.

"The ability to study the insular life of neighborhoods and to observe urban spaces was what Jews, perhaps better than any other segment of the population at that time, were equipped to do." In their photographs of going out, Jewish photographers hinted at the complicated romance that pulsed through New York between the city and its denizens. Young and old, male and female, New Yorkers and out-of-towners gravitated to urban spaces that enticed with promises of escape. Children made do with shabby streets and empty lots, but adult fantasies required more complex prostheses. Commercial culture—high- and low- and middlebrow—stepped up with a panoply of offerings. And Jewish photographers sampled the people's choices, picturing their complicated relationships with urban culture and each other.[42]

5. Waiting

In 1947 Esther Bubley, a young photojournalist, took a bus trip on assignment from Standard Oil. This was not the first time Bubley had taken such a trip as a photographer. Four years earlier she had embarked on a similar journey across the upper South on behalf of Roy Stryker's photography division in the Office of War Information (OWI). Known for supervising the massive Farm Security Administration photography project that documented the devastating impact of the Great Depression, Stryker had pivoted once the United States entered World War II. He moved his photography division to OWI with a mandate to capture the home front of a nation at war. Like many other Americans, Bubley did not know how to drive. She traveled by bus and train. Her situation as a young woman who didn't know how to drive, so different from other, mostly male photographers with whom he worked, spurred Stryker to suggest she document a bus trip. A six-week bus trip seemed a promising way to portray how ordinary Americans—men and women, Black and white, families and servicemen—were traveling across the United States. Bubley's photos captured the experience not just of riding the bus but also of waiting in the terminals.[1]

Stryker subsequently left the OWI for a position with Standard Oil after his unit was attacked and dismantled by Republicans in Congress on the grounds that it contained too many leftist photographers. At Standard Oil, he shifted gears and headed up a massive photography project to promote the significance of oil in the life of the nation. His goal aimed to change Standard Oil's robber-baron and war-profiteering reputation. When he invited Bubley to join the project, she accepted. In late 1943 she moved to New York City and started to work. On her second, postwar bus trip she crossed the Hudson River heading ultimately to Texas, the heart of America's oil country. But she started at the Greyhound Bus Terminal on 34th Street between Seventh and Eighth Avenues in New York City.[2]

Berenice Abbott's photograph of the terminal, located across the street from the more imposing Pennsylvania Station, shows its relatively modest size, with long-distance buses lined up at the bays. Designed by the theater architect Thomas Lamb, the two-story art moderne building was "a swing-era reproach to the fusty grandeur of Penn Station across the street," architectural critic Christopher Gray observed. "Lamb put a showy rounded

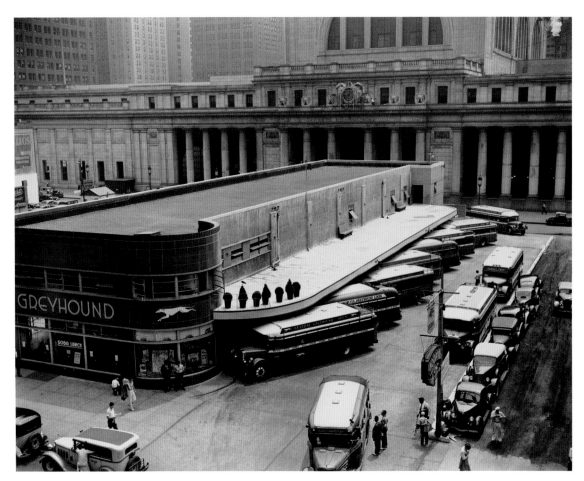

5.1 Berenice Abbott, *Greyhound Bus Terminal, New York City,*
July 14, 1936. Abbott's photograph from above looking south
presents the bus terminal as it stretched between 34th
and 33rd Streets, just across the street from the far more
imposing Pennsylvania Station train terminal. Berenice Abbott
(1898–1991) for Federal Art Project. Museum of the City of New
York, 40.140.132.

corner on the busy 34th Street side and faced the
entire front with enameled steel panels in glossy
blue, the company's trademark color since the
1920s."[3]

Bubley began her trip photographing in the wait-
ing room of the Greyhound Bus Terminal. Waiting
rooms, as historian Helmut Puff observes, "force
us to reflect on conjoined categories. After all, the

waiting room is itself a hybrid: a room where space
and time inform our historical imagination." The bus
terminal contained key elements that organized its
well-lit space: long wooden benches, rows of metal
lockers, kiosks with bus schedules, an accurate
wall clock, discreetly located restrooms, facilities
to purchase food and items for a trip, and ticket
counters. Although Bubley focused on the people,
her photographs also portray the spaces of waiting:
the shared seating back-to-back, the metal arm rests
that divided the wooden benches (in part to discour-
age sleeping in a comfortable position), the lighting

from windows and doors that allowed passengers to notice when their bus pulled into its bay.[4]

Although by 1947 vagrants, delinquents, and petty criminals haunted the bus station waiting room especially at night, Bubley pictured the travelers: the men, women, and children waiting for their buses. Her photographs convey one of the quintessential dimensions of urban life. Waiting somewhere for something to happen—a bus, a friend, a train, an appointment—characterized the city. While waiting, people did all sorts of things to pass the time. Bubley's waiting room photographs depict that reality. They picture time, frozen not just by the camera but also in the postures of the people. Waiting among strangers, New Yorkers arranged themselves to be or not to be noticed. Worried, lest they miss an appointment, interview, or rendezvous, periodically they checked the clock. While waiting, most noticed every stirring of arrivals or departures. These are positions people took in public space, aware of others around them but also doing their best to ignore them. Waiting helped to structure urban spaces.

Photographers practiced the art of waiting as well, hanging out in anticipation that something would happen. "Integral to the art of photography is seeing the image in your mind before it is actually in front of you. What you photograph is the world conforming to your 'mind's eye,' not the other way around." Thus their photos of their fellow New Yorkers waiting present images of pregnant moments filled with motionlessness. This chapter, too, pauses to ponder those years bracketing World War II when the city itself seemed poised in anticipation of changes worth waiting for.[5]

In her photo of two men sitting back-to-back, Bubley deftly depicts class differences. Both fellows are reading newspapers. Reading is a good way to spend time until something else happens (presumably until their bus arrives). Each man appears equally engrossed in his paper and unaware of the photographer. There is a symmetry and stillness to their waiting. Although both wear hats, as was considered proper for men in the 1940s, their clothing and the papers that they read subtly announce their differences. The man on the left, in a fedora and overcoat, reads the *New York Herald Tribune*, a middle-class newspaper. The working-class chap on the right wears a cap and rough jacket but no glasses. He reads a tabloid, the type of newspaper aimed at working-class readers.

Perhaps it's doubly presumptuous to imagine that these gentlemen are regulars, weary yet free from imminent imperatives. But seeing and being seen are not passive activities, as it were. Consider seeing: Bubley's subjects and objects came together as she stalked, took, and exposed this photo. Humans are blind to their eye's constant saccadic twitching, but vision depends on eyes and brains stalking, exposing, and assembling images. This is as true for the passive viewer of pictures as for the active photographer. The photographer Jason Francisco contemplated the paradoxical character of photographs: "a photograph is an image that both severs time and prolongs our sense of it, narrows our perception of space in order to extend our imagination of it, presents causes isolated from effects and effects isolated from causes, solicits explanations and stories to explain what it shows—often quite divergent and incongruous accounts—but certifies none of them." A photo resembles a half-done crossword puzzle. Viewers need to fill in the blanks: empty looks, compromised looks, storylines staring one in the face, like those metal lockers stuffed with cash, a ticking bomb, or both . . . tomorrow's headlines. Each one is linked to an individual who has boxed in their belongings, much like the people waiting in this room are "boxed up." Time to go.[6]

"Of any photographic picture we naturally ask what it gives us to see, what it shows to us," writes the scholar of photography Alan Trachtenberg.

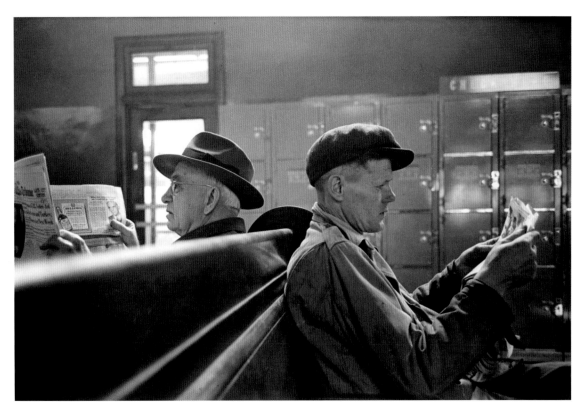

5.2 Esther Bubley, *Greyhound Bus Terminal, New York City,
1947*. Reading a newspaper helped to pass the time as New
Yorkers waited for public transportation, such as an intercity
bus. Standard Oil (New Jersey) Collection, SONJ 49540 M-20,
Archives & Special Collections, University of Louisville, https://
digital.library.louisville.edu/cdm/singleitem/collection/sonj
/id/710/rec/1.

"Ultimately we want to understand the picture as an
act of knowledge, a *knowing*. To say what a photo-
graph *shows* is the simple part; to articulate what it
knows or means is something else." Bubley's photo-
graphs of people waiting depict them in those liminal
moments before action. They also meditate on that
state of being suspended in time. "Whoever makes
us wait celebrates his power over our lives," writes
the journalist Andrea Köhler, "and what's especially
threatening about it is that we can never be sure that
we aren't made to wait for precisely this reason."

The frantic pace of urban life demanded synchroni-
zation from millions of individuals. That translated
into waiting. Puff argues, "for the individual, waiting
can be said to be a temporally bounded condition in
which time becomes experiential."[7]

Consider Bubley's photographs of couples in the
context of the experience of killing time. In one, a
young man, his suitcase at his feet, listens attentively
to an older woman who leans toward him with a
measure of familiarity. Her expression suggests her
pleasure in his company. Light from a window dances
across her face. In the background loiter the metal
lockers. On either side of the twosome sit newspaper
readers. The *New York Post* tabloid headline, "Dewey
Considers Probing City," speaks of a moment in 1947
when the Republican governor of New York was at

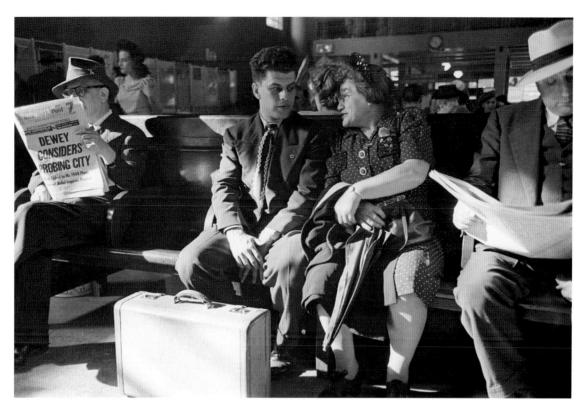

5.3 Esther Bubley, *Greyhound Bus Terminal, New York City, 1947*. Bubley captured the intimacy of their conversation before a bus trip would likely take the young man far away. The accoutrements of the bus terminal interior situate the pair. Standard Oil (New Jersey) Collection, SONJ 49532 M-18, Archives & Special Collections, University of Louisville, https://digital.library.louisville.edu/cdm/singleitem/collection/sonj/id/715/rec/1.

odds with the Democratic and radical left-wing city. Before he became governor, Thomas Dewey made his reputation in the city as a successful prosecutor, putting Jewish and Italian gangsters in prison.

Another of Bubley's photographs of a pair catches two elegantly dressed young Black men in postures that bespeak their comfort in the bus station waiting room as well as an element of public display of ease. This time Bubley's photo records more information surrounding the two men, including a kiosk with bus schedules. It is early afternoon. Both men wear suits and fedoras, but one man has pushed his hat back on his head. The casual gesture complements the man's relaxed position, leaning backward, as well as the dark shirt he has chosen to wear under the suit. Together they suggest a measure of cool style that contrasts with the more formal posture and well-coordinated dress of his interlocutor. His upright posture, with one hand on his hip, conveys authority. Perhaps he is lecturing the other man or giving advice. Bubley's photograph documents the bus terminal's integrated character, unlike the situation in the segregated South. It reminds viewers that photographs can "turn out to be more substantial than one might have thought, being for students of a community's ritual idiom something like what a written text is for students of its spoken language."[8]

"From the vantage point of society," writes Puff, "waiting coordinates social interactions." It also offers

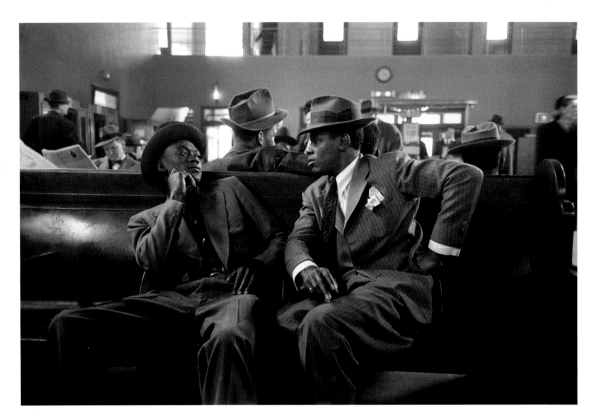

5.4 Esther Bubley, *Greyhound Bus Terminal, New York City, 1947.*
Two well-dressed African American men discuss matters in the
waiting room. Standard Oil (New Jersey) Collection, SONJ 47298
M-14, Archives & Special Collections, University of Louisville,
https://digital.library.louisville.edu/cdm/singleitem/collection
/sonj/id/543/rec/1.

opportunities to experience encounters set apart
from routine. As Erving Goffman observes, "body
idioms" of shared conventions enable city dwellers
"to make sense of one another," in the sociologist Ea-
monn Carrabine's paraphrase. Goffman, he argues,
points to such items as "clothing, comportment,
physical gestures, facial expressions," as distin-
guished from body language. "The information com-
municated in this way lacks the symbolic complexity
of spoken or written language," writes Carrabine.
"Yet the significance of non-verbal communication in
any social encounter is that it never ceases."[9]

Esther Bubley came to New York City from the
Midwest. Her Jewish immigrant parents, Louis and
Ida Bubley, moved the family around from Minnesota

to Wisconsin to upstate New York before settling in
Superior, Wisconsin, in 1931. There Louis opened
an auto tire business while Ida ran a grocery store.
Esther Bubley was ten when the family arrived in
Superior; she attended high school there, graduating
at sixteen. It was not an easy place to be Jewish. The
town's white majority isolated and disdained the
small Jewish minority. Bubley and her three older
sisters excelled academically, a potential path out of
Superior. While she was still in high school in 1936,
the large-format picture weekly *Life* magazine first
appeared. It entranced her. She wanted her high
school yearbook's photos "to be more like" those in
Life.[10]

Bubley gained familiarity with cameras through
itinerant work to contribute to the household econ-
omy, going around Superior to take pictures of chil-
dren, developing and printing them, and then selling
them to parents. With her younger brother, Stanley,

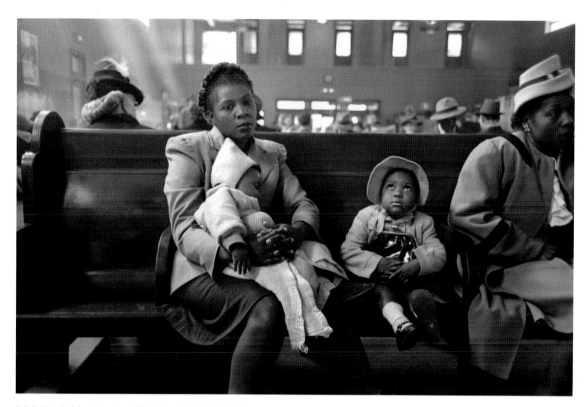

5.5 Esther Bubley, *Greyhound Bus Terminal, New York City, 1947.* The tedium of waiting registers on the young woman's face, although her oldest girl seems quite excited about the upcoming trip, taking in everything that is happening in the bus terminal. Standard Oil (New Jersey) Collection, SONJ 49548 M-19, Archives & Special Collections, University of Louisville, https://digital.library.louisville.edu/cdm/singleitem/collection/sonj/id/534/rec/1.

she set up a darkroom in the basement of their house. Bubley won a scholarship to study photography at the Minneapolis School of Art and completed her studies in 1941. By the time she arrived in New York City, Bubley had joined several documentary photographers whom she admired, part of Stryker's circle. She possessed a strong sense of what she wanted to do as a photographer. Although invited to join the New York Photo League by Sol Libsohn, who also participated in Stryker's Standard Oil project, she demurred.[11]

Bubley photographed people unawares as well as with their implicit acknowledgment, as in a picture of a young mother and her two daughters. One sleeps on her lap and the other looks upward, taking in the action of the waiting room. Her small shiny black pocketbook conveys her responsible position as the older sister. Her self-composed expression of wonder contrasts with that of her mother, who glances downward and appears weary even before the bus ride has started. To the little girl's left sits an older woman, perhaps her grandmother, perhaps unrelated. She, too, is dressed elegantly for the bus trip. A row of high windows illuminates the room while light pours into the space from above. Bubley's photographs make evident how "waiting represents not a stasis, but a relational dynamic." They suggest, as the literary scholar David Caron has argued, how "in the act of waiting—for something yet to come—the present moment becomes defined by, indeed saturated with the future."[12]

One didn't need to plan a trip to find New Yorkers waiting. For the price of a cup of coffee, the city's many cafeterias, diners, and lunchrooms provided

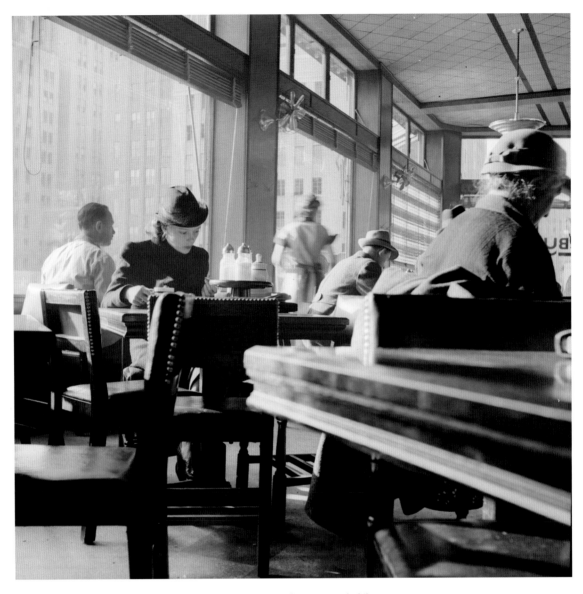

5.6 Sol Libsohn, *Cafeteria*, 1938. Cafeterias offered New Yorkers a place to sit and while away the time for the cost of a cup of coffee. Libsohn's photo suggests how pleasant this means of waiting could be. Sol Libsohn (1914–2001) for Federal Art Project. Museum of the City of New York. 43.131.6.47. Sol Libsohn (1914–2001)/Museum of the City of New York.

a chance to linger. These prosaic spaces were "the temporal poetics of the everyday. From this vantage point, waiting is one mode among others of how humans become aware of living in time as well as of who they are." The Great Depression spurred the growth of self-service restaurants. These well-lit, heated rooms could be found in downtown and midtown Manhattan, where they catered to white-collar workers on lunch or coffee breaks.[13]

A sense of aloneness pervades their public space. Each table comes with its own assortment of condiments. There are no waiters, standing around poised attentively to serve. The customers are on their own, serving themselves. Sol Libsohn's photograph of a cafeteria in midtown summons up the space and mood of New York's cafeterias. Patrons, both men and women, sit at separate tables. The large plate glass windows with the shades rolled up let light flood the room. Massive multistory office buildings can be glimpsed outside across the street. Libsohn's vantage point appears to be from one of the tables in the foreground, out of focus. His camera catches an elegant woman who sits alone, looking down. Perhaps she is reading.

Cafeterias also flourished in working-class residential neighborhoods, like the Brownsville section of Brooklyn, where Jewish immigrants patronized them throughout the day. The socialist literary critic Irving Howe, who grew up in the Bronx, recalled frequenting "cafeterias in which the older comrades, those who had jobs or were on WPA, bought coffee while the rest of us filled the chairs." By the 1930s, cafeterias were woven into the fabric of Jewish neighborhood life in New York City, welcome alternatives for socializing to cramped apartments, street corners, or candy stores. As Howe admitted, "the thought of bringing my friends home was inconceivable, for I would have been as ashamed to show them to my parents as to show my parents to them."[14]

When she settled in New York, Esther Bubley discovered cafeterias and took photographs inside them. Her close portrait of a man sitting against the wall with a coffee cup and spoon at a table conveys the solitariness of waiting, the heaviness of time. His frown and furrowed brow contrasts with Howe's memories that invoked a convivial gathering place. Self-service cafeterias initially gained their appeal from the speed and cheapness with which white-collar workers could grab a meal. But by the postwar period, New York City cafeterias had transformed into spaces where people could also hang out and kill time. This man has unbuttoned his overcoat but beyond that gesture does not appear to have made himself too comfortable. He is suspended in time's thickness. There is, as Caron observes, "a strangerliness at the core of the self" when the future "constitutes the present's only true other." Bubley took the photograph, but the man does not appear to have noticed her. He is lost in his thoughts.[15]

The tension of waiting disappears in an image by Rebecca Lepkoff of a man sitting among empty tables at a Greek café. From the relaxed posture of his hands resting on the table and the back of his chair, he does not appear anxious or eager for anyone to walk through the door. Rather, he is in repose, passing the time. He might be watching the animated street life outside the café window, flitting by like thoughts in one's head. "In the best case, waiting is a gift of time; more often than not," Köhler writes, "it's simply time lost—always, however, it makes time itself palpable," as does Lepkoff's photograph.[16]

Her image suggests an inner state of mind, suspended between inside and outside. The plate glass sends reflections onto a framed picture hanging above the man's head. A handful of Greek letters painted on the café's exterior window reappear inside on the picture, creating a disjointed modernist image. These bouncing reflections compress outside and inside and metaphorically register what the

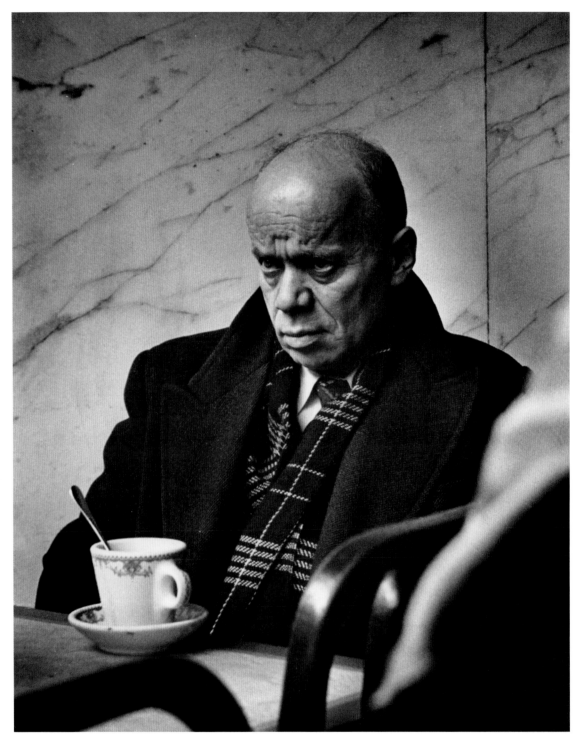

5.7 Esther Bubley, *Automat, New York City, 1948*. Cafeterias could also be soli-
tary places where one could retreat into one's own thoughts. © Esther Bubley.

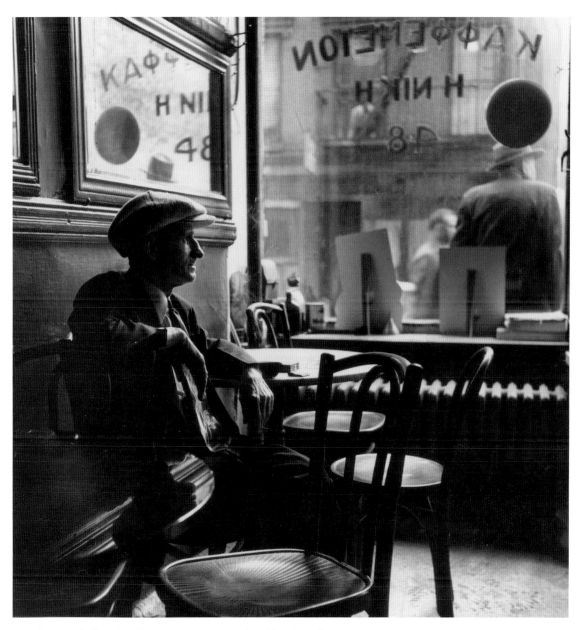

5.8 Rebecca Lepkoff, *Greek Café, 1948*. The man sits comfortably in the café, gazing out the large plate glass window at the quiet street. The mood is far more intimate than the cafeteria. Rebecca Lepkoff Photograph Collection, New-York Historical Society. © Estate of Rebecca Lepkoff. Courtesy of Howard Greenberg Gallery, New York.

figure sitting in the café may be pondering. The city itself is on display—both the movement and motionlessness on the block, including a stationary man standing with his back to the window and a person leaning out of a second-story window across the street. The photograph presents a city that is simultaneously visible, obscured, and fragmented. Inside, Lepkoff gazes at man, café, chairs, radiator, and street, how they compose themselves into a mirror of one of the city's many ethnic worlds. Its intimacy is a far cry from the shiny surfaces of a midtown cafeteria. Yet both speak to the city's rhythms and how its residents experience time.

Most New Yorkers waited standing up, not sitting down, outside on the street, not inside a comfortable room. The city's streets resembled a social arena, much like a café or waiting room, in contrast to observers' assumptions of the city's frenetic pace of constant movement. Photographers noticed how waiting punctuated city dwellers' daily routines. Waiting for a bus or train, working-class New Yorkers stood still. Their posture adapted to the city's architecture: its lampposts and bus signs, railings and doorframes. Waiting could occur alone or together. Children learned to wait, and watch. Adults waited with consciousness of what might happen, even as they took a break from the day's tasks. Streets were not spaces to daydream. They required a steady measure of vigilance, or at least conscious observation. Women, especially, understood that as they waited, they were often under observation, especially by men. Catcalls and whistles reminded them. "Mainstream American discourse," the historian Molly Miller Brookfield observes, "deemed behaviors like ogling or catcalling as the 'right' of white, middle-class, heterosexual men by the mid-twentieth century."[17]

Waiting with the right demeanor epitomized what it meant to be a New Yorker, streetwise and savvy, able to navigate the shifting demands of urban living, attuned to the city's dangers and possibilities. Louis Stettner titled one photograph *Soul of New York*. He drew the attention of a young Black man, impeccably dressed in a suit, tie, and fedora, leaning casually against a lamppost. He is standing a block away from Madison Square Park on the corner of the crosstown street that runs along the park's southern border. The photograph is filled with the city's distinctive street furniture: metal wastebasket, bus sign, mailbox at the corner. A bus has just pulled away from the bus stop, but the man, hands in his pockets, shows no sign of regret at missing it. He is surveying the street and returns Stettner's gaze.

Stettner's title speaks to his impression of what made New York distinctive. He had just returned from five years in Paris, which sharpened his observation of the differences between these cultural capitals. Prior to World War II, New York City "emblematized the future to Americans but even more to observers from overseas who regarded it as a pure expression of forces of modernity glimpsed only partially in European cities," writes art historian Rebecca Zurier. These years of enormous technological development transformed the skyline of New York, but also registered peak immigration from abroad and from the rural South, "which wrought great social transformations. As a magnet for adventurous artists and writers, as well as for millions of other migrants, New York inspired imagery nearly as diverse as its population." Stettner's photograph participates in that image-making, presenting a dapper young Black man as the epitome of New York City.[18]

Stettner grew up in Flatbush, Brooklyn, a prosperous, mostly Jewish neighborhood, and received his

5.9 Louis Stettner, *Soul of New York, 1951–1952*. The man exudes a posture of cool confidence that epitomizes a New Yorker, standing on the corner of 23rd Street and Park Avenue. © Louis Stettner Estate, 2021.

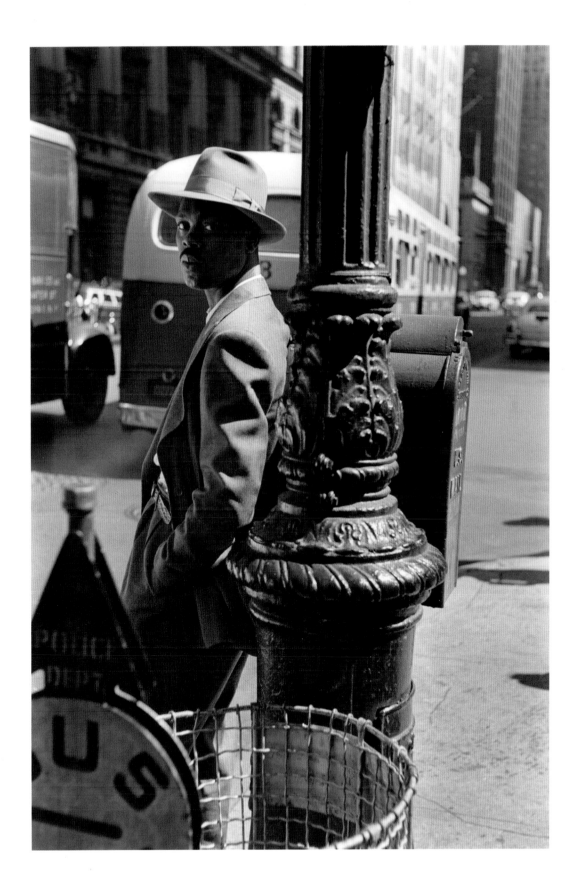

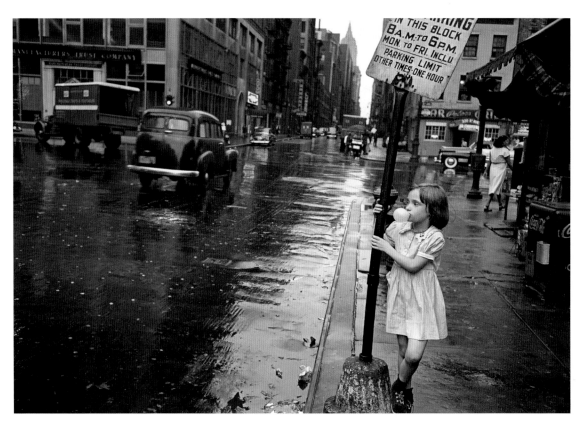

5.10 Vivian Cherry, *Antoinette, c. 1948*. Cherry chose this young girl to feature in a story about city children who would get an opportunity to attend camp in the summer. The photo suggests the ennui of hanging out on city streets. © Estate of Vivian Cherry. Courtesy of Daniel Cooney Fine Art.

first camera as a present from his parents at the bar mitzvah age of thirteen. As a teenager, he regularly frequented the Metropolitan Museum of Art, where he educated himself in photography by reading back issues of Stieglitz's magazine, *Camera Work*. Like Engel, he attended Abraham Lincoln High School and discovered the Photo League in his late teens. Unlike Engel, he knew his father and worked in his furniture store to help pay for his camera equipment. One of four boys, with a twin brother, Stettner's interest in photography was encouraged by his parents. He also took advantage of opportunities to meet other photographers, including Stieglitz, to

expand his knowledge of photography. After serving in the army as a combat photographer in the Pacific theater, he returned to the League and studied with Sid Grossman. Stettner briefly taught at the League before leaving for Paris in 1947, where he studied photography.[19]

"The League taught me that no matter how original and talented the photographer's vision might be, the ultimate success of the photograph was mutually dependent on the photographer and world of reality around him," he later reflected. "If my photographs have always been embedded in daily life, with the emphasis on what is called the 'common man,' it is because my early formative years were deeply politicized by world events." Growing up, Stettner adopted a radical point of view, "with

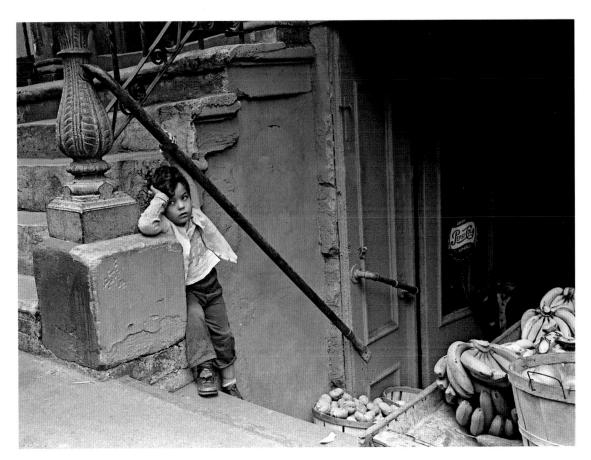

5.11 Vivian Cherry, *Boy on Stairs by Bananas*, ca. 1948. Despite his age, this young boy seems responsible for keeping an eye on the fruits and vegetables, waiting for a customer to come. © Estate of Vivian Cherry. Courtesy of Daniel Cooney Fine Art.

the rise of totalitarianism and what was part of a hurried transformation of the average citizen into a soldier." Military service gave him a new appreciation for diverse Americans, especially working people. But left-wing politics encouraged him to see Black Americans as exemplifying the true spirit, the soul, of New York City.[20]

Photographs of men, women, or children waiting could permeate the topography of the city's streets with emotion. Vivian Cherry's photograph of a young girl blowing a big bubble situates her resting posture in the context of the sidewalks of New York. She is

standing on one leg, holding on to a slightly bent parking sign. Behind her the Empire State Building identifies the city. Both streets and sidewalks appear wet, probably from rain. Cherry took the photograph as part of a story on a summer camp for working-class New York kids. She chose the child she wanted to profile. Both Cherry's and Stettner's photographs portray the various affects that "*inflect* waiting— patience, impatience, excitement, hope, dread, anxiety, trepidation, resignation, equanimity."[21]

Waiting could just be tiresome. Cherry snapped a very different type of portrait of a young boy, head on hand, his elbow leaning on the concrete pediment of a brownstone staircase. Unmoving, he apparently has nothing better to do than to stand around on

some steps slightly below street level. The open door with its large Pepsi sign suggests that this is a fruit and vegetable store, located in the basement. Another young boy stands in the doorway. The owner has placed some of his merchandise on the street level to entice customers. Is the boy responsible for keeping an eye on the food, ready to call an adult when a customer appears? Whatever he is waiting for, it does not animate him. The boy seems bored.

As they waited, New Yorkers responded to the city's architecture, subtly changing its meaning. In one case, a woman stands by an open door leading to the elevated platform. She is waiting for the train, looking at something off camera. Her profile transforms the glass awning overhead as well as the well-worn wooden door with its shattered glass panel. PUSH, the door announces, although its open position belies the command. Lepkoff's photograph is divided symmetrically, with the edge of the door running through the middle of the frame. The woman's presence disrupts that symmetry. By the end of World War II, only the Third Avenue El remained. The others—on Second, Sixth, and Ninth Avenues—could not compete with subway lines for passengers. The city tore down the last elevated tracks on Third Avenue in 1955.[22]

Although the el's metal beams, glass panels, and wooden doors intrigued photographers, they also pictured the dynamic of waiting in conjunction with the city's more prosaic architecture. Young men and women unconsciously arrayed themselves in postures of lounging against urban backdrops that transformed into a kind of mural. In Lepkoff's photograph of a girl standing on one foot as she leans against a building, fashion seems to collaborate with concrete, brick, metal, and wood. The girl's clothes—a dark sweater with white stripes—echo the physical attributes of the buildings and bring beauty to their ordinariness. The horizontal white stripes of the girl's cardigan visually echo the striped shadows of the fire escape: something to catch a photographer's eye. Both sets of stripes disrupt the patterned rectangular building façade, complicating the scene as a piece of graphic design. The shadows of the fire escape stairs create a modernist image, while the rectangle of a raised metal ramp evokes the girl's posture.

In the photograph, Lepkoff captures a moment of nonchalance, albeit one where the girl is glancing sideways. The girl has placed her hands in her pants pockets where they are not being used, a stance of openness and potential vulnerability. She stands on one foot, leaning against a white façade; her body reflects her comfort on the street. She could, in fact, be Lepkoff herself when she was young, though her neat cardigan sweater, crisp white collar, and clean pants do not suggest poverty. Her pants also suggest that this is not a school day, since both public and parochial schools required girls to wear skirts. The girl's face is in shadow, but her body catches the sunlight. Like Lepkoff, she too is watching the street, observing something off camera. It is an ordinary street scene, one easy to overlook. Lepkoff notices, and her photograph invites viewers to stare at one who is also staring. On the closed factory door within its vertical rectangles, girls (to judge from the neat, ornamented handwriting) have repeatedly scribbled "Mother" in chalk. Words are the city's own commentary.

Many years later, Lepkoff remembered waiting patiently across from the fire escape for a boy or girl to come and stand beneath it. At the time she was taking a class with Grossman and had to produce new work each week. She liked the light and different shadows; the girl's sweater and posture gave Lepkoff the photo she desired. The garage door with its repeated chalk graffiti of "Mother" signals that others have spent time at this spot. What did these young people do? Perhaps they were merely hanging out, finding a temporary spot for solitude in the city.[23]

Among the seemingly perpetual motion of Times Square, it was more challenging to catch individuals

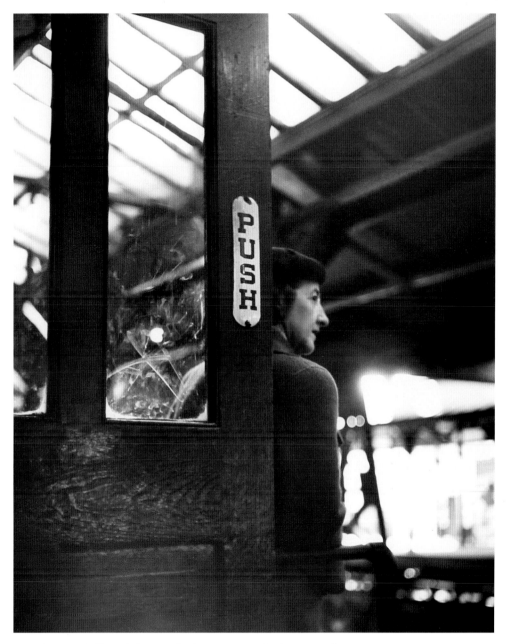

5.12 Rebecca Lepkoff, Untitled (woman by door), ca. 1947–48. When New Yorkers waited for an elevated train, they often aligned themselves with the platform's physical structures, creating a kind of urban frieze. © Estate of Rebecca Lepkoff. Courtesy of Howard Greenberg Gallery, New York.

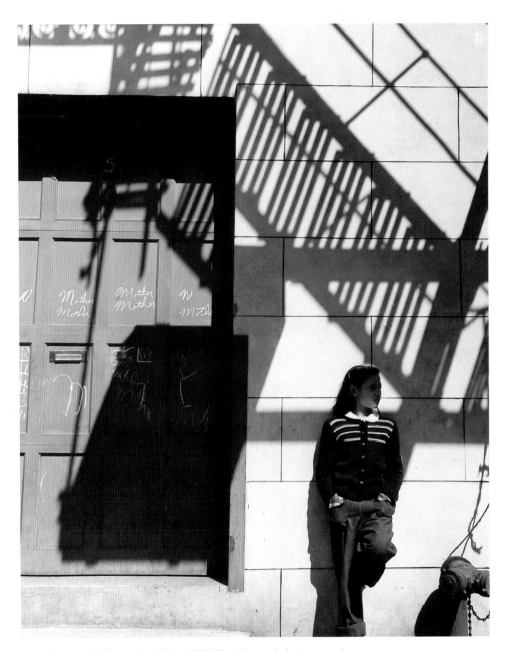

5.13 Rebecca Lepkoff, *Lower East Side*, ca. 1950. The girl's nonchalant pose and her striped sweater echo the architecture of the building's fire escape, letting her blend into the streetscape. © Estate of Rebecca Lepkoff. Courtesy of Howard Greenberg Gallery, New York.

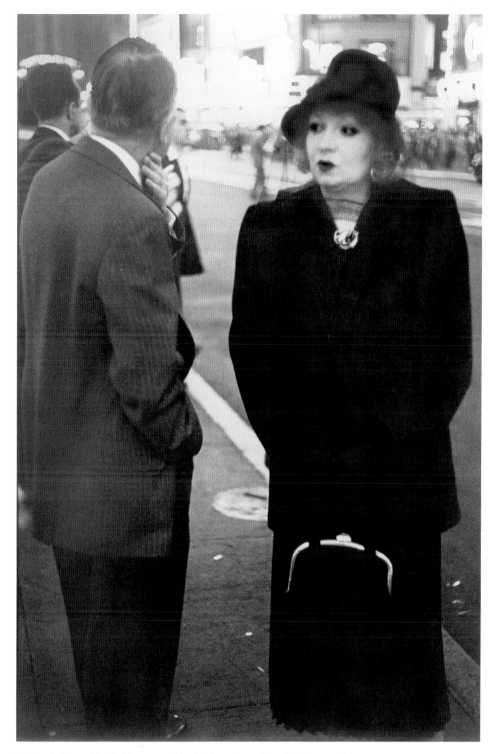

5.14 Louis Faurer, Untitled (woman waiting in Times Square), ca. 1950. Impeccably at-
tired for an evening at the theater, this woman stands still in the middle of the swirling
chaos of Times Square, clutching her purse and waiting. Estate of Louis Faurer.

caught in time, standing still, and picture them in relation to the urban milieu. In his photographs, Faurer conveyed not only the pace of the Great White Way but also the singular experiences of men and women.

In his photograph of a woman at an in-between moment, Faurer notices her aloneness among others. Her pale face, heightened by white makeup, her shiny brooch, and her black pocketbook with its silvery curved top grabbed his attention. "Any reflective surface, from car fenders to shop windows, drew him like a magnet," observed curator Lisa Liebmann. "Faurer's ability to use light as a plastic, formal substance, is probably unsurpassed. He found it everywhere, at any time." In Times Square the white lights of the theaters backlight the woman; the white painted line on the street helps to connect her to the man standing next to her, facing the other direction. It is possible that she isn't actually waiting alone. Perhaps the man, who appears to scan the street she can't see, is also looking for someone. But in Faurer's photograph, she stands as a silent witness, patiently pondering, perhaps the past, perhaps something yet to come.[24]

Unlike Faurer, Sonia Handelman Meyer grew up in New York City, the youngest child of a family of five daughters. With her father not always present, her mother moved from Manhattan to Queens. Handelman Meyer attended Bryant High School and then was a member of the first graduating class of the newly opened Queens College. Although her sister gave her a camera upon graduation from high school, she only discovered the New York Photo League during World War II. She had met Lou Stoumen in Puerto Rico, where he was a staff photographer for the National Youth Administration, and she was working for the OWI. He encouraged her, when she returned to New York, to check out the League. Handelman Meyer followed his advice and took a beginner's course with John Ebstel. After the war when the men returned, she studied with Sid Grossman and became as passionate about photography as he was. She purchased a used Rolleicord and traveled around the city, taking photographs that grabbed her eye.[25]

Men commandeered sections of streets, something Rosenblum noticed in his photograph of *Chick's Candy Store*. A corner United Cigar store offered another convenient place to wait, read the paper, or just hang out and watch the scene. Reading a newspaper in public was a way to pass the time in between activities. Handelman Meyer took two photos of the same situation. In one, a man stands smoking a cigar, an appropriate advertisement for the cigar store. He has placed his hands behind his back, a common male gesture that simultaneously reveals openness and disguise. Who knows what is in his hands? Behind him a poster of a young well-groomed man smoking a cigarette advertises Chesterfields, a kind of sly comment on the cigar-smoking fellow. In the doorway another man, only partially visible, reads a tabloid while around the corner a third man examines items for sale through the window.

United Pipe and Cigar, a chain, had stores around the city. In addition to cigars and cigarettes, pipes and tobacco, its stores sold other merchandise such as lighters and razors. United Cigar did its best to secure a street corner for its shops. Handelman Meyer's second photograph, taken from the corner angle, shows why such a location was considered ideal: it grabbed potential customers from both directions. The second photograph reveals the open door and a glimpse into the rather dimly lit interior. These stores were masculine spaces in the city, although women also smoked. The men standing around reading the newspaper give the impression that they are guarding the shop. A woman would have had to pass by them to enter.

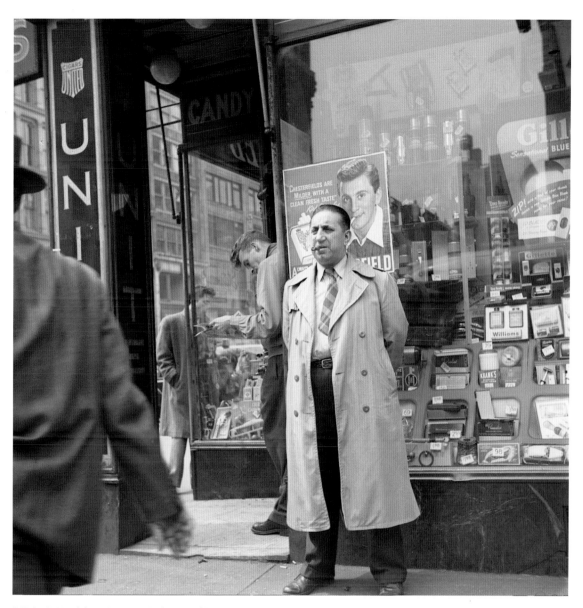

5.15 Sonia Handelman Meyer, *United Pipe and Cigar Store #2*, ca. 1946–53. The men standing around this ubiquitous chain of cigar stores in New York exude a kind of proprietary posture, as if claiming the store and the sidewalk around it as masculine spaces. Sonia Handelman Meyer. © Joseph T. Meyer.

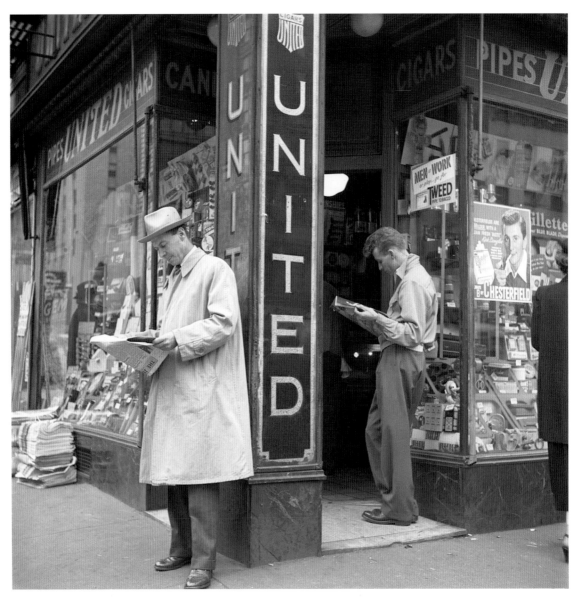

5.16 Sonia Handelman Meyer, *United Pipe and Cigar Store*, ca. 1946–53. Here the advantages of a corner location can be seen, attracting passersby from both sides. Sonia Handelman Meyer. © Joseph T. Meyer.

The mix of men standing in front of the cigar store points to the fact that New Yorkers did not always wait alone. Others similarly paused with them in the same spot. Waiting could also be a collective experience, which changed its character. One warm summer day Handelman Meyer walked by the Hebrew Immigrant Aid Society (HIAS) located on Lafayette Street in the former Astor Library. (The area was still considered part of the Lower East Side, although by the 1960s its nomenclature and character shifted to part of the East Village.) She saw the sign and peered through a gate. "It looked so interesting." So she walked in, and "it was more interesting than I thought," she recalled.[26]

She started to take pictures of the people, such as a photograph of several women, some with young children. The women standing around, including one who appears to be talking, may be using the opportunity while waiting to discuss domestic responsibilities. Their gendered roles and responsibilities for children prompt conversation, unlike the men, who appear to have less reason to converse. Behind the railing some men grip the iron bars. Their posture suggests a measure of boredom and, perhaps, frustration. Visually, the men behind the railings and the women in the foreground give the photograph a compelling and slightly disturbing quality.

HIAS, founded to assist Jewish immigrants to the United States, helped Holocaust survivors and refugees after the war. Handelman Meyer knew the organization's purpose. As she drew closer, she pictured the mix of Jewish refugees waiting for aid. Two children, a boy and girl, sit together on an up-ended crate. The girl leans back, settled in with her legs crossed. She holds a crumpled paper bag in her hands and gazes directly at Handelman Meyer. The boy, perched on a corner of the crate, seems anxious. His position does not suggest comfort. If the girl appears cautiously relaxed, the boy looks uncomfortably alert. Both present a serious demeanor. They

are not involved in any sort of play. They are well behaved, placid. Wearing clean and lovely clothes, they know not to engage in the sort of activity that might dirty themselves. They apparently also know the rules of waiting and follow them carefully. One gets the sense that they have refined the act of waiting, despite their youth. Although they sit in HIAS's courtyard, and not in a cold government hallway or outside on the street before a consulate, they implicitly seem to grasp how difficult it was to make it to New York City after a genocidal war. Apparently nothing is taken for granted.[27]

A group of three older adults display similar skills. The old man with a traditional beard, a middle-aged married woman garbed in a long skirt and blouse with her hair covered, and a younger man wearing a cap stare directly at the photographer. The old man, a faint smile dancing on his lips, grasps a shopping cart in his right hand, as if he had merely paused between ordinary errands. The young man, his finger by his mouth, seems poised to speak. Only the woman's furrowed brow projects a measure of anguish. This portrait of three generations, two of them visibly observant Jews, obscures the destruction wrought by the Holocaust. Yet it also evokes the social costs of exile and emigration, the painfully long wait for visas, passage, help, food, and home, not to mention a livelihood. Historian Beth Cohen argues that the pictures of survivors actually "show a rupture of Jewish life vast and deep: a plethora of thirty-year-old widowers, couples joined together to replace murdered wives and children, youngsters never reaching adolescence, young adults facing life alone." Jewish agencies like HIAS, she charged, interpreted the men, women, and children seeking help as evidence of "resilience: a will to live and begin again."[28]

Certainly, Handelman Meyer's photograph of a bench filled with young mothers and their children would appear to reveal such evidence. They are all attired in summer dresses; the children who sit

5.17 Sonia Handelman Meyer, *Women, Hebrew Immigrant Aid Society, Lower East Side,* ca. 1948.
The women milling around in the courtyard are waiting for assistance of some kind, talking,
and sharing information while they wait. Sonia Handelman Meyer. © Joseph T. Meyer.

5.18 Sonia Handelman Meyer, *Children, Hebrew Immigrant Aid Society, Lower East Side*, ca. 1948.
Two children face the photographer with an intensity in their looks that speaks to their unusual
maturity and their experiences as survivors of the Holocaust that may have produced it. Sonia
Handelman Meyer. © Joseph T. Meyer.

5.19 Sonia Handelman Meyer, *HIAS Family, Hebrew Immigrant Aid Society, Lower East Side*, ca. 1948.
All three generations of this family pose for their portrait while they wait for aid from the Jewish
immigrant organization. Sonia Handelman Meyer. © Joseph T. Meyer.

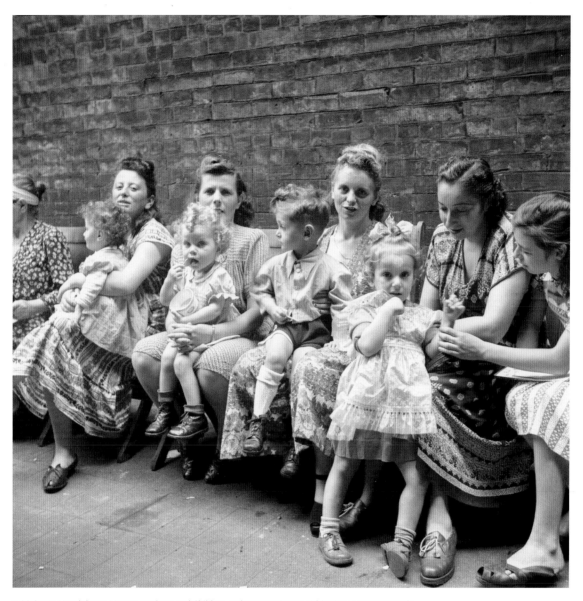

5.20 Sonia Handelman Meyer, *Mothers and Children, Hebrew Immigrant Aid Society, Lower East Side,* ca. 1948. Four women, each with a young child, sit in a line on benches outside of HIAS, a picture of Jewish efforts to reclaim life after the Holocaust. Sonia Handelman Meyer. © Joseph T. Meyer.

on their laps are clean and properly dressed. Two women fuss over a pretty blond girl, sporting a big bow in her hair, who pays attention to the photographer. Cohen suggests that the data, and by implication the photographs, "speak, if we listen closely, about families shattered rather than about those reconstituted, cautioning us to remember the black thread of the Holocaust that continued to weave its way through the immigrants' lives even as they moved forward."[29]

Jewish refugees drew upon past experiences and expert skill at waiting in line. "Getting out meant standing on never-ending lines," the historian Marion Kaplan emphasized. "These sites demanded perseverance and resilience from battered people." Yet "for refugees, these lines . . . represented a foreign state, potential rescue, and a new world." Now that they were waiting at HIAS on line (as New Yorkers put it) in New York City, the stakes declined significantly. No danger of arrest lurked.[30]

"So I took pictures," Handelman Meyer remembered. "Not one person asked me what I was doing. Why are you here? What are you doing here? Nothing. A couple of people smiled." Their seeming passivity surprised her. "It was weird. I took the pictures. I said goodbye to nobody. Nobody answered." Her memories address the gulf that existed between these "new Americans," as Jews optimistically called them, and New York Jews, even those who were conscious of the political dimensions of the Holocaust and empathetic with its human costs, as Handelman Meyer was.[31]

Holocaust survivors were not the only ones who waited for assistance. Even after the end of the Great Depression, breadlines did not disappear. In 1955 the Catholic literary magazine *Jubilee* commissioned Vivian Cherry to photograph activities of the Catholic Worker Movement, founded by Dorothy Day. Day had organized a combination settlement house and soup kitchen located in lower Manhattan's east side on Mott Street. Although New York City had expanded its social welfare provisions to be among the most generous in the nation, religious charity provided an alternative and supplement to public welfare. Cherry photographed the daily lineup of men waiting for a meal. They stand beneath a statue of St. Joseph the Worker, their hands in worn coat pockets or crossed over their chests. While they face forward, most of them glance down at the sidewalk. Unlike the women and children waiting at HIAS, they do not welcome a woman with a camera.[32]

New Yorkers were more familiar with groups suspended in time that involved a social unit. Morris Engel's photograph of truckers at the waterfront waiting for work conveys a very different type of experience from that of Jewish refugees at HIAS or men standing in a breadline. The workmen here have lined up against a wall, most likely in order of arrival. A couple have papers in their hands or pockets that they will probably present to the person at the window. The one Black man reads a newspaper to pass the time, and perhaps to avoid any potential conversation. The others adopt postures of standing that suggest a sense of resignation. They are not being paid to wait. Several notice the photographer, and their looks are not particularly friendly.

Most of the men working by the docks were white; few were past middle age. Engel photographed a somewhat more diverse group than those pictured in the trucker's lineup. These dockworkers include a mix of Black and white, young and old. Although Engel is closer to the men in this photograph, only one eyes him. Leaning against a lamppost with his hands in his overalls, he glances at the photographer. His look questions Engel: What brought you here? Lining up to wait for work occurred throughout the city and formed part of its rhythms.

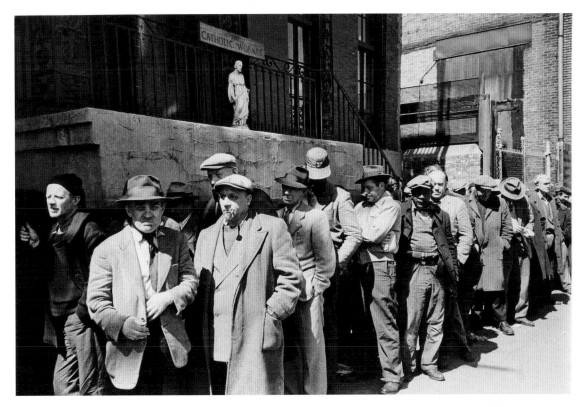

5.21 Vivian Cherry, *Catholic Worker Soup Kitchen Line, 1955.*
The men line up underneath a statue of St. Joseph the Worker,
standing and waiting uncomfortably in public for a meal.
Brooklyn Museum, Gift of Stephen Schmidt. © Estate of Vivian
Cherry. Courtesy of Daniel Cooney Fine Art.

Of course, Engel as a man elicited a different response from male workers than a woman photographer. The "ability to shoot without people looking at you," he commented, was key to "to the philosophy of doing candid work." Lee Sievan's photograph of unemployed men fails to follow that injunction. She pictures them waiting to sign up with a labor boss, who has set up a table in Columbus Park off of Mulberry Street in the Italian section of the Lower East Side. The men do notice her, and her photograph includes a charged reaction from one. Such "gendered interactions are particularly visible when a woman photographer specifically chooses to picture groups of men. Gender is a key discriminator in public. More than class and almost as reliably as race, it enforces circumspection."[33]

Born on the Lower East Side to immigrant Jewish parents from Poland, Sievan grew up in New York City. After graduating from Hunter College in 1929, she took a job as a secretary in Hunter's Biological Sciences Department. Her path to the Photo League started in a history of photography course with Eliot Elisofon, who emphasized the potential of photography as "a social and artistic tool." Sievan learned from Elisofon that photographs should be "clean, clear, and straight." Her love of city streets and the circumstances of her life fed her enthusiasm for straight photography. Because she worked full time, she took photos on weekends, lunch hours, and after work.[34]

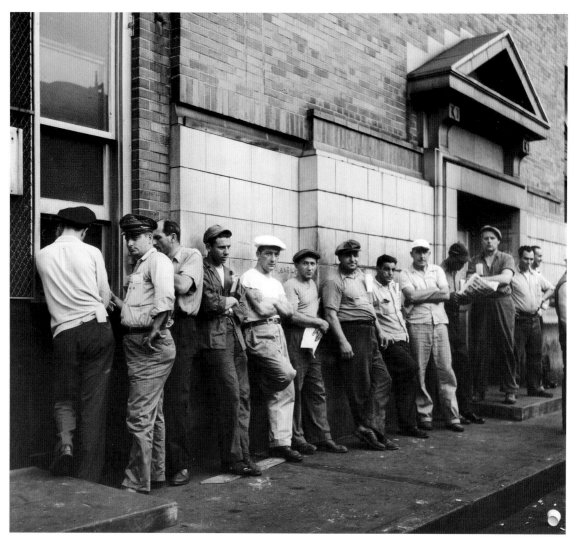

5.22 Morris Engel, Untitled (truckers at the waterfront waiting for work), 1948.
The line of men against the wall, papers in hand or pocket, suggests the kind of
tedium involved in waiting for work. © Morris Engel.

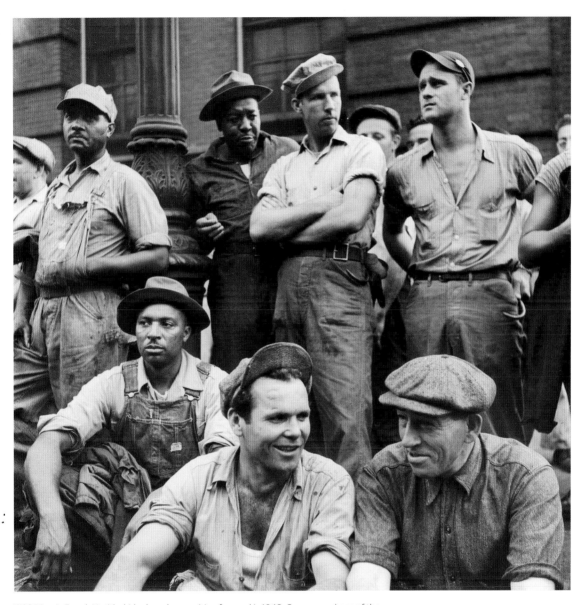

5.23 Morris Engel, Untitled (dockworkers waiting for work), 1948. Some members of the group pictured here seem to know each other. Engel captures an exchange between two men in the foreground. © Morris Engel.

Sievan's photograph of Italian men lounging on the steps waiting for a padrone to offer them employment captures the grace of male bodies at rest. The geometric patterns of floor tiles, stairs, and railings contrast with the drapery of the men's winter coats. "In the foreground she pictures a symmetrical division that helps to structure the image: three men on each side of the column aligned on different steps. The angles of bodies and legs present a kind of tableau vivant arranged against the stairs." On the right, on a landing, several men cluster around a table. One leans over to sign a paper; another appears to be speaking; a third inclines toward him in an inquiring gesture. But most of the men, except for those preparing to sign up, have their hands in their pockets, a typical American gesture. The plaza itself, constructed in 1934, with hexagonal paving stones, metal railings, curved arch, white column, and concrete wall, provides a modernist urban setting for this theater of unemployment. Sievan's title, *Gentlemen of Leisure*, ironically comments on the necessity of men waiting when there is little or no work available.[35]

Most of the men look away. They do not welcome the photographer who seeks to document their situation.

A tall thin man faces left. Others focus on the padrone and his assistant standing near the top of the first group of stairs. One fellow, in the center of the image, eyes the photographer as if to say: Hey babe, you look good with your camera. Like what you see, too? He leans against the wall, his weight on one foot while the other is bent against the stairs. He cocks his head, eyes shaded by his hat brim. His open coat reveals a jacket, sweater, white shirt, and tie. Check it out, his posture says. Not a stranger to the Lower East Side, Sievan, a Jewish woman with a camera, elicits a range of responses from these men. She meets some disinterest along with one sexually charged stare that challenges her gaze through the camera's lens.

The unresponsiveness she arouses, more than the engagement, may also be a remnant of an enduring taboo regarding who has the privilege of staring on the city's streets.[36]

As a man, Faurer possessed that privilege. His photograph of four women lingering before or after attending the theater manages to snag them all looking away. It also instantiates the male gaze. A man, passing by on the right, stares at the foursome, most likely prompted by Faurer's camera to look. The women make an odd tableau, in part because they seem to be in dialogue with the sign behind them. The large poster for Barbara Stanwyck's 1950 movie *No Man of Her Own* advertises a girlfriend's plight: "That night I spent my last nickel to call Steve . . . and tell him that I was [going to] have a baby. [He hung] up—without [a g]oodbye!" A film noir, cowritten by two women based on a novel by a man, dramatized a woman's experience of illegitimacy. The writers "create a haunting character in" Stanwyck's persona. "Their inherent goal is to ennoble her—and most of the other female figures in the film."[37]

The four women present a picture of rectitude unlike the poster's drama of an unmarried pregnant woman spurned. They are all dressed up for a show. The oldest woman wears a hat and white gloves, surely a sign that she did not intend to use her hands doing anything dirty. To her left stands a teenager who could be her daughter, given how close they are, with their arms touching. She, too, wears white gloves, albeit no hat. Her hands hang limply at her sides. She does not carry a purse, a sign that someone else has taken on the responsibility of what a pocketbook signifies for women in the city. She looks in the opposite direction from the older woman. The other two women gaze off at something happening,

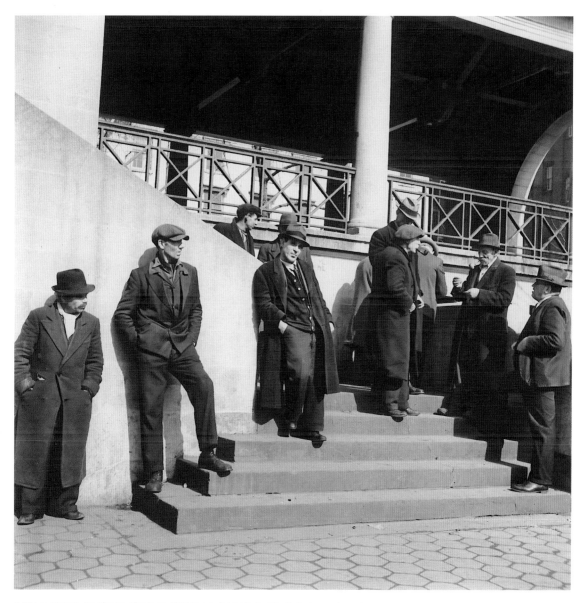

5.24 Lee Sievan, *Gentlemen of Leisure, 1937*. Sievan's ironically titled photograph portrays a lineup of unemployed Italian American men on the Lower East Side, arrayed on the steps in a kind of tableau vivant, waiting to sign with a padrone offering work. © Lee Sievan. Courtesy of Howard Sieven.

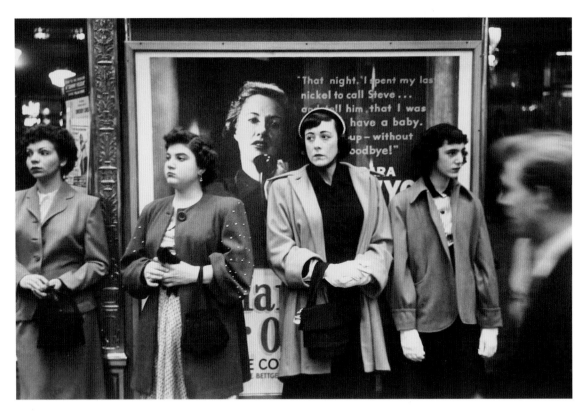

5.25 Louis Faurer, *New York,* 1949. Before or after the show, these four women stand, looking in different directions, in front of a large poster that comments on a single pregnant woman's situation. The photographer has also caught how the act of taking a picture stimulates another man to turn to glance at the women. Estate of Louis Faurer.

perhaps scanning the crowd for someone they planned to meet. They embody multiple horizons of anticipation. Their postures suggest some of the pleasures of waiting, the feeling of anticipation.

Waiting for work or for a show to start or after it has ended differed from hanging out on the street. City ordinances called that form of spending time in the open for no apparent reason "loitering" and forbade it. Stenciled signs on walls, windows, and doors proclaimed "no loitering," usually to no effect. Still, the ordinances allowed police to stop and interrogate people who were out on the street with no apparent purpose. "Reformers have long observed city people loitering on busy corners, hanging around in candy stores and bars and drinking soda pop on stoops, and have passed a judgment, the gist of which is: 'This is deplorable!'" Photographers demurred. They often pictured these groups, rarely presenting them in a threatening or negative light. Rebecca Lepkoff's photographs of clusters of people on the street exemplify that mode of presentation.[38]

In her picture of a corner grocery store on Madison Street on the Lower East Side she captures four people lingering and two in motion. This combination of movement and pause effectively depicts the texture of a working-class neighborhood, where people regularly hung out. Two women sit on a bench, a baby carriage nearby. A man stands by another carriage, watching the entrance. There an older man leans against a column, feet and hands crossed.

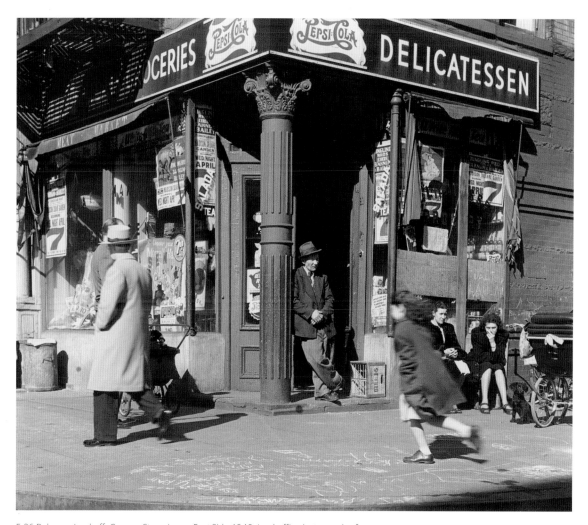

5.26 Rebecca Lepkoff, *Grocery Store, Lower East Side*, 1940. Lepkoff's photograph of a corner
store on Madison Street captures how men and women hung out, watching others pass by.
© Estate of Rebecca Lepkoff. Courtesy of Howard Greenberg Gallery, New York.

Loitering was integrated into the action and stasis of the street. "The tolerance, the room for great differences among neighbors," writes the activist urbanist Jane Jacobs, "are possible and normal in intensely urban life," but only, she warns, "when streets of great cities have built-in equipment allowing strangers to dwell in peace together on civilized but essentially dignified and reserved terms." Loitering often facilitated just those terms, as Jacobs knew. It also could make those deemed an unwelcome presence—especially Black men—feel pressure to leave the neighborhood. The tolerance of difference had its limits, even in liberal New York.[39]

Lepkoff's other photograph of a young woman standing by a local store, wistfully gazing up the block, her purse tucked securely under her arm, provides an almost romantic view of hanging out. Beside the woman two boys plunk themselves in the doorway, one drinking soda pop just as in Jacobs's characterization of reformers' ire. As in the corner store photograph, two women sit on a bench outside the shop. They do not appear to be involved in the drama of longing expressed in the young woman's body language. Neither does the man, who is facing the seated women, arms akimbo. The play of light and shadow on the plate glass windows gives the scene a slightly dreamy quality, amplifying the young woman's yearning look. It's almost as if the city street embraced her eager expectation.

A more provocative image of waiting contrasts the façade of the street with the women who loiter. Helen Levitt's picture of a foursome of women, all dressed in lightweight summer dresses and wearing high heels, offers a version of loitering that simultaneously comments on neighborhood decay. Not much is happening on this stretch of the block. The women are conversing in front of a closed candy store. Unlike Chick's, it no longer serves as a social center for the neighborhood. Samuel Cowen, who was in the real estate business in the Bronx, has

posted a for-rent sign. The other storefront appears abandoned. The women do not seem to notice.

One woman, hand raised behind her head in a somewhat glamorous posture, appears to be talking. A younger woman listens, though her look of concern seems directed to the woman facing her. A third woman notices Levitt. Wearing a dark dress, she seems poised to walk away. She is not the only one who sees the photographer. An older Black woman sits in the open tenement doorway next to the closed candy store. She leans forward, hands in her lap. She has brought a chair or stool downstairs so that she does not need to dirty her white dress by sitting on the steps. The quiet of the streetscape, and the women's clothes and demeanor, suggest that it may be a Sunday.

Looking at these photographs after decades have passed involves a necessary struggle to understand what social knowledge operates in them. "What seems transparent to the eye may turn opaque under the scrutiny of the mind," Trachtenberg observes. What happens when the photographer's eye becomes transparent?[40]

Helen Levitt found just what she was seeking in a photograph that presents a powerful scene of four men waiting and one girl watching the whole scene from a window. "Although the figures stand and sit together, as Levitt composes the image they gaze away in separate directions and seem to confront the camera as if it were an intruder," writes Zurier; "only the girl looking through the window seems to greet the photographer with interest." Perhaps she is a stand-in for the photographer. From the safety of her home, she eyes the world, metaphorically representing the female gaze. Levitt makes visible the gendered character of the streets, an important form of social knowledge.[41]

Street performance intrigued Levitt. Four men hang out. Two of them are sitting and watching

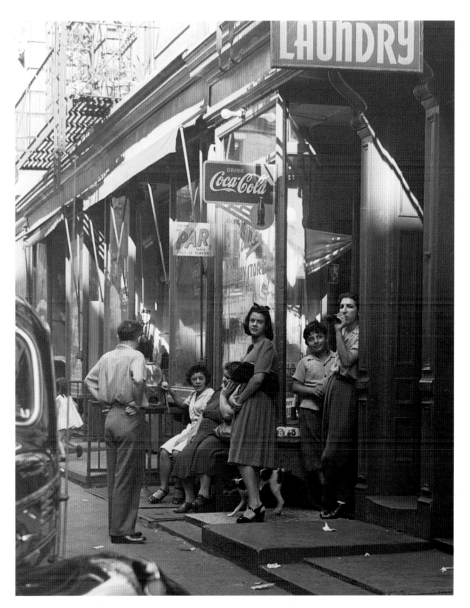

5.27 Rebecca Lepkoff, *Henry Street, Lower East Side, New York*, ca. 1939. The woman gazes dreamily down the block while waiting, her purse tucked under her arm, as two boys standing in the store's open doorway contemplate the photographer. © Estate of Rebecca Lepkoff. Courtesy of Howard Greenberg Gallery, New York.

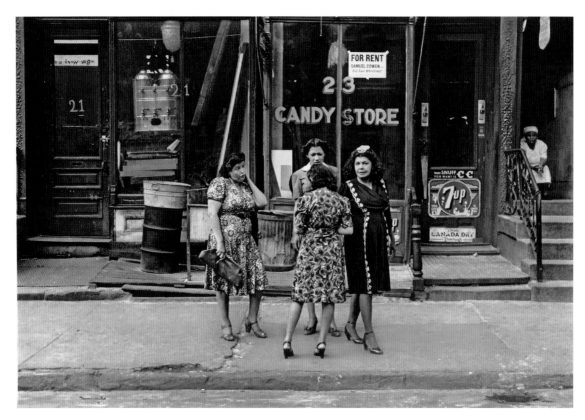

5.28 Helen Levitt, *New York*, ca. 1945. Four women gather on a quiet block in front of an empty storefront dressed in their Sunday best. Levitt pictures them from across the street. Helen Levitt, NY, ca. 1945. © Film Documents LLC. Courtesy of Galerie Thomas Zander, Cologne.

some unseen activity. Apparently, "it is sufficiently interesting for them not to pay attention to the photographer at this moment. A third fellow is standing, cigarette between his fingers, eyes gazing beyond the picture frame. His elegant attire is striking, especially in contrast to the two older men in their shirtsleeves. Tie, suit, hat: they are all of the latest fashion. His style proclaims: New York City." Then there is that guy with his back to the photographer. "Has he had enough? His jacket is off. Maybe he doesn't want his picture taken." His portrait among the foursome, of someone who apparently declines the camera, sparks a question: Why portray this gestural

moment? Perhaps the young girl in the window is wondering about the turned-around man too, for she seems to be watching both him and the photographer. She has composed herself perfectly, with chin comfortably on her hand, a finger at the edge of her mouth, her elbow cradled in her other hand. The photographer watches, but the men look away.[42]

"We see what we see not because those things were there to be seen by us but because the *camera* was there to construct exactly this view," Trachtenberg reiterates. Although he is not discussing Levitt's photograph, what he writes relates to another Levitt photograph that hammers home his point. This one (not reproduced) catches Levitt's interaction with the men. They have all turned around to look directly at her and the camera.[43]

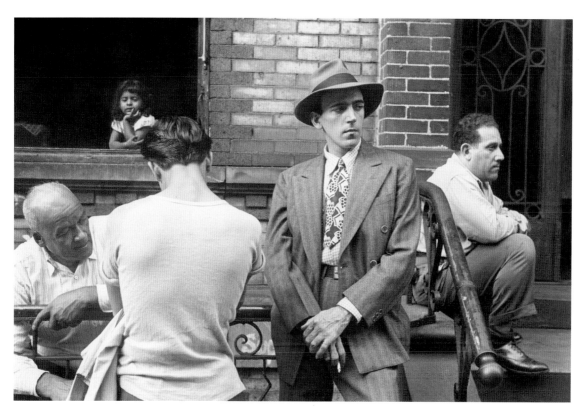

5.29 Helen Levitt, *New York*, ca. 1940. The four men pose for the photographer and the girl in the window, who contemplates the scene with equanimity. Helen Levitt, NY, ca. 1940. © Film Documents LLC. Courtesy of Galerie Thomas Zander, Cologne.

The young man in the undershirt is pictured talking to her, as is the tall well-dressed guy. The older man looks at her with an expression of amusement. Only the little girl seems to be indifferent to the exchange going on between Levitt and the four men. This photograph appears more like a family snapshot. One could imagine the dialogue: Why do you want me to pose for you? What do you have in mind? It's great that you're a photographer, though I'm not sure that's a thing for a girl to do. Okay, I'll turn around. Fine, I'll look off down the block. And then we get a powerful, classic image of hanging out on a city street. But perhaps the second picture followed the classic image. The guy turned around.

Did you get it? he asks. Levitt's family didn't really understand what it meant to be a photographer until she had an exhibit at the Museum of Modern Art in 1943. Then they traveled to Manhattan to see the show and were suitably impressed by the locale. "Social knowledge is what the picture offers, what we passersby can know of the scene's interior reality through the camera," a situation made even more complicated by the passage of time and distance from the New York City of the 1940s.[44]

Perhaps it is best to end with Vivian Cherry's very different photograph of a young girl watching and waiting. Cherry instantiates the power of the threshold to hold both adults and children, to compel them to pause and to hesitate. Her picture makes vivid the presence of adults in children's lives, and implicitly what children learn from them. Though children

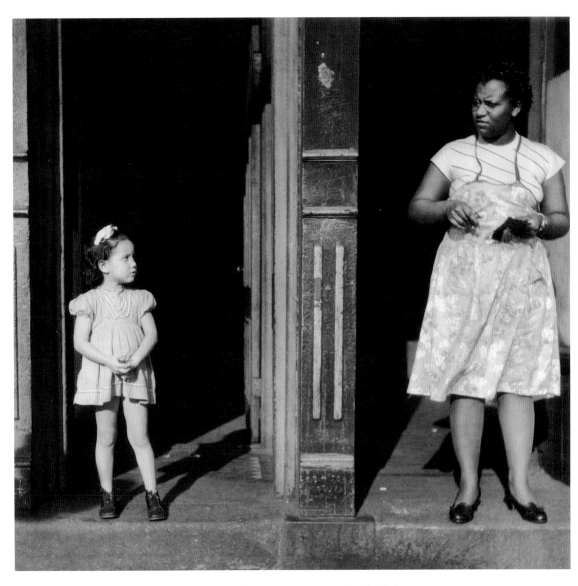

5.30 Vivian Cherry, *New York*, 1940s. A woman and a girl pause on the tenement threshold; the woman gazes out at the street; the girl glances up at the woman. The photograph pictures a story, interrupted. © Estate of Vivian Cherry. Courtesy of Daniel Cooney Fine Art.

often ignored them, they remained aware of adult eyes watching them in the streets.

Here a girl and a woman confront each other. "Both stand in the sunlight on neighboring thresholds." Connecting doorjambs frame them, bringing them together and separating them. "Behind them lurks the darkness of dimly lit tenement hallways." They both pause at the edge of the world of the street, where each will assume a persona on a public gendered stage beyond the tenement's familiar spaces. But they vacillate, the girl eyeing with intense interest the grown-up woman to her left. "The photograph captures a moment of pregnant uncertainty."[45]

Both woman and girl would probably be called Black Americans. The former is dark skinned and the latter is not. The potential tension between the two conveyed in the image invites speculation about their unarticulated relationship: Will this "girl child with a pretty bow in her hair grow up to be the serious woman wearing glasses, an apron, and nylons? Does she recognize this adult from the neighboring tenement? The girl seems anxious; perhaps she is not allowed outside alone. Yet she stands still, gazing upward as if assessing her next move." She is wearing a dress that she is about to outgrow even as she steps onto the sidewalk. "Cherry's photograph emphasizes symmetries: two doorways, two ornamental lines on the doorjamb, two females, two exchanged glances, both dressed in clean clothes with hands in front of their bodies. Yet there are asymmetries as well: within the frames of their encounter, they stand off from one another. Inequalities abound."[46]

In the front matter for a volume of his collected essays, *Steady Work*, Howe recounted a story that epitomizes a classic Jewish perspective on waiting. "Once in Chelm, the mythical village of the East European Jews," he wrote, "a man was appointed to sit at the village gate and wait for the coming of the Messiah. He complained to the village elders that his pay was too low. 'You are right,' they said to him, 'the pay is low. But consider: the work is steady.'" Jewish street photographers of New York City regularly pictured that steady work, day in, day out. Waiting punctuated the choreography of the city's streets, helping to knit together the fabric of social relations. "In the act of waiting, we become who we are." Certainly that was true for New Yorkers. Those lingering observers reminded viewers that for all the hurrying here and there, times in between endured. Steady work available to anyone who chose to pick up the task.[47]

6. Talking

After the Japanese attack on Pearl Harbor on December 7, 1941, mobilization for World War II gradually registered on the home front. The war's battles dominated the newspapers and hovered in the background of conversations. By the fall of 1943, most New Yorkers had a family member—son, brother, father, uncle, cousin—in military service. At that point, Allied troops had landed in Italy, beginning the invasion of the European mainland. Many of the men actively associated with the Photo League—Sid Grossman, Morris Engel, Walter Rosenblum, Louis Stettner, Dan Weiner—enlisted or were drafted into the armed forces. The women remained and continued to photograph on the streets. Sonia Handelman Meyer remembered "what had been a very quiet peaceful darkroom gallery" during the war. Then, after the war, "everything at the League changed 'cause all the men came back. . . . Everything suddenly burst open, and people just poured into the place." But in the absence of men, women's photographic choices emerged.[1]

Women often noticed conversations on the streets. These interactions reflected perceived concepts of community, "an affective notion" as well as a public sphere. "Conversation demands a culture of mutuality, a dialogical culture, a democratic culture," Homi Bhabha, the critical theorist, proposed. His conversation partner in this exchange, the cultural historian Sander Gilman, wasn't so sure about that. "I would hate to fetishize conversation as something necessarily good," he replied. While Gilman demurred, Jewish culture also valorized conversations, even contentious ones, or arguments "for the sake of heaven." And conversations undoubtedly drew New Yorkers together, especially neighbors. While news could be gleaned from radio and newspapers, personal interactions with friends and neighbors depended upon meeting them—on the street, in the grocery, at the candy store, on the stoop, at work, and at school. A bare majority of city households had private telephones in 1948. Few working-class families could afford that indulgence. Conversations rarely occurred remotely.[2]

Conversations among the city's residents intrigued Helen Levitt. She recognized that she could come very close with her camera when people were talking intently. They would not particularly notice her, just like children playing. Conversation engaged adults, not just hearing but also seeing. Gestures and expressions accompanied talk, amplifying and

enriching the words spoken. These modes of expression reflected both gendered and ethnic conventions. Conversations possessed a physical dimension. As the sociologist Erving Goffman elaborated, while an individual "can stop talking, he cannot stop communicating through body idiom," all the information conveyed through clothing, comportment, and gestures.[3]

In one wartime photograph of the home front, it is almost as if Levitt has joined the conversation among three women lounging at the threshold of their tenement. Of course, in some ways what they are saying matters less than how they are saying it. Levitt is absorbed in the language of gesture and female community. She sees a young woman with a sleeping child almost too big for the baby carriage at her side. The woman, wearing a neat blouse and skirt, her hair stylishly done up with a ribbon, is speaking expressively. "Perched a bit precariously on an upended crate, she has crossed her legs, with one hand resting on a knee and the other arm leaning protectively on the carriage handle. The camera catches her unglamorously: head tipped, eyes closed, tongue at her lips."[4]

"Two middle-aged women, perhaps her neighbors, have stopped to listen. One smiles readily. Her raised arm and hand leaning against the doorpost expresses her openness to the young woman's comments. The other woman looks down somewhat skeptically, even superciliously," although she has crossed her legs and is standing on one foot, a sign of her participation in the conversation. "They appear to have paused en route, probably stopping to chat before heading upstairs." A brown paper bag, evidence of their shopping excursion, sits on the step behind the woman wearing a hat. Their attire speaks to gendered social conventions for women going shopping in the city. Both wear stylish patterned dresses, nylons, heels, and light coats, despite the mild weather.[5]

The photograph captures what appears to be the interaction of neighbors. It offers a glimpse into the pace of working-class housewives' lives, regulated by children and household responsibilities. "It suggests, too, these women's unwillingness to stay home in cramped apartments. The streets entice them through opportunities for contact and conversation with other people." Levitt's photograph transforms this ordinary encounter into a moment that projects "vibrancy," as photo historian Naomi Rosenblum argues, "a sense of working-class connectedness."[6]

There is visual complexity as well. "The city's presence intrudes on this meeting of three women." It appears through reflections in the store window: awnings to shade products from the sun, fire escapes, two men ambling on the sidewalk, and a fancy, parked convertible across the street. The larger world, too, demands attention. "These women are connected to a wider conflict." "Will Destroy Nazis/Big Allied Push Gains in Italy," shouts the *Journal American* headline. A fourth woman sits on a crate, immersed in the Hearst newspaper. "To share a city space, unthreatened by your fellow citizens," critic Max Kozloff writes, "is to diffuse solidarity, not eliminate it."[7]

Conversations provided that glue connecting New Yorkers despite their differences. The point of what the urbanist Jane Jacobs called "the social life of city sidewalks is precisely that they are public. They bring together people who do not know each other in an intimate, private social fashion and," she argues, "in most cases do not care to know each other in that fashion." The sociologist Marshall Sklare agreed. "Communication," he wrote, "is the essence of city existence."[8]

Conversation animates the streetscape. Rebecca Lepkoff's photograph of Cherry Street exemplifies Jacobs's and Sklare's contentions. She pictures multiple conversations, visible but not audible: between a woman pushing a baby carriage and a

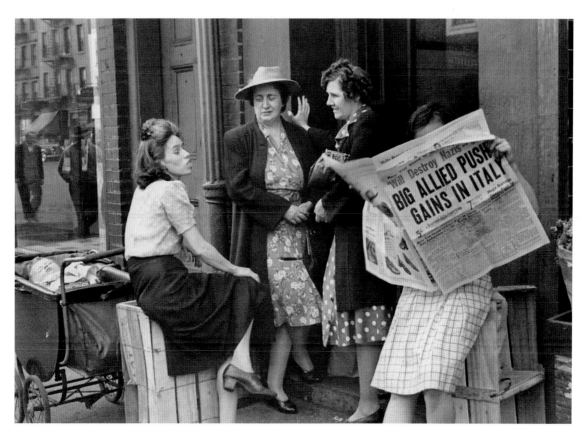

6.1 Helen Levitt, Untitled (three women conversing outside of tenement, one with newspaper), 1943. The gestures of conversation as well as the postures of listening appear vividly in this photograph of neighborhood women catching up with each other. Helen Levitt, NY, 1943. © Film Documents LLC. Courtesy of Galerie Thomas Zander, Cologne.

man, between two babushka-wearing older women, and even among the three young children playing. Talk swirls around the poor neighborhood, yet it is unclear if anyone knows anyone aside from her conversation partner. Who, for that matter, is watching the children? The animated conversations contrast with the building's worn façade, blank windows, and laundry flapping in the cool air. Lepkoff is not interested in dismal living conditions. "Pay attention, she seems to suggest, to the people, to the human interactions of the street" and the inaudible sounds of multiple conversations. Her photograph examines

those crucial gestures of communication that convey sentiment and emotion, "things she might observe as a dancer: the crossed legs and relaxed posture of the man lounging against the tenement doorframe, the clasped hands and slightly bent heads of the two women talking, the sprawl of children unconcerned that they are blocking the stairs," and, of course, the ubiquitous American practice of putting hands in pockets.[9]

"Like many other League images, Lepkoff's photo works in implicit contrast to omissions or exclusions: out-of-date stereotypes of the Lower East Side as a Jewish immigrant neighborhood associated with Yiddish culture and ragtag small-scale commerce." Her picture highlights a range of particular yet common interactions that portray street life in an American

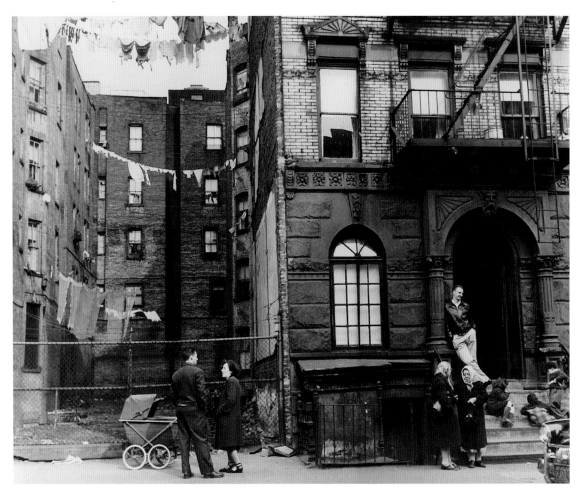

6.2 Rebecca Lepkoff, *Cherry Street*, 1940s. Lively conversations animate this Lower East Side street and present the multigenerational neighborhood as one of friends, or at least of friendly neighbors. © Estate of Rebecca Lepkoff. Courtesy of Howard Greenberg Gallery, New York.

community generally and in a New York City working-class neighborhood specifically. As historian Suzanne Wasserman notes, "the street and the neighborhood were very much about family." Lepkoff urges no explicit political agenda, nor does she issue a reformer's call to eradicate the slums. Rather, she looks at the streets of the Lower East Side as a place of city life, of poverty but also dignity. She knew these blocks of her neighborhood intimately, since she lived across the street.[10]

New Yorkers minded each other's business. Women with children in tow were particularly vulnerable to receive advice. Levitt tended to focus often on more potentially fraught conversations and captured what might be just such an exchange. The children, especially the middle boy, want to leave already but their mother is standing still, talking. Her interlocutor, framed in the tenement doorway, leans forward and emphasizes her point with her right hand. The older boy, patient enough, circles his mother while the youngest, a girl, just watches what is happening

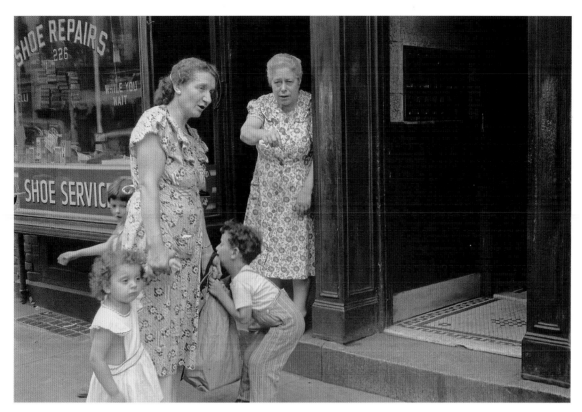

6.3 Helen Levitt, Untitled (mother with children conversing outside of shoe repair store), 1940s. This conversation between two women has several of the children impatient to be moving. One imagines that some advice or serious instruction is being conveyed, given the intensity of the older woman's look and gesture. Helen Levitt, NY, 1940s. © Film Documents LLC. Courtesy of Galerie Thomas Zander, Cologne.

down the block. All this action, next to a shoe repair shop, occupies basically half of the picture frame. The right side is still, providing a glimpse into a tenement hallway with its characteristic tiled floor and mailbox-lined wall.

Children also talked on the street, picking up gestures that copied adult practices. Vivian Cherry paid attention to such conversations. Her photograph of two young girls and a boy in the west side neighborhood known as Hell's Kitchen signals the responsibilities and opportunities of female childhood and its accompanying pleasures. One girl stands with her weight on her right leg, head tilted left, her hands clasping a paper doily. Her beautiful hand-knit matching sweater and hat with its pompom contrasts with the boy's jacket that appears to be a hand-me-down, resized for a younger child. The nicely attired girl listens intently to the other properly dressed girl who wears a double-breasted coat with a velvet collar. She is speaking, her left hand raised to her chest. Her younger brother looks away, supremely uninterested in his older sister's girl talk. Girls' encounters on the street while caring for younger siblings prepared them for adult roles as wives and mothers. Cherry was not alone in picturing how young girls took responsibility for younger siblings. Other photographers of immigrant life also captured such common practice.

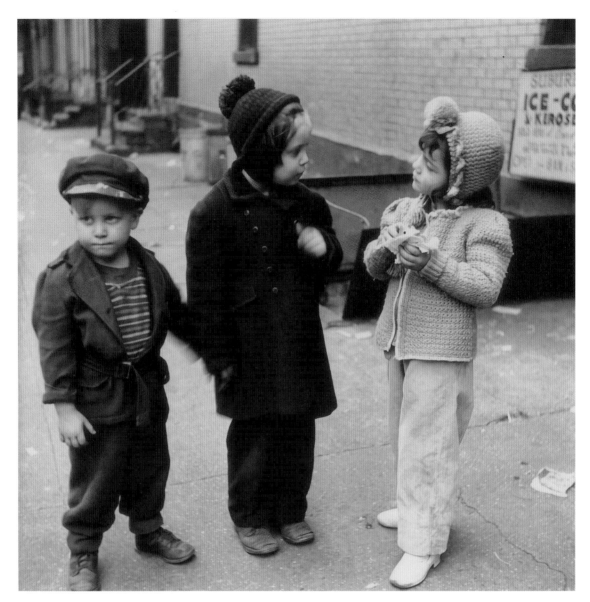

6.4 Vivian Cherry, *Three Young Children Talking*, 1950s. The grownup gestures and serious demeanor of the two girls reveal how children learned to communicate on New York's sidewalks even as the photo, taken in the west side neighborhood of Hell's Kitchen, also documents big sisters' responsibilities for younger siblings. © Estate of Vivian Cherry. Courtesy of Daniel Cooney Fine Art.

Cherry's fascination with conversations extended to adults. Her photograph of an adult threesome offers a kind of model dialogue. The three women, identically attired in housedresses, are talking. They pay attention to each other. The subject interests them. None of them smile; all are attentive. Women employed conversations to keep track of friends

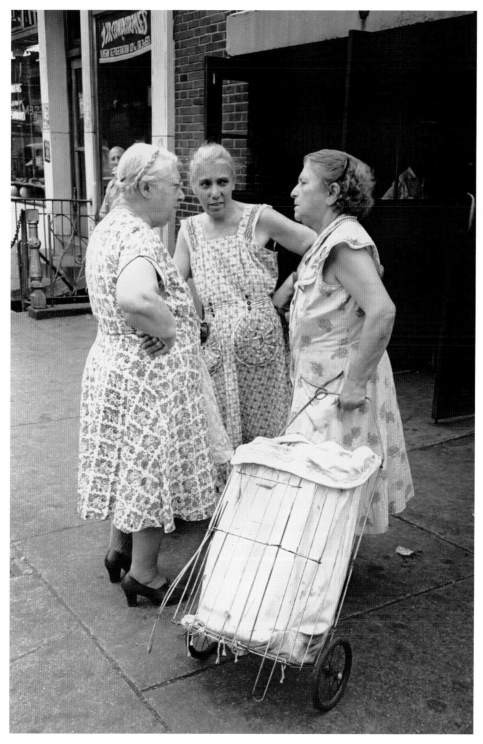

6.5 Vivian Cherry, *Three Women with Wash*, 1950s. Household tasks, especially those like laundry and shopping, took women out of their apartments and onto the city's streets where chance encounters allowed for the pleasures of conversation. © Estate of Vivian Cherry. Courtesy of Daniel Cooney Fine Art.

and neighbors and to stay updated on domestic and other matters. One woman pulls her shopping cart, lined with a white cloth bag indicating that she is probably doing laundry.

In the postwar period laundromats entered working-class neighborhoods, where they flourished. Chinese hand laundries were ubiquitous around the city; one is visible in the Levitt photograph of the broken mirror frame in chapter 4 (figure 4.8). Most catered largely to middle-class customers. Working-class women washed clothes by hand in tenement tubs and hung them to dry on clotheslines on rooftops, strung from windows to tall poles, or occasionally between two buildings, as appears in Lepkoff's photograph of Cherry Street. "My mother did the laundry for seven people and carried it up to the roof to dry," Walter Rosenblum remembered of his childhood on the Lower East Side. "My mother, she died in her fifties from overwork." As New Yorkers enjoyed a significant measure of prosperity after the war, even women living in tenements could afford to cart their laundry to a local laundromat instead of doing it at home. At the laundromat, they could wash and dry their clothes and linens in coin-operated machines. Laundromats invited conversations because one had to wait for the machines to complete their cycles. Cherry didn't enter the laundromat; instead, she recorded a seemingly spontaneous conversational encounter. Laundromats produced new patterns of street culture along with opportunities to chat.[11]

Shopping also fostered conversations. The physical intimacy of conversations among Italian Americans appears in a photograph by Sonia Handelman Meyer. She catches three women outside the Canera Brothers Bakery in Little Italy. The older woman, who apparently works at the bakery, holds a swaddled baby in her arms. She listens intently as another woman, perhaps a regular customer, perhaps a neighbor, emphatically drives home her point with two fingers. The third woman also listens, arms crossed over her body. The bakery features several wrapped cakes on a high shelf. Its sign is missing a few letters. Behind lettering that announces "BRANCH OF 152 SULLIVAN ST" are long loaves of Italian bread, stacked in the window. Handelman Meyer conveys the mix of childcare responsibilities and work that working-class women juggled.

Of course, men talked in public as well. Their conversations differed from those of women. Sports, business, and politics engaged men rather than domestic affairs. Photojournalists like Vivian Cherry or Morris Engel or Arthur Leipzig rarely received assignments to picture conversations. Their photos of conversations usually occurred within other contexts. In Engel's case, it came from having some free time on his hands. When he returned from military service in the navy, he briefly picked up his old job at *PM*. "*PM* was a dying operation, losing money and circulation," he recalled. Engel came into work one day and found a note from the editor: "'Dear Morris, we love you, but goodbye.' They fired forty-two people that day." So he headed back up to Harlem, where the Black population had grown substantially over the previous decade from when he had participated as a teenager in the Photo League's Harlem document.[12]

Engel photographed two well-dressed Black men greeting each other on the sidewalk. Both keep their hands in the pockets of their elegant overcoats; both lean forward in gestures of acknowledgment. Between them yawns a space that other ethnic New Yorkers, such as Jews and Italians, would have found distressing. How can one converse standing so far apart? There is a third man here. He leans on the corner of the storefront, listening in on the conversation. He is older, his hat somewhat battered. He does not appear as prosperous. Unlike the conversation partners, he wears neither tie nor white shirt.

Other action on the street contextualizes this New York conversation: the rows of uniform six-story

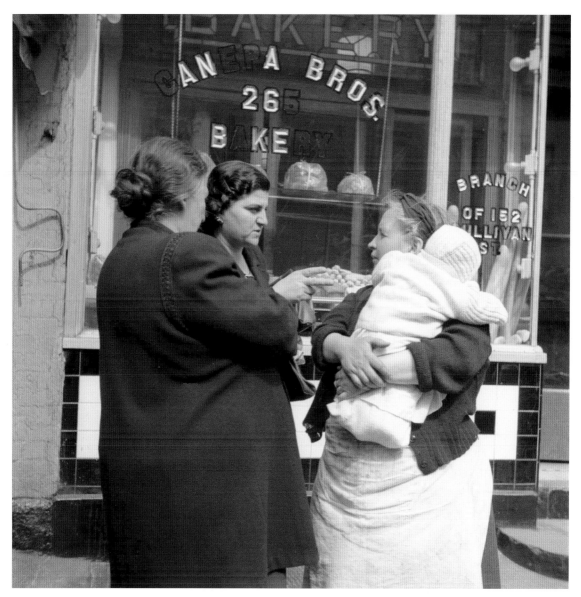

6.6 Sonia Handelman Meyer, *Women at Canera Bros. Bakery,* ca. 1946–53. The three women
stand close to each other to talk, attributes associated with Italian Americans. For working-
class women, childcare and paid labor outside the home overlapped. Sonia Handelman
Meyer. © Joseph T. Meyer.

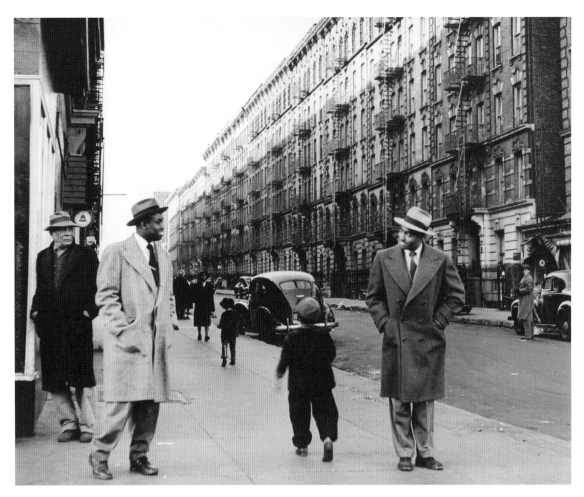

6.7 Morris Engel, Untitled (two men conversing on a Harlem street), ca. 1948. A seemingly serendipitous meeting prompts an exchange of pleasantries and perhaps something more substantial. © Morris Engel.

tenements with their fire escapes lining the block, the children striding down the street with their backs to the camera, even the Bell Telephone sign hanging in front of a storefront, advertising the possibility of conversations across distances. Only a third of Manhattan households possessed telephones in 1940. Most New Yorkers couldn't afford a private telephone subscription, so they used public phones. "In most city neighborhoods, the candy stores, grocers, and druggists were the first to get phones," writes historian David Nasaw. "The whole neighborhood wrote down the phone numbers and used them as their own. When calls came in, kids were roused and sent out to bring back the person wanted on the phone." Boys often hung out waiting for the phone to ring and then ran to the address to fetch the person and score a nickel tip. Not until after the war did private subscriptions for telephone service reach a majority of New York households. At the same time, public telephone service expanded, offering private booths on the sidewalks and in office buildings for public calls.[13]

Given the numbers of people without telephone subscriptions, "pay phones in pharmacies, banks, stores, and street corners remained nexus points for communities, subtly appealing to a sense of civil society in which we are never out of the range of each other's voices." Ariana Kelly notes that when "soldiers started returning from the war, banks of phone booths were erected in preparation for their arrival." The expanding presence of public phones gradually attracted the attention of photographers. While it is impossible to know how many calls returning soldiers made or what was said, "what remains is the indelible image of contact."[14]

Perhaps one of the most moving photographs of a conversation on New York City's streets is Louis Faurer's shot of a deaf person communicating. Faurer doesn't actually picture any words being formed; rather, he presents the intense look on the woman's face and the man's hand touching his ear. Only Faurer's title, *Deaf Mutes*—a term not considered derogatory in the 1950s—signifies the man's identity. The white lights of the city swirl behind the couple, illuminating her face with its expression of deep regard. Faurer represented the type of interhuman dialogue that the Jewish philosopher Martin Buber theorized. "To speak is both nature and work, something that grows and something that is made, and where it appears dialogically, in the climate of great faithfulness, it has to fulfill ever anew the unity of the two." Buber contemplated what produced "genuine dialogue." In that desirable situation, "the turning to the partner takes place in all truth, that is, it is a turning of the being." Faurer's photo invites a viewer to overhear with him the silent conversation, moved by its unspoken power of connection.[15]

Taken for *Flair* magazine on assignment, Faurer's photograph illustrated an article on sign language and communication among deaf New Yorkers. The caption beneath the image read, in part: "Two young persons—both completely deaf from birth, and both pupils of New York's Lexington School for the Deaf hold a . . . conversation at a busy East Side intersection." Although drawings of how to sign decorate the margins of the article's pages, the caption emphasizes that both teenagers "communicate totally without using their hands to 'sign.'" Since they relied on reading lips, they stand beneath a streetlamp in the twilight. The poignant caption concludes: "They are preparing to live in a world of non-deaf persons for whom they will daily form audible words they have never heard, and can never hear." Louis Stettner singled out the photograph in an exhibition of Faurer's work. He grasped the "eerie, Edgar Allen Poe-ish profundity to what looks like just a normal conversation."[16]

William Klein rarely aimed for profundity. His photographs of New York tend toward the offbeat and humorous. Klein's photograph of a father and son in Times Square presents a kind of didactic moment. The sign behind the father says "theater tickets," but he is pointing out something different to his boy, who is smiling. "See," the father seems to say. He gestures with his free hand, the other one clasping his son's. His finger seems to point to a pair of fluorescent lights hanging in a ticket parlor, as though his finger has some special powers. The gesture endows the entire interaction with a touch of surreal humor. Around the pair's conversation swirls the action of the entertainment district: young men and children walking rapidly, perhaps heading to a show. In the foreground, an older kerchief-wearing woman moves in the opposite direction from father and son. There is stasis as well. Even in the middle of this fast-paced movement, two men and one woman wait, standing against a storefront in typical New York postures. Klein's focus takes conversation into a different realm from those of the women photographers. His emphasis on family on an excursion to Times Square, rather than neighbors, stresses bonds of privacy.

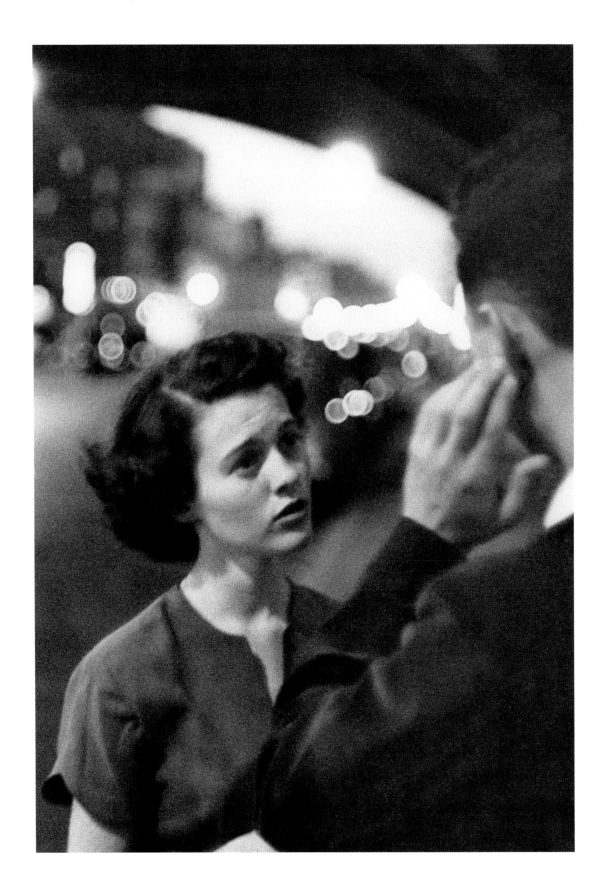

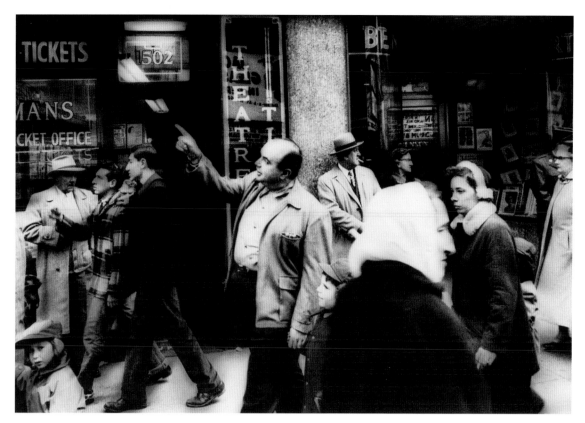

6.9 William Klein, *Theatre Tickets, New York, 1955*. Amid the rush of Times Square, a father points out a sign with one hand while holding his son's hand with the other. The expression on the boy's face registers delight. © William Klein.

Picturing talking invites visual humor. Saul Leiter opted for an expression of wit in his record of a conversation between two women. Both sport mink stoles, but the hat of the woman with her back to the camera steals the show. Its elegant feather seems to arch into a fine inverted question mark. The woman speaking has furrowed her brow, expressing a point of view gently mocked by the hat's feather. "Really?" it seems to say. Beside them stand a couple, man and woman, preoccupied by something else happening on the street. Everyone wears hats, but only one comments on the conversation.

Leiter's attention to hats reflected in part his day job as a fashion photographer. Unlike many of the young men and women who gravitated to the Photo League, Leiter came to New York City to pursue a career as a painter, though he never took any classes. He added photography but stuck with painting, unlike Dan Weiner and Sol Libsohn, who both gave up the latter for the former. Leiter's approach to photography differed from those who were associated with the League, as his picture of two well-to-do women suggests. He walked the streets, but his photos often emphasized people in relation to their physical milieu. And he pictured middle-class and even wealthy New Yorkers as often as workers.

His photos hint at changes occurring in the city. In the 1950s, New Yorkers enjoyed a standard of living

6.8 Louis Faurer, *Deaf Mutes,* ca. 1950. Both the man and woman were born deaf and learned to communicate by reading lips. Faurer's photograph shows them using the light of a streetlamp in the evening dusk. Estate of Louis Faurer.

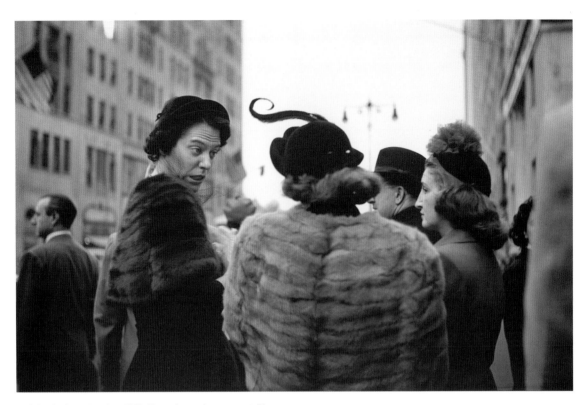

6.10 Saul Leiter, *Hat, circa 1950*. Not only are the women talking in this photo, but their hats appear to be too, or at least raising a question. Leiter could not resist the humor. © Saul Leiter Foundation. Courtesy of Howard Greenberg Gallery, New York.

higher than most American city residents. The city's public culture flourished, although it was difficult to find an audience for personal photography. "Who saw our pictures?" Leiter asked. And he answered: "Not many. We didn't have an audience. It is difficult to explain the sense of emptiness that existed around photography," especially when pictures seemed to be everywhere. "Your personal work became something in a drawer that no one ever saw," he remarked ruefully. And he concluded in retrospect: "It is difficult to maintain a certain enthusiasm when no one cares."[17]

Saul Leiter didn't arrive in New York City until the war had ended. He spent the war years studying in a yeshiva, and he bolted as soon as he could. Born in Pittsburgh, he grew up in a rabbinical family. His father, as he recalled, "was a great Talmudic scholar, learned in many ways, a linguist and a very very charming man." Leiter remembered walks with his father where he would stop to speak to the Italian shopkeeper, and then the Greek shopkeeper. He was worldly, friends with priests and ministers. "But his tolerance did not extend to his sons' lives." Two of Leiter's brothers became rabbis, fulfilling his father's ambitions. Saul Leiter rebelled. His mother gave him a camera at the age of bar mitzvah. "I grew up in a world where I was not prepared for anything," he confessed. "I studied what God wanted."[18]

Leiter wanted to paint and took up photography to earn a livelihood. He experimented with both color and black-and-white photographs. Years later he described his method: "I go out to take a walk, I

see something, I take a picture." The neighborhood around East 10th Street where he lived in New York often served Leiter as his photographic stomping grounds. "I think that mysterious things happen in familiar places," he affirmed. Leiter did not join the Photo League. He didn't see himself as political. He had hoped to exhibit at the League, but it closed just before that happened. Leiter was part of a cohort of somewhat younger Jewish photographers in New York who brought a slightly different sensibility to picturing the city's streets. "When we do not know why the photographer has taken a picture, and when we do not know why we are looking at it, all of a sudden, we discover something that we start seeing," Leiter told an interviewer. "I like this confusion," he confessed.[19]

Younger than Leiter (but the same age as Klein), Garry Winogrand grew up in the Pelham Parkway section of the Bronx in an apartment so crowded that he often walked the streets at night, since the only room where he could be alone was the bathroom. In crowded apartments where everyone shared rooms and often beds, the bathroom offered the only place for privacy. Both of his immigrant Jewish parents worked in the garment industry, his father in leather and his mother sewing neckties. Winogrand graduated from high school, served in the military, and after a year at City College, attended Columbia University in 1948 on the GI Bill.

Unlike Leiter, Winogrand studied painting. Then he learned about the Columbia Camera Club's darkroom, open twenty-four hours a day. Winogrand and a fellow photographer formed the Midnight to Dawn club, spending hours together in the darkroom. Winogrand switched to photography. "I never looked back," he recalled. The following year he attended Alexey Brodovitch's Design Laboratory at the New School for Social Research. "At the time of Winogrand's entrance" on the New York photo scene, according to the curator John Szarkowski, "one could

make a beginning with little more than energy, confidence, and a distaste for regular working hours." Like Leiter, Winogrand also did not join the Photo League. By the mid-1950s he was selling pictures to *Collier's*, *Redbook*, *Life*, *Look*, and *Sports Illustrated*; by 1960 he had his first exhibit at the Image Gallery.[20]

Winogrand made midtown his stomping grounds. He rarely ventured to sections of the city that he might have known from his childhood. For working-class Jews like Winogrand, Manhattan was "the city," an emotional and social distance from home. He was "from New York, but not of New York." The writer Fran Lebowitz thought he retained "a fascination with New York that manifests itself as a kind of wised-up curiosity."[21]

Winogrand found women particularly enticing. He readily assumed the prerogative of a white male who was free to stare at and ogle women. "Mainstream public discourse generally portrayed targets of street harassment as 'respectable' white women," argues the historian Molly Miller Brookfield, "where respectability hinged either on a woman's middle-class or elite social status or her perceived virtuousness." At the same time, like Levinstein, Winogrand recognized the male gaze and its power. The conversation of a prosperous man talking to an elegantly attired white woman whom he is escorting along Fifth Avenue portrays a heterosexual dynamic. The man has doffed his hat and guides the woman by her elbow, demonstrating what was considered proper male demeanor. While she glances down at her one ungloved hand, he looks the photographer in the eye with a kind of masculine acknowledgment. He knows that they are being photographed; she does not. The two men conspire, as it were. Both take pleasure in eyeing a "respectable" woman of elite status. She is her escort's worthy prize, as witnessed by her white fur hat and stole. They catch the sunlight and cast a halo around her face.[22]

Four Italian American men walking down East 42nd Street at two o'clock in midtown present a

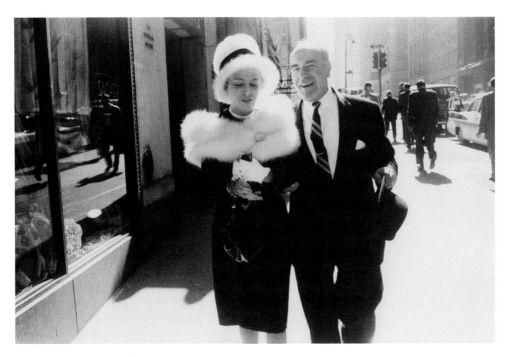

6.11 Garry Winogrand, *New York, c. 1962*. The well-dressed couple are walking and talking, but only the man acknowledges the photographer with a glance that seems to convey acquiescence to the picture being taken. Center for Creative Photography, University of Arizona: Garry Winogrand Archive. © The Estate of Garry Winogrand. Courtesy of Fraenkel Gallery, San Francisco.

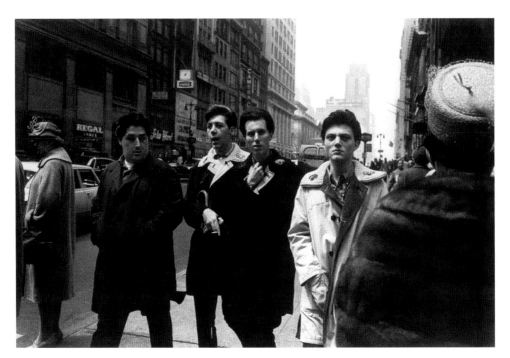

6.12 Garry Winogrand, *New York, 1961*. The men's conversation is interrupted by an elegant woman in a mink stole and veiled hat, who approaches on their left. Only the man speaking appears to resist the impulse to ogle. © The Estate of Garry Winogrand. Courtesy of Fraenkel Gallery, San Francisco.

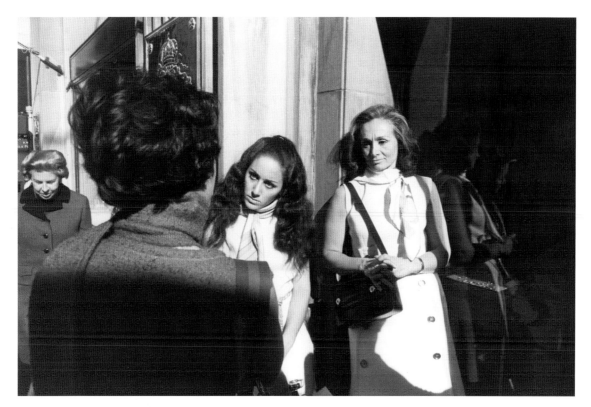

6.13 Garry Winogrand, *New York, 1967*. The photograph captures the intensity of this conversation, peering over the shoulder of the woman standing on the sidewalk at the two women in the sunshine by the plate glass window. © The Estate of Garry Winogrand. Courtesy of Fraenkel Gallery, San Francisco.

conversation interrupted by the male gaze. They express their white heterosexual masculinity through the privilege they possess of scrutinizing women. Winogrand's photograph captures this interaction as he signals clearly just how men walk the streets. One man is talking animatedly, his hands clasped with a cigarette between his fingers. His three friends may be listening, but they are definitely not paying attention. All three are eyeing an expensively dressed woman passing on their left, exactly the respectable type of woman for white men to ogle. It is impossible to know exactly what draws their attention. One man closest to the woman keeps his hands in his pockets

but stares at her intently. His companion gives a more quizzical look, turning his head slightly to stare. The shortest guy near the street also has to turn to look. The similarities of the men's almost identical raincoats—one man has worn his with the light color on the outside while the other two wear theirs with the dark side out—adds an ironic and humorous note to this aggressive encounter.[23]

Winogrand's pictures make visible male photographers' urban presence. Especially as they moved into midtown to snap shots of middle-class and prosperous New Yorkers, their gaze on women on the city's streets let viewers share their perspective. Another Winogrand photograph of a conversation, this time among women, explicitly enacts his own aggressive stare. Standing behind one of the women who appears to be talking, he catches the other two

in sunlight. Their attitudes of response differ. One leans forward in a concentrated posture, her eyes looking directly at the speaker; the other glances down, much as in the conversation that Levitt caught. The women appear to be standing outside of a fancy store, probably on Fifth Avenue. The plate glass window beside them does not reflect much of the street. Winogrand's image captures a quotidian moment, but his camera gives the conversation an erotic charge. By the 1960s, how photographers pictured New Yorkers was changing.

With increasing use of telephones in private homes in the 1950s, public conversations acquired a different valence. By 1960, 78 percent of New York households had phones. As people became accustomed to conversing on the phone in their own private spaces at home and not just in person, the telephone company responded with ever more opportunities to pay to talk. Public telephone booths sprouted everywhere. They became ubiquitous on city street corners, in subway stations, in train and bus stations, and generally in a wide array of public spaces. It cost only a dime to make a five-minute phone call, so short conversations could connect people to each other. "The public phone booth calls attention to itself by its signage, and indeed, there is something both inviting and anticipatory about phone booths," writes Kelly. "It is a public space that is truly public— available twenty-four hours a day, to anyone who wants to use it. They stand with three walls or an unlocked door, waiting to be used."[24]

New Yorkers accepted the idea of holding a conversation on the telephone in the public privacy of a phone booth. The booths' clear walls, a style introduced in 1954, allowed others to watch, especially if they were waiting to use the phone. Photographers, too, observed how telephones changed the intimacy of conversations. "Virtually no one stands up straight; nearly everyone leans, usually against the triangular shelf beneath the telephone, or against the wall of the booth itself." Kelly considered the posture of phone conversations to be "an angle of nonchalance, absorption, self-importance, seduction; they are on the verge of sliding." Like storefronts and tenement doorways, phone booths visually organized city spaces and framed figures standing within them.[25]

"Interstitial spaces, neither wholly public nor wholly private, provisional yet permanent, the earliest phone booths were nevertheless lovely places to be." These liminal spaces represented one of the "first real attempts to create private areas in public spaces," argues Kelly. In crowded cities, "the phone booth was a welcome reprieve, a space in which one could gain breathing room." Phone booths allowed photographers to shoot the conversations, since the men and women talking were on display without a ready means of escape.[26]

As viewed in a phone booth, a conversation became one-sided. Both Klein and Winogrand could not resist the humor of phone conversations in public telephone booths. They saw the performative dimensions of a conversation with an invisible interlocutor. Both also recognized how a phone conversation could absorb the speaker's attention, freeing the photographer to approach with his camera. Despite being visible to those outside a phone booth, a person who entered a booth and closed the door secured a measure of privacy. The phone booth removed one from the pressure of the streets, muting some of its sounds. It provided a place to reflect. As Kelly sardonically observed, "Phone booths often showed communication for what it is, or can sometimes be: a pantomime of connection."[27]

Klein's photograph titled *EPHO, New York, 1955* gently mocks the four letters visible on the telephone booth in the image. This phone booth, one of a row of phone booths in a cigar store at the corner of 42nd Street and Broadway, offered a place to sit

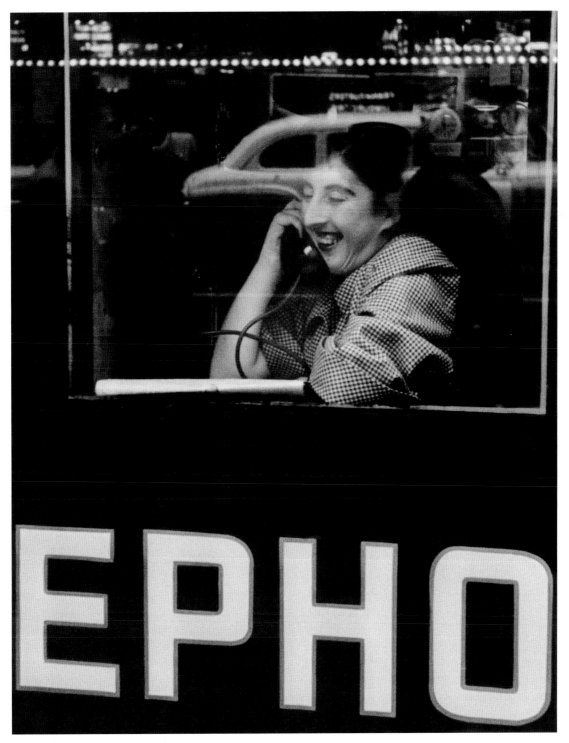

6.14 William Klein, *EPHO, New York, 1955*. Talking on the telephone in a phone booth collapsed private and public: one side of the conversation was visible but not heard. Klein's photo simultaneously presents a visual equivalent that merges the inside of the booth with reflections of the street outside. © William Klein.

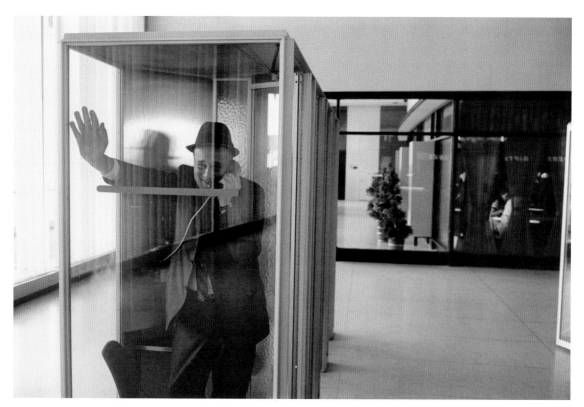

6.15 Garry Winogrand, *John F. Kennedy International Airport, New York, 1968*. All-glass telephone booths offered only aural privacy, not visual, as this photograph reveals. Winogrand saw a surreal dimension to the situation presented in a straight photograph. © The Estate of Garry Winogrand. Courtesy of Fraenkel Gallery, San Francisco.

while talking. The woman on the phone is smiling broadly, clearly enjoying what she is hearing in the receiver. Klein recalled that for more than five minutes he documented her conversation; she was too absorbed to notice. The phone booth's window frames her a second time within the photograph's frame. Although she appears to be removed from the city's bustle, ensconced in the booth's public privacy, the street's chaos is reflected in the glass. A yellow taxi seems to be driving behind her head. Lights from the street ricochet off the glass even as phantom elements of the shop where she is making the call make an appearance behind her back. The clarity

of the EPHO letters in the bottom half of the photo contrasts vividly with the apparent bedlam of the booth's glass. Klein's photograph comments on the phone booth's promise of a place of privacy in public space as well as the character of a conversation that is, per Kelly, "a pantomime of connection."[28]

That pantomime often played out in multiple booths at the same time. John F. Kennedy airport featured the new all-glass phone booths, part of a bank of booths typically installed in places of transit. Their heavy glass construction prevented sound from traveling from one booth to another, although people using the booths could see each other. Winogrand's photo taken in 1968 frames a phone conversation in its rather sterile, almost abstract, modern context of glass and aluminum. The glass reflects none of the street's chaos. Although the terminal appears mostly

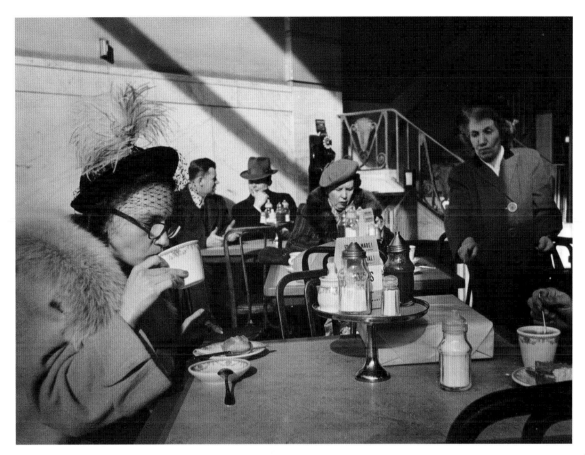

6.16 Esther Bubley, *Automat, New York City, 1948*. The scene of conversation is taking place at a table in the back between two men, with a pay telephone attached to the wall ready for a customer. © Esther Bubley.

empty of others, the conversationalist does not seem to mind. He is talking excitedly. He has turned his back to the phone and stretches one hand to lean against the glass wall. He ignores the seat. There is a sense of urgency here, but also a feeling of pleasure. Perhaps he has just arrived from a trip and is eager to connect on a local call. Perhaps he is about to leave and wants to say a last goodbye. Winogrand's photograph comments wryly on Kelly's conclusions. "Just as the invention of the clock changed our subjective experience of time," she writes, "public phones transformed our subjective experience of communication. They made communication more universal, yes, but they also made it more subject to accident and coincidence. They afforded us some privacy, but also exposed us to the rest of the world."[29]

Telephones, whether in public booths or private homes, did not usurp conversations among New Yorkers. Meeting friends and family, neighbors and business associates for conversations in person endured as a powerful means of communicating. Although chance encounters could produce intense conversations, often New Yorkers planned for the pleasures of talking. They arranged to meet in restaurants and parks, at playgrounds and in stores, to catch up, share news, to experience, potentially,

that elemental togetherness that Buber called the "interhuman."

Esther Bubley's photograph taken in an Automat, one of the many types of self-service cafeterias scattered throughout midtown, conveys that experience. In the foreground a well-attired woman sips a cup of coffee, her conversation partner across from her, out of the frame except for her hand stirring her coffee. Yet the photo records enough to imagine a narrative of their outing. Between them, on the table, lies a package, suggesting that they have been on a shopping expedition together. Although the middle of the photo presents a woman alone, behind her an intense conversation is occurring. On the back wall, next to a public telephone, two men are talking. One man, hatless, opens his hands expressively to make his point. It's a good deal, he might be urging. His partner, hat tilted over his eyes, holds his thumb to his lips, emphasizing a measure of skepticism. Both men and women enjoy conversing, but neither choose to sit with each other. These friendships are homosocial.

Conversations carried New Yorkers through the day and into the evening. Even as telephones became commonplace, the power of talking in person to another endured. Photographers pictured these public conversations as key elements of urban life that sustained connections among the city's diverse peoples. The Bronx-born, Jewish writer Vivian Gornick described just how this worked, how she began "to hear the city, and feel its presence." As she walked the street, "Two men in their twenties, thin and well dressed, brush past me, one saying rapidly to the other, 'You gotta give her credit. She made herself out of nothing. And I mean nothing.'" The fragment of conversation made her laugh. "Nothing heals me of a sore and angry heart like a walk through the very city I often feel denying me," she affirms. Such is the power of conversations, even those overheard fragments of speech.[30]

7. Selling

In 1936, Aaron Siskind, a Jewish American photographer and public school teacher, received an invitation to collaborate on an "extensive cultural analysis" of Black Harlem. Sol Libsohn and Sid Grossman had recently persuaded Siskind to rejoin the reimagined New York Photo League. Wary of left-wing politics, especially of the communist Popular Front launched that same year, Siskind had agreed, with the proviso that he be given freedom to pursue the photographic projects he desired. The Harlem collaboration with a Black sociologist, Michael Carter, fit the type of project he wanted to engage in. Siskind liked the idea of returning to the old Jewish neighborhood, which had given its name to the renaissance of Black writing and art of the 1920s. Harlem was worth revisiting, especially in the wake of riots that had rocked the area the previous year.[1]

Sara Blair, in her book *Harlem Crossroads: Black Writers and the Photograph in the Twentieth Century*, argues that Harlem after the 1935 riots "constituted a special kind of crossroads. It exemplified both the cultural moment of Americans of African descent and the shifting facts on the ground of the mutual mediation" that would emerge from a particular blend of text and image. Black writers and mostly Jewish photographers produced that synthesis. Siskind gathered such a group of photographers who had discovered the Photo League, taken a class in photography, and were ready for a more advanced "Feature Group" project. Several, including Lucy Ashjian and Sol Prom, were in their thirties like Siskind; others, like Morris Engel and Jack Mendelsohn (later Manning), were teenagers. Working collectively, they collaborated over several years as part of a League Feature Group on what would become the Harlem Document. Blair characterizes most photographers who went to Harlem not as leftists but rather as amateurs, autodidacts, immigrants, refugees, and tenement dwellers. They were also "overwhelmingly Jews: not quite white, or only provisionally white in the racial economy of interwar America."[2]

Although the group included non-Jews like Ashjian, the issue of Jewish attitudes toward Black people as expressed in photographs continues to animate discussions of the Harlem Document. Photography scholar Ya'ara Gil-Glazer sees reflected in Siskind's group's photographs a "Jewish sensitivity," albeit one tainted "by an estranged ambivalence." Curator and writer Maurice Berger describes these photographers of Harlem as "white Americans and

cultural intruders" and contends that their status "made them more than just objective witnesses. It also implicated them in the complex social dynamic they were documenting." Had they been more introspective and subjective, the project of photographing "Harlem might also have served as a place to study some of the essentials of white existence—especially the white racial attitudes and beliefs that infiltrated and conditioned the lives of virtually every one of its residents."[3]

Blair takes a different approach to this Feature Group's project. "If, like other photo-documentarians, they imaged the stark limits of Franklin Delano Roosevelt's democratic vistas," she writes, "their interest was focused not on evidence of deprivation or failure but on the everyday social exchanges in which such limits were actively experienced." Her insight extends to Siskind's leadership. He urged his coworkers to eschew "the literal representation of a fact" in favor of "a growing concentration of feeling." Not muckraking or commercial photojournalism but rather, she explains, "detailed exploration" of "the special case." Their collaborative on-site work involved what Siskind called "preparation in excess" or extensive research, note-taking, visits to the neighborhood, casual conversations with subjects, formal interviews, "talking, and listening, and looking, looking."[4]

As a scholar interested in expressions of Jewishness in photography as well as literature, Blair has written extensively and thoughtfully on Jewish resonances in the making and substance of the Harlem Document. She deals with the political, racial, and aesthetic issues that swirled around Siskind and his Feature Group workers. "Privy firsthand to the raw material of Depression-era photojournalism—evictions, foreclosures, strikes, protests, hunger marches, and work actions—Feature Group members were free both to exploit and to meditate on their dual status as social participants and photographic observers of the city's locked-out generation." Rather than emphasize questions of realism, she stresses the "context of the Feature Group's indigeneity to the life-worlds it began by documenting."[5]

The notion of embedded production certainly rang true for the native New Yorkers in the group, even though several, like Engel, had grown up in Brooklyn and not Manhattan. In those years, Manhattan was "the city" as distinct from Brooklyn (or any other borough). Engel remembered what it meant to be part of Siskind's Feature Group. Calling it "the best group I could have joined," he described its leader as "older, probably ten years our senior," a seventeen-year-old's perspective. (Actually, Siskind was fifteen years older.) "He got together a group of 'kids'" who began to work on several projects, one at a time. For Engel, "The feature group became the example of how to make pictures." Indeed, writes Blair, the Feature Group's "early photo-stories resonate with tensions encoded in the images themselves: between strangeness and intimacy, the foreign and the known, interiority and social landscape."[6]

Engel's photograph of a Harlem merchant exemplifies exactly those tensions but adds an additional one: the commerce that is this man's livelihood. He is, after all, a small-scale capitalist, eking out a living within his tiny corner candy stand. Many League photographers championed a socialist form of economy, one that eliminated inherent capitalist exploitation of workers. How to picture buying and selling proved to be a challenge.

Like other left-leaning Jews, Jewish photographers associated with the Photo League often distinguished between "bosses," who employed others, and "workers." Even the Workers Cooperative Colony in the Bronx, "one of the ideologically rigorous Jewish cooperative housing projects in the city, refused to exclude Jewish entrepreneurs from the category of 'workers.' The cooperative's directors restricted the housing project to 'those who earned their living by

the sweat of their brows.' Elaborating the definition of that biblical category," explains historian Beth Wenger, "the directors insisted that 'small business owners' were considered self-employed workers, but bosses, who lived off of the labor of others, were not welcome." Such distinctions perhaps unconsciously guided Jewish photographers' choices.[7]

Harlem Merchant also turned out to be the first photograph that Engel made with a Rolleiflex, which he had borrowed from a friend. It cemented a life-long attachment to the camera, although Engel would go on to master the photojournalist's Speed Graphic as well as motion-picture cameras. Looking at this photograph, the historian of photography Alan Trachtenberg asks: "To whom do the depicted objects make themselves intelligible? What sort of knowledge does the scene take for granted?" In short, if the goal is to make a living, some explanation is required of the items for sale. Both candy and tobacco could be purchased in small quantities and did not spoil. Both offered instant pleasure; both were addictive. Both also required very modest investment on the part of the merchant. Clearly, both must have appealed to potential customers, children and adults, or at least were assumed to attract them. Unlike Chick's Candy Store, this Harlem merchant doesn't sell sodas or stationery or school supplies, although he might aspire to own such an apparently prosperous shop. Like candy and tobacco, the photograph combines aesthetics and politics. "It's hard to imagine a better example of the coexistence of transparency and opacity in a single photograph than *Harlem Merchant*, a masterpiece of balanced ambiguity," writes Trachtenberg. "Balance is of the essence here, a rigorous composition in which frontality and symmetry proclaim their presence and bring the work of the camera itself into play."[8]

This symmetry appears in the framing of the merchant's head within the small window of his stand. Engel pictures him in the upper middle of the photograph, flanked on either side by large jars of candy in a kind of triptych. A small fan behind his head indicates that the stand's interior must have become hot and stuffy. In the lower half of the photograph, beneath a band of advertisements for chewing tobacco, lies a jumble of miscellaneous items, all for sale. "The chaotic pile of tins and packets on display underneath seems to flow across the frame like a stream of detritus," argues Richard Ings. He does not see any particular pride or "proprietorial" pose in the image, which he attributes to Engel's perspective as a white photographer. The photograph exposes "the limits to African American legal ownership of space."[9]

Intrigued with Jewish resonances in New York City photographs, Trachtenberg, like Blair, contemplates their social knowledge, what can be known and what remains speculation. "What does the image reveal about itself in the course of revealing this slice of a 'real' world? Not only knowledge, something already known, but *a way of* knowing, a method, a pedagogy, something taught alongside something shown: face, shop, jars, windows, the command to 'Chew Brown's Mule.'" And he remarks that the photograph's title, *Harlem Merchant*, signifies a place with a history and an occupation with other connotations that together conspire to present a form of social knowledge. He notes the conjunction of place and person. "Entangled associations with a region and style of urban life compressed in the words 'Harlem' and 'Merchant' conjure figurative associations as well." For Engel and his fellow Feature Group photographers, those associations might have referenced New York Jews, reminding contemporary viewers of Jewish merchants in Harlem pilloried in 1935 for their unwillingness to hire Black Americans. Trachtenberg concludes, "The title fills the picture with an informing presence; it is like a friendly angel who makes us feel we know where we are, at home even if we are strangers to this place and this person, at home because we

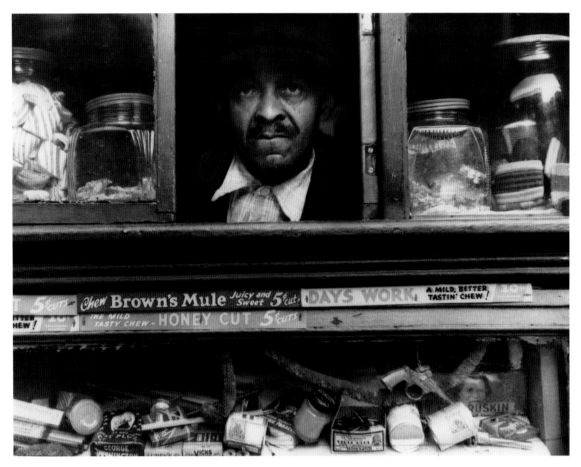

7.1 Morris Engel, *Harlem Merchant, New York,* 1937. Enclosed in his street stand selling candy and tobacco, the man looks directly at the photographer—and at viewers of the photograph—an exchange of stares. © Morris Engel.

believe we know what the terms designate and mean: *Harlem Merchant.*"[10]

This last chapter begins with Engel's photograph because it epitomizes the complexity and layers of questions and understandings that are involved in League photographers' pictures of selling. Commerce stood at the center of the city's economic life along-side manufacturing. The term referenced both large department stores, such as those lining Fifth Avenue or dominating the streets of downtown Brooklyn

or even serving as flagships along Fordham Road in the Bronx, as well as local neighborhood groceries, clothing stores, fresh fish and live chicken markets. It even included such marginal commercial enterprises as newspaper and candy stands, as well as pushcart vendors and shoeshine boys and men. As the writer E. B. White trenchantly observed in 1948: "Thus, no matter where you live in New York, you will find within a block or two a grocery store, a barbershop, a newsstand, a shoe shine shack, an ice-coal-and-wood cellar (where you write your order on a pad outside as you walk by), a dry cleaner, a laundry, a delicatessen (beer and sandwiches delivered at any hour to your door), a flower shop, an undertaker's

parlor, a movie house, a radio-repair shop, a stationer, a haberdasher, a tailor, a drugstore, a garage, a tearoom, a saloon, a hardware store, a liquor store, a shoe repair shop." All were visible from the street.[11]

The prevalence of plate glass windows advertising goods for sale inside a store dominated both large- and small-scale commerce in the city. Both women and girls regularly indulged in window shopping, strolling along the blocks lined with large department stores and contemplating the items for sale. Men indulged as well, perhaps less frequently. Window shopping provided an urban alternative to reading magazine and newspaper ads. It was more fun to share the experience with a friend or family member than to peruse magazines alone. Clothing displays particularly intrigued through their artful presentation and helped to inform viewers of the latest styles. Such forms of display advertising enticed Lisette Model—not to buy but to look. What she saw reflected in these windows entranced her. Model understood a photograph as a "projection" of the material world and a way of exploring its underlying social relations. The photograph shows familiar aspects of our social world, Blair writes, only "to demand that we confront what is unknown, mysterious, or otherwise obscured by our conventions for inhabiting it."[12]

Although Model joined the League, she did not consistently share its politically engaged aesthetic. Nor did she participate in a Feature Group. Rather, she reframed the photograph as providing an occasion to probe "the effects of the actual state of human understanding." Photographs offered a tool for making usable histories and enhancing self-consciousness. "An immaterial [version] of what surrounds us," she wrote, the image makes it possible for the viewer "to be receptive" to social and existential truths "project[ed]" within it. Blair considers her arguments to be inflected by her social dislocation as a European Jewish refugee.[13]

Soon after arriving in New York in 1938, Model started to take a series of photographs under the rubric of "reflections." The term referred not only to the power of plate glass to invite looking inside while standing outside, seeing both simultaneously, but also to a kind of contemplation of aspects of city life. "Model conjures an external projection of an internal world," argues curator and scholar Lisa Hostetler. *First Reflection, New York,* taken on the lower west side of Manhattan dominated by railroad terminals and wholesale markets, features a man's hatted head near the top of the photograph complemented by a hat for sale at the bottom. The store's two bays of plate glass (seen in an uncropped version) frame a recessed entryway, encouraging a potential customer to wander partway into the store to view its sheets and towels as well as clothes without actually entering. But a large *S* occupies the man's face, transforming his gaze into the store window and hinting at a dollar sign. To Hostetler, "the objects seem to be thoughts dancing in his head." At the same time, Model's photograph presents key elements of the street itself: a vertical signpost for a hotel on the left and the massive, pointed towers of Starin's ferry building for railroad freight on the right. These features identify the place, although Model did not name it as Engel had. Yet like Engel she presents a new way to look upon commerce, not as a simple transaction of selling and buying, but as a complex seduction.[14]

Immigrant Jews noticed the prevalence of plate glass throughout the city. A few contemplated its meanings. "Late one evening, I went out to look at Pitkin Avenue," Brownsville, Brooklyn's main shopping street. "Most of the stores were already closed. But the greatest surprise to me," confessed one recent immigrant, "was that not a single store had shutters. The show windows were full of merchandise. One could easily break the glass and take everything out!" The prospect amazed Chaim Kuznetz. He went

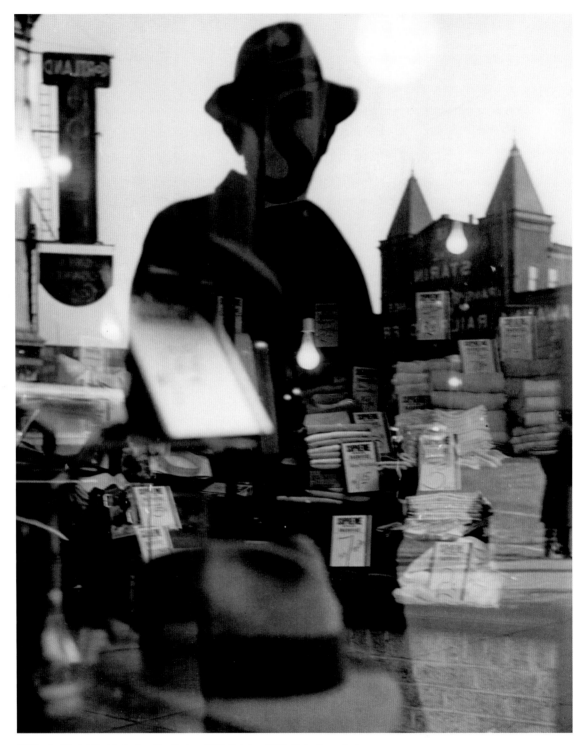

7.2 Lisette Model, *First Reflection, New York,* c. 1939–October 1940. Plate glass window displays tempted potential purchasers by bringing the merchandise to the street. Model's photograph conveys that interaction between a hat-wearing man and a dry goods store.
© Lisette Model Foundation, Inc. Courtesy of the National Gallery of Canada, Ottawa.

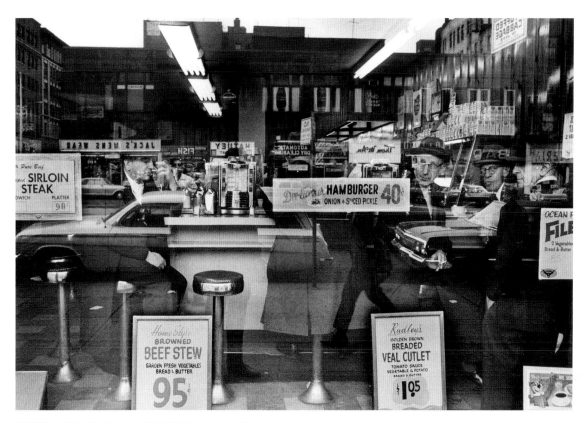

7.3 William Klein, *Hamburger + 40¢, Eighth Avenue, New York, 1955*. A riot of signs plastered on the window accompanies the special chosen for the title. A chaos of reflections produced by plate glass epitomized New York City in midtown Manhattan. © William Klein.

on to imagine what one could do. "At night, one could certainly cart entire stores away without so much as a rooster crowing about it." His conclusion: "America is not only a blessed land, but also a land of pure saints, of strictly honest people."[15]

Although a native New Yorker, William Klein shared Kuznetz's fascination with plate glass and extended it. *Hamburger + 40¢, Eighth Avenue, New York, 1955* obliterates distinctions between interior and exterior. Klein's photograph is an optical joke, a food fight, a crackup. Looking through a diner window, Klein's camera sucks indoors and outdoors into one another, leaving pieces of each plastered on

the plane of glass itself. Fluorescent lights dangle in the sky. Signs promote lunch specials for Lace's Mens Wear, Thom McAn shoes, and for Fish. A woman's skirted backside hangs out beneath the hamburger sign. Three men perched on stools hardly seem to notice that they are as flat as the signs floating all around them, nor that they are tangled up with cabs and striding pedestrians, nor even that Klein has just nominated them to be permanent exhibits in his crazy cabinet of wonders, New York, New York. The "kinetic quality of New York" grabbed Klein, and he tried to "find a photographic style that would come close to it." So he experimented. Straight his photography wasn't. He pushed and pulled his focus, his exposure, his printing, and his processing.[16]

Klein eliminated any presence of an outsider looking in, eyeing what is offered. Only a close

look reveals the photographer himself, who can be glimpsed straddling an empty stool. Otherwise, just a pair of a man's legs, striding rapidly along the sidewalk, hint at the street's presence. Klein brings everything up front, most especially the three hat-wearing men seated around what seems to be a taxi. One man with glasses has spied the photographer standing outside of the diner and looks at him with lips pursed. Klein ignores the glare. He is less interested in the men than he is in the profusion of placards all advertising commerce. The diner has posted modestly priced specials on the plate glass, including beef stew, breaded veal cutlet, and sirloin steak as well as the relatively inexpensive hamburger. Banks of fluorescent lights illuminate the interior space, bouncing rays off its shiny metal surfaces: the gleaming counters, circular stools, jukebox selections. It's a riot of excess, the kind of world that New Yorkers inhabited without particularly paying much attention. Klein noticed, caustically.

Most Jewish street photographers grappled with their capitalist city by focusing on the individuals who earned their livelihoods on the street. They especially gravitated to pushcart vendors, shoeshine boys, and newsstands. These forms of street commerce enlivened a working-class neighborhood and gave it a character that epitomized New York as much as the magnificent emporiums along Fifth Avenue or the ever-present plate glass.

Like Engel, Walter Rosenblum discovered the camera's liberating power as a teenager when he joined the New York Photo League in 1938. Rosenblum grew up on the streets of the Lower East Side and lived its poverty in a three-room cold-water flat in an environment of "religious orthodoxy, economic instability and familial love." The toilet was in the hall (an improvement from privies, the result of tenement house legislation), and the bathroom was in the kitchen. "We never lit the coal stove in the winter until 2:00 in the afternoon because we had no money for coal," he recalled. "You didn't eat properly; my breakfast was a roll soaked in coffee." Like Engel, when he discovered the League, he felt he "had a home." He edited the League's newsletter, *Photo Notes*, until he entered military service. He, too, joined a Feature Group. His group chose Pitt Street on the Lower East Side with a goal to represent the everyday life of ordinary working people. Rosenblum worked on the project for six months, part of a class he took with Sid Grossman. Rosenblum returned repeatedly to the blocks without any particular shooting script. He based his approach instead on his own "observations of social interactions, networks, habits, and institutions." In a 1976 interview, Rosenblum explained what the League and its Feature Groups meant. "It was a whole environmental experience that changed you because of the influences that you came in contact with." He elaborated, "Photography then became part of a total cultural superstructure which related to an economic and social climate of which it was a part."[17]

This journey of self-discovery, shaped by Marxist understanding of the economic basis of society and photography's place within it, carried Rosenblum back to familiar streets. The camera gave him a new way of seeing. "You began consciously or subconsciously to develop an understanding of who you were and what you were about." His photograph *Gypsies and a Vegetable Dealer* captures a complex but prosaic scene. It reveals the interactions of neighbors, the mix of commerce and housing, and conversations that occurred from the stoop to the street and through open windows.[18]

This diverse activity reveals a poor urban milieu where distinctions between public and private space blur. A woman descends the steps with a toddler in tow. She pauses, a smile on her face, and glances up at the open window. There an attractive young woman sits with her fabric where the light is good. "She converses with a bareheaded man standing at

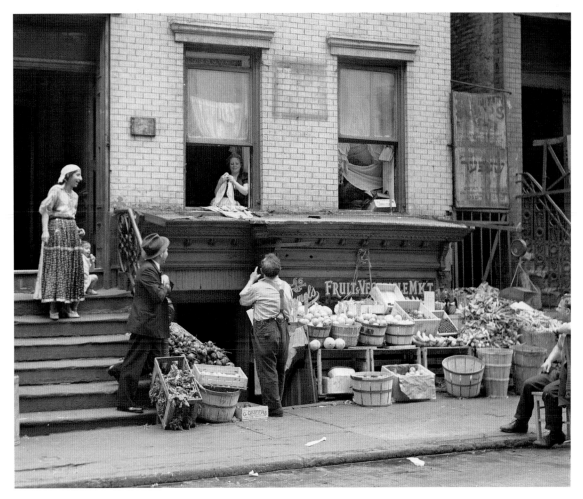

7.4 Walter Rosenblum, *Gypsies and a Vegetable Dealer*, 1938.
This scene unfolded on the Lower East Side, where living quarters and commerce shared spaces. A dealer selling produce from a basement shop on a warm sunny day engaged with neighbors, outside, on the steps, and sitting by the window.

the entry to the fruit and vegetable store, several steps below street level." He holds a sheet of paper in one hand, the other raised as though querying her. Perhaps he is taking an order for some vegetables. The conversation has caught the attention of another man, dressed in suit and hat despite the heat. He leans forward on the tenement railing to listen, smiling. A third man also observes the scene. He sits on a wooden chair in the street by the curb. "He has removed his worn sweater and appears relaxed and poised, perhaps waiting for customers." It is not clear who is the proprietor of the fruit and vegetable stand, who an assistant. To the right above a metal gate leading to a passageway between the two tenements a worn, illegible sign advertises in Yiddish and English, signifying an immigrant Jewish neighborhood. "The scene is ordinary yet intimate. A snapshot of everyday close encounters, it captures a vision of a neighborhood sustained by quotidian exchanges."[19]

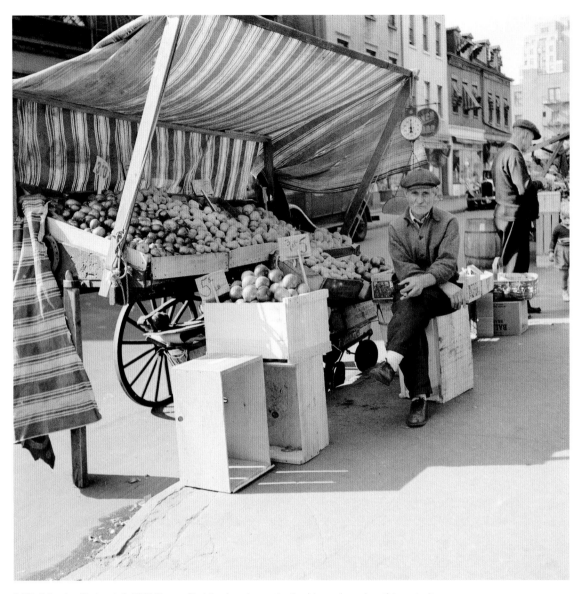

7.5 Sol Libsohn, *Pushcarts 2*, 1938. The sunlit striped awning protecting his produce gives this portrait of an aging man a measure of cheerfulness, but his posture expresses a weariness mixed with resignation. Sol Libsohn (1914–2001) for Federal Art Project. Museum of the City of New York. 43.131.6.144. © Sol Libsohn (1914–2001)/Museum of the City of New York.

Rosenblum documented his own world. "I realized," he later said, "that I worked best when I was photographing something or someone I loved and that through my photographs I could pay them homage." The fruit and vegetable sellers and their produce are part and parcel of tenement living. Commerce coexists with women's home-based labor. Rosenblum also paid attention to the visual complexity of the scene. A band of light enlivens the row of vegetables and fruit that runs parallel to the sunlit sidewalk.[20]

There were many ways to picture street commerce. Sol Libsohn and N. Jay Jaffee each present a somewhat different vision that focuses on a person selling. Libsohn's portrait of an elderly vegetable seller sitting on a crate by his pushcart with his legs and arms crossed endows the man with dignity. The striped awning he has erected to shade his produce—mostly staples such as potatoes and onions—transmits a kind of cheerfulness. The open window awnings on several tenements echo its stripes. But the man's worn face and posture, and Libsohn's distance from him, hint at the boredom and weariness of the work.

In New York, the density of Jewish and Italian neighborhoods "supported the transition of street marketing from an occupation restricted to a small number of itinerant peddlers to an established retail institution." These pushcart vendors did not rove up and down the blocks of a neighborhood but stationed themselves in front of shops where they "developed a steady clientele of housewives." They made certain Lower East Side residential streets synonymous with shopping, the transitions occurring in the late nineteenth century: Hester Street in 1886, Grand Street in 1893, and both Orchard and Rivington Streets in 1898. Historian Daniel Bluestone argues that bans on street selling "sought to accommodate a vision of streets as exclusive travel arteries," and as such pointed to efforts to eclipse

"earlier social uses of the street for political activity, gregarious socializing, and popular amusements." In the 1930s, Mayor Fiorello LaGuardia built a huge indoor market on Essex Street designed to accommodate many street vendors on the Lower East Side. The Essex Street market facilitated the removal of pushcarts, although it did not eliminate them entirely.[21]

LaGuardia's ban did not extend to the other boroughs. Brooklyn born and raised, the photographer N. Jay Jaffee gravitated to familiar streets, as Rosenblum did. Jaffee often walked the blocks of the immigrant Jewish neighborhood of Brownsville and adjacent East New York. Working-class Jews made up the overwhelming majority of Brownsville's residents. In the early decades of the century the neighborhood acquired a reputation for radicalism, repeatedly electing Socialists to the New York State legislature. During the Great Depression, Brownsville gained a reputation for gang violence as the home of Murder, Inc. After World War II, the area attracted Black migrants from the South. By the late 1960s, Brownsville had become a poor Black neighborhood.

Alfred Kazin's memoir of growing up in Brownsville, *A Walker in the City*, evokes the character of the Jewish women, "open, hearty people," who ran the stalls on Belmont Avenue, the major street market. "Their shrewd open-weather eyes missed nothing," he wrote. "The street was their native element; they seemed to hold it together with their hands, mouths, fists, and knees; they stood up in it behind their stands all day long, and in every weather; they stood up for themselves."[22]

Jaffee pictures a woman standing amidst a profusion of vegetables spilling out into the street at her stall not on Belmont but on Blake Avenue, one of the blocks with Italian as well as Jewish immigrants. His photograph captures some of the power Kazin attributed to the Jewish market women. It is a day with warm weather, most likely fall, given the watermelon

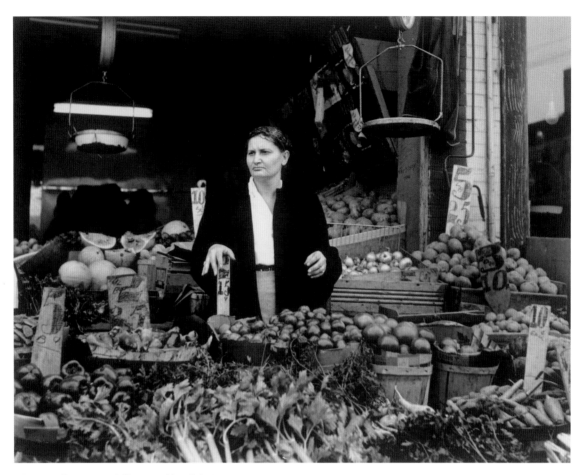

7.6 N. Jay Jaffee, *Woman Selling Vegetables, Blake Avenue, Brooklyn, 1949.* Jaffee's sympathetic portrait of a woman selling fruits and vegetables situates her amid her abundant produce. Street markets, such as the one on Blake Avenue, served large numbers of working-class New Yorkers. © N. Jay Jaffee. All Rights Reserved. Used by permission of the N. Jay Jaffee Trust, www.njayjaffee.com.

for sale. The vendor stands amidst her merchandise, intently watching something off camera, perhaps a customer. Her graceful fingers seem to dance amid the profusion of vegetables.

Jaffee's photograph exemplifies Kazin's "consciously poetizing treatment of the tawdry, everyday details of life in Brownsville," as Benjamin Pollak argues, which implicitly claims "that aesthetic, cultural, and moral riches are no less available in poor Brownsville than in the city's wealthier neighborhoods." Jaffee empathetically presents a woman selling a variety of vegetables, leafy green ones as well as staples, as engaged in a worthy endeavor. The tools of her trade, namely scales, hang beside her and further inside the store. He has framed her right in the middle of the photograph. This is her domain. Many years later Jaffee explained that his postwar photographs, "although not mainly political, revealed my sympathies. They are of working people and their surroundings—people who lived ordinary, unglamorous lives." Like Kazin's life writing,

Jaffee's photographs were "a reflection of who I was. To photograph them was a way of ennobling their existence—and affirming my own."[23]

N. Jay Jaffee was born in Brownsville to Jewish immigrant parents. But after a series of moves, he grew up on Park Place in Brooklyn, located between Crown Heights and Brownsville. His father worked as a skilled cutter in the garment industry. His mother introduced him to the street market on Prospect Place, where family-owned stores lined the blocks and pushcarts lined the curb. "A large selection of fresh produce was always available," he recalled. "The sweet smell of fruits and vegetables permeated the air." Looking back, he remembered: "The hue and cry of the marketplace created a dissonance that was both agitating, but not threatening, knowing that the vendors' shouts were just pleas to the shopper, urging them to buy the produce from their pushcarts or their wares and dry good[s] from the shops along the sidewalks." Jaffee soon made regular trips to the market, sent by his mother. Her death when he was fifteen prompted him to leave school and find work as a typesetter.[24]

Jaffee served three years in the infantry during World War II, seeing combat in the European theater. His politics were progressive: he enlisted to defeat Nazism and fascism. After returning to civilian life and marrying, he found himself at loose ends. His older brother encouraged him in 1947 to purchase his first camera, a Kodak Monitor. In those years he lived in East New York. His foray onto Blake Avenue reminded him of pushcart vendors near his boyhood home. "Such a street was still alive with the ethnic traditions I was familiar with some fifteen years earlier. This market was simply referred to as Blake Avenue." He gravitated to the Blake Avenue market with his camera, seeking "to communicate the atmosphere of the market." Later he realized that the war had blotted out his past. "I was reliving the same smells, the bittersweet street humor and pathos

reminding me of the time when I was beginning to taste life, when I was on the threshold of experiences that were going to shape and mold my character."[25]

In 1948 he took a class with Sid Grossman held at Local 65, the Wholesale and Warehouse Union's hall at Astor Place in lower Manhattan. The union "had become a center for progressive political action in the metropolitan area. Its members never tired of demonstrating for one cause or another." District 65 had a camera club, originally part of its recreation program. Often, the union paper, the *Union Voice*, printed the photographs, rewarding club members' efforts. Members "did stories on different parts of the union, like the industries, the outings, whatever came. The only thing was the technical quality wasn't good because a lot of them didn't have really good cameras," recalled Ed Roth. "These were low-paid workers. So the Union decided to go out and buy a Speedgraphic, which was the camera in use at the time by the press. And we learned how to use it." Roth remembered how "people from the Photo League" who were "sympathetic to our cause" trained union members. "They would orient them to what your function is as a photographer," explained Roth. "You've got to remember who you are. Like if there's a crowd of people, you can't hesitate to push your way to the front and get the pictures. You're a witness for it could be hundreds or thousands of people, maybe millions."[26]

Grossman had left the Photo League by 1948 because of anti-Communist attacks. Jaffee subsequently discovered the League, after it had moved to the basement of the Albert Hotel at the corner of University Place and 10th Street, a couple of blocks from the union hall. He took several classes with Dan Weiner and attended lectures but never joined, having set up his own darkroom at home. Jaffee often photographed the small-scale Jewish commercial establishments along Blake Avenue and in Brownsville. "Blake Avenue reawakened the memories of my

early years. I used the camera in this community in a way that would help rediscover who I was, and where I came from."[27]

Jaffee's photographs of Brownsville's streetscape convey the plethora of signs that dominated the neighborhood's commercial establishments. His picture of the exuberant advertising on a somewhat atypical store, Kishke King, comments on the energy devoted to selling by Jewish immigrants. In addition to its titled product—a sausage made from intestine stuffed with meat, meal, and spices popular among eastern European Jewish immigrants—the building advertises frankfurters long enough for two to share (a heterosexual couple). It promises fourteen bites of pleasure. Beneath the window to place an order, the sign offers "2 Large Hamburgers" for a quarter, a bargain compared with the midtown diner Klein shot on Eighth Avenue. Jaffee thought: "Its announcements and artwork are hysterical—and hilarious." He later wondered "why this building was not the most photographed building in Brooklyn." Probably others didn't picture this place because relatively few photographers made their way out to Brownsville in those years. It had none of the fame of Harlem, none of the magic of Times Square, none of the pleasures of Coney Island, not even the familiar nostalgia of the Lower East Side. "We were the end of line," Kazin wrote. "We were the children of the immigrants who had camped at the city's back door, in New York's rawest, remotest, cheapest ghetto." Brownsville lacked cachet, although this formative Brooklyn Jewish neighborhood presented many of the cultural contradictions of working-class New York, including its mixture of radical politics, religious piety, criminal activity, and commercial striving.[28]

Manhattan looked different from Brooklyn, especially those blocks that were not part of immigrant neighborhoods. Canal Street ran the width of Manhattan with a bridge to Brooklyn on its east end and a tunnel to New Jersey at its western terminus. It cut through both the Lower East and Lower West Sides. Jaffee's picture of Canal Street captures the rhythm of a street that catered to men shopping. "Come In and Browse" invites a sign outside a job lots storefront. Movement in and out of stores, the search for the right piece of equipment or the perfect bargain, animates the block. One can almost feel the summer heat along with the pace. Men walk purposefully, their eyes on what is offered for sale. Hands clasped behind the back suggest a European posture of walking, in contrast to hands thrust in pockets.

The Lower East Side "was a street photographer's paradise," Helen Gee recalled. In the early 1950s, "the tenements had not yet been replaced with giant housing projects, and life was still lived on the streets. Television had not yet made inroads, and the drama was all outside." Gee grew up in a German-American non-Jewish home in Washington Heights in northern Manhattan. She lost her mother as a young child and ran away from home at sixteen, after her father remarried. Coming down to the Lower East Side, an unfamiliar neighborhood, she observed the gendered action. "Women hung out of windows, keeping an eye on their kids; boys played stickball and cops-and-robbers; girls skipped rope and played hopscotch; old people sunned themselves on camp chairs; and neighbors gossiped on stoops." But on Sundays, "people came from all over, to haggle with the vendors, pick up bargains in the mom-and-pop stores, and gorge themselves on blintzes, knishes, and the best kosher frankfurters in town."[29]

Gee traveled downtown with her teacher, Lisette Model, and fellow students. Model regularly brought students in her photography course to visit the neighborhood on Sundays. After the Photo League closed, individual photographers offered private lessons in their own homes. Model taught at the New School for Social Research, earning only a modest income from her class. So she supplemented it,

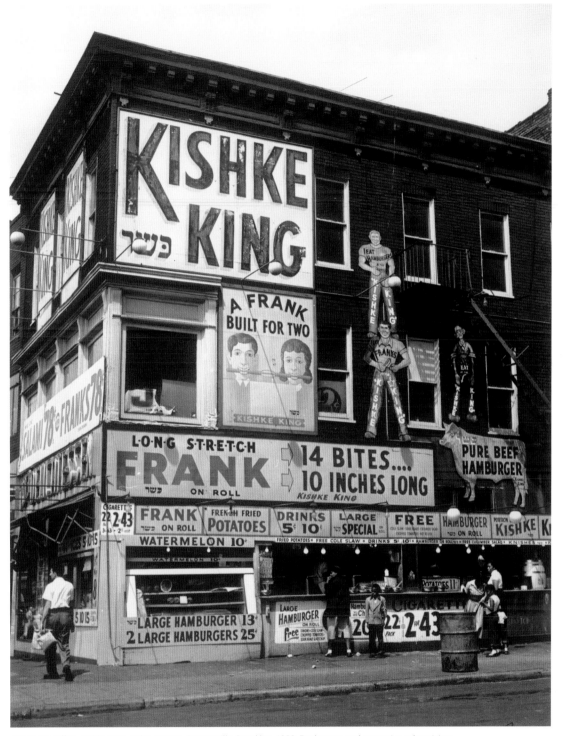

7.7 N. Jay Jaffee, *Kishke King, Pitkin Avenue, Brownsville, Brooklyn, 1953*. Exuberant and excessive advertising covers almost every inch of this building, trying to attract customers to a food stand purveying hot dogs, hamburgers, and kishkes (stuffed intestines). Jaffee couldn't resist the building's humorous presence. © N. Jay Jaffee. All Rights Reserved. Used by permission of the N. Jay Jaffee Trust, www.njayjaffee.com.

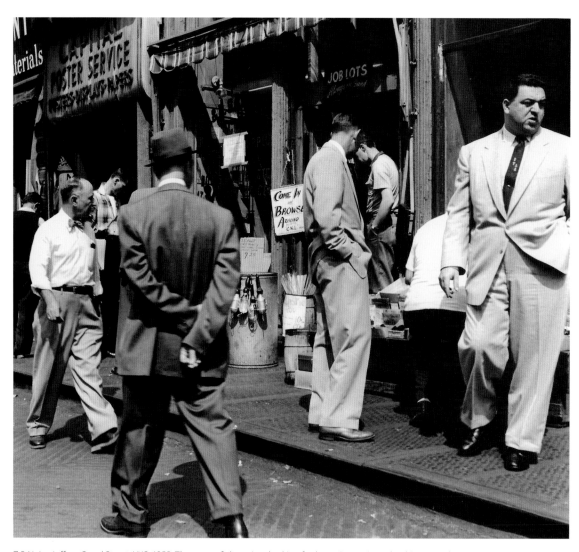

7.8 N. Jay Jaffee, *Canal Street, NYC, 1953*. The pace of shopping, looking for bargains, or just checking out what merchants had on sale attracted shoppers to Canal Street, a major east–west artery in lower Manhattan.

as Grossman had, with private classes and workshops. "Though still uncertain of the workings of the camera," Gee recalled, "I plunged in, excited by everything I saw." As a neophyte, Gee sought to follow Model's advice. "Pushcarts offered all sorts of things—cabbages, corsets, antique jewelry, old clocks—and while I would ordinarily have rooted around for bargains, I was more interested in the vendors than their wares." The men "had wonderful, craggy faces, and since they couldn't leave their pushcarts, I had time to figure out exposures and such. But," Gee admitted, "I was taken aback when one reached out his hand for a modeling fee—fifty cents was the going rate—and another announced no purchase, no picture."[30]

Gee had stumbled into the commerce of street photography. Her discovery illuminated the beginning of changing attitudes toward photographers in the 1950s that accompanied a growing consciousness among New Yorkers of the commercial value of genres of street photography. Individuals on the city's streets gradually became aware of the potential worth of their own image and how photographers earned a living selling their pictures to magazines and newspapers.

Somewhat chagrined, Gee shifted her focus from the vendors to the shoppers. She went charging around the neighborhood. "My only frustration was having to duck into doorways and reload the camera every twelve shots, and after shooting eight rolls in less than two hours, I decided I was too prolific a photographer to stay with a camera as cumbersome as the Rolleiflex, and thought of buying a Leica." Gee's experience produced mostly blurred photographs. It led her to Peerless Camera to purchase film. There she encountered Lou Bernstein at his day job. "'You've *got* to study with Sid Grossman!' Lou Bernstein slammed his fist on the counter, startling the customers waiting to be served. 'He'll change your life.'" Though she protested "I don't want my life

changed," she listened to Bernstein and signed up for a course with Grossman, having dropped out of the class with Model. Grossman did change her life, in utterly unexpected ways. His passion for photography, articulated in eloquent lectures on Friday night in his loft, transformed Gee into someone who also cared for photography.[31]

Looking back on the experience, Gee wrote: "He urged us to live for photography, and if not for photography, then for whatever else we believed in." Gee was a divorced mother with a young daughter. She earned her livelihood as a transparency retoucher, a well-paid skill. She worked for both magazines and advertising agencies. Grossman "inspired either love or hate. In me," Gee confessed, "he inspired both. I loved his integrity, his zeal, his sense of mission; I hated his intolerance and need to disparage others." She stuck out the course but declined to sign up again. Instead, she decided, she would start a coffeehouse and photo gallery, combining photography and commerce in an utterly unusual mix. "Why not subsidize a gallery with coffee beans?" she wondered. Limelight, Gee's coffeehouse and gallery located just south of Sheridan Square in Greenwich Village, helped initiate a significant change in how people thought about photographs. Unlike previous art galleries that included paintings, prints, and photographs, treating the latter as works of art, Limelight only showed photographs. All of them for sale.[32]

As Gee recognized, a key dimension of pushcart commerce involved interactions with purchasers. Both buyer and seller wanted to profit from the exchange, so bargaining inevitably was part of the process. When men sold on the street and women bought, these interactions could become erotically charged, as Dan Weiner suggests in one photograph. The young man, pencil and paper in one hand while gesturing with the other, is explaining something to the rather elegantly dressed young woman. She reaches forward toward the brown paper bags,

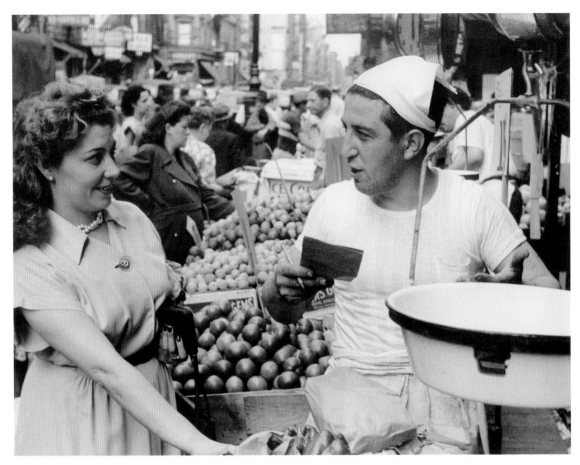

7.9 Dan Weiner, *Male Vendor and Female Customer Engaging in Conversation*, 1950s. Both vendor and purchaser are negotiating something more, it seems, than just items on the pushcart. Neither pays attention to the photographer who captures the busy commercial street scene on the Lower East Side. Photo by Dan Weiner. © John Broderick.

presumably her purchases, as she looks directly at the vendor. She's smiling, so this is probably not a difficult negotiation. He will undoubtedly convince her if he hasn't already. A mood of flirtation emanates from this encounter, suggesting shopping on the street could be fun, or at least a distraction.

But sometimes, the shopper is all business. Sid Grossman recorded a very different interaction on Mulberry Street. The woman shopping wants her change. She can't really be bothered to look at the merchant, who concentrates on giving her what she is owed. The blurred focus, the faded lettering on the wooden sign, and the slanted angle of the dark stores behind the two figures transform their exchange almost into a paused dance step. There appears to be no particular pleasure in this shopping expedition, just a chore to be completed. Commerce does not seduce her.

On occasion, a photographer caught a third mode of interaction: active salesmanship. Esther Bubley pictures a male vendor engaged in selling his wares to two well-dressed young women. Both wear hats with veils, gloves, and jewelry. They are out for a

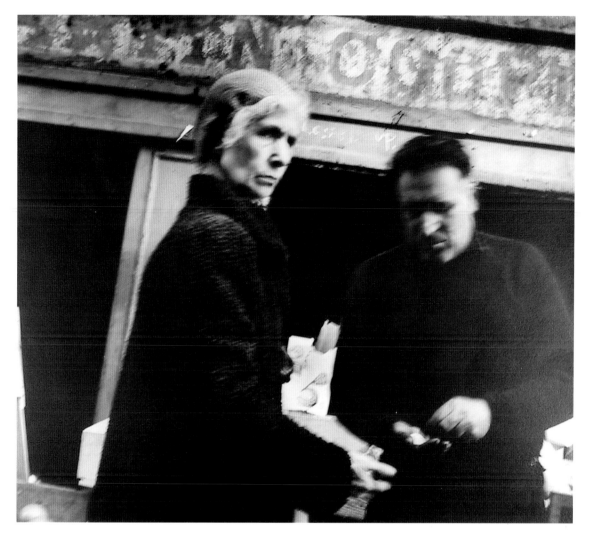

7.10 Sid Grossman, *New York Recent,* ca. 1947. In this exchange of a street vendor and customer, the interaction appears to be all business. The woman wants her change and is not interested in conversation. © Howard Greenberg Gallery, New York.

night on the town, and he is obviously doing his captivating best to convince them that the items for sale are a bargain, just what they wanted, something special for a delicious snack. He seems to have snagged their attention. One woman looks down at the roasted chestnuts and smiles, cradling her bag;

her partner also expresses interest, head slightly tilted. And the handsome guy lays on the charm. He is respectably attired, looking like a trustworthy soul and not at all like a fly-by-night trickster. But behind the women blasts a sign in white lights: *Edge of Doom*. Surely Bubley could not resist the marquee's commentary on this example of ordinary street commerce, although the movie concerned a mentally ill young man who attacks the Catholic church after his mother dies.

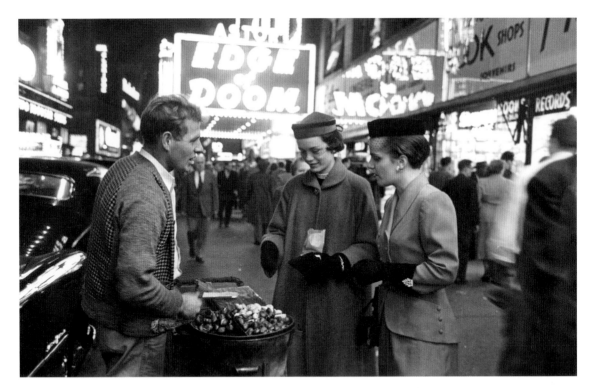

7.11 Esther Bubley, *New York City*. [Times Square, 1950]. Two women eye the chestnuts, a popular street snack during cool weather in New York. Bubley undoubtedly could not resist the movie marquee's blazing comment on this ordinary street commerce: *Edge of Doom*. © Esther Bubley.

Like pushcarts, newsstands stood guard over many streets. Small spaces stuffed with merchandise, they enclosed their proprietors day and evening, in all sorts of weather. In the 1940s and 1950s, New York City's almost eight million people supported many competing newspapers: morning papers and evening papers, foreign-language papers published in the city and foreign newspapers from abroad, not to mention weekly, biweekly, and monthly magazines. The plethora of papers accompanied a lot of competition among vendors, making it difficult to earn a livelihood even with multiple newspapers and magazines to sell. So like candy stores, newsstands added other items: soft drinks

that required a cooler, comics that had a ready audience of children.

Engel's photograph catches two boys as they pause in front of a newsstand. The merchant points his finger toward the comics, lined up outside against the wall behind the grate. The young cowboy is making a beeline for them; the other boy hesitates. Boys, unchaperoned, travel the city's streets. With some coins in their pocket, they are free to satisfy their reading pleasure. Like in his *Harlem Merchant* photograph, albeit obliquely, Engel comments on the business of buying and selling. The merchant is reduced in this case to a torso and hand. Perhaps in a touch of self-reflective irony, his photograph also shows two photography magazines for sale, one with an image by Lewis Hine on the cover.

No customers approach the newsstand Esther Bubley pictures. Her photograph shows just a fragment of the proprietor, who hovers over his

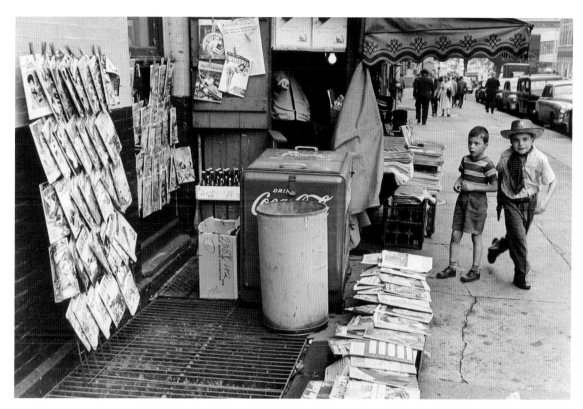

7.12 Morris Engel, *NY Newstand*, 1940s. The boys are on their own, with change in their pocket, ready to purchase comic books that are arrayed on a stand leaning against the wall of a building. The photo captures the newspaperman's finger pointing the boys to what they want at the same time as it pictures the diversity of reading matter for sale. © Morris Engel.

merchandise in the doorway of his small stand. The photo dates from the early 1940s, when she first arrived in New York City. Bubley portrays the plethora of violent pulp magazines, held in place by clothespins. Their lurid headlines scream: Crime, War, Exposed, Witness, Lawbreakers. The most successful pulps, as they were called, sold up to a million copies per issue in the 1940s despite difficulties securing paper due to rationing during the war years. They made the grey newsprint, lying face up, seem pale and humdrum by comparison.[33]

Ever the humanist in search of meaning, Dan Weiner peered inside a newsstand at an elderly couple. The man brings his eyes very close to a paper, suggesting he really could use a pair of glasses to read. The woman faces out through the partially open window. She seems to be speaking to someone deep in the shadows. The lighted newsstand glows with warmth against the early winter darkness. Two people inside transform the shared space into one not just of commerce but of familiarity.

Most newsstand vendors worked alone. Their isolation and need to earn a livelihood no matter the weather attracted Weiner's sympathies as well as his camera's eye. His photograph of a newspaper vendor standing outside in a snowstorm vividly portrays the solitariness of earning a livelihood from "the sweat of his brow." The man's hands are bare, but every other part of his body is bundled up against the weather. His cap's brim shades his face as he looks down at his

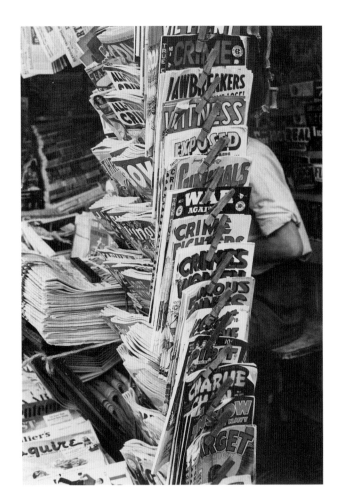

7.13 Esther Bubley, *Newsstand. New York City. c. 1944*. The lurid headlines of the pulp magazines caught Bubley's attention when she first came to New York. Their popularity soared during the 1940s, with hundreds of thousands purchasing each issue. © Esther Bubley.

hands, perhaps figuring out which coin to put into its proper slot in the coin holder hanging on his chest. Unlike the vendor, the merchandise is sheltered from the storm. The stacks of papers remain dry under the newsstand's cover. Behind the vendor, bright lights from a drugstore transform pedestrians into moving shadows.

Klein's *Gun, Gun, Gun, New York, 1955* photograph of the *Daily News*'s final-edition headline eliminates the vendor completely but shares the same fascination with headlines as Bubley's image of pulps. The boldface repetition caught his eye, attuned as it was to the widespread presence of toy guns in New York. Here the headline yells: "Gunman" and the large photograph dominating the front page shows policemen carrying a body out of a building, either the victim or perpetrator of a crime. Although the same newsstand sells *Variety*, the paper that covers show business, Klein doesn't care about that more specialized reading audience. Rather, the multiplication of guns—in headlines and hands—captivates him. Cold War politics permeated the postwar city, evident in the cheap price and widespread availability of toy pistols. (Engel's Harlem merchant from an earlier era features one for sale amid the candy and chewing tobacco.)

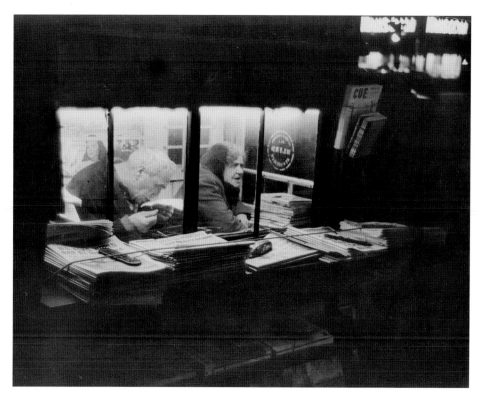

7.14 Dan Weiner, *Elderly Couple inside News Booth*, 1940s. Illuminated by electric light, an elderly man reads a paper while a woman, probably his wife, deals with a customer. The photograph portrays the quotidian details of laboring within the confines of such a small space. Photo by Dan Weiner. © John Broderick.

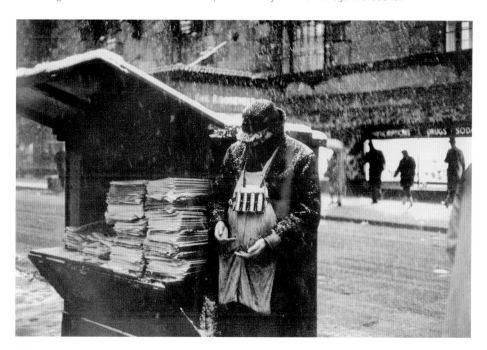

7.15 Dan Weiner, *News Vendor, 1953*. Despite the miserable weather, the vendor stands, bundled up against the cold snow, waiting for customers to purchase a paper, which he has carefully protected from the elements. Photo by Dan Weiner. © John Broderick.

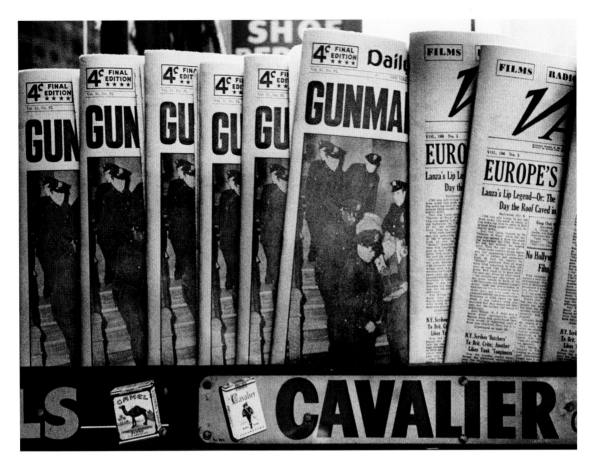

7.16 William Klein, *Gun, Gun, Gun, New York, 1955*. The repeated fragmented headline lined up in the newsstand emphasized in no uncertain terms the prevalence of a gun culture in New York City. The widespread popularity of guns among children struck Klein, who had been living in Paris for close to a decade after the end of World War II. © William Klein.

Like newsstands, shoeshines that occurred on the city's streets also caught the attention of New York Jewish photographers. Although the introduction of shoeshine stands eliminated many of the bootblack boys, neighborhoods without stands allowed kids to earn money shining shoes. To get started shining shoes required some capital investment: a box and polish. Historian David Nasaw notes that the future comedian Joe E. Brown, unable to invest the proper amount of capital, "had to run away from his first customer. He was ashamed to admit that he owned only a can of black polish and could not shine tan shoes."[34]

There were many ways a photographer could approach shoeshines. For example, Esther Bubley photographed boys shining shoes, while N. Jay Jaffee captured the interaction of two men. Bubley focused on the labor itself. It is not clear from her photo whether the boy is working at a stand as hired labor or whether he is on his own, providing shines. Bubley emphasizes the boy, who presents a studious demeanor in part because he wears glasses. The customer is reduced to a shoe, a striped sock, a pants leg, and a hand holding a cigarette, a perspective possibly shared by the shoeshine boy. These

legs and feet occupy one side of the picture frame; the boy dominates the middle. He concentrates on the task, ignoring the people walking behind him on the sidewalk. He sits on a small round hassock that allows him to stretch out one leg as he works. Bubley includes his tools—the polish and rag to buff the shoes. The sidewalk around him is littered with cigarette butts.

Men took over the business of shining shoes in New York City in the early years of the twentieth century, pushing child bootblacks into more marginal areas. Jaffee's photograph, most likely taken at Astor Place in Manhattan, pays equal attention to customer and seller. *Shoeshine Conversation* pulls back from the labor involved to emphasize the interaction. The customer in this case appears to be haranguing the shoeshine man, who smiles affably. He is not going to alienate his patron if he wants to be paid. The bootblack's subservience is obvious. The shoeshine man has carried a wooden chair out onto the sidewalk so that his clients would be comfortable. He kneels on an old cushion. Jaffee's photograph conveys the labor as well as financial investment involved in this form of street commerce.

Italian immigrants came to dominate both the shoeshine and shoe repair businesses in the city in the decades straddling World War II. Rebecca Lepkoff shoots a somewhat elegiac portrait of a shoe repairman on the Lower East Side. Looking at him gazing out of the window of his shop, her photograph details the accoutrements of such a small-scale service industry: sewing machine, wall clock, hanging lamp, and the shoe, painted on the plate glass. She reverses the photographer's gaze, looking out through plate glass rather than looking in at what is reflected. Outside the block seems quiet, just cars parked by the curb with only a single pedestrian.

In 1947 after he left *PM*, Engel decided on his own to do a series on a shoeshine boy. Intrigued by the boy, who had staked out a spot on East 14th Street near Second Avenue, Engel went to meet his parents, who lived on East 10th Street. He requested permission to take some pictures. "There would be no charge," he explained, "and there won't be any problems." When they agreed, Engel shot photographs of Fred as "a shoeshine kid, as a school kid, as part of a family, and his life on the street."[35]

Such a series of photographs focused on a single child differed from the types of pictures Engel previously had taken. None of his Photo League feature projects, his photojournalism for *PM*, or the photographs he snapped as part of the navy's Combat Photo Unit #8 took an individual, especially a child, as its emotional and visual center. His recollection that he told the parents there would be "no charge" suggests how the economics of street photography was shifting. Perhaps representative of increasing individualism in American society, Engel's choice also anticipates his subsequent decision to make a young boy his protagonist in his 1953 film *Little Fugitive*. Since Fred knew that he was being photographed, his consciousness of Engel's presence gives the photos a somewhat posed quality. Although the pictures suggest narratives, they are somewhat tidier, with fewer loose ends than the candid photographs Engel regularly took before the war. His shift anticipates changes that would come with the 1950s. Engel subsequently showed the series to John Morris at *Ladies' Home Journal*. Morris bought it for $1,000, a significant sum, and then offered Engel one of their choice assignments: "How America Lives." These assignments to photograph American families came with credit lines for photographers and brought other jobs to Engel as a photojournalist. In choosing to photograph Fred, Engel had anticipated the coming decade's fascination with family life.[36]

The week that Engel spent with Fred allowed him to picture some of the vicissitudes of shining shoes. Engel records through the mirror of a movie theater a policeman accosting Fred. The scene draws the

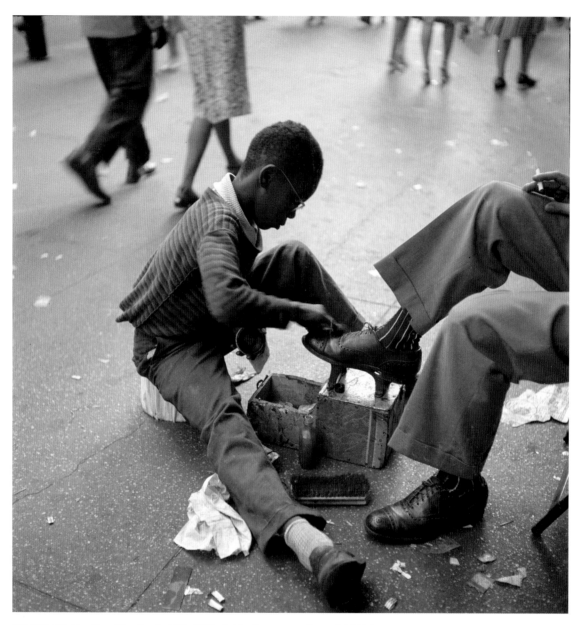

7.17 Esther Bubley, *Shoeshine. New York City,* 1950s. Bubley focuses on a form of child labor still considered acceptable in New York City in the 1950s, although men took over most of the bootblack work. © Esther Bubley.

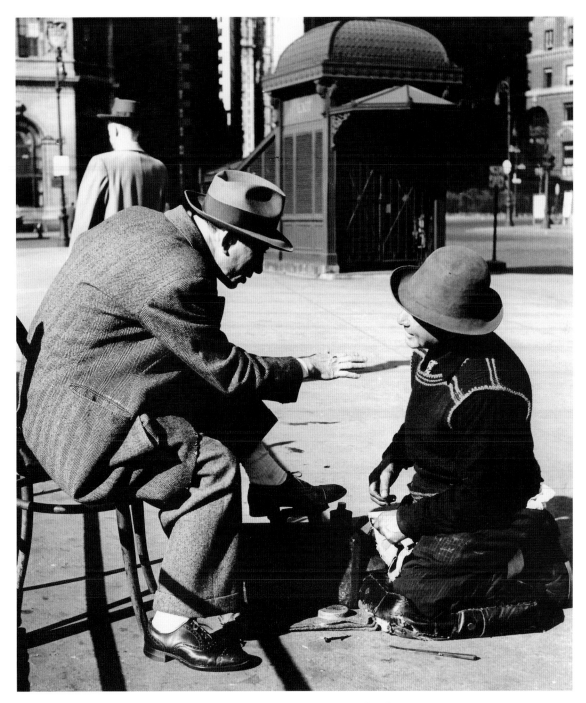

7.18 N. Jay Jaffee, *Shoeshine Conversation, New York City (Downtown)*, 1949. Without a shoeshine stand, the bootblack makes do with a chair for his customer and his box with supplies. He has chosen a spot not far from the corner to set up his business near a subway exit. © N. Jay Jaffee. All Rights Reserved. Used by permission of the N. Jay Jaffee Trust, www.njayjaffee.com.

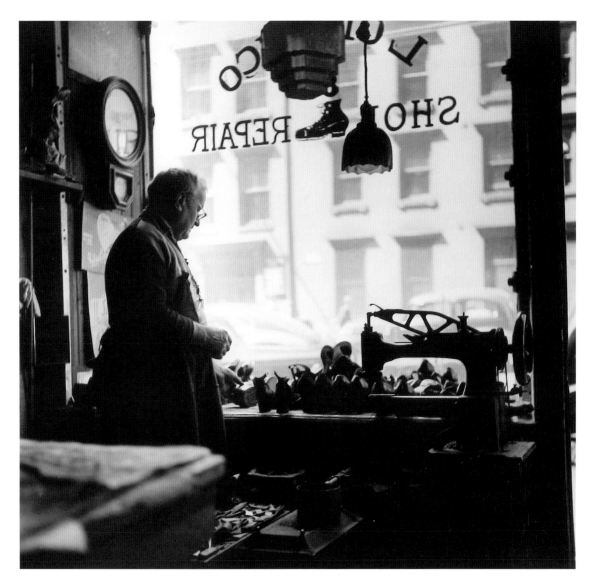

7.19 Rebecca Lepkoff, *Shoemaker, Madison Street, Lower
Manhattan, NYC*, 1940s. Lepkoff's photograph of the cobbler
in his shop presents the view of a customer, looking at the
man by the window at the quiet street on the Lower East Side.
© Estate of Rebecca Lepkoff. Courtesy of Howard Greenberg
Gallery, New York.

attention of a young man leaning back in his chair.
Unlike straight photographs of bootblacks at work,
this picture presents the complicated ways that
the city intrudes on street commerce. The mirrors
and plate glass reproduce not only the police but
also other action occurring on the block. The photo
displays as well the proliferation of words and
typefaces designed to attract attention from foot
traffic. The mirror reflects the marquee, a delightfully

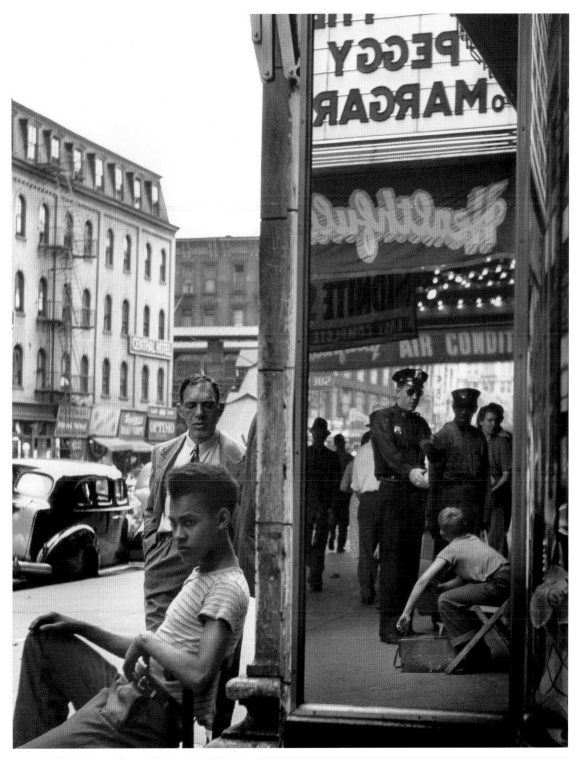

7.20 Morris Engel, *Shoeshine Boy and Cop*, 1947. Through a mirror the photographer captures a policeman questioning the boy who has set up his shoeshine business on East 14th Street. The Third Avenue El, the last of the elevated trains, can be glimpsed in the upper left-hand corner slicing between two tenement buildings. © Morris Engel.

complicated curving sign, and a banner advertising air conditioning, an inducement to enter on a hot summer day. On the upper left, the Third Avenue El cuts between two tenements. Engel's mirror frame recalls the empty mirror frame in Levitt's photograph of children at play in chapter 4 (figure 4.8). In both cases, the frames grab and secure the image, a picture of New York by walkers in the city.

By the middle of the 1950s, commerce was intruding into photography itself, turning prints into commodities. Most of the photographers Helen Gee exhibited at Limelight were pleased to have a show. They wanted people to see their work. Like the exhibitions at the Photo League, those at Limelight attracted modest press (most consistently in the *New York Times* and *Village Voice*). Because of the coffeehouse, Limelight also encouraged photographers to gather and debate photography as they had at the Photo League. Gee did not sponsor lectures nor, of course, were classes offered, but she did manage to provide an alternative place to see photographs and talk about them. The gallery held up to a hundred photographs and exhibits changed every six weeks. When she penned a short rationale for Limelight prior to the initial exhibit, she wrote: "Limelight is dedicated to photography." Gee explained, "Limelight exists primarily to show the work of those photographers, both known and unknown, who have made an outstanding contribution through their serious creative endeavor." Gee identified the men and women as photographers, not workers. In retrospect, Gee claimed: "The sense of isolation that had set in with the closing of the Photo League disappeared in the congenial atmosphere of Limelight."[37]

Like the Photo League, Gee welcomed diverse photographers and presented the personal creative work of men and women who made their living in fashion, photojournalism, advertising, and commerce. She implemented the generous stance of *Photo Notes*: "We must also include the established

workers who have creative desires and who do not find an adequate outlet in their day to day tasks." For example, she exhibited personal photographs by Lou Bernstein, Esther Bubley, Louis Faurer, Harold Feinstein, Leon Levinstein, and Louis Stettner. She recognized how the impact of McCarthyism "cast a pall" over the entire decade of the 1950s. At the same time, she observed: "The power of photographic imagery—its ability to reveal, conceal, explain, distort, to persuade and manipulate—had by midcentury rivaled the power of the pen." The combination made street photographers vulnerable. Someone like Lisette Model, "who, as a European emigree was acutely sensitive to the political climate, expressed their predicament. 'You didn't know *what* to photograph,'" she exclaimed.[38]

Limelight fashioned an alternative venue for viewing photographs: not a public library or community center, and not a museum, but rather a gallery in a coffeehouse. Unlike Photo League Feature Group shows, it did not invite those men, women, and children pictured to come see their lives mirrored through photographs. Instead, it shifted the contexts of seeing even as it tried to nourish an alternative community of photographers and those who loved photography.

Most of the photographers whose work hung on the gallery walls had very little idea about the price they should put on a photograph. Although many had sold prints to the Museum of Modern Art for a nominal fee, they had never sold a print commercially. As Gee recognized, collectors did not collect photographs. So Gee suggested prices, usually $25 per print. Over the course of seven years of Limelight's existence, she made around $5,000 selling photographs from a 25 percent commission. A modest sum, yet one that signaled a profound transition from the political activist aesthetic of the Photo League into a more commercially modernist understanding of street photography.[39]

epilogue

A New York Family Album

In 1964 Garry Winogrand went to the New York World's Fair. The Photo League had faded from consciousness, and several of its key figures, including Sid Grossman and Dan Weiner, had died. No one published a call for a New York Document to reclaim the city from capitalist pictures that didn't show the real New York. Photographs were everywhere. Harold Feinstein called the city "photo central for the entire world." New York City had moved on. Unlike the 1939 World's Fair, this grandiose exhibition, also held at Flushing Meadows, featured the Unisphere as its symbol, no irony intended. Despite the Cold War, despite the continuing hold of European colonialism on the developing world, despite Black Americans pressing for social change and an end to segregation and inequality, despite rent strikes in Harlem against exploitative landlords (some of whom were Jewish), despite hundreds of thousands of white New Yorkers leaving the city (not to mention two of the city's three baseball teams), New York boosters proclaimed their confidence in the city's record of integrating diverse men and women from many nations into a common urban citizenship. New York aspired to status as a global city.[1]

New York in the 1960s differed from the city Winogrand knew as a boy growing up in the Bronx. Jews were an increasing percentage of a declining white population. Many New York Jews were college educated. The total number of New York Jewish residents remained relatively stable at just under two million, but their composition had changed, and was changing. The presence of thousands of refugees, survivors of the Holocaust, reshaped life in local neighborhoods. These newcomers helped compensate for the departure of native-born New York Jews for the suburbs and other cities. New York was still the nation's largest city, although its population had dipped slightly from a peak in 1950. Roughly a million white New Yorkers had decamped to the suburbs of Long Island and of Westchester and Fairfield Counties, and to north and central New Jersey. In their place came thousands of Black migrants. The city's population now included over a million Black New Yorkers. This second great migration more than doubled New York's Black population between 1940 and 1960. They made up 14 percent of the total, a dramatic change from the years prior to World War II. In addition, a substantial number of U.S. citizens

from Puerto Rico migrated during the 1950s while the percentage of foreign immigrants charted a steady decline, the result of ongoing immigration restriction.[2]

When he went to the World's Fair, Garry Winogrand was earning a livelihood as a magazine photographer even as he continued to take street photographs. That, too, marked a difference from the early postwar years. The disappearance of the Photo League coincided with the belated entry of Jews into a rapidly expanding advertising industry as antise-mitic restrictions weakened. This enlarging world of commercial photography not only gave Jewish photographers opportunities to earn a livelihood but also free time to take their own personal street pictures. Jews forged careers in commercial photog-raphy, especially fashion magazines. William Klein jokingly called them "our art magazines," adding that only in publications like *Harper's Bazaar* could "you see pictures of Brassaï or Cartier-Bresson." In the 1950s, the fashion industry wholeheartedly em-braced photography as the medium to promote their high-end products. Fashion photography "followed the move of the fashion industry from the salon to the street." Jews were increasingly employable as art directors. The industry used Jewish photographers in part because their pictures were perceived as intensely yet irreverently engaged with the sensation of American diversity.[3]

Winogrand's image of a bench at the fair exem-plifies that engagement. It captures the energy of sundry people who, as strangers to one another, find themselves sitting together. Sharing a bench was a typical New York City pastime. Sitters knew how simultaneously to claim space and accommodate others. A bench offered the constant opportunity to mix the city's overlapping public and private worlds. A bourgeois urban convention, a bench provided a setting and seat for observation, introspection, relaxation, and commentary. Sitting on a park bench indicated a sense of security and comfort with urban public life, a willingness to watch the scene and to be seen in turn. These benches were not regulated or restricted to men or women, children or adults, Black or white, Jew or Gentile. Winogrand understandably gravitated to these sociable islands on the grounds at Flushing Meadows.

Two men bookend a bench with six young women in groups of three, two, and one sitting between them. An older man, formally attired even on a warm summer day, has secured his right to be alone by reading a newspaper. The other man, his jacket on his lap, listens intently to his conversation partner, whose hand gesture emphasizes her pointed com-ments. To her left a trio of young women sit close together. One has collapsed in exhaustion against her friend. The other two whisper to one another, perhaps about the woman to their right. Something off camera has attracted the full attention of the next pair. Spontaneously, several little worlds percolate all in a row. Winogrand shares his bemusement. Because he caught this moment, he invites viewers to stare without embarrassment and to compose a running commentary to this ballet of forearms, hands, and leaning bodies. "Well sure, but I think . . . can you believe that they . . . what the . . . !" It's urban democracy in action.

A sense of safety pervades the photograph. The trio of women feel no apparent concern about pickpockets or thieves. The whispering woman lets her bag sit untouched and open between herself and a stranger, while the recipient of secrets has placed her unsecured pocketbook on the ground. Maybe they're out-of-towners. On the other hand, the white woman talking with the Black man secures her pock-etbook on her arm as an experienced New Yorker would do. As an international city filled with varied natives and assorted tourists, Gotham regularly accommodated a smorgasbord of passing compan-ions who variously exhibited microaggressions and

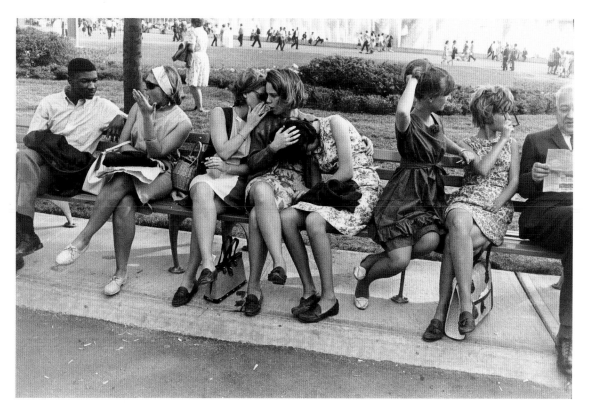

E.1 Garry Winogrand, *World's Fair, New York, 1964*. Located at Flushing Meadows Park, where the 1939 New York World's Fair was held, this new fair promoted a vision of one world, despite all the current divisions and conflicts. Here, the men and women sitting on a bench together share public space without animosity. © The Estate of Garry Winogrand. Courtesy of Fraenkel Gallery, San Francisco.

microaccommodations . . . often simultaneously. On the street, private business is public. Just imagine what it would be like if people talked on their phones in public!

Out-of-towners or locals, Winogrand places them within a kind of New York family album that lets them speak to the pleasures of sharing public space. The idea of a family album suggests articulated connections: visual, cultural, and social. It proposes alternative forms of potential solidarity that fit a moment of liberal rather than leftist politics. Family albums, the scholar Marianne Hirsch points out, contain

"fragments and isolated moments . . . assembled into narrative drafts by one participant," or in this context by two participants sequentially: a photographer and viewer.[4]

After World War II, newspapers regularly featured photos of city people doing ordinary things as part of what were called "human interest" stories. Readers enjoyed viewing folks like themselves on the street, at the beach, at work or play. Advertisers used images of families to promote consumption. Even glossy magazines such as *Ladies' Home Journal* focused on families. In the 1950s the magazine ran a series, "How America Lives," on American families. They often hired Jewish photographers, like Esther Bubley, to portray family relationships. Although the *Journal* aimed to depict American families as molecular building blocks of society, Bubley's photographs often highlighted emotional tensions.[5]

Real families overflow with love, pride, tedium, anxiety, and anger. Fractious relationships within and among families, across neighborhoods, and among Americans more generally often find ethnic, racial, and regional expression. Many Jews, despite differences among themselves, took pride that New York had the largest Jewish population of any city in the world. At the same time, people who disliked Jews and/or New York City sneered at "Jew York." Jews have referred to themselves variously as family, landsmen, and a tribe.

Jewish photographers of the Photo League and those of subsequent decades were linked by a sense that their pictures had redemptive potential. Postwar photographic work of the 1940s and 1950s was charged socially and culturally, but seldom politically. The trope of "family" connects the work associated with the Photo League with much American photography of the 1960s through the turn of the century. Photography scholar Anthony Lee describes how the photographer Diane Arbus, in her last, difficult years, sought a redemptive role for her portraits. "To organize her people as pictures, to reconstitute them as a family in a simulated world of the photographic archive, and to see them safely to the other side of change—in the late 1960s, when forms of belonging everywhere mattered but were nowhere secured, 'Family Album' made much more sense" than counting people as members of a family in any conventional sense. Like the photographer Nan Goldin, Arbus had in mind to save photo portraits into a "Noah's Ark," a life raft for some alternative kind of family.[6]

Other Jewish photographers created "family albums." Larry Sultan's *Pictures from Home* documents the shifting body language of his parents after his father suffered career displacement. Richard Avedon's photographs of his father, Jacob Israel Avedon, late in life traces his father's complex relationship with his

famous son. Lauren Greenfield's *Girl Culture* (2002) is a penetrating work of visual anthropology concerning gendered stress among wealthy children.[7]

Yet the family album was hardly regarded as a serious photographic form until in 1955 Edward Steichen curated *The Family of Man* for the Museum of Modern Art. Steichen brought family and redemptive agendas together under the big top. After its three-month run in New York, the show went on an international tour for eight years. It gave the impression that liberal social and cultural values characterized life in the United States. This enormously popular enterprise of late Enlightenment enthusiasm made a convincing case for the influence of documentary portraiture and included images by Photo League photographers. Nevertheless, its value has not been universally praised. Although the American studies scholar Eric Sandeen observes that the exhibit presented familial similarities across cultural differences, he also characterizes the photographs as work by "world tourists."[8]

By the early 1960s, New York Jewish street photographers increasingly adopted a stance of "professional strangers." They weren't tourists engaged in slumming or viewing the exotic. They would have agreed with Walter Rosenblum's firm assertion that he and his fellow League photographers pictured what they knew. A new generation of documentary portrait photographers felt drawn to variously evolved versions of the family album metaphor. Each one recognized as family the people whose presence felt like home, with all the attendant love and pain that comes with commitment to such intimate relationships. They explored connections that blended intimate awareness with a measure of distance and difference often associated with ethnography. The critic Ben Lifson argues that Winogrand "taught us to see—to see the world we create by acting together in public space, which contains the potential for

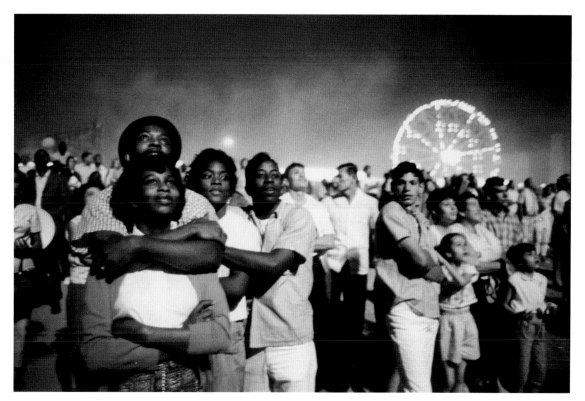

E.2 Bruce Davidson, *USA. New York City. 1962. Coney Island. 4th of July Fireworks*. Part of a series called "Time of Change" that Davidson took in New York City in response to the civil rights movement, this photograph explicitly pictures an integrated group of Blacks and whites, men and women, adults and children, enjoying fireworks on the Fourth of July. © Bruce Davidson/Magnum Photos.

freedom, discourse, sympathy, beauty, and connection between self and the world and, perhaps, between self and others."[9]

Although Bruce Davidson earned a livelihood as a photojournalist, he can be considered something of a throwback to Photo League perspectives and practices. He had joined the photographic cooperative Magnum in 1958 as its youngest member. In 1961 Davidson responded to a call by the *New York Times* for a photographer to travel with the Freedom Riders through the South, to document their struggle against segregated interstate travel practices by bus companies. Years later he recalled walking into a meeting "late one evening in Montgomery, in [the] home of local resident, John Lewis, who wore a large bandage on his head covering a wound inflicted in a previous bus ride beating, [and] calmly presided over the group" that was going to ride. Accompanied by National Guard troops with "grim faces and fixed bayonets," the Freedom Riders arrived safely in Jackson, Mississippi. As they exited the bus, all were arrested. After that assignment, Davidson wrote: "For the first time I was exposed directly to segregation and its oppression." Later, his perspective continued to broaden as he photographed Black people in New York City and out at Coney Island.[10]

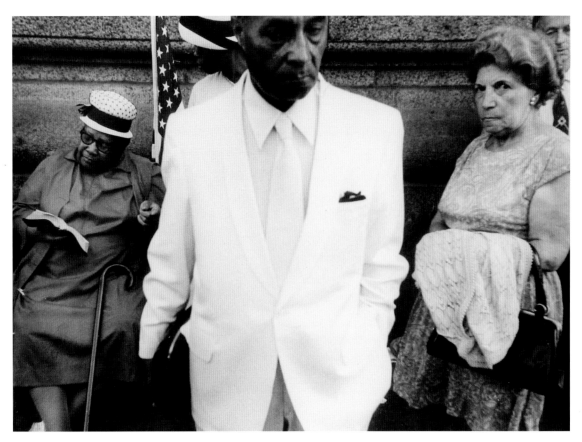

E.3 Leon Levinstein, *Man in a White Suit*, 1950s. The man and two women behind him appear dressed for a parade, although the photograph does not reveal where in the city they are. Levinstein adopted the men and women he photographed as his surrogate family, adding their images to his extensive family album of New Yorkers. © Howard Greenberg Gallery, New York.

A crowd of couples and families watching fireworks appears in a somewhat heroic mode. Unlike Davidson's earlier forays on the beach and boardwalk of Coney Island when he shot Brooklyn gang members relaxing on the sand or engaged in conversation, here he tilts his camera upward. The couple in the foreground gaze toward the sky, clearly engrossed in the show. But one young man on the right, slightly out of focus, notices the photographer and turns to look at the couple as if to ask, What's

special about them? His gaze may trigger viewers' consciousness as spectators. Davidson often took photographs grouped as elements in thematic projects, in this case one on "Time of Change: Civil Rights Photographs, 1961–1965." And although many viewers may sense that he identifies with the people he photographs, they are not treated as family.

Leon Levinstein's perspective differed. As a street photographer, he sometimes provoked unwelcome stares. Yet he felt that his subjects were members of his extended family. In January 1956, Helen Gee mounted an exhibit of Levinstein's work. She later recounted the fascinating process of choosing prints to exhibit. "My first real insight into Leon Levinstein came the night we got together to select the prints

for his show," she recalled. "He arrived at the apartment with a heavy suitcase, having lugged it through the subway to save the price of a cab, and a process that would ordinarily have taken an hour or two took half the night." Gee then explained how Levinstein would "pick up a print, gaze at it lovingly, then talk about the person as if talking about a friend. 'See this old lady? She's been sitting on that stoop ever since I started going down to Delancey Street. I'll bet she cooks a good chicken soup.'" This process went on with each of the photographs. "By the time Leon left, I'd met all his 'friends.'" Finally Gee realized, "they were more than friends, they were family. With a click of the shutter, he made them his own—street vendors, vagrants, sunbathers, whores, rabbis, lovers, teenagers, old men and women, and kids of all ages—they were all part of one large family." Gee grasped the significance of these photographs for Levinstein. She understood that she was looking at Levinstein's family album. "And having watched his expression as he gazed at his pictures—he showed amusement, affection, even at times pride—I suspected that Leon was not as lonely as I thought. He had a family of hundreds," she concluded, "a family that made no demands, didn't argue or fight, needed nothing in the way of financial support, and could be kept under wraps until needed."[11]

In one photograph, probably occasioned by a parade, Levinstein drew the penetrating attention of a woman who eyes him critically (a reminder of the stare he received from the man at Coney Island, figure 3.24). The photo features a man who, though dressed to the nines, stands expressionless, with downcast eyes. The American flag leans against a wall, between a wheelchair-bound woman who's reading a Bible and a younger woman with a white hat who gazes down toward her. Levinstein often photographed people up close. He bears witness to the possibilities of family at a tumultuous time in New York City history.[12]

Photography gave Levinstein the means to extend and deepen his kinship circles. Gee's perceptive comments call to mind that all viewers of a photograph, including the person who takes the picture, are audience members. The framed facts of a photo trigger simultaneously imagination and memory. Photographs place visual facts that all vie for attention. They invite hunting for clues: about the individuals pictured, about the photographer's apparent points of view, and about contexts that might help to make sense of initial responses. Flesh and blood people give off looks like scents and deploy looks like masks. Photography can restage such layered interactions for each viewer's privileged gaze.

A brash, aesthetically avant-garde photographer like William Klein also found himself at least metaphorically connecting with that relic of genteel sentiment: the family album. For *Macy's Thanksgiving Day Parade, Broadway, 1954*, Klein ignored the raucous capitalist celebration around him and instead focused on faces in the crowd. Using a short telephoto lens, he so tightly framed these four heads that they might have been assembled in a collage. Although Levinstein also worked close to his subjects, his camera lens took in a wider view, which accounts for a photographic perspective that slightly exaggerates the spatial depth of the scene. Klein, however, presents nothing but faces, packed in like sardines at rush hour.

Stand-up comic Lenny Bruce joked that Christians celebrate holidays, but Jews observe them. Here, like a beat Norman Rockwell, Klein observes extreme Thanksgiving togetherness, together with in-your-face diversity: of class, ethnicity, and race. Klein described it as a "Pseudo-poster for The American Dream: Italian cop, integrated Hispanic, Yiddish mama, African-American lady + beret." This pot is cooking, but maybe not melting. Examining the photograph today, without Klein's helpful gloss, it is more challenging to decode the urban ethnicities he

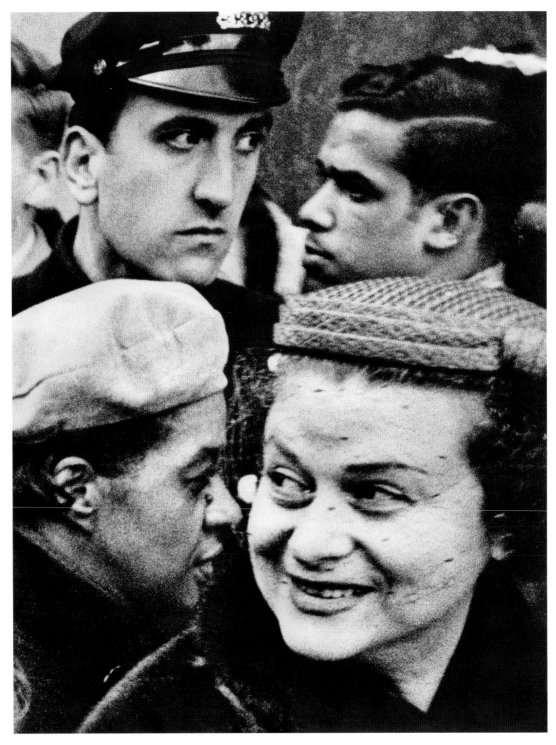

E.4 William Klein, *4 Heads, Macy's Thanksgiving Day Parade, New York, 1954.* Although the crowds gathered to see the enormous balloons that traveled down from Central Park to Macy's store on 34th Street, Klein prefers to focus on the ethnic mix of New Yorkers who showed up to watch.
© William Klein.

pictures. Under the sway of Euro-American immigrant categories, the cop and the Jewish mother would be classified as white, albeit still subject to derision as maybe not quite white enough, while the Hispanic and the Black woman would be racialized as people of color.[13]

Klein's project pictured New Yorkers in the mix together. His insider/outsider mindset and manner let him get along with strangers and capture his notion of their distinctiveness on film. "One time in Harlem," Klein said in an interview, "I cooled things down by saying I was French. 'Hey! This guy ain't white. He's French!'" In the pages of his book *Life Is Good and Good for You in New York! Trance Witness Revels*, Klein juxtaposed photographs of people who would have seemed as strange to one another as they probably do to people who've bought the book. "The New York book was a visual diary," he wrote, "and it was also a kind of personal newspaper." A native New Yorker who had taken up residence in Paris as a successful fashion photographer, Klein wanted to make it clear that "I didn't relate to European photography. It was too poetic and anecdotal for me." He described his book, initially supported by *Vogue* magazine, as a mix of the "family album with the New York *Daily News*." Smartly, offhandedly, as if he were putting a reader on, Klein here precisely expressed the transition that New York photography was undergoing.[14]

The late 1950s revealed these conflicts in photography. The critic Max Kozloff recognized the growing appeal of street photography as a genre that "opens itself deliberately to unpredictable results, it can be neither formulaic nor consistent in subject. . . . It even lacks a method of approach, unless one is improvised or just grabbed. For these reasons," he argued, "the mode became the preferred idiom of 1950s photographers eager to work in New York outside editorial supervision." Joel Meyerowitz, who discovered the camera in the late 1950s while working as an art director for a small advertising company, articulated the street smarts that one needed to do street photography. Not everyone could do it, he admitted, although he viewed the streets as public space, where "everyone and everything there is fair game." To take photographs in the streets, he confessed, one "must have an appetite for life on the street. The street is chaos." The successful fashion photographer Richard Avedon agreed. "I didn't like invading the privacy of perfect strangers," he admitted. "It seemed such an aggressive thing to do. Also, I have to control what I shoot, and I found that I couldn't control Times Square."[15]

In a how-to book for budding photographers, Meyerowitz extolled one of "the great joys of being on the street," namely, "staying alert to the unexpected." He linked that to his experience as a boy growing up in the Bronx, in what he characterized as "a real tough, working-class neighborhood." Meyerowitz credited his father, "a street-smart New Yorker and an athletic man (a professional boxer, in fact)," with teaching him "how to protect myself so I wouldn't get hurt in street rumbles." This hyperawareness of what was happening turned out to be good training to be a photographer. In fact, Meyerowitz acknowledged, his father "taught me to read the street." Meyerowitz took two key lessons from his father: "a childhood awareness of having to look out for myself and an understanding that the world repeats itself over and over again."[16]

In the spring of 1966 John Szarkowski, the new director of photography at the Museum of Modern Art, submitted a proposal for an exhibition. Its goal was to describe "the work of those younger American photographers who have adopted the aesthetic of documentary photography and used it toward ends which are fundamentally non-social, non-hortatory, and personal." At the same time, Nathan Lyons was organizing *Toward a Social Landscape* for George Eastman House in Rochester, New York. Meanwhile, at Brandeis University, Thomas Garver was assembling *12 Photographers of the American Social Landscape* for the Rose Art Museum. Shifting art world standards

shaped their decisions. The concept of a New York family album did not resonate as a way of framing street photography.[17]

The goals of modern American visual arts became more formal and personal. The ends of the Photo League photographers had led them to produce "documentary pictures of social significance," in the words of a 1942 FBI report. During the Cold War, such "ends" got many creative individuals blacklisted. They also shuttered the Photo League. This was one of the contexts that influenced a new generation of street photographers. Another was the move of many second- and third-generation Jews out to the suburbs.[18]

A number of New York Jewish photographers, notably Diane Arbus, Garry Winogrand, and Bruce Davidson, continued to work through a political, Jewishly inflected aesthetic associated with the Photo League. The theme of a family album remained an important flexible metaphor from the postwar years onward.

These Jewish photographers did not abandon the city's streets. They sought to assemble a kind of New York portrait that explicitly paid attention to the city's diversity. When they went to the World's Fair, as Winogrand did, it was to encounter the scene, not to critique it. After the war a more individual, personal form of street photography, often focused on interactive portraits, emerged. It was a different way of picturing the city, one that retained a sensibility of solidarity with its people even without an implicit political message. Previously, a photograph shown at the Photo League was, as the FBI made clear, presumed to be agitprop. As Meyerowitz explained, "creating a meaningful street photograph is about awareness. It involves making connections with what is happening around you."[19]

These changes in Jewish photographers' understanding of their enterprise stemmed in part from a movement away from collective responsibility for urban images to individual encounters on city streets. Photographers sought simultaneously to picture quotidian urban life and to reflect upon it. Their pictures transformed everyday sights concretely exemplified in photos of ordinary people into both ethnographic evidence and works of art. As Kozloff argued, these street photographers shared a common approach that integrated "the moral goal of credibility, the philosophical context of contingency, and the professional requirement of freedom and spontaneity." Viewing the circumstances of existence, of life as lived, stimulated reflection upon the fabric of social life. This postwar move by photographers from sociologically engaged street photography to ethnographically intriguing city people paralleled an emphasis among social scientists on theories of interaction as the glue connecting urban residents. "It took technological developments in photography, generational change (literally, as baby boomers achieved dominance) in outlook, and a sea change in the parameters of high art for street photography to come into its own." Ties of kinship and metaphors of family connections describe this shift in perceptions.[20]

These then are some themes that characterize Jewish walkers in the city and the street photography they helped to define: from the common ground of New York City to a redefined family album; from collective photographic projects designed to change how New Yorkers saw their neighbors to individual collections of images designed to change how urbanites saw strangers; from a search for similarities and shared humanity despite differences of class and race and gender to a recognition of alterities despite apparent commonalities. Throughout run threads of moral responsibility for looks taken and given alongside an uneasy search for solidarity despite the looks that are withheld.

appendix

Photographers

Photographers included in *Walkers in the City* fall into cohorts, in part based on their age. Many, but not all, started to take photographs as teenagers and came to know others around the same age as peers; they often met an older generation as teachers. The following brief biographies are presented in birth order to highlight the webs of relationships that developed among peers and between generations. When available, each biography includes a reference to a major piece of writing on the photographer to encourage further reading.

Alfred Stieglitz (1864–1946), born in Hoboken, New Jersey, to immigrant Jewish parents, grew up in New York City, studied photography in Germany, and then returned to champion photography as an art form. He not only photographed throughout his life, but he also promoted the work of other artists and photographers through his New York City galleries and his magazine, *Camera Work*. As a pioneer of photography in the United States, Stieglitz has been the subject of many biographies and exhibits. Bonnie Yochelson's *Alfred Stieglitz New York* (New York: Skira Rizzoli, 2010) collects his photographs of the city.

Lewis W. Hine (1874–1940), born in Oshkosh, Wisconsin, to a non-Jewish family, studied sociology at the University of Chicago and Columbia University and pedagogy at New York University. He came to New York City in 1901, living in the suburbs with his wife and son. He embraced photography to portray social facts, especially the lives of workers. He briefly taught at the Ethical Culture School in Manhattan but left to take a position as photographer for the National Child Labor Committee, documenting the lives of child workers. In the 1930s he took a series of labor portraits of the construction of the Empire State Building. Judith Mara Gutman, *Lewis W. Hine and the American Social Conscience* (New York: Walker and Company, 1967), provides a broad overview.

Paul Strand (1890–1976), born in New York to Jewish immigrant parents, discovered photography at the Ethical Culture School under Lewis Hine. He met Stieglitz as a teenager, was inspired by him, and the two became friends. Strand followed his early photography in New York with work as a filmmaker, making documentaries, before returning to still photography. He lectured and taught at the New York Photo League. His left-wing political commitments

shaped his photographic choices and ultimately spurred him to move to France because of American McCarthyism. *Paul Strand: Master of Modern Photography*, ed. Peter Barberie and Amanda Block (Philadelphia: Philadelphia Museum of Art; New Haven, CT: Yale University Press, 2014), offers several interpretive essays.

Martin Munkácsi (1896–1963), born in Kolozsvar, Hungary (now Romania), to Jewish parents, made his career as a photojournalist first in Budapest, then Berlin in the 1920s, and after Hitler's rise, as a freelance photographer in New York in the 1930s and 1940s. Photographs of motion—in sports, on the street, in fashion—defined his most influential images. *Martin Munkacsi: An Aperture Monograph* (New York: Aperture, 1992) includes a biographical essay by Susan Morgan.

Berenice Abbott (1898–1991), born in Springfield, Ohio, to non-Jewish parents, came to New York City initially to study painting. She left after World War I for Paris, where she worked in the studio of the Jewish American photographer Man Ray. When she returned to New York in 1929 she brought with her the work of the recently deceased Parisian photographer Eugene Atget. Abbott took an influential series of photographs of New York in the 1930s. A member of the New York Photo League, she lectured there and subsequently taught at the New School for Social Research. Julia Van Haaften's *Berenice Abbott: A Life in Photography* (New York: W. W. Norton & Company, 2018) offers a comprehensive biography.

Ralph Steiner (1899–1986), born in Cleveland, Ohio, to Jewish parents whose families came from Prague, attended Dartmouth College, then studied photography at Clarence White's School of Photography in New York. In the 1920s he earned a living as a freelance photographer. In the 1930s he turned to films,

making several documentaries with Paul Strand. He taught briefly at the New York Photo League and in the 1940s worked as photo editor of *PM*, a liberal New York picture newspaper. Ralph Steiner, *A Point of View* (Middletown, CT: Wesleyan University Press, 1979), offers Steiner's own autobiographical reflections and a broad selection of his photographs.

Weegee (Arthur [Usher] Fellig) (1899–1968), born in a small town near Lemberg, in Austrian Galicia (now Ukraine), to a Jewish family, immigrated as a child of ten and settled with his family in Brooklyn. He started working as a photographer as a teenager, then held various jobs with photo agencies until he became a freelance photographer in the mid-1930s and adopted the name "Weegee." He exhibited his work at the New York Photo League and secured a regular position as a photojournalist with *PM*. In 1945 he published *Naked City*, a collection of his photographs of crime, fires, Coney Island, and urban life, which became a bestseller. Christopher Bonanos, *Flash: The Making of Weegee the Famous* (New York: Henry Holt, 2018), is a compelling biography.

Lisette Model (Elise Amélie Felicie Stern) (1901–83), born in Vienna to a wealthy, mixed Jewish-Catholic family, was baptized as a Catholic. After her father's death, she moved with her mother and sister to Paris, where she studied photography to earn a livelihood. She emigrated with her Jewish husband, a painter, to New York City in 1938 and found work as a freelance photographer. She became an influential street photographer. She joined the New York Photo League and subsequently taught at the New School for Social Research. Ann Thomas, *Lisette Model* (Ottawa: National Gallery of Canada, 1990), provides an excellent biography.

Aaron Siskind (1903–91), born in New York to immigrant Jewish parents, began a career as a public

school English teacher after attending City College. He received his first camera as a wedding present. He joined the New York Photo League in 1936 and for several years led one of its most extensive and influential documentary projects on Harlem. Siskind moved away from documentary photography and into abstraction by 1950. He subsequently taught at the Institute of Design at Chicago's Illinois Institute of Technology. *Aaron Siskind: Another Photographic Reality* (Austin: University of Texas Press, 2014) offers a broad overview of his career.

Lee Sievan (Lina Gertrude Culik) (1907–90), born to Polish Jewish immigrants on the Lower East Side, experienced a childhood punctuated by her parents' repeated separations. She earned a BA from Hunter College in 1929. She then took a job as a secretary in Hunter's Biological Sciences Department, which she held for forty-two years, the salary from which supported her and her painter husband, Maurice Sievan. In 1938 she picked up a camera initially to photograph her husband's paintings and then took courses, first with Eliot Elisofon and later at the New York Photo League and with Berenice Abbott at the New School for Social Research. She worked as Weegee's darkroom assistant. Leslie Nolan's essay on Lee Sievan in *Creative Lives: New York Paintings and Photographs by Maurice and Lee Sievan* (New York: Museum of the City of New York, 1997) is the best biographical overview available.

Arnold Eagle (1909–92), born to Jewish parents in Hungary, immigrated with them to New York City in 1929. Eagle found employment as a photo retoucher, bought his first camera in 1932, and joined the radical Workers Film and Photo League. He helped establish its successor, the New York Photo League, and engaged in several documentary projects, including one on Orthodox Jews on the Lower East Side. In the 1940s he collaborated with Roy Stryker

on the Standard Oil photography project, freelanced as a photojournalist, and worked as a cinematographer. He subsequently taught filmmaking at the New School for Social Research. Arnold Eagle, *At Home Only With God: Believing Jews and Their Children on the Lower East Side* (New York: Aperture, 1992), includes an interpretive essay by Rabbi Arthur Hertzberg.

Leon Levinstein (1910–88), born in Buckhannon, West Virginia, to Orthodox Jewish parents, graduated from high school in Baltimore and took evening classes at Maryland Institute of Art. After military service in the Pacific in World War II, he moved to New York City with a cousin and set up an advertising agency. He studied at the New York Photo League with John Ebstel and Sid Grossman and at the New School for Social Research with Alexey Brodovitch. By 1952 he had found his own style in street photographs, which he took over many decades. Bob Shamis, *The Moment of Exposure: Leon Levinstein*, exhibition catalog (Ottawa: National Gallery of Canada, 1995), contains two valuable essays by Bob Shamis and Max Kozloff.

Lou (Judah Leon) Bernstein (1911–2005), born in Williamsburg, Brooklyn, to immigrant Jewish parents, received his first camera when his first child was born in 1935. He set up a darkroom in his apartment and started to take photos of bar mitzvahs and weddings to supplement his income. He joined the New York Photo League and studied with Sid Grossman. In the 1940s he started working at the Peerless Camera store in Manhattan, where he met a wide array of professional photographers. He mostly photographed on Sundays when he had time off. He subsequently taught briefly at Cooper Union, in his home in Williamsburg, and later when he moved to Flatbush. His son, Irwin Bernstein, wrote a brief biography, http://www.loubernstein legacy.com/introducing_lou.html.

Eliot Elisofon (1911–73), born in New York City to Latvian Jewish immigrants, grew up on the Lower East Side and graduated from DeWitt Clinton High School and Fordham University. A founding member of the New York Photo League, he served briefly as its president, taught courses on photojournalism, and participated in exhibits. He worked for *Life* magazine starting in 1937 and covered General George S. Patton's North Africa campaign as a photojournalist during World War II. Roy Flukinger wrote a brief biography to accompany a retrospective exhibit at the Harry Ransom Center, "To Help the World to See," https://web.archive.org/web/20120926121013/ http://www.hrc.utexas.edu/exhibitions/2000 /elisofon/elisofon2.html.

Helen Levitt (1913–2009), born in Bensonhurst, Brooklyn, to Jewish parents, left high school to learn photography in a portrait studio. She joined the Workers Film and Photo League and exhibited at the New York Photo League, as well as at the Museum of Modern Art. Her photographs of children at play particularly attracted attention. Levitt also made several films and worked as a cinematographer. *A Way of Seeing*, a compilation of her photographs with an essay by James Agee, appeared in 1965, although the photographs had been taken in the 1940s. *Helen Levitt* (San Francisco: San Francisco Museum of Art, 1991), a catalogue accompanying a retrospective exhibit, includes two valuable essays by Sandra S. Phillips and Maria Morris Hambourg.

Sid Grossman (1913–55), born in New York City to immigrant Jewish parents, started taking pictures as a boy with a used camera, a gift from a more prosperous cousin. In 1936 he helped to guide the New York Photo League to welcome amateurs and in 1938 to initiate its school. In the 1930s Grossman joined the Communist Party; he was committed to socially oriented documentary photography that could serve as an instrument for social change. He became known as a powerful and provocative teacher, influencing several cohorts of photographers. After Grossman served in Panama during World War II, his photography became more personal and expressive. Keith F. Davis, "As Personal as a Name, a Fingerprint, a Kiss: The Life and Work of Sid Grossman," in Keith F. Davis, *The Life and Work of Sid Grossman* (New York: Steidl/Howard Greenberg Gallery, 2016), is a comprehensive biography.

Sol Libsohn (1914–2001), born in Harlem, New York, to immigrant Jewish parents, grew up in the Bronx. He received his first camera, a broken one he fixed, from a neighbor. He met Sid Grossman at City College, and together they helped move the New York Photo League in new directions, welcoming amateurs and establishing a school. Libsohn taught at the Photo League and led several documentary projects, including one on the Chelsea neighborhood. After the war, he moved to Roosevelt, New Jersey, participated in Roy Stryker's Standard Oil project, and freelanced for magazines. An oral history interview by Gary Saretsky from January 28, 2000, included at "Remembering the 20th Century: An Oral History of Monmouth County," provides good biographical information.

Rebecca Lepkoff (1916–2014), born on the Lower East Side to immigrant Jewish parents, used the money she earned, her first taste of expendable income, from dancing at the 1939 World's Fair to purchase a camera. She took a course with Arnold Eagle under Federal Youth Administration auspices, one of the New Deal agencies. After the war, she joined the New York Photo League and studied with Sid Grossman. For more than a decade, she made her Lower East Side neighborhood the focus of her photographs. A good biographical essay by Suzanne Wasserman can be found in *Life on the Lower East*

Side: Photographs of Rebecca Lepkoff, 1937–1950 (New York: Princeton Architectural Press, 2006).

Louis Faurer (1916–2001), born in Philadelphia to Jewish immigrant parents, purchased his first camera from a high school friend. After winning a newspaper photography contest, he decided it would become his career. He served in the Signal Corps during World War II and after the war opened a studio with friends in New York City. Faurer did fashion photography to earn a living coupled with personal photography on his own time. Anne Wilkes Tucker, in *Louis Faurer*, exhibition catalog (Houston: Museum of Fine Arts; London: Merrell, 2002), provides a compelling biographical essay.

Lou Stoumen (1917–1991), born in Springtown, Pennsylvania, to non-Jewish parents, grew up in Bethlehem, Pennsylvania, and graduated from Lehigh University. He discovered photography as a kid, using his mother's Kodak. He came to New York and took a course with Sid Grossman at the New York Photo League, often arguing with him about photography. During World War II he served as a combat photographer for the U.S. Army magazine, *Yank*, in India, Burma, and China. He subsequently turned to documentary films, making *The Naked Eye* about photography. Lou Stoumen, *Ordinary Miracles: The Photography of Lou Stoumen* (Los Angeles: Hand Press, 1981), contains biographical and autobiographical essays.

Arthur Leipzig (1918–2014), born in Brooklyn to Jewish immigrant parents, discovered the New York Photo League and photography after an injury in a glass factory prompted him to look for an alternative career. He studied with Sid Grossman, joined the League, and participated in its activities. In 1942 Ralph Steiner hired him as a staff photographer for *PM*, launching Leipzig's career as a photojournalist.

He subsequently worked as a freelance photographer and taught photography for many decades at Long Island University. His book *Growing Up in New York* (New York: David R. Godine, 1995) contains autobiographical reflections.

Morris Engel (1918–2005), born in Brooklyn to Jewish immigrant parents, joined the New York Photo League as a teenager. He participated in the Harlem Document project with Aaron Siskind; subsequently Ralph Steiner hired him as a staff photographer for *PM*, launching a career in photojournalism. Engel served in a combat photo unit of the navy during World War II. After the war, he met Ruth Orkin, a Jewish photographer from California, when she moved to New York City, and they collaborated on a feature film, *Little Fugitive*, about a boy who runs away to Coney Island. They married and continued to work together on films and photography. Morris Engel and Ruth Orkin, *Outside: From Street Photography to Filmmaking*, ed. Stefan Cornic (Paris: Carlotta, 2014), covers both of their careers.

Harold Corsini (1919–2008), born in New York to Italian immigrant parents, discovered photography in high school. He joined the New York Photo League as a teenager and participated in the Harlem Document project with Aaron Siskind. Corsini worked as Arnold Eagle's assistant and on Roy Stryker's Standard Oil photography project. In 1950 he accompanied Stryker to Pittsburgh for another photographic project. Corsini set up a commercial photography firm in Pittsburgh, doing work for large corporations like U.S. Steel. The Jewish Museum has a brief biography: https://thejewishmuseum.org/collection/artist/harold-corsini-american-1919-2008.

Walter Rosenblum (1919–2006), born in New York to Jewish immigrant parents, grew up on the Lower East Side. He joined the New York Photo League as

a teenager and became an active member, studying with Sid Grossman and Paul Strand, participating in group projects, and serving as president. He served in the Signal Corps in World War II and photographed D-Day on Normandy beach. After the war, he returned to New York and the Photo League. In 1947 he started teaching photography at Brooklyn College. The bilingual (German and English) *Walter Rosenblum* (New York: Aperture, 1991) briefly covers his career.

Dan Weiner (1919–59), born in New York to Jewish immigrant parents, received his first camera at fifteen as a gift from an uncle. He left home after high school and joined the New York Photo League after meeting and marrying Sandra Smith, who also studied at the Photo League. He served stateside in the Signal Corps during World War II and returned to teach briefly at the Photo League. He opened a commercial studio but after a few years made a career as a photojournalist. His wife, Sandra Weiner, also a photographer, wrote brief personal reflections as "Personal Recollections," in *Dan Weiner, 1919–1959*, ed. Cornell Capa and Sandra Weiner (New York: Grossman, 1974).

Vivian Cherry (1920–2019), born in New York to Jewish immigrant parents, studied dance with Helen Tamiris. An injury led her to work developing and printing photographs, which stimulated her to take up photography. She joined the New York Photo League in 1947 and studied with Sid Grossman. Cherry made a career as a freelance photographer whose photo essays appeared in magazines. Some are collected in Vivian Cherry, *Helluva Town: New York City in the 1940s and 50s* (Brooklyn, NY: powerHouse books, 2008).

Sonia Handelman Meyer (1920–2022), born in Lakewood, New Jersey, to Jewish immigrant parents, grew up in Queens and graduated from Queens College of the City of New York. She received a camera as a graduation present and joined the New York Photo League during World War II, later serving as its paid secretary. She studied with Sid Grossman after the war and pursued photography until her marriage in 1950 and the subsequent the closing of the League. Although she worked with Ralph Steiner in the 1950s, she put aside photography for family responsibilities. A catalogue accompanying an exhibit, *Into the Light—Sonia Handelman Meyer: The Photo League Years*, includes an essay by Lili Corbus Geer (Raleigh, NC: Boson Books, 2009).

Jack Manning (Mendelsohn) (1920–2001), born in New York to Jewish immigrant parents, found his way to the New York Photo League as a high school student. He joined the Harlem Document project led by Aaron Siskind. After graduating from high school, he worked as a freelance photographer. During World War II he worked as a war correspondent, and after the war he lived for a decade in Barcelona. He returned to New York in 1964 as staff photographer for the *New York Times*. Douglas Martin's obituary in the *New York Times*, November 6, 2001, covers his career in brief.

Esther Bubley (1921–98), born in Minnesota to Jewish immigrant parents, grew up in Superior, Wisconsin. She studied photography at the Minneapolis School of Art before coming to Washington, D.C., where she joined Roy Stryker's photography project at the Office of War Information. When Stryker left for the Standard Oil project, he recruited Bubley, who moved to New York City. Bubley continued to work for Standard Oil even after Stryker left. She became a successful freelance photojournalist, publishing photo essays in a variety of magazines, including several as part of a series on "How America Lives" for

Ladies' Home Journal. Bonnie Yochelson, *Esther Bubley: On Assignment* (New York: Aperture, 2005), includes a biographical essay.

N. (Nathan) Jay Jaffee (1921–99), born in Brooklyn to Jewish immigrant parents, did not start to photograph until after military service in World War II. Then he attended New York Photo League lectures with Paul Strand and W. Eugene Smith, took a class with Dan Weiner, and studied with Sid Grossman (albeit not at the League), and began a career as a freelance photographer. Jaffee published *Coney Island to Caumsett: The Photographic Journey of N. Jay Jaffee, 1947–1997* (Huntington, NY: Heckscher Museum of Art, 1999) as part of a retrospective look at his career.

Louis Stettner (1922–2016), born in Brooklyn to Jewish immigrant parents, began photographing as a teenager with a folding camera that his parents gave him. He joined the New York Photo League and studied there with Sid Grossman. Stettner served as a combat photographer in the Pacific theater during World War II. After the war he briefly settled in New York, taught a course at the League, and then left for Paris. In 1952 he returned to New York, did photojournalism, taught, and did freelance work in both Europe and the United States. American McCarthyism and blacklisting denied him opportunities. He also pursued his own creative work in New York that he had started in Paris. His "Autobiography," in Louis Stettner, *Wisdom Cries Out in the Streets* (Paris: Flammarion, 1999), presents many compelling details.

Richard Avedon (1923–2004), born in New York to Jewish parents, started photographing at the camera club of the Young Men's Hebrew Association. He graduated from DeWitt Clinton High School,

where he coedited the school's literary magazine with James Baldwin. During World War II he served as a photographer's mate in the merchant marines. After the war he studied with Alexey Brodovitch and began doing freelance fashion work. Avedon helped to bring fashion photography into the streets. He ran a successful commercial studio and became the first photography editor at the *New Yorker* in 1992. Richard Avedon, *Evidence, 1944–1994* (New York: Random House, 1994), includes essays by Jane Livingston and Adam Gopnik.

Saul Leiter (1923–2013), born in Pittsburgh, Pennsylvania, to Jewish immigrant parents, received a camera from his mother as a boy. His father wanted him to become a rabbi, but Leiter wanted to be an artist. He came to New York after World War II, having spent the war years studying in a yeshiva. Leiter pursued fashion photography for a living while he devoted time to personal photographs and painting. He experimented with color photographs that have a painterly quality. *All About Saul Leiter*, exhibition catalog (Kyoto: Seigensha, 2018), covers his career in a bilingual edition.

Robert Frank (1924–2019), born in Zurich, Switzerland, to Jewish parents, left Europe for New York City as soon as possible after World War II ended. He initially found work for fashion magazines. In 1955 Frank received a Guggenheim fellowship to travel throughout the United States taking photographs that he would subsequently assemble into *The Americans*, an extraordinarily influential volume published in 1959. He later shifted to making avant-garde films. *Looking In: Robert Frank's "The Americans,"* ed. Sarah Greenough (Washington, D.C.: National Gallery of Art/Steidl, 2009), is a comprehensive biography of Frank's early years.

Jerome Liebling (1924–2011), born in Brooklyn to Jewish immigrant parents, received his first camera from them as a teenager. He served in World War II as a telephone lineman with the 82nd Airborne. After the war he went to Brooklyn College on the GI Bill and studied with Walter Rosenblum, who introduced him to the New York Photo League, where he met Paul Strand. Liebling headed the League's Membership Committee. In 1949 he left New York for a teaching position at the University of Minnesota. Twenty years later he took a teaching position at Hampshire College. Jerome Liebling, *The People, Yes* (New York: Aperture, 1995), covers four decades of his photography.

Ida Wyman (1926–2019), born in Malden, Massachusetts, to Jewish immigrant parents, grew up in the Bronx. She started taking photographs in high school and joined the Walton High School camera club. After graduation, she worked developing and printing photographs at Acme Newspictures and established a career as a photojournalist. She joined the New York Photo League and participated in its activities. In 2014 she published a collection of her photographs: Ida Wyman, *Chords of Memory* (Chicago: Think Ink and Design).

William Klein (1928–2022), born in New York to Jewish immigrant parents, graduated from high school at fourteen and attended City College, majoring in sociology. He enlisted during World War II and served in the army of occupation in Europe and then used his GI benefits to study art in Paris with Fernand Léger. A photography project brought him to the attention of *Vogue*, and under the magazine's assignment, he returned to New York City with his French wife to keep a visual diary. Klein's photographs of New York appeared in a book of his own design, *Life Is Good & Good for You in New York! Trance Witness Revels*, in 1956. He made a career in fashion photography,

documentary films, and urban photography, producing books on Tokyo, Moscow, and Rome. William Klein, *Celebration* (Paris: La Fabrica, 2019), includes selections of photographs covering his career.

Garry Winogrand (1928–84), born in the Bronx to Jewish immigrant parents, fell in love with photography at Columbia University after military service. He also studied at the New School for Social Research and then worked for Pix, a photo agency. After a trip across the United States, he returned to New York City as a freelance photojournalist, taking personal photographs on the street on his own time. Geoff Dyer, *The Street Photography of Garry Winogrand* (Austin: University of Texas Press, 2018), offers an insightful view of Winogrand's photographs.

Harold Feinstein (1931–2015), born in Brooklyn to immigrant Jewish parents, the youngest of six children, discovered photography as a teenager. He left home, joined the New York Photo League, and studied with Sid Grossman. After military service in Korea, where he photographed his fellow recruits, he returned to New York City. He became a master printer and worked with W. Eugene Smith. In the late 1950s he was invited to teach at the University of Pennsylvania, so he moved to Philadelphia. His photography workshops attracted diverse students. He later turned to photographing flowers, shells, and other natural objects. *Harold Feinstein: A Retrospective*, intro. by Phillip Prodger (Portland: Nazraeli, 2012), provides an overview.

Bruce Davidson (b. 1933), born in Chicago to Jewish parents who subsequently divorced, grew up in his maternal grandparents' home. He received his first camera as a boy and subsequently studied photography at Rochester Institute of Technology. After one semester at Yale University, he entered military service, where he gained recognition for his skill as

a photographer. Davidson then moved to New York City and worked as a freelance photographer in fashion and journalism. He joined the Magnum group as its youngest member in 1958. Throughout his career, in addition to assignments as a photojournalist, he has chosen his own projects, many of them focused on New York City and its street cultures. Vicki Goldberg's biography, *Bruce Davidson: An Illustrated Biography*, Magnum Legacy (New York: Magnum Foundation, Prestel, 2016), is an insightful introduction to Davidson's career.

Joel Meyerowitz (b. 1938), born in the Bronx to Jewish parents, studied painting at Ohio State University, graduating with a BFA in 1959. He taught himself photography and started working in color with a large-format camera in the 1960s. His advocacy for color photography helped to change attitudes toward the medium as an expressive form. Although he sees himself in the tradition of street photography and coauthored *Bystander: A History of Street Photography* with Colin Westerbeck (1994), he also photographs landscapes and portraits. His first book, *Cape Light* (1978), became a bestseller, with over 150,000 copies sold. Given exclusive access to Ground Zero after 9/11, Meyerowitz produced powerful images of the destruction and work of clearing the site.

appendix

List of Photographs

Prologue

P.1 Alfred Stieglitz, *The City of Ambitions,* 1910
P.2 Paul Strand, *Wall Street, New York, 1915*
P.3 Berenice Abbott, *Seventh Avenue Looking South from 35th Street*, December 5, 1935

Chapter 1

1.1 Walter Rosenblum, *Chick's Candy Store*, 1938
1.2 Sid Grossman, Untitled (woman standing by 23rd Street IRT station, from the series "Chelsea Document"), ca. 1938–39
1.3 Berenice Abbott, *Under Riverside Drive Viaduct*, November 10, 1937
1.4 Berenice Abbott, *Hell Gate Bridge I*, May 25, 1937
1.5 Harold Corsini, *Playing Football,* ca. 1935–37
1.6 Morris Engel, Untitled (young Black boy in front of fountain), ca. 1936
1.7 Ewing Galloway, *The Empire State Building*, 1931
1.8 Lewis Hine, *Two Workers Attaching a Beam with a Crane*, 1931
1.9 Dan Weiner, *Portrait of Arthur Miller, 1956*
1.10 Samuel Gottscho, *Financial District from Foot of Fulton Street East River, Tug in Foreground*, ca. 1930
1.11 Sid Grossman, *Colonial Park Pool below Sugar Hill*, 1939

1.12 Sid Grossman, *Swimming Pool and Children*, 1939
1.13 Sid Grossman, *Harlem, WPA*, ca. 1939
1.14 Morris Engel, *East Side Sweet Evelyn*, ca. 1937
1.15 Jerome Liebling, *Union Square, New York City, 1948*

Chapter 2

2.1 Helen Levitt, *New York*, ca. 1940
2.2 Helen Levitt, Untitled (Black boys and men on a stoop), ca. 1940
2.3 Ida Wyman, *The News Girl*, 1945
2.4 Helen Levitt, Untitled (jitterbug dancers), ca. 1940
2.5 Sol Libsohn, *Hester Street, 1938*
2.6 Dan Weiner, *Crowd Watching UN Cornerstone, 1949*
2.7 Lou Stoumen, *Sitting in Front of the Strand, Times Square, 1940*
2.8 Sid Grossman, *Mulberry Street, New York*, 1947
2.9 Sid Grossman, *Mulberry Street*, ca. 1948
2.10 Dan Weiner, *San Gennaro Smoker, NYC, 1952*
2.11 Sid Grossman, *Mulberry Street*, 1948
2.12 Sid Grossman, *San Gennaro Festival, New York City, 1948*
2.13 Louis Faurer, *Robert and Mary Frank, San Gennaro Festival, New York*, 1950

2.14 Louis Faurer, *San Gennaro Festival, New York, NY,* 1950

2.15 William Klein, *Dance in Brooklyn, 1954*

2.16 William Klein, *The bars of a 2 by 4 park. A bench, home for the homeless, New York, 1955*

Chapter 3

3.1 Weegee, *Coney Island, July 21, 1940*

3.2 Morris Engel, Untitled (boy at the beach with an inner tube), ca. 1938

3.3 Morris Engel, Untitled (water fountain, Coney Island, NYC), ca. 1938

3.4 Morris Engel, Untitled (woman drying a small boy), ca. 1938

3.5 Harold Feinstein, *Father and Son by Water's Edge, Coney Island, 1949*

3.6 Harold Feinstein, *Haitian Father and Daughter, Coney Island, 1949*

3.7 Harold Feinstein, *Boy on Dad's Shoulders, Coney Island, 1951*

3.8 Harold Feinstein, *Man at Parachute Jump, Coney Island, 1949*

3.9 Harold Feinstein, *Men in Fedoras, Coney Island, 1950*

3.10 Harold Feinstein, *Coke Sign Boardwalk, Coney Island, 1949*

3.11 Ida Wyman, *Man Looking in Wastebasket,* ca. 1950

3.12 Lisette Model, *Promenade des Anglais, Nice,* ca. 1934–37

3.13 Lisette Model, *Coney Island Bather, New York,* ca. 1939–July 1941

3.14 Lisette Model, *Coney Island Bather, New York,* ca. 1939–July 1941

3.15 Martin Munkácsi, Lucile Brokaw, Piping Rock Beach, Long Island, *Harper's Bazaar,* December 1933

3.16 Sid Grossman, *Coney Island, Labor Day,* ca. 1947–48

3.17 Dan Weiner, *Individuals Lying on Each Other at Coney Island,* 1949

3.18 Harold Feinstein, *Teenagers on the Beach, 1949*

3.19 Morris Engel, Untitled *(Coney Island Embrace),* 1940s

3.20 Lou Bernstein, *Father and Child, 1943*

3.21 Lou Bernstein, *Steeplechase, 1951*

3.22 Bruce Davidson, *USA. Coney Island, NY. 1959. Brooklyn Gang.*

3.23 Bruce Davidson, *USA. Coney Island, NY. 1959. Brooklyn Gang. On the Boardwalk at West Thirty-Third Street, Coney Island. Left to right: Junior, Bengie, Lefty.*

3.24 Leon Levinstein, *Coney Island,* ca. 1959

Chapter 4

4.1 Arthur Leipzig, *Chalk Games, Prospect Place, Brooklyn, 1950*

4.2 Arthur Leipzig, *Stickball, 1950*

4.3 Arthur Leipzig, *Rover, Red Rover, 1943*

4.4 Arthur Leipzig, *War Games on Dean Street,* ca. 1943

4.5 Weegee, *The Cop Spoils the Fun, 1937*

4.6 Rebecca Lepkoff, *Kick the Can, Ridge St., Lower East Side, 1947*

4.7 Rebecca Lepkoff, *Lower East Side (Boys on Sidewalk),* ca. 1939

4.8 Helen Levitt, *New York,* ca. 1940

4.9 Helen Levitt, *New York,* ca. 1940

4.10 Vivian Cherry, *Game of Lynching, 1947*

4.11 Vivian Cherry, *Game of Lynching, 1947*

4.12 Vivian Cherry, *Game of Lynching, 1947*

4.13 Vivian Cherry, *Crossfire, Game of Guns 2, 1947*

4.14 Vivian Cherry, *Yorkville Swastika, 1948* (plus detail, 4.14a)

4.15 William Klein, *Gun 1, 103rd Street, New York, 1954*

4.16 N. Jay Jaffee, *Fools of Desire (aka Stadium Theater with Children, Brownsville, Brooklyn), 1950*

4.17 Louis Faurer, *Times Square, 1947*

4.18 Louis Faurer, *City of Sin, 1950*

4.19 Louis Faurer, *Times Square, New York, N.Y. (Home of the Brave), 1950*

4.20 Louis Faurer, *Broadway, New York,* ca. 1949–50

4.21 William Klein, *Selwyn, 42nd Street, New York, 1955*

Chapter 5

5.1 Berenice Abbott, *Greyhound Bus Terminal, New York City,* July 14, 1936

5.2 Esther Bubley, *Greyhound Bus Terminal, New York City, 1947*

5.3 Esther Bubley, *Greyhound Bus Terminal, New York City, 1947*

5.4 Esther Bubley, *Greyhound Bus Terminal, New York City, 1947*

5.5 Esther Bubley, *Greyhound Bus Terminal, New York City, 1947*

5.6 Sol Libsohn, *Cafeteria,* 1938

5.7 Esther Bubley, *Automat, New York City, 1948*

5.8 Rebecca Lepkoff, *Greek Café, 1948*

5.9 Louis Stettner, *Soul of New York, 1951–1952*

5.10 Vivian Cherry, *Antoinette, c. 1948*

5.11 Vivian Cherry, *Boy on Stairs by Bananas,* ca. 1948

5.12 Rebecca Lepkoff, Untitled (woman by door), ca. 1947–48

5.13 Rebecca Lepkoff, *Lower East Side,* ca. 1950

5.14 Louis Faurer, Untitled (woman waiting in Times Square), ca. 1950

5.15 Sonia Handelman Meyer, *United Pipe and Cigar Store #2,* ca. 1946–53

5.16 Sonia Handelman Meyer, *United Pipe and Cigar Store,* ca. 1946–53

5.17 Sonia Handelman Meyer, *Women, Hebrew Immigrant Aid Society, Lower East Side,* ca. 1948

5.18 Sonia Handelman Meyer, *Children, Hebrew Immigrant Aid Society, Lower East Side,* ca. 1948

5.19 Sonia Handelman Meyer, *HIAS Family, Hebrew Immigrant Aid Society, Lower East Side,* ca. 1948

5.20 Sonia Handelman Meyer, *Mothers and Children, Hebrew Immigrant Aid Society, Lower East Side,* ca. 1948

5.21 Vivian Cherry, *Catholic Worker Soup Kitchen Line, 1955*

5.22 Morris Engel, Untitled (truckers at the waterfront waiting for work), 1948

5.23 Morris Engel, Untitled (dockworkers waiting for work), 1948

5.24 Lee Sievan, *Gentlemen of Leisure, 1937*

5.25 Louis Faurer, *New York,* 1949

5.26 Rebecca Lepkoff, *Grocery Store, Lower East Side,* 1940

5.27 Rebecca Lepkoff, *Henry Street, Lower East Side, New York,* ca. 1939

5.28 Helen Levitt, *New York,* ca. 1945

5.29 Helen Levitt, *New York,* ca. 1940

5.30 Vivian Cherry, *New York,* 1940s

Chapter 6

6.1 Helen Levitt, Untitled (three women conversing outside of tenement, one with newspaper), 1943

6.2 Rebecca Lepkoff, *Cherry Street,* 1940s

6.3 Helen Levitt, Untitled (mother with children conversing outside of shoe repair store), 1940s

6.4 Vivian Cherry, *Three Young Children Talking,* 1950s

6.5 Vivian Cherry, *Three Women with Wash,* 1950s

6.6 Sonia Handelman Meyer, *Women at Canera Bros. Bakery,* ca. 1946–53

6.7 Morris Engel, Untitled (two men conversing on a Harlem street), ca. 1948

6.8 Louis Faurer, *Deaf Mutes,* ca. 1950

6.9 William Klein, *Theatre Tickets, New York,* 1955

6.10 Saul Leiter, *Hat, circa 1950*

6.11 Garry Winogrand, *New York, c. 1962*

6.12 Garry Winogrand, *New York,* 1961

6.13 Garry Winogrand, *New York,* 1967

6.14 William Klein, *EPHO, New York,* 1955

6.15 Garry Winogrand, *John F. Kennedy International Airport, New York,* 1968

6.16 Esther Bubley, *Automat, New York City, 1948*

Chapter 7

7.1 Morris Engel, *Harlem Merchant, New York,* 1937

7.2 Lisette Model, *First Reflection, New York,* ca. 1939–October 1940

7.3 William Klein, *Hamburger + 40¢, Eighth Avenue, New York,* 1955

7.4 Walter Rosenblum, *Gypsies and a Vegetable Dealer,* 1938

7.5 Sol Libsohn, *Pushcarts 2,* 1938

7.6 N. Jay Jaffee, *Woman Selling Vegetables, Blake Avenue, Brooklyn, 1949*

7.7 N. Jay Jaffee, *Kishke King, Pitkin Avenue, Brownsville, Brooklyn, 1953*

7.8 N. Jay Jaffee, *Canal Street, NYC, 1953*

7.9 Dan Weiner, *Male Vendor and Female Customer Engaging in Conversation*, 1950s

7.10 Sid Grossman, *New York Recent,* ca. 1947

7.11 Esther Bubley, *New York City.* [Times Square, 1950].

7.12 Morris Engel, *NY Newstand*, 1940s

7.13 Esther Bubley, *Newsstand. New York City. c. 1944.*

7.14 Dan Weiner, *Elderly Couple inside News Booth,* 1940s

7.15 Dan Weiner, *News Vendor,* 1953

7.16 William Klein, *Gun, Gun, Gun, New York, 1955*

7.17 Esther Bubley, *Shoeshine. New York City,* 1950s

7.18 N. Jay Jaffee, *Shoeshine Conversation, New York City (Downtown),* 1949

7.19 Rebecca Lepkoff, *Shoemaker, Madison Street, Lower Manhattan, NYC,* 1940s

7.20 Morris Engel, *Shoeshine Boy and Cop,* 1947

Epilogue

E.1 Garry Winogrand, *World's Fair, New York, 1964*

E.2 Bruce Davidson, *USA. New York City. 1962. Coney Island. 4th of July Fireworks.*

E.3 Leon Levinstein, *Man in a White Suit,* 1950s

E.4 William Klein, *4 Heads, Macy's Thanksgiving Day Parade, New York, 1954*

notes

Prologue

1 Alfred Kazin, *A Walker in the City* (New York: Harcourt, Brace and Company, 1951), 13.

2 Anne Tucker, "A History of the Photo League: The Members Speak," *History of Photography* 18, no. 2 (Summer 1994): 174–84. See 177 for physical description of rooms.

3 Joanne Lukitsch, "Alone on the Sidewalks of New York: Alfred Stieglitz's Photography, 1892–1913," in *Seeing High & Low: Representing Social Conflict in American Visual Culture*, ed. Patricia Johnston (Berkeley: University of California Press, 2006), 224. Lukitsch argues (225) that Stieglitz "did not present himself as a photographic witness to New York's modernization. Instead, the changes in the city's physical environment measure a passage of time."

4 Lukitsch, "Alone on the Sidewalks," 223, 225.

5 Tara Kohn, "An Eternal Flame: Alfred Stieglitz on New York's Lower East Side," *American Art* 30, no. 2 (Fall 2016): 116; Lukitsch, "Alone on the Sidewalks," 225. Another formulation was: "I was born in Hoboken. I am an American. Photography is my passion. The search for Truth is my obsession." Quoted in Malcolm Daniel, "The Big Three," in Malcolm Daniel, *Stieglitz, Steichen, Strand: Masterworks from the Metropolitan Museum of Art*, exhibition catalog (New York: Metropolitan Museum of Art; New Haven, CT: Yale University Press, 2011), 11.

6 Strand quoted in Hans-Michael Koetzle, "Paul Strand, Blind Woman," in *Photo Icons: The Story behind the Pictures, 1897–1927* (Cologne: Taschen, 2002), 169; dedication from Paul Strand, *Paul Strand: A Retrospective Monograph, the Years 1915–1968* (New York: Aperture, 1971).

7 Alfred Stieglitz, "A Plea for Art Photography in America," *Photographic Mosaics* 28 (1892), reprinted in *Stieglitz on Photography: His Selected Essays and Notes*, ed. Richard Whelan (New York: Aperture, 2005), 30; Strand quoted in Daniel, "The Big Three," 18.

8 Koetzle, "Paul Strand, Blind Woman," 170.

9 Mitra Abbaspour, "Berenice Abbott, American, 1898–1991," MoMA, 2014, https://www.moma.org/artists/41; Abbott quoted in Takayuki Yamada, "An Analysis of Berenice Abbott's 'Changing New York': People and Lives of the Heterogeneous City," *Waseda Rilas Journal* 4 (2016): 225.

10 Andrew S. Dolkart, "The Fabric of New York City's Garment Industry: Architecture and Development in an Urban Cultural Landscape," *Buildings and Landscapes: Journal of the Vernacular Architectural Forum* 18, no. 1 (Spring 2011): 16.

11 Deborah Dash Moore, *At Home in America: Second Generation New York Jews* (New York: Columbia University Press, 1981), 21; Deborah Dash Moore et al., *Jewish New York: A History of a City and a People* (New York: New York University Press, 2017), part 3.

12 White Protestants constituted approximately 15 percent of New York's population in 1940 and were a small minority in these neighborhoods. Ira Rosenwaike, *A Population History of New York City* (Syracuse: Syracuse University Press, 1972), 130.

13 Max Kozloff, "Jewish Sensibility and the Photography of New York," in *New York: Capital of Photography*, exhibition catalog (New York: Jewish Museum; New Haven, CT: Yale University Press, 2002), 77.

14 Kozloff, "Jewish Sensibility," 70–75.

1. Toward a New York Document

1 Keith F. Davis, "As Personal as a Name, a Fingerprint, a Kiss: The Life and Work of Sid Grossman," in Keith F. Davis, *The Life and Work of Sid Grossman* (New York: Steidl/Howard Greenberg Gallery, 2016), 24.

2 Sol Libsohn, interview by Gary Saretzky, January 28, 2000, part of "Remembering the 20th Century: An Oral History of Monmouth County"; Beverly Moore Bethune, "The New York City Photo League: A Political History" (PhD diss., University of Minnesota, 1979), 63.

3 Quoted in Leah Ollman, "The Photo League's Forgotten Past," *History of Photography* 18, no. 2 (Summer 1994): 157; the Workers International Relief, established in 1921 in Berlin to assist workers on strike, helped to support the establishment of Workers Film and Photo Leagues. For a full discussion of the splits and origins of the Photo League, see Elizabeth Jane VanArragon, "The Photo League: Views of Urban Experience in the 1930s and 1940s" (PhD diss., University of Iowa, 2006), 27–29. She writes (29), "the Photo League began as an organization engaged in the communication of social concerns through images, based on its political origins in the [Film and Photo League]." Photo League members published photographs in *Life*, *Look*, and smaller publications, but not in their own *Photo Notes*. See Ollman, "The Photo League's Forgotten Past," 156–57.

4 Libsohn quote from interview by Saretzky. Anne Tucker, "A History of the Photo League: The Members Speak," *History of Photography,* 18, no. 2 (Summer 1994), 176, writes that James Richter, a freelance photographer, led the group that opposed Grossman. "Richter blamed Grossman for knocking the commercial business apart." The group that moved across the street called itself Photo Tel. According to Richter, "Grossman tried to keep us, but we didn't want to stay where we didn't have the privileges that we had worked for."

5 *Photo Notes*, August 1938, 1, in *Photo Notes, February 1938–Spring 1950*, A Visual Studies Reprint Book (Rochester: Visual Studies Workshop, 1977). The editor of *Photo Notes* for 1938 appears to be Michael Carter. For 1939 it is Henry Rothman. Anne Tucker, "A History of the Photo League," 176.

6 *Photo Notes*, August 1938, 1; VanArragon, "The Photo League," 31.

7 *Photo Notes*, June 1939, 1; Bethune, "The New York City Photo League," 69–70. Production groups were also known as "Feature Groups." The language of "advanced worker" rather than "photographer" reflected the radical spirit of the League.

8 Weiner quoted in Tucker, "A History of the Photo League," 177; Engel quoted in Tucker, "A History of the Photo League," 174. Anne Wilkes Tucker worked for many years to rehabilitate the New York Photo League. See Anne Wilkes Tucker, "The Photo League: A Center for Documentary Photography," in Anne Wilkes Tucker, Claire Cass, and Stephen Daiter, *This Was the Photo League: Compassion and the Camera from the Depression to the Cold War* (Chicago: Stephen Daiter Gallery; Houston: John Cleary Gallery, 2001), 12. In an interview on women of the Photo League, Catherine Evans quotes Berenice Abbott: "Talk about male chauvinism, I never saw it so badly expressed as there." Evans also recognizes that attitudes may have changed depending on when a woman joined the League. Patricia Silva, "Interview with Curator Catherine Evans about Women in the Photo League," *Eye to Eye* (blog), ICP-Bard College MFA, March 11, 2012, https://icpbardmfa.wordpress.com/2012/03/11/an-interview-with-catherine-evans-about-women-in-the-photo-league/.

9 Rosenblum quoted in VanArragon, "The Photo League," 66; see also 77.

10 VanArragon, "The Photo League," 90. She goes on to argue that "Strand's selection of images appears to tie into the discussion of photographic practice as a new kind of seeing." For a full discussion of Grossman's pedagogy, including the readings he and Sol Libsohn assembled on the history of photography, see Ya'ara Gil-Glazer, "'To Put the Camera Back in the Hands of Honest Photographers': The Activist Pedagogy of the Photo League," *photographies* 12, no. 1 (December 24, 2018): 25–28.

11 Rosenblum quoted in Bethune, "The New York City Photo League," 73.

12 Hasia R. Diner, "American Jewish Business: At the Street Level," in *Doing Business in America: A Jewish History*, ed. Hasia R. Diner, Casden Institute for the Study of the Jewish Role in American Life, Annual Review, 16 (West Lafayette, IN: Purdue University Press, 2018), 16, writes, "The stores and shops provided places to gossip, sites for planning public activities, as well as venues for getting the goods defined as both necessary and desirable."

13 Tucker, "The Photo League: A Center for Documentary Photography," 10; Tucker, "A History of the Photo League," 174–75. See also Membership Application Card, *Photo Notes*, January 1940, 1. It was substantially cheaper than the two other schools where one could learn photography in New York: Clarence White's School of Photography and the New School for Social Research; VanArragon, "The Photo League," 57. Gil-Glazer, "'To Put the Camera Back,'" 20; Davis, "As Personal as a Name," 24. Originally there had been five darkrooms, but four of them were consolidated for class use and so that four people could work on contact printing and enlarging at the same time. *Photo Notes*, October 1938, 2; Sally Stein, "Mainstream Differences: The Distinctive Looks of *Life* and *Look*," in *"Life" Magazine and the Power of Photography*, ed. Katherine A. Bussard and Kristen Gresh, Princeton University Art Museum (New Haven, CT: Yale University Press, 2020), 99–109.

14 Engel quoted in Tucker, "A History of the Photo League," 175; "Morris Engel: Photographer/Filmmaker," interview by Julia Van Haaften, October 2, 1999, in *Morris Engel: Early Works* (New York: Morris Engel and Ruth Orkin Photo Archive, 1999), 2–4; see also Dinitia Smith, "A Filmmaker Who Valued Art More than Family," *New York Times*, February 7, 2002, arts section; Gilbert quoted in Fiona M. Dejardin, "The Photo League: Aesthetics, Politics, and the Cold War" (PhD diss., University of Delaware, 1993), 66–67; Rosenblum quoted in Lili Corbus Bezner, *Photography and Politics in America: From the New Deal into the Cold War* (Baltimore: Johns Hopkins University Press, 1999), 33.

15 Deborah Dash Moore, "On City Streets," *Contemporary Jewry* 28 (2008): 86. Gil-Glazer, "'To Put the Camera Back,'" 21, characterizes this as modern workshop learning or learning through practice. She contrasts it to the technical proficiency emphasized by other photography schools. Gene Smith interviewed by Beverly Bethune (1975) quoted in Anne Tucker, "The Photo League," *Creative Camera* 223–24 (July/August 1983): 1017; Matthew Baigell, "From Hester Street to Fifty-Seventh Street: Jewish American Artists in New York," in *Painting a Place in America: Jewish Artists in New York, 1900–1945*, ed. Norman L. Kleeblatt and Susan Chevlowe, exhibition catalogue (New York: Jewish Museum, 1991), 40–43.

16 For a full discussion of the Photo League and Communist Party connections, see Dejardin, "The Photo League: Aesthetics, Politics, and the Cold War," as well as Fiona M. Dejardin, "The Photo League: Left-wing Politics and the Popular Press," *History of Photography* 18, no. 2 (Summer 1994): 159–73. Dejardin, "The Photo League: Aesthetics, Politics, and the Cold War," 32, writes that both Sol Libsohn and Sid Grossman openly declared their membership in the Communist Party, although neither took leading roles in running the Photo League; rather, they were important in the school. Rebecca Lepkoff, interview by Deborah Dash Moore, July 16, 2009; Bethune, "The New York City Photo League," 81; Weiner quoted in Tucker, "A History of the Photo League," 177; Harris quoted in Tucker, "A History of the Photo League," 176. On the American Labor Party, see Daniel Soyer, *Left in the Center: The Liberal Party of New York and the Rise and Fall of American Social Democracy* (Ithaca: Cornell University Press, 2021), 24–35.

17 Davis, "As Personal as a Name," 31–32.

18 Davis, "As Personal as a Name," 33.

19 Suzanne Bloom, "Sidney Grossman—Images of Integrity," *Artweek*, March 28, 1981.

20 *Photo Notes*, January 1939, 1.

21 Joel Stewart Zuker, "Ralph Steiner: Filmmaker and Still Photographer" (PhD diss., New York University, 1976), 287, writes, "The film informs us that life is bad in the city, but it also reinforces the notion that not everyone will escape, that, in fact, most of the people here will never escape. 'The City,' in retrospect, draws a strong division between city people and rural people, as well as between the rigid hierarchical division between planned communities and urban chaos." Quote in the text from 288. The film's lunch-counter imagery anticipates some of Robert Frank's photographs of Detroit lunch counters taken in the 1950s. For a thorough discussion of ogling women and its acceptability in the interwar decades, see Molly Miller Brookfield, "Watching the Girls Go By: Sexual Harassment in the American Street, 1850–1980" (PhD diss., University of Michigan, 2020), 169.

22 Ralph Steiner, letter to Zuker, February 14, 1975, quoted in Zuker, "Ralph Steiner," 290.

23 George M. Spencer, "Restless Eye," *Dartmouth Alumni Magazine*, November–December 2018, https://dartmouthalumnimagazine.com/articles/restless-eye; see also "Ralph Steiner," Wikipedia, last modified January 10, 2022, https://en.wikipedia.org/wiki/Ralph_Steiner. Zuker, "Ralph Steiner," 32, writes, "From 1937 to early 1939, Steiner ironically went back to commercial photography for money and to personal photography for real and rich self-challenge and gratification." Zuker (33) considers that the opening urban scenes present "excitement and

thrill" rather than the "originally intended moods of despair and frustration."

24 Quoted in Takayuki Yamada, "An Analysis of Berenice Abbott's 'Changing New York': People and Lives of the Heterogeneous City," *Waseda Rilas Journal* 4 (2016): 226, 228. See also 230–31 on publication history.

25 Gaëlle Morel, "Berenice Abbott," trans. Timothy Stroud, Archives of Women Artists, Research and Exhibitions, 2013, https://awarewomenartists.com/en/artiste /berenice-abbott/. Yamada, "An Analysis of Berenice Abbott's 'Changing New York,'" 231, argues that she did photograph people, but that the publisher's demands altered the character of the book, eliminating these photos to promote the book as a guide to New York.

26 *Photo Notes*, January 1939, 1. Abbott was not a member of the committee.

27 Lisa Hostetler, *Street Seen: The Psychological Gesture in American Photography, 1940–1959*, exhibition catalog (New York: Delmonico Books-Prestel, 2010), 21, writes, "The term 'street photography' can be misleading. The street, per se, is rarely the subject of the images to which the term is applied, and 'street photography' refers only occasionally to the practice of an itinerant entrepreneur who makes unsolicited snapshots of passersby and then tries to sell them to the subjects." Documentary also had its negative dimensions. The American photographer Walker Evans bridled at the term "documentary." At most he would concede that he worked in a "documentary-style." But Evans, like other photographers with gallery ambitions, wanted to be thought of as an art worker, if not an artist. Weegee quoted in Christopher Bonanos, *Flash: The Making of Weegee the Famous* (New York: Henry Holt and Company, 2018), 17.

28 *Photo Notes*, February 1938, 2.

29 *Photo Notes*, April 1939, 3.

30 Deborah Dash Moore, "Walkers in the City: Young Jewish Women with Cameras," in *Gender and Jewish History,* ed. Marion A. Kaplan and Deborah Dash Moore (Bloomington: Indiana University Press, 2011), 282.

31 *Photo Notes*, April 1939, 3. On restricted neighborhoods in Queens, see Deborah Dash Moore, Jeffrey S. Gurock, Annie Polland, Howard B. Rock, and Daniel Soyer, *Jewish New York: The Remarkable Story of a City and a People* (New York: New York University Press, 2017), 197.

32 Tucker, Cass, and Daiter, *This Was the Photo League*, 166. The Photo League received two hundred photo submissions by the deadline of May 30, 1939. The jury included members of the original New York Document committee: Disraeli, McCausland, Funaroff, as well as Abbott, Strand, Max Yavno, and Willard Morgan. They subsequently chose roughly a quarter of the photos to exhibit at the New School for Social Research from August 18 to September 8. The exhibition included work by eight non-League members and ten League members. Sol Libsohn and Sam Dinin each had seven photos in the exhibition, the largest number for an individual. After showing at the New School, the exhibit went on tour. *Photo Notes*, April 1939, 3, and September 1939, 2.

33 *Photo Notes*, April 1939, 3.

34 *Photo Notes*, February 1938, 2. Corsini subsequently worked at *Life* magazine before joining Roy Stryker's Standard Oil project in 1943. He later set up a commercial studio in Pittsburgh, taking a teaching job after he retired in 1975. Daniel Malloy, "Harold Corsini: Photographer Who Chronicled Steel Industry," *Pittsburgh Post-Gazette*, January 5, 2008, https://www.post-gazette.com/ news/obituaries/2008/01/05/Obituary-Harold -Corsini-Photographer-who-chronicled-steel-industry /stories/200801050098.

35 Elisofon reply to F. R. Fraprie, photography editor of the American Photographic Publishing Company, *Photo Notes*, October–November, 1940, 3; Moore, "On City Streets," 91.

36 This approach reflected a political as well as an artistic perspective. Photo League members encouraged "art with social purpose, photography that could improve living conditions and better civil liberties," argues the photo historian Lili Corbus Bezner, "and they were doing this, at times, in a language popularized by radical Depression-era politics and born from the Marxism of the Russian revolution." Bezner, *Photography and Politics in America*, 24.

37 Ya'ara Gil-Glazer argues that Engel's photograph, with its "dramatic light- and shadow- games and the low vantage point on a wet child distant from the group of children playing with a water spray . . . creates a dramatic atmosphere far from the childhood play he was documenting. The child's intense facial expression due to the extreme contrast, and his closed eyes, probably due to the sun in front of him, make him seem lonely and forlorn, and older than his age." She concludes that "this over-stylized photo seems to violate the League teachers' instructions to their students to avoid

documenting people in a strange or picturesque manner and avoid sentimentalism and overkill." Ya'ara Gil-Glazer, "'We Weren't Jewish (We Were Concerned Photographers)': The Photo League's Archive of Black Lives in New York," *Jewish Culture and History* 20, no. 4 (2019): 370–71. "Harold Corsini, American, 1919–2008," The Jewish Museum, https://thejewishmuseum.org/collection/artist/harold-corsini-american-1919-2008.

38 John Dewey, *Art as Experience* (1934; repr. New York: Capricorn Books, 1958), 162, 214; Tucker, "A History of the Photo League," 176; *Photo Notes*, January 1948, 7.

39 According to Jack Manning, "The critics liked to disparage us by calling us the Ashcan School of Photography—but I liked the title." Quoted in Douglas Martin, "Jack Manning, 80, Photographer with a Long Career at the Times," *New York Times*, November 6, 2001; Helen A. Harrison, "Making Murals Modern: Social Consciousness and Formal Innovation," in *The 1930s: The Reality and the Promise*, ed. J. B. Bennington, Zenia Sacks DaSilva, and Michael D'Innocenzo (Newscastle-upon-Tyne: Cambridge Scholars Press, 2016), 207.

40 Ralph Steiner, *A Point of View* (Middletown, CT: Wesleyan University Press, 1978), 9; *PM* spread quoted in Bethune, "The New York City Photo League," 84.

41 Michael Lesy, *Long Time Coming: A Photographic Portrait of America, 1935–43* (New York: W. W. Norton, 2002), 11; Alan Trachtenberg, "From Image to Story," in *Documenting America, 1935–1943*, ed. Carl Fleischhauer, Beverly W. Brannan, and Lawrence W. Levine (Berkeley: University of California Press, 1989), 65.

42 Dejardin, "The Photo League: Aesthetics, Politics, and the Cold War," 65; Ronald H. Bayor, *Neighbors in Conflict: The Irish, Germans, Jews, and Italians of New York City, 1929–1941* (Baltimore: Johns Hopkins University Press, 1978), especially chap. 8, "In the Neighborhoods"; Jewish and German and Irish voting patterns also diverged sharply (chap. 7). Stettner quoted in VanArragon, "The Photo League," 163.

43 Debra E. Bernhardt and Rachel Bernstein, *Ordinary People, Extraordinary Lives: A Pictorial History of Working People in New York City* (New York: New York University Press, 2020), 198; "1939 New York World's Fair," Wikipedia, last modified March 30, 2022, https://en.wikipedia.org/wiki/1939_New_York_World%27s_Fair. On the Empire State Building, see Carol Willis, "Form Follows Finance: The Empire State Building," in *The Landscape of Modernity: Essays on New York City, 1900–1940*, ed. David

Ward and Olivier Zunz (New York: Russell Sage Foundation, 1992), 160–87.

44 S[ol] L[ibsohn], "A Statement on Exhibition Policy," *Photo Notes*, December 1939, 5.

45 The League also created a committee to take care of the negatives. Bethune, "The New York City Photo League," 83.

46 S. Grossman, "Hine Exhibition Opens," *Photo Notes*, January 1939, 4.

47 Arthur Miller, "Dan Weiner," in *Dan Weiner, 1919–1959*, ed. Cornell Capa and Sandra Weiner, ICP Library of Photographers (New York: Grossman, 1974), 10.

48 Before developing a commercial practice in the mid-1920s as an architectural photographer, Gottscho had sold fabrics. Together with his son-in-law, William Schleisner, Gottscho took thousands of photographs of the buildings that transformed New York City in the years prior to World War II. Builders hired him to photograph their newly constructed apartment and office buildings for business and personal purposes. Forty thousand prints are at the Museum of the City of New York and twenty-nine thousand are in the Library of Congress. Max Kozloff, *New York: Capital of Photography*, exhibition catalog (New York: The Jewish Museum and New Haven, CT: Yale University Press, 2002), 188.

49 On Parkchester, see Jeffrey S. Gurock, *Parkchester: A Bronx Tale of Race and Ethnicity* (New York: New York University Press, 2019); Nicholas Dagen Bloom and Matthew Gordon Lasner, eds., *Affordable Housing in New York* (Princeton: Princeton University Press, 2016); on subways, see Clifton Hood, *722 Miles: The Building of the Subways & How They Transformed New York* (Baltimore: Johns Hopkins University Press, 2004), part 2.

50 Sidney Grossman, Journal, March 30, 1933. Sidney Grossman papers 69-246, reel 2910, Smithsonian Archives of American Art. Davis, "As Personal as a Name," 34. The Federal Art Project was much better than his previous WPA pick-and-shovel job. On his early years, see 11, 13, 236n20.

51 Davis, "As Personal as a Name," 34.

52 Davis, "As Personal as a Name," 34–35; conversation with Rebecca Zurier, February 9, 2021; Jeff Wiltse, *Contested Waters: A Social History of Swimming Pools in America* (Chapel Hill: University of North Carolina Press, 2007), 140.

53 Davis, "As Personal as a Name," 35.

54 Paul Strand, "Engel's One Man Show," *Photo Notes*, December 1939, 2.

55 Brookfield, "Watching the Girls Go By," 171.

56 Brookfield, "Watching the Girls Go By," 175–79.

57 Rebecca Zurier, *Picturing the City: Urban Vision and the Ashcan School* (Berkeley: University of California Press, 2006), 76. Gordon's biographer, Michael Stanislawski, argues that this "catchphrase" has almost universally been misunderstood. Whereas Gordon sought to capture a parallelism between menshlichkeit and yidishkeyt, suggesting that Jews needed to be both universal men well versed in European culture and civilized Jews fluent in Hebrew language and heritage, he has more often been understood as positing a dichotomy between man and Jew, secular and sacred, public and private, street and home. Michael Stanislawski, *For Whom Do I Toil? Judah Leib Gordon and the Crisis of Russian Jewry* (New York: Oxford University Press, 1988), 4–5, 49–52.

58 Quoted in Tucker, "A History of the Photo League," 174; "Sing Me a Song with Social Significance," *Pins and Needles*, https://www.stlyrics.com/lyrics/pinsandneedles/singmeasongwithsocialsignificance.htm; Dejardin, "The Photo League: Aesthetics, Politics, and the Cold War," 17. Bethune, "The New York City Photo League," 148, adds that the report noted, "As an outfit they seem to get along well together—there are no internal ructions or opposition factions or any of that sort of thing which is prevalent in most organizations of this type."

59 Dejardin, "The Photo League: Left-wing Politics and the Popular Press." Bethune, "The New York City Photo League," 89, notes that in 1947 the League sent a group of thirty-six photos to the Jewish Congregation of Lawrence, Long Island, depicting Jewish life in America from the arrival of the immigrants and their life on the Lower East Side to Jewish war veterans and a memorial to the six million Jews murdered in the Holocaust.

60 Joshua B. Freeman, *Working Class New York: Life and Labor since World War II* (New York: New Press, 2000), 7, 39.

61 Bethune, "The New York City Photo League," 92, 152–60. For a full discussion of communist politics at the Photo League, see Dejardin, "The Photo League: Aesthetics, Politics, and the Cold War."

62 Estelle Jussim, "The Photographs of Jerome Liebling, a Personal View," in *Jerome Liebling: Photographs 1947–1977* (California: Friends of Photography, 1978), 3–11; Jerome Liebling, "Biography," https://www.jeromeliebling.com/biography/. Walter Rosenblum, "Interview by Colin Osman," *Creative Camera* 223–24 (July/August 1983): 1020;

Tucker, "The Photo League," 8–19; Jerome Liebling, *The People, Yes* (New York: Aperture, 1995).

63 Freeman, *Working Class New York*, 179.

64 Naomi Rosenblum quoted in William Meyers, "Jews and Photography," *Commentary* 115, no. 1 (January 2003): 47.

65 Meyers, "Jews and Photography," 47.

66 Erving Goffman, *The Presentation of Self in Everyday Life*, Social Science Research Centre (Edinburgh: University of Edinburgh, 1956).

67 Jane Livingston, *The New York School: Photographs, 1936–1963* (New York: Stewart, Tabori, and Chang, 1992); Hostetler, *Street Seen*.

68 Max Kozloff, "Jewish Sensibility and the Photography of New York," in *New York: Capital of Photography* (New York: Jewish Museum; New Haven, CT: Yale University Press, 2002), 69–78.

69 Moore, "On City Streets," 103.

2. Looking

1 Elizabeth Margaret Gand, "The Politics and Poetics of Children's Play: Helen Levitt's Early Work" (PhD diss., University of California, Berkeley, 2011), 6.

2 Deborah Dash Moore, "Walkers in the City: Young Jewish Women with Cameras," in *Gender and Jewish History*, ed. Marion A. Kaplan and Deborah Dash Moore (Bloomington: Indiana University Press, 2010), 291–92.

3 Jane Livingston, *The New York School: Photographs, 1936–1963* (New York: Stewart, Tabori, and Chang, 1992), 303; Jane Jacobs, *The Death and Life of Great American Cities* (New York: Vintage, 1961), 50; Moore, "Walkers in the City," 292.

4 Quoted in Adam Gopnik, "Improvised City: Helen Levitt's New York," *New Yorker*, November 11, 2001. Subsequently she claimed to realize the limitations of such a politicized approach.

5 Moore, "Walkers in the City," 281. For a good discussion of women's responses to men ogling and cat calling, see Molly Miller Brookfield, "Watching the Girls Go By: Sexual Harassment in the American Street, 1850–1980" (PhD diss., University of Michigan, 2020).

6 Adam Gopnik, "Foreword," in Helen Levitt, *Here and There* (Brooklyn, NY: powerHouse books, 2003), 9–10; Brookfield, "Watching the Girls Go By," 206; Moore, "Walkers in the City," 299–300.

7 Ida Wyman quoted in Melanie Herzog, "Ida Wyman: Chords of Memory," copy in possession of author;

originally included in the American Photography Archives Group.

8 Levitt quoted in Gopnik, "Improvised City." The full quote is "People think I love children, but I don't. Not more than the next person." Gand, "Politics and Poetics of Children's Play," 7.

9 Prose (and Gopnik) quoted in Gopnik, "Improvised City"; John Szarkowski, *Looking at Photographs: 100 Pictures from the Collection of the Museum of Modern Art* (New York: Museum of Modern Art, 1973), 138, quoted in "Color Photographs by Helen Levitt," Museum of Modern Art, press release, no. 95, September 26, 1974.

10 E. B. White, *Here Is New York* (1949, rpt., New York: The Little Bookroom, 1999), 24.

11 John Berger, "Understanding a Photograph," in *The Look of Things*, ed. Nikos Stangos (New York: Viking Press, 1971), 180. Berger writes (179), "Photographs bear witness to a human choice being exercised in a given situation." Barbara Kirshenblatt-Gimblett, "Objects of Ethnography," in *Destination Culture: Tourism, Museums, Heritage* (Berkeley: University of California Press, 1998), 25.

12 Helen Levitt, quoted in Livingston, *New York School*, 269. Levitt recalled watching Alexander Dovzhenko's 1935 movie about the construction of a utopian Soviet city, *Aerograd*, a half dozen times. Films helped Levitt to see the city through other lenses.

13 Elizabeth Gand, "Helen Levitt (1913–2009) and the Camera," *American Art* 23, no. 3 (Fall 2009): 98; Gand, "Politics and Poetics of Children's Play," 59. Levitt's book was published initially in 1965, almost two decades after Levitt conceived it. Gand, "Politics and Poetics of Children's Play," 59, contends that Janice Loeb, with whom Levitt collaborated on her film *In the Street*, was equally, if not more, important than some of these male photographers. Some sources (including Gopnik, "Improvised City") say that Levitt, like Shahn, adopted the strategy of using a right-angle finder device that allowed her to pretend to take a picture in one direction when actually snapping the shutter with a different view. Gand, "Helen Levitt," 98.

14 Gand argues that Levitt's interest in children responded to the rise of attention to vernacular subjects and the influx of surrealism in American culture in the 1930s. Gand, "Politics and Poetics of Children's Play," 5; *Photo Notes*, June 1943, 1, in *Photo Notes, February 1938–Spring*

1950, A Visual Studies Reprint Book (Rochester: Visual Studies Workshop, 1977).

15 William Thomas, "The Definition of the Situation," in *Self, Symbols and Society: Classic Readings in Social Psychology*, ed. Nathan Rousseau (Lanham, MD: Rowman and Littlefield, 2002), 103–15; Berger, "Understanding a Photograph," 180. Richard Nagler's photobook *Looking at Art: The Art of Looking* (Berkeley: Heyday, 2014) conveys the gallery experience of people looking at photos very well.

16 George Herbert Mead, "The Self and the Organism," section 18 in *Mind, Self, and Society from the Standpoint of a Social Behaviorist*, ed. Charles W. Morris (Chicago: University of Chicago Press, 1934), 138. "It is the characteristic of the self as an object to itself that I want to bring out." The phrase "liquid condition" is Max Kozloff's. He writes, "For them [many Jewish photographers], solidarity is a created and always liquid condition, reversible as a tide, not a solid state to be taken for granted. That may be why children of many backgrounds are so often monitored by New York Jewish photography: at play and work, they're being inducted into that system, and pictures of them subtly describe the process." *New York: Capital of Photography,* exhibition catalog (New York: Jewish Museum; New Haven, CT: Yale University Press, 2002), 75.

17 Deborah Dash Moore, "On City Streets," *Contemporary Jewry* 28 (2008): 92. As Berger notes, "The immediate relation between what is present and what is absent is particular to each photograph." Berger, "Understanding a Photograph," 181.

18 Moore, "On City Streets," 92–93.

19 Moore, "On City Streets," 93.

20 Arthur Leipzig recalled that Strand responded snidely: "We will all take out the crying towels and weep with you and offer our condolences, but when you put a photograph on the wall it either works as a totality or it doesn't and all the excuses, rationale and captions underneath will not make it any better." Quoted in Elizabeth Jane VanArragon, "The Photo League: Views of Urban Experience in the 1930s and 1940s" (PhD diss., University of Iowa, 2006), 168.

21 Libsohn quoted in VanArragon, "The Photo League," 169.

22 Sol Libsohn, interview by Gary Saretzky, January 28, 2000, part of "Remembering the 20th Century: An Oral History of Monmouth County."

23 Libsohn, interview by Saretzky.

24 On New York liberal politics, see Joshua B. Freeman, *Working-Class New York: Life and Labor since World War II* (New York: New Press, 2000), 55–70.

25 Sandra Weiner, "Personal Recollections," in *Dan Weiner, 1919–1959*, ed. Cornell Capa and Sandra Weiner, ICP Library of Photographers (New York: Grossman, 1974), 92–95; Dan Weiner Biography, Steven Kasher Gallery, http://www.stevenkasher.com/artists/dan-weiner; bio at Dan Weiner website, http://danweiner.org/bio/. Weiner wrote, "Mine is the first generation that can say that our understanding of the world and concepts of the forces and direction of society have been shaped not through the literary or the auditory, but the visual."

26 MacDonald Moore and Deborah Dash Moore, "Observant Jews and the Photographic Arena of Looks," in *You Should See Yourself: Jewish Identity in Postmodern American Culture*, ed. Vincent Brook (New Brunswick, NJ: Rutgers University Press, 2006), 187.

27 Moore and Moore, "Observant Jews," 187.

28 Lou Stoumen, "Sworn Testimony of a Street Photographer," in *Ordinary Miracles: The Photography of Lou Stoumen* (Los Angeles: Hand Press, 1981), 96.

29 Le Corbusier quoted in Robert A. Orsi, "Introduction," in *Gods of the City: Religion and the American Urban Landscape*, ed. Robert A. Orsi (Bloomington: Indiana University Press, 1999), 40. Also see Eamonn Carrabine, "Unsettling Appearances: Diane Arbus, Erving Goffman and the Sociological Eye," *Current Sociology* 67, no. 5 (March 2019): 669–85.

30 Charles Lemert, "Goffman," in *The Goffman Reader*, ed. Charles Lemert and Ann Branaman (Malden, MA: Blackwell, 1997), xxi.

31 Erving Goffman, "The Self as Ritual Object" from "The Nature of Deference and Demeanor," in Lemert and Branaman, *The Goffman Reader*, 32.

32 Erving Goffman, "Self-Presentation" from "The Presentation of Self in Everyday Life," in Lemert and Branaman, *The Goffman Reader*, 23, 25.

33 Joseph Sciorra, "'We Go Where the Italians Live': Religious Processions as Ethnic and Territorial Markers in a Multi-ethnic Brooklyn Neighborhood," in Orsi, *Gods of the City*, 310, 317.

34 Keith F. Davis, "As Personal as a Name, a Fingerprint, a Kiss: The Life and Work of Sid Grossman," in Keith F. Davis, *The Life and Work of Sid Grossman* (New York: Steidl/Howard Greenberg Gallery, 2016), 128.

35 "Feast of San Gennaro," Wikipedia, last modified March 23, 2022, https://en.wikipedia.org/wiki/Feast_of_San_Gennaro; Helen Gee, *Limelight: A Greenwich Village Photography Gallery and Coffeehouse in the Fifties. A Memoir by Helen Gee* (Albuquerque: University of New Mexico Press, 1997), 3.

36 Thanks to Leonard Norman Primiano for these identifications. Sciorra, "'We Go Where the Italians Live,'" 310.

37 Orsi, "Introduction," 57.

38 Grossman quoted in Lili Corbus Bezner, *Photography and Politics in America: From the New Deal into the Cold War* (Baltimore: Johns Hopkins University Press, 1999), 120, 91. Gee, *Limelight*, 25–26. She also observed (26) that her feelings about Grossman "kept changing from week to week, and by the end of the course, I'd lost fifteen pounds and was much too thin. Rather than go on riding an emotional roller-coaster—and risk getting an ulcer—I decided not to repeat the course in the fall."

39 See George H. Roeder, Jr., *The Censored War: American Visual Experience during World War II* (New Haven, CT: Yale University Press, 1993).

40 Eric J. Sandeen, *Picturing an Exhibition: "The Family of Man" and 1950s America* (Albuquerque: University of New Mexico Press, 1995), 14–15, quote on 14.

41 Debra E. Bernhardt and Rachel Bernstein, *Ordinary People, Extraordinary Lives: A Pictorial History of Working People in New York City* (New York: New York University Press, 2020), 84, 202. New York still handled 19 percent of the nation's printing in 1963.

42 Klein quoted in John Heilpern, "Profile," in *William Klein: Photographs* (New York: Aperture, 1981), 13; William Klein, preface to *New York 1954–55* [version of *Life Is Good & Good for You in New York! Trance Witness Revels*] (Manchester: Dewi Lewis Publishing, 1995), 4.

43 Klein, *New York 1954–55*, 4; Moore, "On City Streets," 100.

44 Klein, *New York 1954–55*, 4.

45 Klein continued: "The photographers I knew mostly were Walker Evans, Weegee, maybe Riis and Hine. For me photography was good old-fashioned muckraking and sociology. The kinetic quality of New York, the kids, dirt, madness—I tried to find a photographic style that would come close to it. So I would be grainy and contrasted and black. I'd crop, blur, play with the negatives. I didn't see clean technique being right for New York. I could imagine my pictures lying in the gutter like the New York *Daily News*. I was a newspaperman! If there was trouble I'd say I was from the *News*." Klein, *New York 1954–55*, 15–16.

46 Lisa Hostetler, *Street Seen: The Psychological Gesture in American Photography, 1940–1959*, exhibition catalog (New York: Delmonico Books-Prestel, 2010), 131.

47 Klein, *New York 1954–55*, 4, 16.

48 Klein quoted in Richard B. Woodward, "An American Skeptic in Paris," *New York Times*, April 6, 2003.

49 Moore, "On City Streets," 100.

50 Moore, "On City Streets," 100.

51 Anthony Lane, "William Klein," in *Nobody's Perfect: Writings from the New Yorker* (New York: Vintage, 2003), 703; Moore, "On City Streets," 100.

52 Klein and Avedon quoted in Livingston, *New York School*, 270; Moore, "On City Streets," 101.

53 Klein quoted in Anthony Lane, "The Shutterbug," *New Yorker*, May 21, 2001, 81.

54 John Cohen, ed., *The Essential Lenny Bruce* (New York: Ballantine, 1967), 41–42. It would be nice to think that Klein's comparison references culture, not biology. See Kozloff, *New York*, 70.

3. Letting Go

1 Christopher Bonanos, *Flash: The Making of Weegee the Famous* (New York: Henry Holt and Company, 2018), 119–22, 124–26, quote on 126.

2 John F. Kasson, *Amusing the Millions: Coney Island at the Turn of the Century* (New York: Hill & Wang, 1978), 40–49. Kasson notes the popularity, as well, of picture postcards and stereopticon slides.

3 Delmore Schwartz, "In Dreams Begin Responsibilities," in *Jewish American Stories*, ed. Irving Howe (New York: New American Library, 1977), 192.

4 Kasson, *Amusing the Millions*, 44; Jeffrey Stanton, "Coney Island—Nickel Empire (1920's–1930's)," 1997, https://www.westland.net/coneyisland/articles/nickelempire.htm.

5 *Fortune* quoted in Robin Jaffee Frank, "'The Nickel Empire' 1930–1939," in *Coney Island: Visions of an American Dreamland*, ed. Robin Jaffee Frank (New Haven, CT: Yale University Press and the Wadsworth Atheneum Museum of Art, 2015), 79–80; also quoted in Charles Denson, *Coney Island Lost and Found* (New York: Ten Speed Press, 2001), 65.

6 Stanton, "Coney Island—Nickel Empire."

7 Adler quoted in "Life in the Gut," in Denson, *Coney Island Lost and Found*, 74.

8 Mason quoted in James Tobin, "Who Loves America?" *Michigan Today*, August 22, 2019, https://michigantoday.umich.edu/2019/08/22/who-loves-america/.

9 "Biography: Morris Engel (1918–2005)," Morris Engel Archive, https://www.engelphoto.com/career/biography/.

10 *The WPA Guide to New York City* (1939; repr., New York: Pantheon, 1982), 471; Denson, introduction to *Coney Island Lost and Found*, viii.

11 Engel quoted in Alan Trachtenberg, "Photography and Social Knowledge," *American Art* 29, no. 1 (Spring 2015): 5; Charles Musser, "Cameras at Coney, 1940–1953," in Frank, *Coney Island*, 233.

12 Engel quoted in Musser, "Cameras at Coney," 228.

13 Mildred Adams, "The Carnival of Pleasure We Call Coney," *New York Times*, August 14, 1932, quoted in Frank, "'The Nickel Empire,'" 102.

14 Harold Feinstein, "At a Photo League Meeting, 1949: Lost and Found Photographs," November 5, 2012, https://www.haroldfeinstein.com/lost-and-found-photographs-from-a-photo-league-meeting-1949/. "I first started going to meetings shortly after the U.S. Attorney's office blacklisted the League in 1947. . . . My photographic eye was already attuned to my own journey of bearing witness to the life around me and the movement toward humanistic social commentary was part of my innate sensibility."

15 Harold Feinstein, "Artist Statement," Leica Gallery, Los Angeles, https://web.archive.org/web/20210615194056/http://leicagalleryla.com/gallery-view/harold-feinstein/ (accessed August 13, 2020); *Last Stop Coney Island: The Life & Photography of Harold Feinstein*, directed by Andy Dunn, 2019, https://www.haroldfeinstein.com/documentary/; Killian Fox, "Photographer Harold Feinstein, the Unsung Chronicler of Coney Island," *The Guardian*, May 5, 2019.

16 *A Walk Through with Harold Feinstein*, 1989 Retrospective, Penn State's Erwin W. Zoller Gallery; Robin Jaffee Frank, "A Coney Island of the Mind," in Frank, *Coney Island*, 133, 135.

17 Feinstein quoted in *Last Stop Coney Island*; Feinstein, "Artist Statement," Leica Gallery.

18 For a caricatured version of a (Jewish) woman photographer with a Brownie camera, see Paul Cadmus's 1934 painting *Coney Island*, reproduced in Frank, "'The Nickel Empire,'" plate 73.

19 Quoted in Melanie Herzog, "Ida Wyman: Chords of Memory," *Wisconsin People & Ideas*, Winter 2014, https://www.wisconsinacademy.org/magazine/ida-wyman-chords-memory.

20 Ann Thomas, *Lisette Model* (Ottawa: National Gallery of Canada, 1990), 30–32, 37–39, 44–45, quote on 44.

21 Frank, "'The Nickel Empire,'" 112.

22 MacDonald Moore and Deborah Dash Moore, "Observant Jews and the Photographic Arena of Looks," in *You Should See Yourself: Jewish Identity in Postmodern American Culture*, ed. Vincent Brook (New Brunswick: Rutgers University Press, 2006), 185–86.

23 Model quoted in Frank, "'The Nickel Empire,'" 112; *Harper's Bazaar* quoted in Mason Klein, "Modern Look: Photography, Innovation, and the American Magazine," in *Modern Look: Photography and the American Magazine*, ed. Mason Klein, exhibition catalog (New Haven, CT: Yale University Press; New York: Jewish Museum, 2020), 46.

24 In 1928, an image from a roll of film he had shot from a tram in Budapest coincidentally turned out to include ambiguous evidence of an altercation and killing (anticipating, as his wife later noted, Antonioni's 1966 movie *Blow-Up*, itself based on a story by Cortázar). The notoriety helped to land Munkácsi regular work in Germany. He covered an international beat, taking dynamic, dramatically composed pictures of sports, news, and celebrities. One of his clients, the strikingly modern *Berliner Illustrierte Zeitung*, would inspire the 1936 rebirth of *Life* as a photo news and culture magazine. Susan Morgan, "Europe: The Art of Spontaneity," in *Martin Munkacsi* (New York: An Aperture Monograph, 1992), 5.

25 Carmel Snow, *The World of Carmel Snow* (New York: McGraw-Hill Book Company, 1962), 88–90, quoted in Susan Morgan, "America: Creating the Impromptu Attitude," in *Martin Munkacsi*, 47. Avedon is the éminence grise of another story about how one photo transformed a plain Jane into an overnight fashion sensation. In the 1957 movie *Funny Face*, Audrey Hepburn starred along with Fred Astaire. His character, Dick Avery, is a fashion photographer struck by the crazy notion to shoot fashion pictures in, of all places, a bookstore. Avery was explicitly modeled on Richard Avedon, another photographer discovered by Snow in 1945, four years after Model. He took photos that were used in the film. Avedon spent his illustrious career as an action fashion photographer of outdoor shoots. Katherine A. Bussard, introduction to *Unfamiliar Streets: The Photographs of Richard Avedon, Charles Moore, Martha Rosler, and Philip-Lorca diCorcia* (New Haven, CT: Yale University Press, 2014), 16.

26 Sid Grossman quoted in Anne Tucker, "Sid Grossman—Major Projects," *Creative Camera* 223–24 (July/August 1983): 1041.

27 Grossman quoted in Tucker, "Sid Grossman—Major Projects," 1041.

28 Tucker, "Sid Grossman—Major Projects," 1041.

29 Paul Milkman, *PM: A New Deal in Journalism, 1940–1948* (New Brunswick, NJ: Rutgers University Press, 1997), 5.

30 Feinstein, "Artist Statement," Leica Gallery; *A Walk Through with Harold Feinstein*.

31 *Last Stop Coney Island*.

32 *Last Stop Coney Island*; *A Walk Through with Harold Feinstein*.

33 Irwin Bernstein, "Introducing Lou Bernstein," 2008/2009, http://loubernsteinlegacy.com/introducing_lou.html; interview with Irwin Bernstein by Deborah Dash Moore, 2004.

34 Bruce Davidson, *Brooklyn Gang* (1959; repr., Santa Fe, NM: Twin Palms Publishers, 1998), 81; Davidson quoted in Sean O'Hagan, "Joker in the Pack: Bruce Davidson's Photographs of a Brooklyn Gang," *The Guardian*, June 21, 2010, https://www.theguardian.com/artanddesign/2010/jun/21/bruce-davidson-photography-brooklyn-gang.

35 On *West Side Story*, see Irene G. Dash, *Shakespeare and the American Musical* (Bloomington: Indiana University Press, 2010), 80–91.

36 Vicki Goldberg writes in her biography *Bruce Davidson: An Illustrated Biography*, Magnum Legacy (New York: Magnum Foundation, Prestel, 2016), 29–30, how his experience in the military changed after his photographs of Yale's football team were published in *Life*. In fall 1956, Davidson was posted to a counterintelligence unit in France, not far from Paris. See 11–27 for biographical details.

37 Davidson, *Brooklyn Gang*, 81; Goldberg, *Bruce Davidson*, 50–51. The photograph of the Statue of Liberty became the opening image in Davidson's *Brooklyn Gang* book.

38 Davidson quoted in Goldberg, *Bruce Davidson*, 53.

39 Carlos Gollonet, "Introduction," *Bruce Davidson* (New York: Aperture, Fundación MAPFRE, 2016), 25, writes that Davidson's photographs "turned out to be difficult to assimilate to *Life*'s conventional gaze. After he showed them to the magazine, the editors asked him where one could find hope in such images. He responded that he didn't see any, and they suggested he return when he found some." *Esquire* published the photographs in June 1959.

40 Quoted in Jacob Deschin, "Flash! Camera Club Carries Out Program," *Popular Photography*, February 1943, in Bob Shamis, "Leon Levinstein: His Life and Photographs,"

in Bob Shamis, *The Moment of Exposure: Leon Levinstein*, exhibition catalog (Ottawa: National Gallery of Canada, 1995), 19–20.

41 Shamis, "Leon Levinstein," both quotes on 38.

42 Max Kozloff, "Leon Levinstein and the School of New York," in Shamis, *The Moment of Exposure*, 46; Shamis, "Leon Levinstein," 43.

4. Going Out

1 Arthur Leipzig, *Growing Up in New York* (Boston: David R. Godine, 1995), n.p.

2 David Nasaw, *Going Out: The Rise and Fall of Public Amusements* (New York: Basic Books, 1993), 4, 240.

3 Leipzig, *Growing Up in New York*.

4 Paul Milkman, *PM: A New Deal in Journalism, 1940–1948* (New Brunswick, NJ: Rutgers University Press, 1997), 1.

5 David Margolick, "*PM*'s Impossible Dream," *Vanity Fair*, January 1999, 121; Engel quoted at 122. Leipzig quoted in Milkman, *PM*, 44. The other photographers on staff included Gene Badger, Wilbert Blanche, John DeBiase, Steven Derry, Alan Fischer, Morris Gordon, Irving Haberman, Martin Harris, Mary Morris, and Ray Platnick; see Milkman, *PM*, 46.

6 Leipzig, *Growing Up in New York*; David Nasaw, *Children of the City: At Work and at Play* (Garden City, NY: Anchor Press, 1985), 19–20; Catherine Evans, "As Good as the Guys: Women of the Photo League," in Mason Klein and Catherine Evans, *The Radical Camera: New York's Photo League, 1936–1951*, exhibition catalog (New York: Jewish Museum; New Haven, CT: Yale University Press, 2011), 51.

7 Gus Tyler, "The Intellectual and the ILGWU," in *Creators and Disturbers: Reminiscences by Jewish Intellectuals of New York*, ed. Bernard Rosenberg and Ernest Goldstein (New York: Columbia University Press, 1982), 159.

8 Douglas Martin, "Arthur Leipzig, Photographer of Everyday Life in New York, Dies at 96," *New York Times*, December 5, 2014, https://www.nytimes.com/2014/12/06/nyregion/arthur-leipzig-a-photographer-inspired-by-everyday-life-in-new-york-dies-at-96.html; Leipzig, *Growing Up in New York*.

9 Mason Klein, "Of Politics and Poetry: The Dilemma of the Photo League," in Klein and Evans, *The Radical Camera*, 21.

10 "McKesson Corp. History, Profile and Corporate Video," Companies History, https://www.companieshistory.com/mckesson/.

11 Leipzig, *Growing Up in New York*.

12 Nasaw, *Children of the City*, 24; Weegee (Arthur Fellig), "A Book is Born," in *Naked City* (New York: Essential Books, 1945), 12. He added, "To me a photograph is a page from life, and that being the case, it must be real."

13 For discussion of women's dress as photographers, see Patricia Silva, "Interview with Curator Catherine Evans about Women in the Photo League," *Eye to Eye* (blog), ICP-Bard College MFA, March 11, 2012, https://icpbardmfa.wordpress.com/2012/03/11/an-interview-with-catherine-evans-about-women-in-the-photo-league/.

14 Later she learned to write Yiddish, having learned the spoken language growing up. Rebecca Lepkoff, interview by Deborah Dash Moore, July 16, 2009.

15 Suzanne Wasserman, "Choreography of the Streets: The Life and Work of Rebecca Lepkoff," in Rebecca Lepkoff, *Life on the Lower East Side: Photographs by Rebecca Lepkoff, 1937–1950* (New York: Princeton Architectural Press, 2006), 32–37.

16 Lepkoff, interview by Moore; Wasserman, "Choreography of the Streets," 32–37; Rebecca Lepkoff, interview with Suzanne Wasserman, quoted in the acknowledgments of Lepkoff, *Life on the Lower East Side*, 9.

17 Lepkoff, interview by Moore; Lepkoff quoted in Wasserman, "Choreography of the Streets," 39.

18 Quoted in Wasserman, "Choreography of the Streets," 40.

19 Quoted in Wasserman, "Choreography of the Streets," 40.

20 Elizabeth Gand, "Helen Levitt (1913–2009) and the Camera," *American Art* 23, no. 3 (Fall 2009): 98–99.

21 Maria Morris Hambourg quoted in Elizabeth Margaret Gand, "The Politics and Poetics of Children's Play: Helen Levitt's Early Work" (PhD diss., University of California, Berkeley, 2011), 4.

22 Players each took a country as their name. The player who was "it" threw a ball up in the air and designated the person to catch the ball with that expression "bombs over [country]," while everyone else ran as far as possible.

23 Tom Engelhardt, *The End of Victory Culture: Cold War America and the Disillusioning of a Generation* (New York: Basic Books, 1995), 7–8, 82. More than half a century later, William Klein and Diane Arbus, famous for their portrait and street photographs, are widely identified, respectively, with *Gun 1*, 1954, and *Child with Toy Hand Grenade*, 1962. In the early 1980s Nan Goldin photographed herself and her boyfriend: *Nan and Brian in Bed*,

1983. The apprehension on her face previews the physical and emotional devastation evident a year later in *Nan One Month after Being Battered*. Although Goldin claimed that none of her photos were "prearranged, prethought, premeditated," she set up and then remotely triggered both of these photographs. Today they are among her best-known pictures. Tom Holert, "Tom Holert Talks to Nan Goldin—'80s Then—Interview," *Art Forum International* 41, no. 7 (March 2003): 233.

24 Richard Sandomir, "Vivian Cherry, Whose Photographs Captured Gritty New York, Dies at 98," *New York Times*, March 15, 2019.

25 Silva, "Interview with Curator Catherine Evans."

26 Ronald H. Bayor, *Neighbors in Conflict: The Irish, Germans, Jews, and Italians of New York, 1929–1941* (Baltimore: Johns Hopkins University Press, 1978), 57. Bayor, 60, notes that "the hub of the Nazi movement remained in New York."

27 Beth S. Wenger, *New York Jews and the Great Depression: Uncertain Promise* (Syracuse: Syracuse University Press, 1999), 20–25; Margolick, "*PM*'s Impossible Dream," 128.

28 Vivian Cherry, interview by Deborah Dash Moore, June 9, 2009.

29 Jessica Stewart, "97-Year-Old Pioneer of Street Photography Captures New York Since the 1940s," My Modern Met, June 5, 2018, https://mymodernmet.com/vivian -cherry-street-photography/.

30 Quoted in Susan Hartman, "A New York Street Photographer Keeps on Clicking," *Christian Science Monitor*, March 26, 2008, http://www.csmonitor.com/2008/0326/p20s01 -ussc.html?page=1.

31 Quoted in Klein, "Of Politics and Poetry," 12.

32 William Klein, *New York 1954–55* [version of *Life Is Good & Good for You in New York! Trance Witness Revels*] (Manchester: Dewi Lewis Publishing, 1995), 10. In the original book, Klein devoted an entire section to "Gun."

33 Lisa Hostetler, *Street Seen: The Psychological Gesture in American Photography, 1940–1959*, exhibition catalog (New York: Delmonico Books-Prestel, 2010), 131.

34 Laura Greenberg, "Street Games in Brooklyn," in *Jews of Brooklyn*, ed. Ilana Abramovitch and Sean Galvin (Waltham, MA: Brandeis University Press, 2002), 206–8, quote on 208.

35 *Photo Notes*, January 1939, in *Photo Notes, February 1938– Spring 1950*, A Visual Studies Reprint Book (Rochester: Visual Studies Workshop, 1977).

36 David C. Hammack, "Developing for Commercial Culture," in *Inventing Times Square: Commerce and Culture at the Crossroads of the World*, ed. William R. Taylor (Baltimore: Johns Hopkins University Press, 1991), 46.

37 Quoted in David W. Dunlap, "Irwin Chanin, Builder of Theaters and Art Deco Towers, Dies at 96," *New York Times*, February 26, 1988, http://www.nytimes.com/1988/02/26/obituaries/irwin-chanin-builder-of -theaters-and-art-deco-towers-dies-at-96.html; Chanin quoted from "The Chanins of Broadway," *American Magazine*, August 1928, in Diana Agrest, "A Romance with the City: The Work of Irwin Chanin," in *A Romance with the City: Irwin S. Chanin* (New York: Cooper Union Press, 1982), 10.

38 By 1929, 250,000 people came nightly to Times Square. Katherine A. Bussard, introduction to *Unfamiliar Streets: The Photographs of Richard Avedon, Charles Moore, Martha Rosler, and Philip-Lorca diCorcia* (New Haven, CT: Yale University Press, 2014), 163; Betsy Blackmar, "Uptown Real Estate and the Creation of Times Square," in Taylor, *Inventing Times Square*, 64.

39 Faurer quoted in Anne Wilkes Tucker, "So Intelligent, . . . So Angry, and Having Such a Passion for the World," in *Louis Faurer* (Houston: Museum of Fine Arts Houston; London: Merrill Publishers Limited, 2002), 24.

40 Quoted in Tucker, "So Intelligent," 13, 24; Jean-Christophe Agnew, "Times Square: Secularization and Sacralization," in Taylor, *Inventing Times Square*, 7–8.

41 Lisa Liebmann, "Louis Faurer on City Streets," *Aperture*, no. 88 (1982): 5.

42 Klein, "Of Politics and Poetry," 12.

5. Waiting

1 Melissa A. McEuen, "Exposing Anger and Discontent: Esther Bubley's Portrait of the Upper South during World War II," in *Searching for Their Places: Women in the South across Four Centuries*, ed. Thomas H. Appleton and Angela Boswell (Columbia: University of Missouri Press, 2003), 238–56.

2 Steven W. Plattner, introduction to *Roy Stryker, USA, 1943–1950: The Standard Oil (New Jersey) Photography Project* (Austin: University of Texas Press, 1983), 11–25. Photographers were paid at the munificent sum of $150/ week plus expenses (17).

3 Christopher Gray, "A Bus Terminal, Overshadowed and Unmourned," *New York Times*, November 3, 2011, https:// www.nytimes.com/2011/11/06/realestate/the-west-30s -streetscapes-a-bus-terminal-overshadowed-and-un mourned.html.

4 Helmut Puff, "We Have Been Early Modern for a While," *Sixteenth Century Journal* 50, no. 1 (Spring 2019): 346.

5 Alan Behr, email communication with author, December 18, 2020.

6 Jason Francisco, "Esther Bubley, Self-Portrait c. 1950," *#PhotosWeLove* (blog), Medium, May 8, 2016, https://medium.com/photos-we-love/esther-bubley-self-portrait-c-1950-jason-francisco-for-photoswelove-adcc8a1781e2.

7 Alan Trachtenberg, "Photography and Social Knowledge," *American Art* 29, no. 1 (Spring 2015): 6; Andrea Köhler, *Passing Time: An Essay on Waiting*, trans. Michael Eskin (New York: Upper West Side Philosophers, 2011), 47; Helmut Puff, "Waiting in the Antechamber," in *Timescapes of Waiting: Spaces of Stasis, Delay, and Deferral*, ed. Christopher Singer, Robert Wirth, and Olaf Berwald (Leiden: Brill Rodopi, 2019), 19.

8 Erving Goffman quoted in Eamonn Carrabine, "Unsettling Appearances: Diane Arbus, Erving Goffman and the Sociological Eye," *Current Sociology* 67, no. 5 (March 2019): 672.

9 Puff, "Waiting in the Antechamber," 17; Carrabine, "Unsettling Appearances," 679.

10 See "Bubley Family" 6/24/2014 and Enid Bubley application for admission to Michael Reese Hospital School of Nursing, Chicago, courtesy of Jean Bubley, Esther Bubley Archives, Brooklyn, New York; copy in possession of author. Bubley quoted in Leslie T. Davol, "Shifting Mores: Esther Bubley's World War II Boarding House Photos," *Washington History* 10, no. 2 (Fall/Winter 1998–99): 46.

11 Melissa Fay Greene, "Introduction," in *The Photographs of Esther Bubley*, ed. Amy Pastan, Fields of Vision (London: Giles in association with the Library of Congress, 2010), xi. Bonnie Yochelson, *Esther Bubley: On Assignment* (New York: Aperture, 2005), 5, notes that Bubley learned studio technique using a view camera, tripod, and carefully controlled lighting. Sol Libsohn, interview by Bonnie Yochelson, June 28, 2000; transcript courtesy of Jean Bubley, Esther Bubley Archives.

12 David Caron, "Queer Relationality and the Dying Mother: Waiting and Caring in Sébastien Lifshitz's *Wild Side* and Jacques Nolot's *L'arrière-pays*," in "French Thanatology," ed. Enda McCaffrey and Steven Wilson, special issue, *L'Esprit Créateur* 61, no. 1 (Spring 2021): 14.

13 Puff, "Waiting in the Antechamber," 31.

14 Irving Howe, "A Memoir of the Thirties," in *Steady Work* (New York: Harcourt, Brace and World, 1966), 354–55.

15 Caron, "Queer Relationality and the Dying Mother," 14.

16 Köhler, *Passing Time*, 61.

17 Molly Miller Brookfield, "Watching the Girls Go By: Sexual Harassment in the American Street, 1850–1980" (PhD diss., University of Michigan, 2020), xii, argues that "men's harassment of women in public places had a material impact on women's ability to navigate public space freely. Men's harassment contributed to women's discomfort and sexual violence in public space."

18 Rebecca Zurier, "Whose Metropolis, Whose Mental Life? Rethinking Space and the Local in Urban Imagery," in *Complementary Modernisms in China and the United States: Art as Life/Art as Idea*, ed. Zhang Jian and Bruce Robertson (Santa Barbara: Punctum Books, 2020), 142.

19 William Grimes, "Louis Stettner, Who Photographed the Everyday New York and Paris, Dies at 93," *New York Times*, October 14, 2016, https://www.nytimes.com/2016/10/15/arts/design/louis-stettner-dead.html; Louis Stettner, *Louis Stettner's New York, 1950s–1990s* (New York: Rizzoli, 1996), 126; Louis Stettner, "Autobiography," in *Wisdom Cries Out in the Streets* (Paris: Flammarion, 1999), 17–21.

20 "Biography," Louis Stettner Estate, https://www.louisstettner.com/biography.

21 Caron, "Queer Relationality and the Dying Mother," 15.

22 Vivian Cherry did a series of photographs on dismantling the Third Avenue El, portraying both the workers and watchers. Some are reproduced in Vivian Cherry, *Helluva Town: New York City in the 1940s and 50s* (Brooklyn, NY: powerHouse books, 2008), 15–37, especially 26–37.

23 Rebecca Lepkoff, interview by Deborah Dash Moore, July 16, 2009.

24 Lisa Liebmann, "Louis Faurer on City Streets," *Aperture*, no. 88 (1982): 6.

25 Sonia Handelman Meyer, interview by Deborah Dash Moore, July 27, 2020; Lou Stoumen, in "Biographies," in Anne Wilkes Tucker, Claire Cass, and Stephen Daiter, *This Was the Photo League: Compassion and the Camera from the Depression to the Cold War* (Chicago: Stephen Daiter Gallery; Houston: John Cleary Gallery, 2001), 172–73.

26 Later the building was turned into the home of Joseph Papp's Public Theater. Handelman Meyer, interview by Moore.

27 For a brief history of HIAS, see https://www.hias.org/who/history; for a timeline, see https://ajhs.org/hias-timeline. Mark Wischnitzer, *Visas to Freedom: The History of HIAS* (New York: World Publishing Company, 1956).

28 Beth Cohen, *Case Closed: Holocaust Survivors in Postwar America* (New Brunswick, NJ: Rutgers University Press, 2007), 27.

29 Cohen, *Case Closed*, 27.

30 Marion Kaplan, *Hitler's Jewish Refugees: Hope and Anxiety in Portugal* (New Haven, CT: Yale University Press, 2020), 36.

31 Handelman Meyer, interview by Moore.

32 On *Jubilee* magazine, 1953–67, see Claire Kelley, "Remembering *Jubilee* Magazine," Melville House, February 13, 2013, https://www.mhpbooks.com/remembering-jubilee-magazine/. Coedited by Robert Lax and Thomas Merton, *Jubilee* featured poetry, photographs, essays, and spiritual writing. Its mission was to "act as a forum for addressing issues confronting the contemporary church."

33 Engel quoted in Trachtenberg, "Photography and Social Knowledge," 6; Deborah Dash Moore, "Walkers in the City: Young Jewish Women with Cameras," in *Gender and Jewish History*, ed. Marion A. Kaplan and Deborah Dash Moore (Bloomington: Indiana University Press, 2010), 296.

34 She was born Lina Gertrude Culik. Leslie Nolan, "Lee Sievan (1907–1990), a New York Photographer," in *Creative Lives: New York Paintings and Photographs by Maurice and Lee Sievan,* exhibition catalog (New York: Museum of the City of New York, 1997): 2; Elisofon quoted on 5.

35 Moore, "Walkers in the City," 297.

36 Moore, "Walkers in the City," 298–99.

37 Frank M. Young, "No Man of Her Own (1950)," Noir of the Week, December 12, 2010, http://www.noiroftheweek.com/2010/12/no-man-of-her-own-1950.html. The film critic Bosley Crowther didn't care for the movie and called it, scathingly, "a lurid and artificial tale, loaded with far-fetched situations and deliberate romantic clichée's [*sic*]. And the script which Sally Benson and Catherine Turney prepared from a novel by William Irish ('I Married a Dead Man') makes a silly botch of same. This sort of female agonizing, in which morals are irresponsibly confused for the sake of effect, makes diversion for none but the suckers, we feel sure." Bosley Crowther, "The Screen in Review: 'No Man of Her Own,' Starring Barbara Stanwyck, Opens at the Paramount Theatre," *New York Times*, May 4, 1950.

38 Jane Jacobs, *The Death and Life of Great American Cities* (New York: Vintage, 1961), 55.

39 Jacobs, *Death and Life of Great American Cities*, 74.

40 Trachtenberg, "Photography and Social Knowledge," 6.

41 Zurier, "Whose Metropolis," 150–51.

42 Deborah Dash Moore, "On City Streets," *Contemporary Jewry* 28 (2008): 97.

43 Trachtenberg, "Photography and Social Knowledge," 7.

44 Trachtenberg, "Photography and Social Knowledge," 8.

45 Moore, "Walkers in the City," 292–93.

46 Moore, "Walkers in the City," 293–94.

47 Howe, *Steady Work*, iv; Jason Farman, *Delayed Response: The Art of Waiting from the Ancient to the Instant World* (New Haven, CT: Yale University Press, 2018), 185.

6. Talking

1 Sonia Handelman Meyer, interview by Deborah Dash Moore, July 27, 2020.

2 Homi Bhabha and Sander Gilman, "Just Talking," in *Talk Talk Talk: The Cultural Life of Everyday Conversation*, ed. S. I. Salamensky (New York: Routledge, 2001), 6. Only 58 percent of New Yorkers subscribed to private telephone service. Statistics of the Communication Industry, Table 11, Communications of Common Carriers, Federal Communications Commission, *Statistics of the Communications Industry in the United States, Year Ended December 31, 1948* (Washington: Federal Communications Commission, 1950), 40.

3 Goffman quoted in Eamonn Carrabine, "Unsettling Appearances: Diane Arbus, Erving Goffman and the Sociological Eye," *Current Sociology* 67, no. 5 (2019): 679.

4 Deborah Dash Moore, "Walkers in the City: Young Jewish Women with Cameras," in *Gender and Jewish History*, ed. Marion A. Kaplan and Deborah Dash Moore (Bloomington: Indiana University Press, 2010), 289.

5 Moore, "Walkers in the City," 289.

6 Moore, "Walkers in the City," 289; Naomi Rosenblum, *A History of Women Photographers* (New York: Abbeville Press, 1994), 224.

7 Hearst papers occupied the opposite political pole from *PM*. Max Kozloff, *New York: Capital of Photography*, exhibition catalog (New York: Jewish Museum; New Haven, CT: Yale University Press, 2002), 75; Moore, "Walkers in the City," 289.

8 Jane Jacobs, *The Death and Life of Great American Cities* (New York: Vintage, 1961), 55; Marshall Sklare, "Jews, Ethnics and the American City," in *Observing America's Jews*, ed. Jonathan D. Sarna (Waltham, MA: Brandeis University Press, 1993), 134.

9 Moore, "Walkers in the City," 287–88.

10 Moore, "Walkers in the City," 288; Suzanne Wasserman, "Choreography of the Streets: The Life and Work of Rebecca Lepkoff," in Rebecca Lepkoff, *Life on the Lower East Side: Photographs by Rebecca Lepkoff, 1937–1950* (New York: Princeton Architectural Press, 2006), 37.

11 In 1934, 84 percent of Chinese workers in New York worked in laundries or restaurants. Debra E. Bernhardt and Rachel Bernstein, *Ordinary People, Extraordinary Lives: A Pictorial History of Working People in New York City* (New York: New York University Press, 2020), 46; interview with Walter Rosenblum (1992) quoted in Lili Corbus Bezner, *Photography and Politics in America: From the New Deal into the Cold War* (Baltimore: Johns Hopkins University Press, 1999), 33.

12 Morris Engel, "Morris Engel: Photographer/Filmmaker," interview by Julia Van Haaften, October 2, 1999, in *Morris Engel: Early Works* (New York: Morris Engel and Ruth Orkin Photo Archive, 1999), 7. The Black population of Harlem peaked in 1950 at 98 percent of the total population of 233,000; "Demographics" in "Harlem," Wikipedia, last modified March 28, 2022, https://en.wikipedia.org/wiki/Harlem#Demographics.

13 David Nasaw, *Children of the City: At Work and at Play* (Garden City, NY: Anchor Press, 1985), 191.

14 Ariana Kelly, *phone booth* (New York: Bloomsbury Academic, 2015), 43–44.

15 Martin Buber, "Elements of the Interhuman," in *The Knowledge of Man: Selected Essays*, ed. Maurice Friedman, trans. Maurice Friedman and Ronald Gregor Smith (New York: Harper and Row, 1965), 85–86.

16 "World of Silence," *Flair*, 1953 Annual, 16; Lou Stettner, "Man against Metropolis," September 1977, in *Speaking Out: Essays on Photography, 1971–1979* (privately published by the Estate of Louis Stettner, 2021), 202, from *Camera* 35 (1977).

17 Saul Leiter quoted in Anne Wilkes Tucker, "'So Intelligent, . . . So Angry, and Having Such a Passion for the World,'" in *Louis Faurer*, exhibition catalog (Houston: Museum of Fine Arts; London: Merrell Publishers Limited, 2002), 37.

18 Saul Leiter, "Saul Leiter on the Art of Going Unnoticed," interview by Sam Stourdzé, in *Saul Leiter* (Göttingen: Steidl, 2008), 11.

19 Leiter, interview by Stourdzé, 11–13, quote on 13.

20 Naomi Blumberg, "Garry Winogrand: American Photographer," *Brittanica*, last updated March 15, 2022, https://www.britannica.com/biography/Garry-Winogrand;

John Szarkowski, "The Work of Garry Winogrand," in *Winogrand: Figments from the Real World*, exhibition catalog (New York: Museum of Modern Art, 1988), 12, 15; Winogrand quote on 12. George Zimbel, a student at Columbia University who wrote and photographed for the *Columbia Daily Spectator,* introduced Winogrand to the Columbia Camera Club darkroom. Zimbel studied at the Photo League in the summer of 1949. He became a photojournalist. https://georgezimbel.com/about/; accessed May 31, 2022.

21 Fran Lebowitz, "On Winogrand's New York," in Garry Winogrand, *The Man in the Crowd: The Uneasy Streets of Garry Winogrand*, exhibition catalog (San Francisco: Fraenkel Gallery, 1999), 13.

22 Molly Miller Brookfield, "Watching the Girls Go By: Sexual Harassment in the American Street, 1850–1980" (PhD diss., University of Michigan, 1920), xii.

23 Brookfield, "Watching the Girls Go By," xii. The gestures of the guy talking suggest a homosexual identity, but in the 1950s, most gay men in New York remained resolutely in the closet.

24 By 1954, telephone subscriptions in the United States were increasing at an exponential rate. Telephone switching was also automated in the 1940s, eliminating party lines and expanding privacy in phone calls. Kelly, *phone booth*, 36, 54; see also 20–21.

25 Kelly, *phone booth*, 18.

26 Kelly, *phone booth*, 26.

27 Kelly, *phone booth*, 86.

28 William Klein, *New York, 1954–1955* (New York: Dewi Lewis Publishing, 1995), 8.

29 Kelly, *phone booth*, 117–18.

30 Vivian Gornick, "On the Street: Nobody Watches, Everyone Performs," in *Approaching Eye Level* (Boston: Beacon Press, 1996), 9–11.

7. Selling

1 Sara Blair, *Harlem Crossroads: Black Writers and the Photograph in the Twentieth Century* (Princeton: Princeton University Press, 2007), 19, 32, 39. On Harlem's history as a Jewish neighborhood, see Jeffrey S. Gurock, *The Jews of Harlem: The Rise, Decline, and Revival of a Jewish Community* (New York: New York University Press, 2016). For a comprehensive discussion of the March 19, 1935, Harlem riot and its aftermath, see Mark Naison, *Communists in Harlem during the Depression* (Urbana: University of Illinois Press, 1983), 140–50.

2 Blair, *Harlem Crossroads*, quotes on 9, 14, 16. Ashjian, who was not Jewish, was already married; she had grown up in Indianapolis and come to NYC with her husband. Sean Corcoran, "Lucy Ashjian and the Photo League," MCNY Blog: New York Stories, December 1, 2015, https://blog.mcny.org/2015/12/01/lucy-ashjian-and-the-photo-league/. Prom was a pseudonym for Solomon Fabricant, who was a doctoral student at NYU in sociology, a field in which he made his career. Anne Wilkes Tucker, "A Rashomon Reading," in Mason Klein and Catherine Evans, *The Radical Camera: New York's Photo League, 1936–1951*, exhibition catalog (New York: Jewish Museum; New Haven, CT: Yale University Press, 2011), 75.

3 Ya'ara Gil-Glazer, "'We Weren't Jewish (We Were Concerned Photographers)': The Photo League's Archive of Black Lives in New York," *Jewish Culture and History* 20, no. 4 (2019): 366; Maurice Berger, "Man in the Mirror: Harlem Document, Race, and the Photo League," in Klein and Evans, *The Radical Camera*, 39.

4 Blair, *Harlem Crossroads*, 23–24.

5 See Sara Blair, "Visions of the Tenement: Jews, Photography, and Modernity on the Lower East Side," *Images* 4 (2010): 57–81, for a discussion of these issues, and her conclusion (81) that the most lasting effect of these photographs "was to install at the heart of the ongoing project of imaging American modernity an intense preoccupation with modes of experience and perception inflected by histories of Jewish life in America." Blair, *Harlem Crossroads*, 28.

6 Morris Engel, "Morris Engel: Photographer/Filmmaker," interview by Julia Van Haaften, October 2, 1999, in *Morris Engel: Early Works* (New York: Morris Engel and Ruth Orkin Photo Archive, 1999), 4; Blair, *Harlem Crossroads*, 30.

7 Beth Wenger, *New York Jews and the Great Depression: Uncertain Promise* (Syracuse: Syracuse University Press, 1999), 18–19.

8 Alan Trachtenberg, "Photography and Social Knowledge," *American Art* 29, no. 1 (Spring 2015): 6.

9 Richard Ings, "Making Harlem Visible: Race, Photography and the American City, 1915–1955" (PhD diss., University of Nottingham, 2003), 147. He goes on to argue that the portrait is "much more specific about the spatial consequences of an economic Depression unfairly weighted against an impoverished community."

10 Trachtenberg, "Photography and Social Knowledge," 8.

11 E. B. White, *Here Is New York* (New York: Harper & Brothers, 1949), 28–29.

12 Blair, *Harlem Crossroads*, 17.

13 Model quoted in Blair, *Harlem Crossroads*, 17.

14 Lisa Hostetler, *Street Seen: The Psychological Gesture in American Photography, 1940–1959*, exhibition catalog (New York: Delmonico Books-Prestel, 2010), 35.

15 Chaim Kuznetz, "Why I Left the Old Country and What I Have Accomplished in America," in *My Future Is in America: Autobiographies of Eastern European Jewish Immigrants*, ed. Jocelyn Cohen and Daniel Soyer (New York: New York University Press, 2006), 262.

16 John Heilpern, "Profile," in *William Klein: Photographs* (New York: Aperture, 1981), 16.

17 Walter Rosenblum, "Interview by Colin Osman," *Creative Camera* 223–24 (July/August 1983): 1019; Shelley Rice, "Walter Rosenblum: Paying Homage through Photography," in Shelley Rice and Naomi Rosenblum, *Walter Rosenblum: Photographer* (Dresden: Verlag der Kunst; Weingarten: Kunstverlag Weingarten, 1990), 5; Walter Rosenblum interview (1992) quoted in Lili Corbus Bezner, *Photography and Politics in America: From the New Deal into the Cold War* (Baltimore: Johns Hopkins University Press, 1999), 33; Elizabeth Jane VanArragon, "The Photo League: Views of Urban Experience in the 1930s and 1940s" (PhD diss., University of Iowa, 2006), 77. She notes (76) that the Pitt Street series was also produced in the context of a class with Grossman, so there was a specific audience in mind. See sidebar in Rosenblum, "Interview by Colin Osman," 1020.

18 Rosenblum, "Interview by Colin Osman," 1020. Rosenblum also gave the photograph a more generic title: *Lower East Side Street*.

19 Deborah Dash Moore, *Urban Origins of American Judaism* (Athens: University of Georgia Press, 2014), 136.

20 Quoted in Rice, "Walter Rosenblum," 15. Rosenblum always gave out pictures to the people he photographed on Pitt Street. It was part of the exchange he felt he owed the men and women he photographed. Bezner, *Photography and Politics in America*, 236.

21 Andrew R. Heinze, "Jewish Street Merchants and Mass Consumption in New York City, 1880–1914," *American Jewish Archives* 41, no. 2 (Fall/Winter 1989): 203; Daniel Bluestone, "The Pushcart Evil," in *The Landscape of Modernity: Essays on New York City, 1900–1940*, ed. David Ward and Olivier Zunz (New York: Russell Sage Foundation, 1992), 287–88.

22 Alfred Kazin, *A Walker in the City* (New York: Harcourt, Brace and Company, 1951), 31.

23 Benjamin Pollak, "Reassessing *A Walker in the City*: Alfred Kazin's Brownsville and the Image of Immigrant New York," *American Jewish History* 97, no. 4 (October 2013): 406; N. Jay Jaffee, "Reflections: My Early Photographs," September 17, 1996, http://njayjaffee.com/writing/reflections-my-early-photographs/.

24 Arthur Leipzig's photograph of *Chalk Games* was taken on Prospect Place; see chapter 4. N. Jay Jaffee, "An Era Past," 1995, http://njayjaffee.com/writing/an-era-past/.

25 Jaffee, "Reflections"; Jaffee, "An Era Past."

26 N. Jay Jaffee, "Remembering Sid Grossman," 1993, http://njayjaffee.com/writing/remembering-sid-grossman/; Ed Roth quoted in Debra E. Bernhardt and Rachel Bernstein, *Ordinary People, Extraordinary Lives: A Pictorial History of Working People in New York City* (New York: New York University Press, 2020), 3.

27 N. Jay Jaffee, "The Photo League: A Memoir," August 1994, http://njayjaffee.com/writing/the-photo-league-a-memoir/; Jaffee, "An Era Past."

28 Kazin, *A Walker in the City*, 12. In 2021 dollars, Klein's forty-cent hamburger is almost $4, while Jaffee's two burgers for a quarter are $2.75. Jaffee, "Reflections." By contrast, Sig Klein's Fat Man Shop poster sign on Third Avenue by the elevated train was photographed repeatedly.

29 Helen Gee, *Limelight: A Greenwich Village Photography Gallery and Coffeehouse in the Fifties. A Memoir by Helen Gee* (Albuquerque: University of New Mexico Press, 1997), 21.

30 Gee, *Limelight*, 21.

31 Gee, *Limelight*, 23. Gee writes about Model's husband and his advances toward her that made both her and Lisette Model uncomfortable.

32 Gee, *Limelight*, 25–26, 4.

33 "Pulp Magazine," Wikipedia, last modified April 12, 2022, https://en.wikipedia.org/wiki/Pulp_magazine.

34 David Nasaw, *Children of the City: At Work and at Play* (Garden City, NY: Anchor Press, 1985), 191.

35 Engel, "Morris Engel: Photographer/Filmmaker," interview by Van Haaften, 8.

36 Engel, "Morris Engel: Photographer/Filmmaker," interview by Van Haaften, 8.

37 Gee, *Limelight*, 54; Helen Gee, *Photography of the Fifties: An American Perspective* (Tucson: Center for Creative Photography, 1980), 17.

38 *Photo Notes*, August 1938, 1, in *Photo Notes, February 1938–Spring 1950*, A Visual Studies Reprint Book (Rochester: Visual Studies Workshop, 1977). See list of exhibits, Gee, *Limelight*, 293. Model quoted in Gee, *Photography of the Fifties*, 4; Gee quote, *Photography of the Fifties*, 2.

39 "Helen Gee (curator)," Wikipedia, last modified April 1, 2022, https://en.wikipedia.org/wiki/Helen_Gee_(curator). This translates into around $49,000 in 2022. Gee notes that prices ranged from $25 per photograph set by Ansel Adams to an "absurd $125" (her characterization) set by Paul Strand. In general, two photos sold per show. Julien Levy never had a client for a photograph in his gallery and sold only to friends for very low prices. Gee, *Photography of the Fifties*, 15.

Epilogue

1 *Last Stop Coney Island: The Life & Photography of Harold Feinstein*," directed by Andy Dunn, 2019, https://www.haroldfeinstein.com/documentary/.

2 For statistics, see Ira Rosenwaike, *A Population History of New York City* (Syracuse: Syracuse University Press, 1972), 131–68. For Jewish population, see Deborah Dash Moore et al., *Jewish New York: A History of a City and a People* (New York: New York University Press, 2017), 288, 291.

3 William Klein quoted in Jane Livingston, *The New York School: Photographs, 1936–1963* (New York: Stewart, Tabori, and Chang, 1992), 265, 313; Susan Kismaric and Eva Respini, *Fashioning Fiction in Photography since 1990* (New York: Museum of Modern Art, 2004), 12, quote on 22.

4 Marianne Hirsch, "Introduction: Familial Looking," in *The Familial Gaze*, ed. Marianne Hirsch (Hanover: University Press of New England, 1999), xi.

5 Eric J. Sandeen, *Picturing an Exhibition: "The Family of Man" and 1950s America* (Albuquerque: University of New Mexico Press, 1995), 23. See, for example, *Ladies' Home Journal*, February 1950, January 1951, June 1951, October 1951, February 1952, October 1952, January 1953, October 1953.

6 On the transition between post–World War II suburban family ideals and "alternative family" lifestyles of threat and promise, see Anthony W. Lee, "Arbus, the Magazines, and the Streets," in *Diane Arbus: Family Albums*, ed. Anthony W. Lee and John Pultz (New Haven, CT: Yale University Press, 2003), 24–28. Lee also quotes Irving Howe, *A Margin of Hope* (New York: Harcourt, Brace, Jovanovich, 1982), 337–39, where he writes elegiacally, "all that we had left of Jewishness had come to rest in the family." See also MacDonald Moore and Deborah Dash Moore, "Observant Jews and the Photographic Arena of Looks,"

in *You Should See Yourself: Jewish Identity in Postmodern American Culture*, ed. Vincent Brook (New Brunswick, NJ: Rutgers University Press, 2006), 191.

7 Larry Sultan, *Pictures from Home* (New York: Abrams, 1992); Richard Avedon, "Jacob Israel Avedon," *Camera Magazine*, November 1974; Lauren Greenfield, *Girl Culture* (San Francisco: Chronicle Books, 2002).

8 Perhaps one should count *Let Us Now Praise Famous Men*, a 1936 collaborative look at three southern sharecropper families by Walker Evans and James Agee, published in 1941. Usually understood as an example of documentary photography, it can also be considered a type of family album. Harold Feinstein withdrew his submission for *The Family of Man* when Steichen asked to have the negatives so that he could control how the images were cropped and sized. Feinstein wanted to maintain the integrity of his photographs. Later, he admitted it was probably "the most foolish decision of my career." Feinstein quoted in Killian Fox, "Photographer Harold Feinstein, the Unsung Chronicler of Coney Island," *The Guardian*, May 5, 2019; Sandeen, *Picturing an Exhibition*, 75.

9 Ben Lifson, "Garry Winogrand's Art of the Actual," in Garry Winogrand, *The Man in the Crowd: The Uneasy Streets of Garry Winogrand*, exhibition catalog (San Francisco: Fraenkel Gallery, 1999), 154.

10 Bruce Davidson, "Afterword," in *Time of Change: Civil Rights Photographs 1961–1965* (Los Angeles: St. Ann's Press, 2002), n.p.; Vicki Goldberg, *Bruce Davidson: An Illustrated Biography*, Magnum Legacy (New York: Magnum Foundation, Prestel, 2016), chap. 3, 63–85.

11 Helen Gee, *Limelight: A Greenwich Village Photography Gallery and Coffeehouse in the Fifties. A Memoir by Helen Gee* (Albuquerque: University of New Mexico Press, 1997), 152–53. Limelight's exhibit of Levinstein's photographs was a success, garnering positive reviews in the *New York Times* as well as the *Village Voice*. He sold four prints, and Steichen acquired nineteen for the Museum of Modern Art.

12 The photographer Nan Goldin, who created an alternative family for herself through her friends, described "bonds stronger than blood-bonds, because the family was bonded by sensibilities, political views, aesthetics, sense of humor, shared history." Tom Holert, "Tom Holert Talks to Nan Goldin —'80s Then—Interview," *Art Forum International* 41, no. 7 (March 2003): 274.

13 William Klein, *New York 1954–55* [version of *Life Is Good & Good for You in New York! Trance Witness Revels*] (Manchester: Dewi Lewis Publishing, 1995), 16.

14 Klein, preface to *New York 1954–55*, 4; see also 15–16. American publishers wouldn't touch his material, but eventually his book appeared in France as Klein designed it. The book's title gives a taste of the offhand, try-anything style of his work.

15 Max Kozloff, "New Documents Revisited," in *Arbus, Friedlander, Winogrand: New Documents, 1967*, exhibition catalog (New York: Museum of Modern Art, 2017), 23; Joel Meyerowitz, *How I Make Photographs*, Masters of Photography (London: Lawrence King Publishing, 2019), 17; Avedon quoted in Katherine A. Bussard, *Unfamiliar Streets: The Photographs of Richard Avedon, Charles Moore, Martha Rosler, and Philip-Lorca diCorcia* (New Haven, CT: Yale University Press, 2014), 21.

16 Meyerowitz, *How I Make Photographs*, 31.

17 Sarah Hermanson Meister, "Newer Documents," in *Arbus, Friedlander, Winogrand*, 9.

18 Quoted in Anne Tucker, "A History of the Photo League: The Members Speak," *History of Photography* 18, no. 2 (Summer 1994): 174.

19 Meyerowitz, *How I Make Photographs*, 39.

20 Max Kozloff, "A Way of Seeing and the Act of Touching: Helen Levitt's Photographs of the Forties," in *The Privileged Eye: Essays on Photography* (Albuquerque: University of New Mexico Press, 1987), 31; Julia Van Haaften, "A Solitary Walker in Brooklyn," in Larry Racioppo, *Brooklyn Before: Photographs, 1971–1988* (Ithaca: Three Hills Press, 2018), 19. Diane Arbus's *Two American Families*, for a series in the London *Sunday Times Magazine* in 1968, carries this theme into new, personal territory that explicitly explores class, gender, and ethnicity.

selected bibliography

Many of these sources were consulted in the writing of this book and are included in the notes. In addition, there are valuable publications for readers interested in street photography to deepen their knowledge, as well as some scholarship on Jewish photographers in the United States. Several dissertations contain fascinating, detailed discussions. At the end can be found some interviews of photographers.

Baskind, Samantha. "Weegee's Jewishness." *History of Photography* 34, no. 1 (February 2010): 60–78. https://doi.org/10.1080/03087290903361449.

Berger, Maurice. "Man in the Mirror: Harlem Document, Race, and the Photo League." In Mason Klein and Catherine Evans, *The Radical Camera: New York's Photo League, 1936–1951*, 30–45. New York: Jewish Museum; New Haven, CT: Yale University Press, 2011. Published in conjunction with an exhibition of the same name, organized by and presented at the Jewish Museum and the Columbus Museum of Art, November 4, 2011–March 25, 2012.

Bernhardt, Debra E., and Rachel Bernstein. *Ordinary People, Extraordinary Lives: A Pictorial History of Working People in New York City*. New York: New York University Press, 2020.

Bethune, Beverly Moore. "The New York City Photo League: A Political History." PhD diss., University of Minnesota, 1979. ProQuest Dissertations Publishing, 1979. 8006503.

Bezner, Lili Corbus. *Photography and Politics in America: From the New Deal into the Cold War*. Baltimore: Johns Hopkins University Press, 1999.

Bezner, Lili Corbus. *Women of the Photo League: January 24–March 22, 1998*. Charlotte, NC: Light Factory, 1998.

Blair, Sara. *Harlem Crossroads: Black Writers and the Photograph in the Twentieth Century*. Princeton: Princeton University Press, 2007.

Blair, Sara. "Jewish America through the Lens." In *Jewish in America*, edited by Jonathan Freedman and Sara Blair, 113–34. Ann Arbor: University of Michigan Press, 2004.

Blair, Sara. "Visions of the Tenement: Jews, Photography, and Modernity on the Lower East Side." *Images* 4, no. 1 (2010): 57–81. https://doi.org/10.1163/187180010X547648.

Bonanos, Christopher. *Flash: The Making of Weegee the Famous*. New York: Henry Holt and Company, 2018.

Brookfield, Molly Miller. "Watching the Girls Go By: Sexual Harassment in the American Street, 1850–1980." PhD diss., University of Michigan, 2020.

Bussard, Katherine A. *Unfamiliar Streets: The Photographs of Richard Avedon, Charles Moore, Martha Rosler, and Philip-Lorca diCorcia*. New Haven, CT: Yale University Press, 2014.

Capa, Cornell, and Sandra Weiner, eds. *Dan Weiner, 1919–1959*. ICP Library of Photographers, vol. 4. New York: Grossman, 1974.

Carrabine, Eamonn. "Unsettling Appearances: Diane Arbus, Erving Goffman and the Sociological Eye." *Current*

Sociology 67, no. 5 (March 2019): 669–85. https://doi
.org/10.1177/0011392118823828.

Cherry, Vivian. *Helluva Town: New York City in the 1940s and
50s*. Text by Barbara Head Millstein and Vivian Cherry.
Brooklyn, NY: powerHouse books, 2008.

Davidson, Bruce. *Brooklyn Gang*. 1959. Reprint, Sante Fe, NM:
Twin Palms Publishers, 1998.

Davis, Keith F. *The Life and Work of Sid Grossman*. New York:
Steidl/Howard Greenberg Gallery, 2016.

Dejardin, Fiona M. "The Photo League: Aesthetics, Politics,
and the Cold War." PhD diss., University of Delaware,
1993. ProQuest Dissertations Publishing, 1993.
9419504.

Dejardin, Fiona M. "The Photo League: Left-wing Politics
and the Popular Press." *History of Photography* 18, no. 2
(Summer 1994): 159–73. https://doi.org/10.1080/030872
98.1994.10442346.

Dyer, Geoff. *The Street Philosophy of Garry Winogrand*. Austin:
University of Texas Press and Center for Creative Photog-
raphy, University of Arizona, 2018.

Engel, Morris. *Morris Engel: Early Work*. New York: Morris
Engel and Ruth Orkin Photo Archive, 1999.

Evans, Catherine. "As Good as the Guys: Women of the
Photo League." In Mason Klein and Catherine Evans,
*The Radical Camera: New York's Photo League, 1936–
1951*, 46–59. New York: Jewish Museum; New Haven,
CT: Yale University Press, 2011. Published in conjunc-
tion with an exhibition of the same name, organized
by and presented at the Jewish Museum and the
Columbus Museum of Art, November 4, 2011–March
25, 2012.

Frank, Robin Jaffee, ed. *Coney Island: Visions of an American
Dreamland, 1861–2008*. New Haven, CT: Yale University
Press and the Wadsworth Atheneum Museum of Art,
2015.

Freeman, Joshua B. *Working-Class New York: Life and Labor
since World War II*. New York: The New Press, 2000.

Gand, Elizabeth. "Helen Levitt (1913–2009) and the Camera."
American Art 23, no. 3 (Fall 2009): 98–102. https://doi.org
/10.1086/649790.

Gand, Elizabeth Margaret. "The Politics and Poetics of Chil-
dren's Play: Helen Levitt's Early Work." PhD diss., Univer-
sity of California, Berkeley, 2011. ProQuest Dissertations
Publishing, 2011. 3469270.

Garner, Gretchen. *Disappearing Witness: Change in Twentieth-
Century American Photography*. Baltimore: Johns Hopkins
University Press, 2003.

Gee, Helen. *Limelight: A Greenwich Village Photography Gallery
and Coffeehouse in the Fifties. A Memoir by Helen Gee*. Albu-
querque: University of New Mexico Press, 1997.

Gee, Helen. *Photography of the Fifties: An American Perspec-
tive*. Tucson: Center for Creative Photography, University
of Arizona, 1980.

Gee, Helen. "Photography in Transition." In *Decade by
Decade: Twentieth-Century American Photography from the
Collection of the Center for Creative Photography*, edited
by James Enyeart, 62–71. Boston: Bulfinch Press, Little,
Brown and Company, 1989.

Gil-Glazer, Ya'ara. "'To Put the Camera Back in the Hands of
Honest Photographers': The Activist Pedagogy of the
Photo League." *photographies* 12, no. 1 (December 24,
2018): 19–44. https://doi.org/10.1080/17540763.2018.1
501724.

Gil-Glazer, Ya'ara. "'We Weren't Jewish (We Were Con-
cerned Photographers)': The Photo League's Archive of
Black Lives in New York." *Jewish Culture and History* 20,
no. 4 (2019): 359–381. https://doi.org/10.1080/14621
69X.2019.1662626.

Goldberg, Vicki. *Bruce Davidson: An Illustrated Biography*.
Magnum Legacy. New York: Magnum Foundation, Pres-
tel, 2016.

Gopnik, Adam. "Improvised City: Helen Levitt's New York."
New Yorker, November 11, 2001.

Herzog, Melanie. "Ida Wyman: Chords of Memory." *Wisconsin
People & Ideas*, Winter 2014. https://www.wisconsin
academy.org/magazine/ida-wyman-chords-memory.

Hirsch, Marianne. *Family Frames: Photography, Narrative, and
Postmemory*. Cambridge, MA: Harvard University Press,
1997.

Hirsch, Marianne. "Introduction: Familial Looking." In *The Fa-
milial Gaze*, edited by Marianne Hirsch, xi–xvi. Hanover:
University Press of New England, 1999.

Hostetler, Lisa. *Street Seen: The Psychological Gesture in
American Photography, 1940–1959*. New York: Delmonico
Books-Prestel, 2010. Published in conjunction with an
exhibition of the same name, organized by and pre-
sented at the Milwaukee Art Museum, January 30–April
25, 2010.

Ings, Richard. "Making Harlem Visible: Race, Photography
and the American City, 1915–1955." PhD diss., University
of Nottingham, 2003. http://eprints.nottingham.ac.uk
/id/eprint/14161.

Jacobs, Jane. *The Death and Life of Great American Cities*. New
York: Vintage, 1961.

Jaffee, N. Jay. *Photographs 1947–1955*. Published by N. Jay Jaffee, 1976.

Jaffee, N. Jay. "Reflections: My Early Photographs." September 17, 1996. http://njayjaffee.com/writing/reflections-my-early-photographs/.

Kazin, Alfred. *A Walker in the City*. New York: Harcourt, Brace and Company, 1951.

Kelly, Ariana. *phone booth*. Object Lessons Series. New York: Bloomsbury Academic, 2015.

Kismaric, Susan, and Eva Respini, *Fashioning Fiction in Photography since 1990*. New York: The Museum of Modern Art, 2004. Published in conjunction with an exhibition of the same name organized by the Museum of Modern Art, April 16–June 28, 2004.

Klein, Mason. "Modern Look: Photography, Innovation, and the American Magazine." In *Modern Look: Photography and the American Magazine*, edited by Mason Klein, 22–85. New Haven, CT: Yale University Press; New York: Jewish Museum, 2020. Published in conjunction with the exhibition of the same name organized by the Jewish Museum, May 1–September 13, 2020.

Klein, Mason. "Of Politics and Poetry: The Dilemma of the Photo League." In Mason Klein and Catherine Evans, *The Radical Camera: New York's Photo League, 1936–1951*, 10–29. New York: Jewish Museum; New Haven, CT: Yale University Press, 2011. Published in conjunction with an exhibition of the same name, organized by and presented at the Jewish Museum and the Columbus Museum of Art, November 4, 2011–March 25, 2012.

Klein, William. *New York 1954–55* [version of *Life Is Good & Good for You in New York! Trance Witness Revels*]. Manchester: Dewi Lewis Publishing, 1995.

Köhler, Andrea. *Passing Time: An Essay on Waiting*. Translated by Michael Eskin. New York: Upper West Side Philosophers, 2011.

Kohn, Tara. "An Eternal Flame: Alfred Stieglitz on New York's Lower East Side." *American Art* 30, no. 3 (Fall 2016): 112–29. https://doi.org/10.1086/690269.

Kozloff, Max. "Leon Levinstein and the School of New York." In Bob Shamis, *The Moment of Exposure: Leon Levinstein*, 45–52. Ottawa: National Gallery of Canada, 1995. Published in conjunction with the exhibition *Leon Levinstein* organized by the National Gallery of Canada, February 9–June 18, 1995; Museum of Modern Art, July 20–October 17, 1995; Nickle Arts Museum, November 3, 1995–January 1996.

Kozloff, Max. "New Documents Revisited." In *Arbus, Friedlander, Winogrand: New Documents, 1967*, exhibition catalog, 21–27. New York: Museum of Modern Art, 2017.

Kozloff, Max. *New York: Capital of Photography*. New York: Jewish Museum; New Haven, CT: Yale University Press, 2002. Published in conjunction with an exhibition of the same name, organized by and presented at the Jewish Museum, April 28–September 2, 2002; Madison Art Center, Madison, Wisconsin, December 7, 2002–February 16, 2003; Musee de Elysée, Lausanne, Switzerland, April 10–June 9, 2003.

Kozloff, Max. "A Way of Seeing and the Act of Touching: Helen Levitt's Photographs of the Forties." In *The Privileged Eye: Essays on Photography*, 29–42. Albuquerque: University of New Mexico Press, 1987.

Kozol, Wendy. *Life's America: Family and Nation in Postwar Photojournalism*. Philadelphia: Temple University Press, 1994.

Lebowitz, Fran. "On Winogrand's New York." In Garry Winogrand, *The Man in the Crowd: The Uneasy Streets of Garry Winogrand*, 13–14. San Francisco: Fraenkel Gallery, 1999. Published in conjunction with an exhibition held at Fraenkel Gallery, San Francisco, January–February 1999.

Lee, Anthony. "Arbus, the Magazines, and the Streets." In *Diane Arbus: Family Albums*, edited by Anthony W. Lee and John Pultz, 21–62. New Haven, CT: Yale University Press, 2003.

Leipzig, Arthur. *Growing Up in New York*. Boston: David R. Godine, 1995.

Lesy, Michael. *Long Time Coming: A Photographic Portrait of America, 1935–43*. New York: W. W. Norton, 2002.

Levitt, Helen. *Helen Levitt*. Brooklyn, NY: powerHouse books, 2008.

Levitt, Helen. *Here and There*. Brooklyn, NY: powerHouse books, 2003.

Liebmann, Lisa. "Louis Faurer on City Streets." *Aperture*, no. 88 (1982): 4–7. http://www.jstor.com/stable/24472151.

Lifson, Ben. "Garry Winogrand's Art of the Actual." In Garry Winogrand, *The Man in the Crowd: The Uneasy Streets of Garry Winogrand*, 152–61. San Francisco: Fraenkel Gallery, 1999. Published in conjunction with an exhibition held at Fraenkel Gallery, San Francisco, January–February 1999.

Livingston, Jane. *The New York School: Photographs, 1936–1963*. New York: Stewart, Tabori and Chang, 1992.

Lukitsch, Joanne. "Alone on the Sidewalks of New York: Alfred Stieglitz's Photography, 1892–1913." In *Seeing High &*

Low: Representing Social Conflict in American Visual Culture, edited by Patricia Johnston, 210–27. Berkeley: University of California Press, 2006.

Marcus, Alan. "Looking Up: The Child and the City." *History of Photography* 30, no. 2 (Summer 2006): 119–33. https://doi.org/10.1080/03087298.2006.10442854.

McEuen, Melissa A. "Exposing Anger and Discontent: Esther Bubley's Portrait of the Upper South during World War II." In *Searching for Their Places: Women in the South across Four Centuries*, edited by Thomas H. Appleton and Angela Boswell, 238–56. Columbia: University of Missouri Press, 2003.

Meister, Sarah Hermanson. "Picturing New York." In *Picturing New York: Photographs from the Museum of Modern Art*, 9–21. New York: Museum of Modern Art, 2009. Published in conjunction with an exhibition of the same name organized by and presented at the Museum of Modern Art, New York, March 26–June 14, 2009.

Meyerowitz, Joel. *How I Make Photographs*. Masters of Photography. London: Lawrence King Publishing, 2020.

Meyers, William. "Jews and Photography." *Commentary* 115, no. 1 (January 2003): 45–48.

Milkman, Paul. *PM: A New Deal in Journalism, 1940–1948*. New Brunswick, NJ: Rutgers University Press, 1997.

Moore, Deborah Dash, Jeffrey S. Gurock, Annie Polland, Daniel Soyer, and Howard Rock. *Jewish New York: A History of a City and a People*. New York: New York University Press, 2017.

Moore, MacDonald, and Deborah Dash Moore. "Observant Jews and the Photographic Arena of Looks." In *You Should See Yourself: Jewish Identity in Postmodern American Culture*, edited by Vincent Brook, 176–204. New Brunswick, NJ: Rutgers University Press, 2006.

Moore, Deborah Dash. "On City Streets," *Contemporary Jewry* 28 (2008): 84–108. https://doi-org.proxy.lib.umich.edu/10.1007/BF03020933.

Moore, Deborah Dash. "Walkers in the City: Young Jewish Women with Cameras." In *Gender and Jewish History*, edited by Marion A. Kaplan and Deborah Dash Moore, 281–304. Bloomington: Indiana University Press, 2011.

Nasaw, David. *Children of the City: At Work and at Play*. Garden City, NY: Anchor/Doubleday, 1985.

Nolan, Leslie. "Lee Sievan (1907–1990), a New York Photographer." In *Creative Lives: New York Paintings and Photographs by Maurice and Lee Sievan*, 2–32. New York: Museum of the City of New York, 1997. Published in conjunction with an exhibition of the same name at the Museum of the City of New York, June 17–November 9, 1997.

Ollman, Leah. "The Photo League's Forgotten Past." *History of Photography* 18, no. 2 (Summer 1994): 154–58. https://doi.org/10.1080/03087298.1994.10442345.

Photo Notes, February 1938–Spring 1950. A Visual Studies Reprint Book. Rochester: Visual Studies Workshop, 1977.

Pollak, Benjamin. "Reassessing *A Walker in the City*: Alfred Kazin's Brownsville and the Image of Immigrant New York." *American Jewish History* 97, no. 4 (October 2013): 391–411. https://doi.org/10.1353/ajh.2013.0030.

Puff, Helmut. "Waiting in the Antechamber." In *Timescapes of Waiting: Spaces of Stasis, Delay, and Deferral*, edited by Christopher Singer, Robert Wirth, and Olaf Berwald, 17–34. Leiden: Brill Rodopi, 2019.

Rice, Shelley, and Naomi Rosenblum. *Walter Rosenblum: Photographer*. Dresden: Verlag der Kunst: Kunstverlag Weingarten, 1990.

Rosenblum, Naomi. "From Protest to Affirmation: 1940–1950." In *Decade by Decade: Twentieth-Century American Photography from the Collection of the Center for Creative Photography*, edited by James Enyeart, 48–61. Boston: Bulfinch Press, Little, Brown and Company, 1989.

Rosenblum, Naomi. *A History of Women Photographers*. New York: Abbeville Press, 1994.

Sandeen, Eric J. *Picturing an Exhibition: "The Family of Man" and 1950s America*. Albuquerque: University of New Mexico Press, 1995.

Sandweiss, Martha A. "The Way to Realism: 1930–1940." In *Decade by Decade: Twentieth-Century American Photography from the Collection of the Center for Creative Photography*, edited by James Enyeart, 35–47. Boston: Bulfinch Press, Little, Brown and Company, 1989.

Seaborne, Mike, and Anna Sparham. *London Street Photography: 1860–2010*. Stockport: Dewi Lewis Publishing, 2011.

Shamis, Bob. "Leon Levinstein: His Life and Photographs." In Bob Shamis, *The Moment of Exposure: Leon Levinstein*, 10–44. Ottawa: National Gallery of Canada, 1995. Published in conjunction with the exhibition *Leon Levinstein* organized by the National Gallery of Canada, February 9–June 18, 1995; Museum of Modern Art, July 20–October 17, 1995; Nickle Arts Museum, November 3, 1995–January 1996.

Stettner, Louis. "Autobiography." In *Wisdom Cries Out in the Streets*, 17–21. Paris: Flammarion, 1999.

Stettner, Louis. "Cezanne's Apples and the Photo League: A Memoir." *Aperture*, no. 112 (Fall 1988): 14–35.

Strand, Paul. *Paul Strand: A Retrospective Monograph, the Years 1915–1968*. New York: Aperture, 1971. Published in conjunction with a major retrospective exhibition by the Philadelphia Museum of Art, City Art Museum of St. Louis, Boston Museum of Fine Arts, Metropolitan Museum of Art, Los Angeles County Museum of Art, M. H. de Young Memorial Museum of San Francisco.

Taylor, William R., ed. *Times Square: Commerce and Culture at the Crossroads of the World*. Baltimore: Johns Hopkins University Press, 1991.

Thomas, Ann. *Lisette Model*. Ottawa: National Gallery of Canada, 1990. Published in conjunction with an exhibition of the same name organized by the National Gallery of Canada, Ottawa, October 5, 1990–January 6, 1991; International Center of Photography, New York, February 2–March 23, 1991; Museum of Art, San Francisco, April 18–June 9, 1991; Vancouver Art Gallery, Vancouver, July 17–September 9, 1991; Museum of Fine Arts, Boston, Autumn 1991; Museum Ludwig, Cologne, Spring 1992.

Trachtenberg, Alan. "Photography and Social Knowledge." *American Art* 29, no. 1 (Spring 2015): 5–8. https://doi.org/10.1086/681649.

Tucker, Anne. "A History of the Photo League: The Members Speak." *History of Photography* 18, no. 2 (Summer 1994): 174–84. https://doi.org/10.1080/03087298.1994.10442347.

Tucker, Anne. "The Photo League," *Creative Camera* 223–24 (July/August 1983): 1013–19.

Tucker, Anne Wilkes. "The Photo League: A Center for Documentary Photography." In Anne Wilkes Tucker, Claire Cass, and Stephen Daiter, *This Was the Photo League: Compassion and the Camera from the Depression to the Cold War*, 8–19. Chicago: Stephen Daiter Gallery; Houston: John Cleary Gallery, 2001.

Tucker, Anne Wilkes. "A Rashomon Reading." In Mason Klein and Catherine Evans, *The Radical Camera: New York's Photo League, 1936–1951*, 72–85. New York: Jewish Museum; New Haven, CT: Yale University Press, 2011. Published in conjunction with an exhibition of the same name, organized by and presented at the Jewish Museum and the Columbus Museum of Art, November 4, 2011–March 25, 2012.

Tucker, Anne Wilkes. "So Intelligent, . . . So Angry, and Having Such a Passion for the World." In *Louis Faurer*, 13–47. Houston: Museum of Fine Arts; London: Merrill Publishers Limited, 2002. Published in conjunction with an exhibition *Louis Faurer Retrospective* organized by the Museum of Fine Arts, Houston, January 13–April 14, 2002; Addison Gallery of American Art, Phillips Academy, Andover, Massachusetts, May 4–July 18, 2002; Museum of Photographic Arts, San Diego, California, August 11–October 20, 2002; The Art Institute of Chicago, November 9, 2002–January 26, 2003; Philadelphia Museum of Art, June 14–September 7, 2003.

Tucker, Anne Wilkes, Claire Cass, and Stephen Daiter. *This Was the Photo League: Compassion and the Camera from the Depression to the Cold War*. Chicago: Stephen Daiter Gallery; Houston: John Cleary Gallery, 2001.

VanArragon, Elizabeth Jane. "The Photo League: Views of Urban Experience in the 1930s and 1940s." PhD diss., University of Iowa, 2006. ProQuest Dissertations Publishing, 2006. 3225681.

Van Haaften, Julia. "A Solitary Walker in Brooklyn." In Larry Racioppo, *Brooklyn Before: Photographs, 1971–1988*, 13–31. Ithaca: Three Hills, an imprint of Cornell University Press, 2018.

Wasserman, Suzanne. "Choreography of the Streets: The Life and Work of Rebecca Lepkoff." In Rebecca Lepkoff, *Life on the Lower East Side: Photographs by Rebecca Lepkoff, 1937–1950*, 32–44. New York: Princeton Architectural Press, 2006.

Weegee (Arthur Fellig). *Naked City*. New York: Essential Books, 1945.

Westerbeck, Colin, and Joel Meyerowitz. *Bystander: A History of Street Photography*. Boston: Little, Brown and Company, 1994.

Yamada, Takayuki. "An Analysis of Berenice Abbott's 'Changing New York': People and Lives of the Heterogeneous City." *Waseda Rilas Journal* 4 (2016): 225–41.

Yochelson, Bonnie. *Esther Bubley: On Assignment*. New York: Aperture, 2005.

Zuker, Joel Stewart. "Ralph Steiner: Filmmaker and Still Photographer." PhD diss., New York University, 1976. University Microfilms.

Zurier, Rebecca. *Picturing the City: Urban Vision and the Ashcan School*. Berkeley: University of California Press, 2006.

Zurier, Rebecca. "Whose Metropolis, Whose Mental Life? Rethinking Space and the Local in Urban Imagery." In *Complementary Modernisms in China and the United States: Art as Life/Art as Idea*, edited by Zhang Jian and Bruce Robertson, 138–57. Santa Barbara: Punctum Books, 2020. https://doi.org/10.21983/P3.0269.1.00.

Interviews

Bernstein, Irwin. Interview by Deborah Dash Moore, summer 2004.

Cherry, Vivian. Interview by Deborah Dash Moore. July 9, 2009.

Engel, Morris. "Morris Engel: Photographer/Filmmaker." Interview by Julia Van Haaften, October 2, 1999, in *Morris Engel: Early Works*, 1–9. New York: Morris Engel and Ruth Orkin Photo Archive, 1999.

Handelman Meyer, Sonia. Interview by Deborah Dash Moore, July 27, 2020.

Kattelson, Sy. Interview by Deborah Dash Moore. August 2, 2008.

Kerner, Sid. Interview by Deborah Dash Moore. July 23, 2009.

Leiter, Saul. "Saul Leiter on the Art of Going Unnoticed." Interview by Sam Stourdzé, in *Saul Leiter*. Göttingen: Steidl, 2008.

Lepkoff, Rebecca. Interview by Deborah Dash Moore. July 16, 2009.

Libsohn, Sol. Interview by Gary Saretsky. January 28, 2000. "Remembering the 20th Century: An Oral History of Monmouth County." Monmouth County Library Headquarters. https://www.co.monmouth.nj.us/documents /106/SolLibsohn.pdf.

Rosenblum, Walter. "Interview by Colin Osman." *Creative Camera* 223–24 (July/August 1983): 1019–21.

Wyman, Ida. Interview by Noa Gutterman. August 28–29, 2012.

index

Note: Page numbers in italics refer to figures.

9/11, 251

Abbott, Berenice, 5, 244
 Changing New York, 19–21, 260n25
 Greyhound Bus Terminal, 139–40
 Hell Gate Bridge I, 19, *21*
 at Photo League, 19, 20, 244, 258n8
 Under Riverside Drive Viaduct, 19, *20*
 Seventh Avenue Looking South from 35th Street, 5, *6*
 as teacher, 245
Abraham Lincoln High School, 77
Abrashkin, Raymond (Ray Ashley), 78
Adler, Florence, 77
advertising, 14, 131–32, 207, 210, 216, *217,* 234–35
Aerograd (film), 263n12
aesthetics, 24, 34, 111, 241
 commercial, 232
 Jewish, 43, 72, 204, 242
 native New Yorkers contesting, 35–39
 and politics, 8, 12, 15, 43, 128, 205, 242
 and poverty, 214
Agee, James, 52, 274n8
Agnew, Jean-Christophe, 134–35
air conditioning, 135
Álvarez Bravo, Manuel, 52

American Labor Party, 16
antisemitism, 15–16, 23, 122, 236
 in film, 124
 in New York, 28, 126–28, 268n26
Arbus, Diane, 236, 242, 267n23, 274n20
art
 commercial photography as, 40, 234
 galleries, 52, 219, 232, 273n39, 274n11
 and life, boundaries between, 122
 photography as, 2, 12, 241–42
 workers, photographers as, 260n27
 world, antisemitism in, 16
 See also Federal Art Project
"Ashcan School of Photography," 27, 55, 261n39
Ashjian, Lucy, 203, 272n2
Ashley, Ray (Raymond Abrashkin), 78
Atget, Eugene, 5, 19, 244
audiences, 52–53, 194
Automats, 147, *148, 201,* 202
Avedon, Richard, 72, 95, 236, 241, 249, 266n25

Baldwin, James, 249
Barberie, Peter, 244
Bayor, Ronald H., 268n26
Bengie (gang leader), 104–5
Berger, John, 50, 52, 263n11, 263n17
Berger, Maurice, 203–4

Bernstein, Irwin, 245
Bernstein, Leonard, 102
Bernstein, Lou
 background of, 101–2, 245
 Father and Child, 1943, 101
 on Grossman, 219
 Steeplechase, 1951, 102, *103*
Bezner, Lili Corbus, 248, 260n36
Bhabha, Homi, 181
Black New Yorkers, 7, 271n12
 as business owners, 204–6
 children, 45–47, *46*
 as city's soul, 150, 153
 conversations between, 188, 190
 and Harlem riots, 203
 increasing numbers of, 233
 influx of, 42, 81
 Jewish photographers of, 203–4
 parents and children, *80, 85,* 101
 segregation of, 34, 109, 233
Blair, Sara, 203, 204, 207, 272n5
Block, Amanda, 244
Bloom, Suzanne, 18
Bluestone, Daniel, 213
body idioms, 144, 182
body language, 43, 198
Bonanos, Christopher, 75, 244
Bourke-White, Margaret, 110
Brassaï, 234
breadlines, 166
Brodovitch, Alexey, 91, 195, 245
Brokaw, Lucile, *94,* 95

Brookfield, Molly Miller, 150, 195, 269n17
Brooklyn. *See specific neighborhoods*
Brown, Joe E., 226
Brownsville, 1, 130, 147, 207, 213–16
Bruce, Lenny, 72, 239
Brueghel, Peter, 110
Buber, Martin, 191
Bubley, Esther, 139, 140–43, 269n11
 Automat photos of, 147, *148, 201,* 202
 background of, 144, 247
 chestnut seller captured by, 220–21, *222*
 family tensions captured by, 235
 Greyhound Bus Terminal series, *142–145*
 Newsstand. New York City. c. 1944., 222–23, *224*
 Shoeshine. New York City, 226–27, *228*

cafeterias and diners, 145–50, 202
Camera Work (magazine), 2, 152, 243
candy stores, 13–14, *14,* 205–6, 258n12
Capa, Robert, 64
Caron, David, 145, 147
Carrabine, Eamonn, 144
cars, 138
Carter, Michael, 203, 258n5
Cartier-Bresson, Henri, 52, 234
catcalling, 150, 195, 269n17
Catholics, 7
 intrareligious conflict between, 7, 102
 San Gennaro festival and, 59–66, *67, 69*
Catholic Worker Movement, 166
Central Park, 7
chalk games, 111, *112, 119,* 121
Chanin, Irwin, 132
Chelsea, 16–18, 22
"Chelsea Document," 16–18, 22, 55
Cherry, Vivian, 115, 269n22
 Antoinette, 152, 153
 background of, 128, 248
 Boy on Stairs by Bananas, 153, 153–54
 Catholic Worker commissioning, 166, *167*
 conversations captured by, 185–88
 Crossfire, Game of Guns 2, 1947, 124, *126*

Game of Lynching, 1947, 122, *123–25*
Three Women with Wash, 187
Three Young Children Talking, 186
 woman and girl on threshold photographed by, 177–79, *178*
 Yorkville Swastika, 1948, 124–28, *127*
chestnut sellers, 220–21, *222*
children, 49, 111, 184–85, 263n16
 chalk games of, 111, *112, 119,* 121
 conversations between, 185
 dancing, 45–47, 49–50, 52, 69–70
 imaginative play of, 47, 52, 111, 113, 122, 138
 interracial play of, 47, 111–12, *113,* 122
 at newsstands, 222
 playing, generally, 7–8, 71–72, 109–10
 playing in hydrants, 113–14, *116*
 and police, 113–14, 227, 230
 refugees, 161
 self-consciousness of, 113
 shining shoes, 226–27, 230–32
 street as domain of, 110–11
 waiting, 153–54, *156,* 161, *162–63*
 war games of, 113, *115,* 122–26, 267n22
 women caring for, 81, 161, 182, 184–85, 188
 women photographing, 115–16
Children's Games (Brueghel), 110
Chinese New Yorkers, 188, 271n11
choice, photography involving, 263n11
The City (Steiner and van Dyke film), 18–19, 259n21, 259n23
class differences, 97, 141, 242
 in Leiter's photographs, 193–94
 Libsohn on, 55
 and movies, 130, 132
 See also working-class people
Cohan, George M., 132
Cohen, Beth, 161, 166
Cold War, 97, 122, 224, 233
Columbia Camera Club, 195
commerce, 132, 138, 188, 207
 advertising and, 14, 131–32, 207, 210, 216, 234–35
 bargaining and, 219–20
 and Black-owned businesses, 204–6
 and commercial entertainment (*see* movies)

leftist Jews depicting, 204–6
marginal, 183, 206–7, 210–16
newspaper sellers, 49, 222–26
New York defined by, 206–7
pushcart vendors and, 206, 210, 213, 215, 219–20
shoeshines, 226–32
Standard Oil project and, 139, 245, 246, 247, 268n3
street, 49, 109, 210–16
street photography as, 22, 219, 227, 232
and window shopping, 207–10
commercial photography, 193, 195, 219, 232, 234, 247
 and advertising, 40, 102, 234, 235
 of buildings, 28, *29,* 261n48
 galleries, 52
 Jews as outsiders to, 16
 Jews in, 234
 League opposition to, 11–12, 22, 23, 31–33, 258n4
 rise of, 40
 at the World's Fair, 18–19, 22, 23, 28
 See also fashion photography
communication, nonverbal, 144
communism, 11, 16, 128
 investigations of, 39, 40, 97, 242
 See also leftism
Communist Party members, 246, 259n16
Coney Island, 75–78
 boardwalk, 77, 81, 84–85, *87–89,* 104–5
 drinking fountain, 78, *80,* 81
 eroticism at, 95–101
 female photographers at, 85, 89
 Fourth of July fireworks at, *237,* 238
 gangs at, 102, 103–5
 heterogeneous crowds at, 81, 84–85, *237,* 238
 Puerto Ricans at, 95–97, *96*
 as US microcosm, 85
 working-class people at, 75–76, 78–81, 99
conversations, 201–2
 among men, 188–90, 195–97
 among women, 182–85, 186–88, 197–98
 and body language, 182, 183
 between children, 185, *186*
 and democracy, 181, 234–35
 humor in, 191, 193

Jewish thinking about, 181, 191
 overheard, 202
 with shoe shiners, 227, *229*
 telephone, 190–91, 198–201
 women photographing, 181–88
Corsini, Harold, 247, 260n34
 Playing Football, 24, *25*, 26
Cowen, Samuel, 174
cropping, 16, 35, *37*, 55, 95, 97
Crossfire (film), 124
Crowther, Bosley, 270n37

dancing, children, 45–47, 49–50, *51*, 52,
 69–70
darkroom, Photo League, 11, 13, 15,
 259n13
Davidson, Bruce, 102, 103–5, 107, 242
 background of, 102–3, 237,
 250–51
 Coney Island photographs of, *104,
 105, 237,* 238
 Freedom Riders photographed
 by, 237
 and *Life*, 266n36, 266n39
 military service of, 103, 266n36
Davis, Keith F., 16–18, 34, 35, 61, 246
Day, Dorothy, 166
Dejardin, Fiona, 28, 259n16, 262n58
democracy, 181, 234–35
demographics, 7, 8, 233, 236, 257n12,
 271n12
Denson, Charles, 77
Dewey, John, 27
Dewey, Thomas, 142–43
dialogue, street photography as, 8,
 43, 191
Diner, Hasia R., 258n12
Dinin, Sam, 260n32
Disraeli, Robert, 21
diversity
 at Coney Island, 76, 81, 84–85, 97,
 102, *237*, 238
 of New Yorkers, generally, 8, 55, 62,
 233–35, 239–41
 of working-class people, 45–47, 81,
 153, 166
Documentary Group of New York
 Photo League, 22
documentary photography, 22,
 260n27
Dovzhenko, Alexander, 263n12
Durkheim, Emile, 59
Dyer, Geoff, 250

Eagle, Arnold, 27, 247
 background of, 245
 Lepkoff taught by, 118, 246
East Harlem, 126, 128
Ebstel, John, 158, 245
Elisofon, Eliot, 21, 24, 167
 background of, 246
Ellis Island, 2
Empire State Building, 5, 28–31, *29,
 30,* 153
Engel, Morris, 12, 15, 16, 23, 181
 background of, 77, 247
 Black boy photographed by, 24, *26,*
 27, 260n37
 on candid photography, 167
 Coney Island photographed by, 77,
 78–81, *82,* 99–101
 East Side Sweet Evelyn, 36, *38,* 39
 Harlem Merchant, 204, 205–6, 222,
 224, 272n9
 Harlem photographed by, 24, 27,
 188, 190, 203, 204–6, 247
 Little Fugitive (film), 78, 227, 247
 NY Newstand, 222, *223*
 at *PM*, 110
 shoeshine boy photographed by,
 227, 230, *231,* 232
 Strand on, 35–36
 workers photographed by, *168, 169*
 Wyman and, 89
Engelhardt, Tom, 122
eroticism
 at Coney Island, 95–101
 in street commerce, 219–20
Essex Street market, 213
Ethical Culture School, 2, 243
ethnography, 68, 242, 274n20
Evans, Catherine, 258n7
Evans, Walker, 52, 55, 260n27, 274n8

families
 chosen, 274n12
 and family albums, 235, 236–37,
 238–42, 274n8, 274n20
 Jewish, 273n6
 Lower East Side characterized by,
 184
 subjects as members of, 238–39
 tensions in, 235–36
The Family of Man (MoMA exhibit), 236,
 274n8
Farm Security Administration, 18,
 27–28, 139

fashion, New York, 84–85, *89,* 176, 193,
 194
fashion photography, 193, 244, 247,
 249, 250, 266n25
 as apolitical, 40, 134
 magazines, 91, 95, 132–34, 234
 New York's centrality to, 132–34
 transgressive, 91–95
 See also commercial photography
father-child relationships, 81–84,
 85–86, 101, 134, 191, *193*
Faurer, Louis, 66–68, 247
 background of, 132–34
 Broadway, New York, 136
 City of Sin, 1950, 134
 Deaf Mutes, 191, *192*
 light used by, 158
 New York, 170, 172
 Robert and Mary Frank, 66, *67*
 *San Gennaro Festival, New York,
 NY, 69*
 Times Square, 1947, 133
 *Times Square, New York, N.Y. (Home
 of the Brave), 133*
 Untitled (woman waiting in Times
 Square), *157,* 158
Federal Art Project, 19, 34, 261n50
Feinstein, Harold
 background of, 81, 250
 *Boy on Dad's Shoulders, Coney
 Island, 1951, 86*
 *Coke Sign Boardwalk, Coney Island,
 1949, 89*
 at Coney Island, 81–84, 97
 and *The Family of Man*, 274n8
 *Father and Son by Water's Edge,
 Coney Island, 1949, 83*
 *Haitian Father and Daughter, Coney
 Island, 1949, 85*
 *Man at Parachute Jump, Coney
 Island, 1949, 87*
 *Men in Fedoras, Coney Island, 1950,
 88*
 on photography in New York, 233
 Photo League and, 81, 265n14
 Teenagers on the Beach, 1949, 99
Fellig, Arthur (Weegee), 22. *See also*
 Weegee
female gaze, 47, 174, *176–77*
Field, Marshall, III, 110
filmmakers *vs.* photographers, 55
Flukinger, Roy, 246
Fourth of July, *237,* 238

Francisco, Jason, 141
Frank, Robert, 66, 134, 249, 259n21
Frank, Robin Jaffee, 84
Fred (shoeshine boy), 227, 230–32
Freedom Riders, 237
Freeman, Joshua, 40, 42
Funny Face (movie), 266n25

Galloway, Ewing, 28, *29*
games. *See* play
Gand, Elizabeth, 45, 49, 52, 122,
 263n13, 263n14
gangs, 102, 103–5
garment industry, 5, *6*, 66, 84
Garver, Thomas, 241
Gee, Helen, 61–62, 64
 background of, 216
 on Grossman, 64, 219, 264n38
 on Levinstein, 238–39
 and Model's husband, 273n31
 Model teaching, 216, 219
 photographers exhibited by, 232,
 273n39, 274n11
gender, 7, 8, 236, 242
 and children's games, 111, 112, *114*
 Coney Island and, 85, 89, 99, 105–7
 and gendered spaces, 13–14, 72,
 158, 174
 of photographers, 47, 85, 89, 115,
 167, 195, 197
 race and, 47, *48*
 roles and responsibilities of, 161,
 166, 182, 188
 and rules of looking, 115, 167, 170
 and social convention, 182
 Times Square and, 138
 and voyeurism, 39
 See also men; women
German neighborhoods, 28, 261n42
"ghettos," 22
Gilbert, George, 15
Gil-Glazer, Ya'ara, 203, 259n15,
 260n37
Gilman, Sander, 181
Goffman, Erving
 background of, 57, 59
 on human interactions, 43, 59, 62,
 144, 182
 "The Nature of Deference and
 Demeanor," 59
"going out," 109

Goldberg, Vicki, 251, 266n36
Goldin, Nan, 236, 267n23, 274n12
Gopnik, Adam, 47, 49, 249, 262n4,
 263n13
Gordon, Yehudah Leib, 39, 262n57
Gornick, Vivian, 202
Gottscho, Samuel, 32–33, 261n48
Gray, Christopher, 139–40
Great Depression, 5, 7, 8, 39
 Automats and, 147
 documenting effects of, 47, 139,
 204
 Farm Security Administration and,
 18, 27–28, 139
 New York in, 5–7, 16, 77, 132, 166,
 213, 272n9
 and public housing, 33–34
Great Migration, 150
Greenberg, Laura, 130
Greenfield, Lauren, 236
Greyhound Bus Terminal, 139–40,
 142–45
Grossman, Sid, 11–12, *13*, 203, 246,
 258n4
 amateurs treated as equals by,
 11–12, 258n4
 in Chelsea, 16–18
 Colonial Park Pool below Sugar Hill,
 34, *35*
 as Communist Party member, 246,
 259n16
 Coney Island, Labor Day, 95–97
 at Coney Island, 95–97
 Gee on, 64, 219, 264n38
 Harlem, WPA, 37
 on Hine exhibition, 31
 investigation of, 97, 105
 leaving Photo League, 215
 military service of, 60, 64, 181, 246
 Mulberry Street series, *60–61,*
 64–65
 New York Recent, 220, *221*
 religious festivals photographed
 by, 60–62, 64, *65*
 Swimming Pool and Children, 34–35,
 36–37, 55
 as teacher, 57, 64, 105, 110, 118, 219
 WPA work of, 34–35, *36,* 261n50
 youth of, 34
guns, 128–30, 224, 267n23
Gutman, Judith Mara, 243

Hambourg, Maria Morris, 246
Handelman Meyer, Sonia
 background of, 158, 248
 conversations captured by, 188
 HIAS photographed by, 161–66
 United Pipe and Cigar Store, 160
 United Pipe and Cigar Store #2, 159
 on wartime Photo League, 181
 Women at Canera Bros. Bakery,
 189
Harlem, 7, 22, 24, 28, 68
 1935 riots in, 203
 Black population of, 271n12
Harlem Document, 27, 188, 203–4, 205,
 247, 248, 272n5
Harper's Bazaar, 91–93, 95, 234
Harris, Suzie, 16
Hearst newspapers, 182, 270n7
Hebrew Immigrant Aid Society (HIAS),
 161–66, 269n26
Herald Square, 132
Hertzberg, Arthur, 245
heterogeneity. *See* diversity
Hille, Marion "Pete," 16
Hine, Lewis, 2
 background of, 243
 Photo League exhibition of, 31,
 261n45
 *Two Workers Attaching a Beam with a
 Crane, 30,* 31
 "Work Portraits" of, 28, 31, 243
Hirsch, Marianne, 235
Hitler, Adolph, 16, 95, 126
the Holocaust, 40, 66, *127,* 161–66,
 262n59
Home of the Brave (film), *135,* 136
homosexuality, 271n23
honesty
 and morality, 72
 Photo League prizing, 18, 24–27, 31,
 50, 72, 89–91, 260n37
 in Times Square photographs,
 132
 Weegee "fudging," 75
Hostetler, Lisa, 43, 130, 207, 260n27
Howe, Irving, 147, 179, 273n6
human interactions. *See* social
 relations
human interest stories, 235, 248–49
humanity, shared, 242
humor, 191, 193, 197, 198–200, *217*

identity
 Italian American, 62
 Jewish, 42–44, 124
 and self-presentation, 45, 59
immigration restrictions, 7, 234
Independent Subway, 34
"In Dreams Begin Responsibilities"
 (Schwartz), 76
Ingersoll, Ralph, 110
Ings, Richard, 205, 272n9
International Ladies Garment Workers
 Union, 39
The Iroquois Trail (film), *134, 135*
Italian Americans, 213, 239
 conversations among, 188, *189,*
 195–97
 dominating shoe-related busi-
 nesses, 227
 fascist, 126
 gangs of, 102
 San Gennaro festival and, 59–66,
 67, 69
 waiting for work, 170, *171*
 See also Corsini, Harold

Jacobs, Jane, 47, 174, 182
Jaffee, N. Jay
 background of, 213, 215, 249
 Canal Street, NYC, 1953, 216, *218*
 *Fools of Desire (aka Stadium Theater
 with Children, Brownsville, Brook-
 lyn), 1950,* 130, *131*
 *Kishke King, Pitkin Avenue, Browns-
 ville, Brooklyn, 1953,* 216, *217,*
 273n28
 politics of, 214–15
 *Shoeshine Conversation, New York
 City (Downtown),* 226, 227, *229*
 *Woman Selling Vegetables, Blake
 Avenue, Brooklyn, 1949,* 213–15
Jewish American culture, 40, 239,
 262n59
Jewish immigrants, 7
 documenting, 2, 216, 262n59
 foods popular with, 216
 neighborhoods of, 7, 147, 183, 211,
 213, 216
 postwar, 40
 second generation of, 7–8, 53
 See also Jewish refugees
Jewish Museum, 247

Jewish neighborhoods, 7, 53, 147,
 261n42. *See also specific
 neighborhoods*
Jewishness
 conscious, 72
 and the family, 273n6
 vs. goyishness, 72
 as malleable, 43
 menshlichkeyt and, 262n57
 as normative, 39
Jewish photographers
 Klein on, 72–73, 234
 Kozloff on, 8, 43, 263n16
 neighborhoods studied by, 138
 politics of, 1, 8, 42–43
 as "professional strangers,"
 236–37
 search for solidarity by, 8, 12, 23,
 242, 263n16
 style created by, 8, 39, 43–44,
 263n16
 young lives of, 8–9
Jewish refugees, 40, 233, 244
 at Hebrew Immigrant Aid Society
 (HIAS), 161–66
 social dislocation of, 207
Jews, whiteness and, 203, 204, 241
John F. Kennedy Airport, 200–201
Jubilee (magazine), 166, 270n32
Judaism, observance of, 68, 194, 245,
 249. *See also* Jewishness
Junior Bazaar, 134

Kaplan, Marion, 166
Kasson, John, 76, 265n2
Kazin, Alfred, 1, 213, 214, 216
Kelly, Ariana, 191, 198, 201
Kirshenblatt-Gimblett, Barbara, 51
Kishke King, 216, *217*
Klein, Mason, 111
Klein, William, 103, 138, 250
 *4 Heads, Macy's Thanksgiving Day
 Parade, New York, 1954,* 239–41
 background of, 250
 *The bars of a 2 by 4 park. A bench,
 home for the homeless, New York,
 1955,* 71–72
 book by, 241
 chatting with subjects, 70–71
 Dance in Brooklyn, 1954, 69–70
 on fashion magazines, 234

Gun, Gun, Gun, New York, 1955, 224,
 226
Gun 1, 103rd Street, New York, 1954,
 129, 267n23
*Hamburger + 40¢, Eighth Avenue,
 New York, 1955,* 209–10, 273n28
on Jewishness, 72–73, 265n54
*Life Is Good and Good for You in New
 York! Trance Witness Revels,* 241,
 268n32, 274n12
on New York, 68–69, 264n45
phone booth photographs of,
 198–200
on play violence, 128, 130
Selwyn, 42nd Street, New York, 1955,
 137
Theatre Tickets, New York, 1955, 191,
 193
Köhler, Andrea, 142
Kozloff, Max, 241, 242
 on Jewish photographers, gener-
 ally, 8, 43, 263n16
 on Levinstein, 107, 245
 on urban solidarity, 182
Kramer, Stanley, 136–38
Kuznetz, Chaim, 207, 209

Ladies' Home Journal, 227, 235, 248–49
LaGuardia, Fiorello, 213
Lamb, Thomas, 139–40
laundromats, 188
Lebowitz, Fran, 195
Lee, Anthony, 236
leftism, 11, 15, 22, 51–52
 and anticommunist pressure, 40
 of the "ashcan school," 27
 Jewish, 1, 8, 16, 42–43
 and racial analysis, 153
 See also McCarthyism
Leipzig, Arthur, 109, 110, 114, 263n20
 background of, 111, 247
 *Chalk Games, Prospect Place, Brook-
 lyn, 1950,* 111, *112,* 273n24
 at *PM,* 110
 Rover, Red Rover, 1943, 112, *114*
 Stickball, 1950, 111–12, *113*
 War Games on Dean Street, 113, *115*
Leiter, Saul, 193–95
 background of, 249
Lepkoff, Rebecca, 16, 246–47
 background of, 116–18, 267n14

Cherry Street, 182–84
Greek Café, 1948, 147–50
*Kick the Can, Ridge St., Lower East
 Side, 1947,* 115–16, *117*
loiterers photographed by, 172–74,
 175
Lower East Side, 154, *156*
*Lower East Side (Boys on Sidewalk),
 119, 121*
at Photo League, 118
*Shoemaker, Madison Street, Lower
 Manhattan, NYC,* 227, *230*
street conversations captured by,
 182–84
Untitled (woman by door), 154, *155*
Lesy, Michael, 27–28
Let Us Now Praise Famous Men (Agee
 and Walker), 52, 274n8
Levinstein, Leon, 105–7, 191, 274n11
background of, 105, 245
Coney Island, 106, 239
Man in a White Suit, 238–39
Levitt, Helen, 45–49
Aerograd and, 263n12
background of, 246
on Black subjects, 47
breakthrough of, 52, 177
on children, 49, 263n8
children photographed by, 45–50,
 51, 115, *120,* 121–22, 263n14
conversations captured by, 181–82,
 183, 184–85
family of, 177
female gaze captured by, 174,
 176–77
as movie-goer, 51–52
New York, 45–47
politics of, 47, 262n4
Untitled (Black boys and men on a
 stoop), 47, *48,* 52
Untitled (Jitterbug dancers), 49–50,
 51, 52
women loitering photographed by,
 174, *176*
Levy, Julien, 52, 273n39
Lewis, John, 237
Libsohn, Sol, 11, 12, 16, 145, 193, 203
background of, 55, 246
Cafeteria, 146, 147
as Communist Party member,
 259n16

Hester Street, 1938, 52–55, 85
on Hine, 28, 31
in "New York Exhibition," 260n32
Pushcarts 2, 212, 213
Liebling, Jerome
background of, 41–42, 250
Union Square, New York City, 1948,
 40–41
Liebmann, Lisa, 135–36, 158
Life (magazine), 15, 144, 266n24,
 266n36, 266n39
Lifson, Ben, 236–37
Limelight, 219, 232, 273n39, 274n11
Livingston, Jane, 43, 52, 249
Loeb, Janice, 263n13
loitering, 172–74, *175*
looking
as active, 141, 239
camera's role in, 176, 177, 236–37
gendered rules of, 115, 167, 170
and the male gaze, 18, 36, 39,
 105–7, 150, 170, 195–98, 259n21,
 269n17
moral responsibility for, 242
power of, 107
self as subject and object of, 39,
 52–53, 73
self-conscious, 50–51, 52
as subject, 53, 55, *56*
lotteries and raffles, 62, *65*
love, eyes of, 84, 213
Lower East Side, 7, 53–55
Lepkoff and, 116–18, 121, 183–84,
 227, *230,* 246
Rosenblum capturing, 210–13
San Gennaro festival, 59–66, *67, 69*
shopping in, 210–13
Lukitsch, Joanne, 257n3
lunch-counter imagery, 18, 259n21
Lyons, Nathan, 241

Magnum, 103, 237, 251
Manhattan
vs. Brooklyn, 1, 216
center of, shifting uptown, 5, 7
wealth and power of, 1–2
See also specific neighborhoods
Manning, Jack (Mendelsohn), 23, 203,
 261n39
background of, 248
Martin, Douglas, 248

Mason, Gabriel, 77
Mayer, Alfred, 19
McCarthyism, 40, 70, 215, 232, 242,
 244, 249
Mead, George Herbert, 263n16
men
conversations among, 188–90,
 195–97
street commandeered by, 13, 158
women harassed by, 150, 195,
 269n17
See also gender
Mendelsohn, Jack. *See* Manning, Jack
 (Mendelsohn)
Meyerowitz, Joel, 241, 242
background of, 251
Meyers, William, 42
Midnight to Dawn (club), 195
Milkman, Paul, 97, 110
Miller, Arthur, 31–32, *32*
mirrors, *120,* 121, 227, 230–32
Model, Lisette, 91–95, 97, 216, 219, 232
background of, 91, 207, 244
Coney Island Bather, 91–93, 95
display advertising depicted by,
 207
First Reflection, New York, 207, *208*
husband of, 273n31
Promenade des Anglais, Nice, 91
modernism, 12, 24
morality, 59, 72, 73, 242, 243
Morgan, Susan, 244
Morris, John, 227
Moses, Robert, 34
mothers and children, 78–81, *82,* 145,
 161, 166, 184–85
movies, 51–52, 109–10
antisemitism portrayed in, 124, *126*
children seeing, 130, *131*
and movie palaces, 132, *134,* 138
racism portrayed in, 136–38
and segregation in cinemas, 109
Times Square and, 132–38
waiting for, 170, *172*
See also specific titles
Munkácsi, Martin, *94,* 95, 97, 244,
 266n24
Museum of Modern Art, 52, 236,
 274n8, 274n11
museums, 13, 110
Musser, Charles, 78

Naked City (Weegee), 244
narrative, still photographs and, 78–81
Nasaw, David, 109, 110, 226
National Child Labor Committee, 243
National Youth Administration, 27, 158
"Negroes in New York" project, 34
neighborhoods. *See specific neighborhoods*
neighbors, 73, 174, 181–82, 210–11, 242. *See also* conversations
Newhall, Beaumont, 128
newspaper sellers, 49, *50,* 222–26
New York
 antisemitism in, 28, 126–28, 268n26
 challenges of, to photographers, 1–2, 5, 8
 Jewish vision of, 9, 39, 42
 people of, photographers ignoring, 19, 20
 as "photo central," 233
 picturesqueness of, 31–33
 printing in, 66, 264n41
 segregation in, 34, 109, 233
 social welfare services in, 166
 World War II changing, 40, 66, 81, 97, 102, 107, 215
"New York Document," 21–23, 84, 128
"New York Exhibition," 23–24, 260n32
New York Photo League
 amateur members of, 12, 23, 246, 258n4
 closing of, 42, 97, 232, 234, 241
 collegiality of, 262n58
 commerce depicted by, 204, 206
 and commercial photography, 11–12, 22, 23, 31–33, 258n4
 darkroom, 11, 13, 15, 259n13
 government persecution of, 39, 97, 105, 242, 262n58, 264n14
 Hine exhibition of, 31, 261n45
 honesty prized by, 18, 24–27, 31, 50, 72, 89–91, 260n37
 Jewishness of, 15–16, 28, 111
 membership in, 14–15, 128, 158
 members leaving, 215
 "New York Document" of, 21–23, 84, 128
 "New York Exhibition" of, 23–24, 260n32
 origins of, 1, 11, 245, 246, 258n3

people prioritized by, 22, 31–32, 39
personal turn of, 40
and *PM,* 110
politics of, 11–12, 15–16, 22, 27, 40–43, 81, 260n36
production groups, 12, 258n7
school, 12, 13, 246, 259n13
as "subversive," 40
union workers trained by, 215
women in, 12–13, 258n8
New York Public Library, 1
"New York School of Photography," 43
"nickel empire." *See* Coney Island
Nolan, Leslie, 245
No Man of Her Own (film), 170, *172,* 270n37
Nykino, 11

objectivity, 24
observation. *See* looking
Office of War Information (OWI), 139
optometry, 53
Orkin, Ruth, 16, 78, 247
Orsi, Robert, 62

parks, 71–72
parody, 68
Phillips, Sandra S., 246
photographers, 61, 64, 204, 239
 attitudes toward, 42, 99, 104
 vs. filmmakers, 55
 gender of, 47, 85, 89, 115, 167, 195, 197
 military service of, 39–40, 57, 68, 152, 153, 181, 215
 and subjects, give-and-take between, 28, 35, 47, 52–55, 57, 69–72
 waiting, 141
 war changing status of, 66
 as workers, 12, 258n7
photographs
 beach close-ups, 95
 as Coney Island souvenirs, 76, 97
 discomfort provoked by, 73
 as moral statements, 72
 presence and absence in, 263n17
 viewers' role in, 141–42
photography
 as ethnography, 68, 242, 274n20
 as industry, 102

as looking made self-conscious, 50–51, 52
 New York as center of, 40
 power of, 8, 12, 39, 232, 236
 and sense of purpose, 8, 18
 social embeddedness of, 210
 war changing, 64–66
 See also commercial photography
photography clubs, 77
photography schools, 259n13
 Photo League, 12, 13, 246, 259n13
 and workshop learning, 259n13
photojournalists, 66, 227
 of Depression era, 204
 posing as, 70–71
 Standard Oil hiring, 139–41, 142–45, 245–46, 248, 260n34, 268n2
 in World War II, 246, 250–51
Photo Notes (New York Photo League's newsletter), 12, 18, 210, 232, 258n5. *See also* "New York Document"
pictorialism, 5, 12
Pins and Needles, 39
Pitt Street, 210, 272n17
plate-glass shop windows, 207–10
play, 7–8, 71–72, 109–10
 chalk games, 111, *112, 119,* 121
 in hydrants, 113–14, *116*
 and imaginative, 47, 52, 111, 113, 122, 138
 interracial, 47, 111–12, *113,* 122
 war games, 113, *115,* 122–26, 267n22
 See also violence in play
PM, 75, 110, 126–28, 188, 244, 267n5
police, 40–41
 children and, 113–14, *116,* 227, 230, *231*
 and loiterers, 172
 and women photographers, 118
political rallies, 40–41
politics. *See* communism; leftism; socialism
Pollak, Benjamin, 214
Popular Front, 16, 78, 203
posing subjects, 24, *92, 93,* 95, 128–30, 177, 267n23
poverty, 22, 42, 45, 48, 166. *See also* Great Depression; working-class people

pricing photographs, 232
privacy, 191, 271n24
 absence of, 77, 195
 and public phones, 198–201
Prom, Sol (Solomon Fabricant), 203,
 272n2
Prose, Francine, 49
public spaces, 9, 72, 147, 234–35,
 236–37
 conversations in, 181–82
 privacy in, 198–200
 and private, blurring of, 76, 77, 89,
 122, 210, 234–35
 the street as, 109, 241
 waiting rooms, 140–42
 women harassed in, 150, 269n17
public works, 33–34
Puerto Rican New Yorkers, 42, 81,
 233–34
 at Coney Island, 95–97, 96
Puff, Helmut, 140, 142, 143
pulp magazines, 223, 224, 226
pushcart vendors, 206, 210, 212, 213,
 215, 219–20

race, 167, 204, 241, 242
 in children's games, 47, 111–12,
 113, 122
 at Coney Island, 81
 gender and, 47, 48
 of Jews, 203, 204, 241
 and movie theater segregation,
 109
 socializing by, 111
 in West Side Story, 102
Ray, Man (Emmanuel Radnitsky), 5,
 244
reading, 141
recreation, 109. See also Coney Island;
 movies; play
recreation centers, 34
Red Scare, 40
Reed-Johnson Act, 7
relationships
 in Coney Island photos, 76, 78–85,
 86
 father-child, 81–84, 85–86, 101, 134,
 191, 193
 mother-child, 78–81, 82, 145, 161,
 166, 184–85
 portraying, 36–39

religion, 7
 Catholicism, 59–66
 Judaism, 68, 194, 245, 249
 white Protestant, 257n12
resilience, pictures of, 161, 166
Richter, James, 258n4
Ripley's Believe It or Not!, 23
rituals of address, 57
Robbins, Jerome, 102
Roosevelt, Franklin D., 16
Rosenblum, Naomi, 12–13, 42, 43, 182
Rosenblum, Walter, 12–13, 181, 236
 background of, 42, 188, 210, 247–48
 Chick's Candy Store, 13–14, 158
 on emotion, 27
 Gypsies and a Vegetable Dealer,
 210–13
 Pitt Street photographed by, 13,
 210, 272n17, 272n20
Roth, Ed, 215
Rothman, Henry, 258n5

Sandeen, Eric, 66, 236
San Gennaro festival, 59–66, 67, 69
Saretsky, Gary, 246
Schleisner, William, 261n48
Schwartz, Delmore, 76
Sciorra, Joseph, 59
seeing. See looking
segregation
 of Black New Yorkers, 34, 109, 233
 Freedom Riders protesting, 237
self
 as object, 52, 263n16
 performance of, 57, 59, 73
 religion and, 62
 as subject and object, 39, 52–53, 73
Selwyn (movie theater), 137, 138
Shahn, Ben, 52, 55, 263n13
Shamis, Bob, 107, 245
shoeshines, 226–32
shopping. See commerce
Sievan, Lee, 167
 background of, 245
 Gentlemen of Leisure, 1937, 170, 171
Sig Klein's Fat Man Shop, 273n28
sign language, 191
Singer Tower, 2
Siskind, Aaron, 203, 204
 background of, 244–45
Sklare, Marshall, 182

skyscrapers, 2, 5, 28–31, 33
Sloan, John, 55
Smith, W. Eugene, 15
snapshots, origin of, 2
Snow, Carmel, 91, 95, 266n25
social conventions, 144, 182, 207
socialism, 16, 260n36. See also leftism
social relations
 capturing, 24, 53–55
 easing of, 76
 The Family of Man depicting, 236
 as glue connecting city residents,
 182, 242
 Goffman on, 43, 59, 62, 144, 182
 self-presentation in, 57, 59, 62
 street conversations and, 181–82
 at World's Fair, 234–35
 See also families; strangers
sporting events, 95
sports, street, 24, 25
Standard Oil, 139, 245, 246, 247,
 268n3
Stanislawski, Michael, 262n57
Steichen, Edward, 236, 274n11
Steiner, Ralph, 18–19, 27, 248, 259n23
 background of, 244
Stettner, Louis, 28, 181
 background of, 150–52, 249
 on Faurer's Deaf Mutes, 191
 politics of, 152–53
 Soul of New York, 150, 151
Stieglitz, Alfred, 2, 243, 257n3
 Camera Work, 152, 243
 The City of Ambitions, 2, 3, 5
 Libsohn and Grossman visiting, 55
 vocation of, 5, 257n5
Stouman, Lou, 158
 background of, 247
 Sitting in Front of the Strand, Times
 Square, 1940, 57, 58
"straight" photography, 27, 68, 167
 definition of, 24
 departures from, 97, 209, 230–32
 See also honesty
Strand, Paul, 2, 13, 55, 81, 258n10
 background of, 243–44
 on Engel, 35–36
 on Libsohn's Hester Street, 53,
 263n20
 politics of, 5, 243–44
 Wall Street, New York, 1915, 4, 5

strangers, 73, 147, 173, 242
 professional, photographers as, 71,
 72, 236, 241
 sharing space with, 234–35
the street
 as children's domain, 110–11
 and the family, 184, 227
 as home, 110
 "loitering" on, 172–74, *175*
 men commandeering, 13, 158
 organization of, 57
 as a stage, 49, 53–55, 73
 waiting on, 150–58
street commerce, 49, 109, 210–16
street photography, 49, 66–73
 appeal of, 241
 candid, 66, 73, 78, 167
 as commerce, 22, 219, 227, 232
 connotations of, 22, 260n27
 as dialogue, 8, 43, 191
 as family album, 235, 236–37,
 238–42, 274n8, 274n20
 photographers' discomfort with,
 241
 subjects' engagement with, 28, 35,
 37, 71–72, 170
 technique of, 24
street smarts, 8, 71, 241
Stryker, Roy, 27, 28, 139, 245–48,
 260n34
subjects
 dignity of, 43
 as family album, 238–39
 give-and-take with, 28, 35, 47,
 52–55, 57, 69–72
 interaction between, 36, *38*, 39
 posing, 24, *92, 93,* 95, 128–30, 177,
 267n23
 seen through loving eyes, 84, 213
 unaware of the camera, 78, 89,
 107
 unfriendly photographs of, 91
suburbanization, 18
Sultan, Larry, 236
Szarkowski, John, 49, 195, 241

Tamiris, Helen, 128, 248
telephones, 14, 181, 190–91, 198–201,
 270n2, 271n24
theater, 110
Third Avenue El, 154, *231,* 269n22

Thomas, Ann, 244
Times Square, 5, 57, *58,* 130–32,
 268n38
 cars in, 138
 movies and, 132–38
 photo booth, 198–200
 waiting in, 154, *157,* 158
 and working-class people, 130
tolerance, 174
Trachtenberg, Alan, 28, 141–42, 174,
 205–6
traffic, 18–19
travel, documenting, 139
Triborough Bridge, 34
Truffaut, François, 78
Truman, Harry, 138
Tucker, Anne Wilkes, 134, 247, 258n4,
 258n8
Tyler, Gus, 111

Unisphere, 233
United Cigar, 158, *159, 160*
United Nations building, 55, *56*
United States armed forces, 39–40,
 124, 138, 181

VanArragon, Elizabeth Jane, 258n3,
 258n10, 272n17
van Dyke, Willard, 18
Van Haaften, Julia, 244
violence in play, 113, *115,* 122, 267n22
 antisemitic, 122, 124–28
 guns and, 128, *129,* 130, 224,
 267n23
 posed, 128, *129,* 130
 racial, 122–24
voyeurism, 39, 84, 97, 107

waiting, 139–47
 architecture transformed by, 154
 for assistance, 161, 166
 children, *152,* 153–54, *156*
 in diners and lunchrooms, 145–50
 Jewish perspective on, 179
 as "loitering," 172–74, *175*
 as relational, 145, 179
 on the street, 150–58
 in Times Square, 154, *157,* 158
 for work, 166–67, 170
waiting rooms, 139, 140–45
Wasserman, Suzanne, 184, 246–47

A Way of Seeing (Agee and Levitt), 52,
 263n13
Weegee, 22, 66, 75, 110, 267n12
 background of, 244
 Coney Island, July 21, 1940, 74, 75
 The Cop Spoils the Fun, 113–14, *116*
 Sievan assisting, 245
Weiner, Dan, 16, 28, 181
 background of, 55, 57, 193, 248
 at Coney Island, 97, *98*
 Crowd Watching UN Cornerstone,
 1949, 55, *56*
 Elderly Couple inside News Booth,
 223, *225*
 on his generation, 264n25
 Individuals Lying on Each Other at
 Coney Island, 97, *98*
 Male Vendor and Female Customer
 Engaging in Conversation,
 219–20
 News Vendor, 1953, 223–24, *225*
 Portrait of Arthur Miller, 31–32
 San Gennaro Smoker, NYC, 1952,
 62, *63*
Weiner, Sandra, 12, 16, 28, 57, 248
Wenger, Beth, 205
West Side Story, 102
White, E. B., 50, 206–7
Wholesale and Warehouse Union Local
 65, 215
Williamsburg, 7
window shopping, 207–10
Winogrand, Garry, 68, 242, 271n20
 background of, 195, 250
 Lifson on, 236–37
 at the New York World's Fair, 233,
 234–35, 242
 phone conversation captured by,
 200–201
 women photographed by, 195–98
women
 blending in, 115, 118
 children cared for by, 81, 161, 182,
 184–85, 188
 children photographed by, 115–16
 conversations among, 182, *183,*
 184–85, 186–88, 197–98
 conversations photographed by,
 181–88
 and the female gaze, 47, 174, *177*
 home-based labor of, 213

women (*continued*)
 and the male gaze, 18, 36, 39,
 105–7, 150, 170, 195–98, 259n21,
 269n17
 modesty of, 99
 photographers, *vs.* men, 47, 85, 89
 Photo League leadership of, 13
 "respectable," 195, 197
 in the San Gennaro festival, 60,
 62, *64*
 street markets run by, 213–15
 and the war effort, 66
 See also gender; *specific names*
workers
 and bosses, 31
 children as, 226–27, *228,* 230, *231,*
 232
 skyscraper, 28–31
 small business owners as, 204–5
 See also working-class people
Workers Cooperative Colony, 204–5
Workers Film and Photo League, 11, 52,
 55, 245, 258n3

Workers International Relief, 258n3
working-class people, 9, *17,* 18, 27
 children, 45–47, 130
 cityscape of, 43
 at Coney Island, 75–76, 78–81, 99
 heterogeneity of, 45–47, 81
 and postwar boom, 40, 66
"works of art," 27
Works Progress Administration (WPA),
 19, 77
World's Fair of 1939, 18–23, 118, 233
 The City (film) shown at, 18–19,
 259n21, 259n23
 and skyscraper photographs,
 28–31, 33
World's Fair of 1964, 233, 234–35, *235*
World War II, 39–40, 132, 150
 children's war games and, 113, *115,*
 122–26, 267n22
 photographers' service in, 39–40,
 57, 68, 152–53, 181, 215, 247–51
 photographs, 64–66
 Photo League during, 181

 and telephone service, 191
 women's photography during, 181,
 182
Wyman, Ida, 49
 background of, 250
 at Coney Island, 85, 89, *90*
 Man Looking in Wastebasket, 85,
 89, *90*
 The News Girl, 49, *50*
 Photo League and, 89, 91

Yamada, Takayuki, 260n25
Yiddish, 7, 267n14
Yochelson, Bonnie, 243, 249, 269n11
Yorkville, 124–28

Zimbel, George, 271n20
Zuker, Joel Stewart, 259n21, 259n23
Zurier, Rebecca, 39, 150, 174